上海市高校教育高地建设项目

大师艺术教育经典

吕坚主编

上海书画出版社

# 前　言

天榭星飞，松帘月落，
在云霞巅跌宕，在风雨中疾行，
曾经步履维艰，又始终神采激扬。
风雨兼程，
共和国步履与时俱进也与世同行；
江山多娇，
共和国艺坛叠印沧海之日赤城之霞！

大道无情，运行日月，
几曾北傲荆窗，情遣荒原苍雪，
也曾西出玉门，啜饮戈壁黄沙！
铿锵的脚步踏平重重关山，
风霜的画笔记载逝水流年。
椽笔如剑，挂壁龙鸣，
雄狮吼兮苍龙翔，
短歌微吟更能长！

大道无名，长养万物，
艺术源自生活兮，复有梦想。

指尖风雨，窗外烟尘，
曾一同经历心灵的雪崩，
慰藉苍楚的斜阳；
画船载月，笔担挑云，
曾受教前辈耋硕们金针微度，
意会时雄姿英发！

大道无形，延伸天地，
多彩的印象与磅礴的理想，
在新生代手中传承发扬。
感怀父辈血汗铸就荣耀，
多少无名英雄静默付出，
成就今天的平坦与辉煌，
前路真力弥满，万象在旁。

前赴后继，望居传统，
根稳扎在磐石之上，
枝叶自如伸展于苍穹。
风萧萧兮明月铸身，

云茫茫兮奇葩塑魂，
用数番颠簸的经验，
换取一路神会的心香，
开启智慧、激发创想！

秋实盈衍，亦蕴其珍，
在丰硕的收获季节，
翻开新中国美术教育之华章，
用挂满风尘的脚步，
打下坚实的初始烙印，
铭记故人之叮咛，
谛听历史之回响！

日月既揭，乾坤清夷，
生命铸成画卷，未来建构历史。
多元化的当代中国艺坛，
重重帷幕正层层展开，
求变守成，抱朴存真，
清酒既载，其香始升！

2007年12月20日

# 献 词

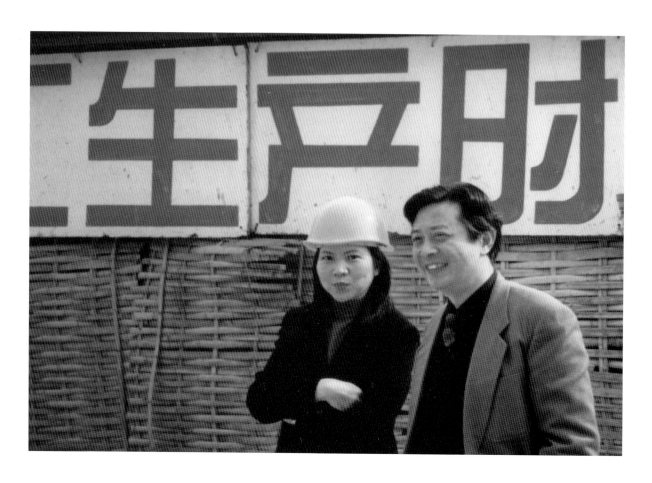

此书首先要献给
王国丽（1962—2008）、陈增灏（1949—2005）。
如果没有他们为上海大学美术学院的玻璃艺术专业所做
出的努力，那么就没有我们今天所取得的丰硕成果。

# 目　录

**第一章　艺术人生** ........................ 1

答《富丽珍奇的瑰宝》 ............ 基恩·卡明斯 2

跨文化的交响乐 ................... 庄小蔚 4

步入玻璃的殿堂 ................... 关东海 7

透明的存在

　　——布华顿与中国当代玻璃艺术教育的不解之缘... 薛吕 9

妙人·趣文·愚译·悦读 ............... 赵炯蔚 11

**第二章　艺术教育** ........................ 13

布华顿与中国玻璃艺术教育 ........... 汪大伟 14

新玻璃经济 ........................ 17

玻璃之路 ......................... 19

玻璃缘 ..................... 吕坚 25

**第三章　艺术观念** ........................ 29

玻璃时代 ......................... 30

安东尼·勒彼里耶：流动的半透明不明液体 ......... 31

楼梯的灵魂：安·沃尔夫"观察"展 ......... 38

如鱼得水：凯文·戈登新作 ......... 43

玻璃之门

　　——关东海"城门"玻璃雕塑展 ......... 48

触摸虚空 ......................... 51

迈克尔·帕特利 ................... 56

富丽珍奇的瑰宝 ................... 63

试金石 ........................... 66

论制作：关于玻璃诗学 ............... 71

火精：给斯洛维奥·维里阿图罗 ............... 75

2003雷纳莫克玻璃奖 ............... 77

走出黑暗——2004英国玻璃双年展 ......... 80

喻象 ............................. 83

贝壳 ............................. 87

**第四章　评论与访谈** ........................ 93

人类尺度——何云昌行为艺术 ......... 94

欧文·皮科克：物的秘密生活 ......... 100

格架层：戴维·琼斯烧制陶器新作 ......... 103

流动的地平线 ..................... 106

安德鲁·布华顿（Andrew Brewerton）访谈 ........ 110

**艺术简历** ........................ 117

**英语原文** ........................ 121

**图版** ........................ 161

**后记** ........................ 237

第一章　艺术人生

# 答《富丽珍奇的瑰宝》

1980年，丹尼斯·波特（Dennis Potter）在斯图亚特水晶工坊安装水壶把柄

就本质而言，所有艺术都是一种自我写照。正如列奥纳多·达芬奇（Leonardo da Vinci）开玩笑似地说过："短腿的艺术家画中的人物注定是短腿的。"于是，当我读到安德鲁·布华顿（Andrew Brewerton）将我的作品描述为"丰富而奇特"时，让我不得不重新思考起这个问题。因为我从未认为我是丰富的，也从未认为我是奇特的。然而我却发现他对于我作品的表现方法和创作动机的解读是准确而富启示性的。

汤姆·菲利普斯（Tom Phillips）将艺术家称做"只是一些几十岁还在玩玩具的人"。而作为一名完全符合这一定义的艺术家，我多年来一直过于专注自己的创作，以至根本没有弄清其中丝丝缕缕的关联。故此，我大概是缺乏界定或思考这些关系所必要的洞察力和客观性吧。

谢默斯·希尼（Seamus Heaney）曾经将诗定义为一种自私和无私同在的活动。我之所以在这里提到这一点，是想要说，既然人类创作的目的是为了歌颂和表达自身的存在，那么所产生的艺术作品就要既能向别人倾诉，也能为其他人说话。我承认我作品的动机是出于一种需要：重新塑造由我选择的世界的各个方面，从而创造出我自己对于现实的看法，不管这种看法是真实的、历史的还是想象的。

20世纪所崇尚的艺术其首要之处在于独创性。这个世纪选择毕加索（Picasso）作为最伟大的艺术家之一，就已完全说明问题了。当我在20世纪50年代末上大学时，我就迫不及待地接受了这种信念，因为这种信念令你能够有机会延续童年时期对于创造个人世界方式的探寻。如构成主义艺术家库尔特·施维特斯（Kurt Schwitters）和我的导师维克多·帕斯莫尔（Victor Pasmore）所树立的榜样，引领我认识了集合艺术。这是一种完全可能使创作的组成部分均保留其原有生命力、功能性、制作法以及历史语境的艺术形式的方式。布华顿的文章中提到了化石、武器和珠宝，从而令我明白了它的出处。

我是在伦敦长大的，那时正值战后艰苦的岁月，许多时候我都呆在南肯辛顿，一半时间呆在路一边的自然历史博物馆，另一半时间则呆在路另一边的维多利亚与艾伯特博物馆（Victoria and Albert Museum），它们对我有着同样的吸引力。那些古老的骨骸和化石，如同刀剑、珠宝以及神圣的圣骨匣一样，是其原始存在的残遗。这些物体被置于玻璃后面，只能通过眼睛来欣赏它们、理解它们。而数十年

后，它们却又在我的玻璃作品中重现。

我选择以玻璃材质和窑制方法进行创作。这种创作方式不仅使我在素材、形态、色彩和质感方面获得了前所未有的丰富性，也使我得以采用一种在本质上结合改变了我记忆中形态的要素和断片，并通过冶炼将它们转化成一个崭新的整体工艺。那些赐予我灵感的形态正是形态本身，是恰当与不恰当使用——有时是被埋藏的经历——在它们身上留下的历史痕迹。在我眼里，这些痕迹使得它们更富于吸引力，而非减少其吸引力。就像布华顿所指出的那样，正是这些原因致使我在作品形态和名字上采取了模棱两可的态度。

因此，我无法也不愿将这篇关于我的创作说明看作是除了对布华顿文章的回应之外的其他任何东西。因为它阐明了关于我创作的方方面面，而一直以来它们都是若隐若现的。

当英国才子剧作家奥斯卡·王尔德 (Oscar Wilde) 说出"直到惠斯勒 (Whistler) 画了雾，伦敦才有了雾"这句话时，他并不只是洞察了惠斯勒创作其著名的薄雾笼罩的《夜曲》(Nocturnes) 时所表现出的独创性，当然，这种洞察本身就是极富纪念意义的。更重要的是，王尔德以自身的文学造诣和知识，揭示了艺术活动的基本事实，那就是艺术向我们展示了先前被我们熟识的或被偏见所掩盖的世间百态。

这种写作方式在艺术评论中是并不常见的，尤其是如果讨论的范围限于手工艺的话，就更为罕见了。在我看来，许多当代艺术评论，都有两个主要类别：描写或说明。我这样说是指评论家选择从物质或技术角度描写其评论的作品，或试图解释艺术家创作的目的所在，而通常回避更为宽泛的问题，比如关于其特质或文化背景的评价。

能够补其不足的评论则致力于解决这类困难问题，但并非武断地迎头痛击，而是更偏重有根据地剖析，也因此在同类文章中令人印象深刻。

显而易见，评论家的教育和阅历积累了语言和知识，从而形成见解。布华顿的评论写作就无疑是源自其独特的背景，结合了他在许多各有差别却又相互联系的领域中的亲身经历。例如，他必须要在大学里学习绘画或是文学之间做出选择。当然，他选择了后者，并在此期间成了发表多部作品的诗人。

从剑桥大学毕业后，布华顿出人意料地转向了制造业，先后成为了两家专业生产高档手工玻璃制品的公司设计主管。随之，他又回归学术界，成为了伍尔弗汉普顿大学 (University of Wolverhampton) 的学科带头人和学院院长，接着是达汀敦艺术学院 (Dartington College of Arts) 的校长。所有这些经历都明显地反映在他的文章和诗歌中，就像一整套灵敏（且极为锋利）的外科手术器械一样互为配合，可以用来解剖也可以用来缝合。对哲学的兴趣、对文学的了解、对手工艺活动的默契特质的认识和同情通过诗人的感性和用词淋漓尽致地表达了出来。

由此他所创作的文章，就像王尔德的看法那样，超越了纯粹的文艺评论范畴。因此，我在尝试介绍它们时，就必须像布华顿那样避免纯粹的描写。此外，这些文章等着我们去阅读。如果我可以间接发表看法的话，我会将它们联系起来加以讨论的。

对一位新艺术家的艺术作品的记录（与说明不同），有着沿循和卓越的历史；弗兰西斯·培根 (Francis Bacon) 对委拉斯开兹 (Velazquez) 的记录突然浮现在我的脑海里。从某些方面来说，布华顿的文章记录了他所评论的创作和活动，从而成为了半独立的存在。这样的存在将关于手工艺的评论从浅水区拖曳到了深水区，并在那里令读者得以了解到文化的潜流和潮汐运动。

是的，布华顿正在尝试写作一种全新的关于手工艺的评论，一种把最终作品以及把创作该作品的艺术家仅仅看作是深层文化潮流的表面现象的评论。

基恩·卡明斯 (Keith Cummings)
2008年6月

1980年，德瑞克·百利斯 (Derek Bayliss)，在斯图尔特水晶工坊吹制玻璃

1996年，在斯图尔特水晶工坊

在上海大学新校区工地上

# 跨文化的交响乐

## 一种新的艺术

与庄小蔚合影

玻璃艺术作为一个新的专业之所以在艺术院校中展露锋芒，这与安德鲁·布华顿（Andrew Brewerton）教授的文化传播理念有关（20世纪末开始的中国艺术院校玻璃工作室建设的主力军来自于以玻璃艺术教育和传播闻名的英国伍尔弗汉普顿大学（University of Wolverhampton）美术设计学院，布华顿时任学院院长），其观点是非常清晰的：即始终坚持交流思想和知识的信念，致力于跨文化的广泛传播，在这种广泛的交流和传播中，涵盖艺术和材料科学不同的领域，以丰富的人文知识、新颖的思想，促进对人类自身的更真实、更全面的认识，以及彼此的了解。

在布华顿教授看来，玻璃作为一种材料，当它通过艺术家之手变成艺术品时，无论是表达内心深处的感情，还是描写现实的表象，都能从中观察到一种绝对独特的艺术形式所具有的典型特点。他提醒我们注意：玻璃艺术作为学科地位的确立在上世纪60年代末期，这样一种艺术形式的出现正是在那些形式多样或连绵不断的文化似乎耗尽了它们借以传授给我们的表现形式的时候。工业革命推动了玻璃材料的发展，温度自动控制系统的出现，使困惑了人们几千年的玻璃分相、析晶和应力问题得以轻易地解决。在思想与行为的一切领域里，许多观念大破大立，有待于实现的力量和需要的概念与艺术家个人的才能和目标结合在一起，出现了提出新的表现方式以适应这些需要与力量的紧迫追求。作为文化和技术发展的产物，玻璃艺术便成为满足这一需求的自然手段。正如音乐、舞蹈成为原始民族表达其神话文化的方式，建筑推动着世界文化的融合，以表现自身在其中得以完美体现的社会文化一样。这是一次在现代艺术史上称之为"玻璃工作室运动"（the Glass Studio Movement）的十分巧合的聚会，各种不同的思想、价值观和技术在这一领域得以相互接触。在一些全然陌生的艺术形式，如达达主义、行为艺术、观念艺术，突然出现在我们面前，打破了我们根深蒂固的审美观念，在我们的心头播下了怀疑和痛苦的种子的时候，玻璃艺术作为一门学科问世了。

1998年至2000年，我有幸作为一名研究生在伍尔弗汉普顿大学玻璃艺术系学习并参与了欧洲的"玻璃工作室运动"。在那里完成了一系列玻璃艺术的创作和相关的理论研究。作为导师的布华顿是一个才华横溢的人，他在玻璃艺术教育和传播领

域有非凡的影响力，指导着英国和中国大学玻璃艺术学科的方向。在本文中，我试图清晰地勾画出布华顿教授关于玻璃艺术的两个重要的概念，它提供了对玻璃作为一种艺术的见解。如果说具有独立表现形式的玻璃艺术是一次真正意义上的独创，那么它也一定有几个将被载入当代艺术史的关键人物在起作用，我认为，布华顿是其中的一个。

## 技术和想象力

这是布华顿教授与我们讨论的比较多的问题之一。考虑到玻璃艺术制作的全过程所具有的技术特性，我们能否确定其艺术地位呢？如果玻璃艺术真的表现出艺术家的情感志向，纵情抒发其情怀，就理应具有一种社会地位。我们无疑是可以这么做的。正如建筑艺术是运用了许多十分严格的科学一样，精确的科学和严密的技术是玻璃艺术的基础，在创作的过程中得到了运用。

在这里再三强调技术的重要性，即玻璃艺术最主要的视觉特征是非常重要的。因为有关玻璃艺术的整个问题的解决是包含在技术问题的解决之中的。要进一步强调的是：这是整个问题。如果不在一开始就将此问题与视觉创造联系在一起，在这方面就不可能取得任何进步。如果看不到技术是一种创造视觉经验的工具，玻璃艺术就会走进死胡同，就不会取得成功。

必须承认，我们尚不清楚什么是超然的，或者说，对技术的启示和服从竟然会使艺术家复杂的情感和细微的心理变化成为通向观众情感的不可逾越的障碍，犹如丁字尺、圆规并不妨碍人们欣赏帕台农神庙所体现的完美的矩形空间比例一样。除了设计，难道就没有任何别的直接的方式能使艺术家与他们努力感染的人们进行思想交流吗？难道任何时候都没有某种技术存在于艺术和材料之间吗？玻璃艺术如果没有"技术"的参与，是决不会打动观众的。交响乐借助于形式各异的乐器，各种相同的符号系统灵活自如地将十分复杂的管弦乐曲注入到这些乐器之中，才产生了这样一种伟大的样式。同样，玻璃技术也是存在于在它面前展现的奇妙而多样的表现效果和置身于其后的艺术家两者之间的中介。任何艺术总是需要艺术家的智慧去对构成这件作品的一切因素加以取舍、编排、组合和配置的。

布华顿教授告诉我们，玻璃艺术的伟大贡献是凭借着它的技术手段向我们展示了一些艺术家所理解的色彩关系和形式，使我们想到了他们观察事物的眼光，一种有个性的眼光。光效应艺术家B．Biley 和 R．Neal向我们展现了新的空间，仿佛让我们看到了光通过玻璃反射或者折射下来的艺术形式。多媒体艺术对光的调节展现波澜起伏、微妙无穷的背景变化也不是在暗示着玻璃世界的景象吗？

从本质上说，英国玻璃艺术家Keith Cummings、Stuart Garfoot、Colin Reid在当代艺术领域发挥的作用，与印象派绘画在美术史、中国水墨艺术在人文方面所起的作用毫无二致。他们都是有远见卓识的人。他们在一本别人看不到的书中毫无困难地诠释着现实，这是玻璃艺术以其魔幻般的材料和精确的技术在我们面前所展现的世界，它给我们的启示与其自身发展的技术过程是完全同步的。比如，光通过特殊加工的玻璃可以产生"漫射"的效果，如同电影中的"慢动作"，表现出来的是一粒子弹穿越鸡蛋的细部运动方式，通过它使我们了解到运动中表现出来的那种动态平衡的诗一样的意境奥秘。就视觉的辩证的演进和由此而产生的形而上学的分析而言，令人叫绝的技术的每一个启示都代表了沿着这条道路迈出的极其稳健且史无前例的一步。

## 视觉捕捉到的人生旋律

布华顿教授在教学中不断强调视觉与人生的关系，在我们的大脑中记忆最深

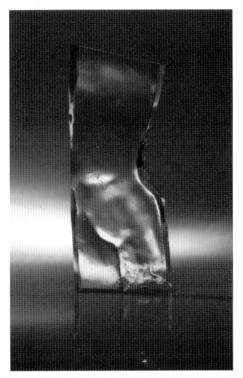

身体 庄小蔚 长120mm，宽80mm，高250mm，2003年

编织 庄小蔚，长20mm，宽10mm，高25mm，2003年

方尖碑 庄小蔚 长12mm，宽12mm，
高55mm，2004年

蓝笛 庄小蔚 长180mm，宽180mm，
高620mm，2006年

的是和感情有关的东西：小溪的流水、落入干涸大地的雨点、摇曳的玉米和树冠、潮水般的人群、车轮在铁轨上有节奏地滚动。如果我们试图用视觉语言去解释这一切，就会产生一些特别的意义，这种如音乐般的抽象解释通过视觉能够引起人们内心深处的激荡。

用热玻璃技术记录的图像所展示的形态，在任何时候都能确保严谨的科学程序和崇高的审美情趣，并使两者相互统一和进行有益的交流。它们融为一体，出现在统一的表现形式之中，为我们的感官所理解，使我们用观察个人的方式所留下的印象与这种方式在我们的脑海中产生的情感同时并存。玻璃艺术用互相依存的视觉感知激发了在空间上互相依存的音乐感知，是一种通过视觉传递给我们的音乐形式。这一令人难以置信的现象似乎包含着一种表现力的奥秘，这种力量的统一是我们的精神力量的表达，是一种出乎人意料的艺术才能，显示出了一种不同凡响的想象力和有节律的神韵，这是充满自由、欢乐和不懈地创造的诗的火焰。

我们已经拥有了无限的能力，可以贯穿整个人生，甚至是人的视力最难看到的人生的表现方式，以及视觉形态中难以察觉的分子振动和与思想脉搏的节奏紧密相连的表现效果，走向用视觉和节奏形式解释世界的道路。从而使上述表现结果进入一种有生命的活跃的状态，进入我们的内心世界，在视觉品味及其情感语言之间存在着一种持续不断的交流过程，这种表现结果将影响我们的心理态度，甚至我们的习惯性思维方式。同时，在我们看来，玻璃语言的表现力实际上几乎是无限的——指的不单单是技术，它在一个广阔的领域超出了三维的物质形态的范畴，在一个充满了视觉和运动的现实之中，通过热玻璃的熔融状态逐渐地推进玻璃的形态，这一过程与音乐作品十分相似——任何优秀的艺术形式，都会有这样一种效果。

布华顿教授说："毫无疑问，在目前动荡不安的艺术状态下，正在出现一种裂变，玻璃艺术可能对当代艺术产生积极的影响，它是一种技艺精湛的语言，在艺术发展史上有着特殊的意义。"

## 结语

处于动荡不安的现代艺术，犹如交响乐开始演奏之前聚集在一起的管弦乐队的喧闹声。自包豪斯运动以来，作为艺术家个人正在加入到越来越广泛的人群之中，迫切要求建立强有力的组织方式。伟大时代的艺术一定是一种合成的技术。艺术必须成为材料、技术、情感和抒情意境的集合体，成为人类精神世界中一个完美、和谐的管弦乐团，一个有众多乐器组成的，富有情感、智慧的众多人士组成的管弦乐团。优秀的玻璃作品要求观众有共享的感觉，激发普遍的情感，它如同宗教，如同基督大教堂中弥漫的"神秘音乐"。可以说，玻璃艺术是思维的进化和科技发展的表现结果。一个新的世界进入我们的中间，这个世界使人们发现了一种无法想象的语言，一种直觉创造的语言，一种跨文化的交响乐。

我们感谢布华顿，他是这场交响乐的指挥之一。

庄小蔚

## 步入玻璃的殿堂

有时人们说，一个事物如果具备了产生的条件，那么到了一定的时候它自然就产生了，但说起中国当代玻璃艺术教育的产生，就一定关系到一个重要的人物——布华顿教授。在上个世纪90年代末，布华顿教授便着手于搭建中国玻璃艺术家培养的途径，也许出于他在Stuart & Sons Ltd 工作的经历，或是在伍尔弗汉普顿大学（University of Wolverhampton）艺术与设计学院做院长时的远瞻，他感受到中国巨大的玻璃产业力量和它自身存在的问题，以及与之相应的设计人才需求；感受到中国作为一个经济正在崛起的大国，在发展达半个世纪之久的国际工作室玻璃运动中不应该再缺席了。可以讲，那时的中国极少有人了解所谓的玻璃艺术，以及它在国际上的发展现状。于是布华顿教授展开他积极的行动，与中国著名的艺术院校建立交流合作关系，通过讲座向中国学生介绍英国的玻璃艺术教育情况，指导和帮助那些想学习玻璃艺术的人到英国学习。我便是他这种工作影响下的受益者之一。

2006年，在关东海的玻璃工作室

第一次与布华顿教授相识，他温和的性格和儒雅的举止留给我很深的印象。在他的努力下，先后有十余位中国学生到伍尔弗汉普顿大学学习玻璃艺术（相信他推动中英文化教育交流的理念影响了他在伍尔弗汉普顿大学的继任者）。记得在与美国著名玻璃艺评家、考宁博物馆前任馆长Susanne Frantz的一次交谈中，她疑惑地问我："为什么中国的学生都选择在伍尔弗汉普顿大学学习（玻璃）而不是去美国？"我告诉她，一是因为伍尔弗汉普顿大学方面积极地前来中国帮助中国学生了解去英国学习的途径，另外的原因是去美国不容易获得签证。

在英国学习时常可以感受到布华顿教授对中国学生的特殊情感。他总是给予这些身处异乡的学生力所能及的帮助。在结束留学生活前，他一定会邀请中国学生去他家里做客。记得在他家里的墙上挂着汉字语音图，折射出他本人对中国文化的推崇。另外，让我感受深刻的是，伍尔弗汉普顿大学非常重视发展与中国艺术院校的长期交流合作关系，他们始终不懈地在做更多更广的学术交流活动。虽然布华顿教授现在不在伍尔弗汉普顿大学工作了，但是基于他对培养中国玻璃艺术人才所作的重要贡献，在2008年8月21日即将举办的'GLASS ROUTES：from Wolverhampton to China'展览和'CREATIVE PATHWAYS SYMPOSIUM'请他作为特殊嘉宾参加和发言，并在展览画册上发表文章。

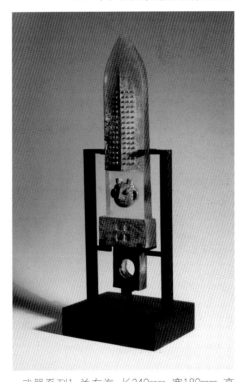

武器系列1 关东海 长240mm，宽180mm，高640mm，2006年

离开伍尔弗汉普顿大学后，布华顿教授仍然致力于推进中国和西方玻璃艺术

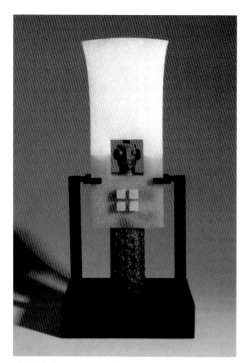

武器系列2 关东海 长235mm，宽180mm，高
510mm，2006年

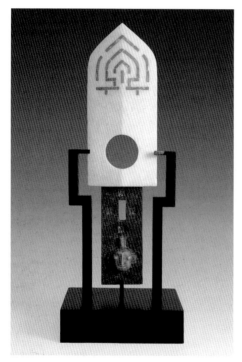

武器系列3 关东海 长140mm，宽160mm，
高510mm，2006年

家之间的学术交流。他曾试图在由他策展的瑞典著名玻璃艺术家安·沃尔夫（Ann Wolff）的个人巡回展览中加入中国站，并为中国玻璃艺术家撰写评论文章。他的无私帮助和人格魅力得到所有曾经在伍尔弗汉普顿大学学习过的中国艺术家的尊重。相信他会为加强中英艺术家之间的艺术交流活动做出更多的贡献。

关东海
2008年6月22日

## 透明的存在
—— 布华顿与中国当代玻璃艺术教育的不解之缘

1996年至今，安德鲁·布华顿（Andrew Brewerton）院长与上海大学美术学院建立合作关系已经历了整整十个年头，一个新的学科在此期间酝酿、激荡、诞生。

布华顿院长既是中国玻璃工作室运动的催化剂，也是播种者，或许他算不上一个地道的玻璃艺术家，没有太多的玻璃实践与制作，但其深厚的哲学、文学素养以及多年浸润在玻璃工厂的管理经验赋予了他豁达的思维能力。

布华顿院长有着丰富的人生经历和广泛的学术背景：他是诗人、哲学家、玻璃艺术评论家和策展人，曾经先后担任过英国Stuart Crystal 产品部经理和Dartington Crystal设计部经理，后任英国伍尔弗汉普顿大学艺术与设计学院院长，现为英国Dartington艺术学院院长。他毕生从事着与玻璃艺术相关的各种工作，为推动当代国际玻璃工作室运动的发展做出了巨大的贡献。

冬景·月亮 薛吕 直径158mm 2006年

20世纪末，在中国经济迅速发展的时代背景中，布华顿先生凭借其敏锐的目光和教育者的直觉将注意力投向了上海。此时，中国的艺术设计教育也似春笋一般，正坚毅地褪去束缚的层层外壳，处于不间断的上升时期，不断完善的设计类学科渴望新鲜养分的滋润，发掘新材料、探索新道路的趋势使全国各大美术学院相继成立了集教科研、创作于一体的各类工作室，如陶艺工作室、版画工作室、数码工作室等，在工作室的浪潮中，这位怀着第一个吃螃蟹理念的英国人只身前往中国，开辟中国玻璃工作室运动之路。无论是怀着怎样的心情和憧憬，对他来说，千里迢迢的旅程只是开端，接踵而来的困难显而易见，语言交流障碍、文化差异的互识以及建立长期合作关系中遇到的挫折等，如今在他看来都已经成为历史。

冬景·池塘 薛吕 直径158mm 2006年

布华顿院长对中国玻璃工作室的建立起到的关键性作用不言而喻，值得关注的是他对中国当代玻璃艺术现今以及未来起到的持续性作用。

布华顿院长是流动的资源，他的足迹踏遍了世界各地，每年他都会来中国，访问教育、学术机构及艺术家、博物馆、画廊等，涉及的领域包括音乐、舞蹈、纯艺术、设计等，交流范围广泛。他总会带来一些新的思路和意见，就我个人与他六年多的合作与交往中的所见所闻而言，他带来的不仅是知识，更是一种获取知

识的途径和方法。不巧的是在我赴英学习期间他已离开了伍尔弗汉普顿大学，前往Dartington艺术学院担任院长一职，但在伍尔弗汉普顿大学的玻璃工作室我依然感受到了他教育思想的延续，也渐渐地体会到了他曾经在上海玻璃工作室建设中提及的关于跨学科教育、鼓励学生与工厂交流联系、进行多样性合作等许多开拓性的意见，显然这些理念都已经渗透到了伍尔弗汉普顿大学艺术与设计学院的每个角落。最典型的例子就是陶艺工作室与玻璃工作室合并的举措，大大地增加了交叉学科互相学习的机会，体现了资源共享的互利原则，扩展了材料语言的范围。在他的领导和管理下，以基恩·卡明斯（Keith Cummings）教授为代表的一些天才当代玻璃艺术家和教育家才得以淋漓尽致地发挥他们的才能，培养了一批杰出的当代玻璃艺术领军人物，通过几代人的共同努力，将伍尔弗汉普顿大学艺术与设计学院的玻璃工作室打造成至今享有国际盛名的学习当代玻璃艺术的基地和摇篮。

也许将伍尔弗汉普顿大学的玻璃工作室比作中国玻璃工作室运动的实验室并不十分贴切，但事实是，布华顿院长成功地将伍尔弗汉普顿大学玻璃工作室培育的种子小心地移植到了中国的土地上，并用中国的"土壤、水和气候"培养它茁壮成长。不夸张地说，当今中国实践玻璃艺术的学者都与布华顿院长以及伍尔弗汉普顿大学有着不解的学术渊源。

不可否认美国和英国等当代玻璃艺术发达的西方国家都经历了几代人的努力才将玻璃从传统的工厂材料、手工艺材料慢慢地转变为一种当代实验性艺术媒介。布华顿院长贯穿中西的突出贡献是引入西方玻璃工作室模式，引导着中国的玻璃艺术（学院派）直接走向纯艺术的范畴。首先确立了玻璃艺术在学院教育机构中的地位和作用，为中国当代玻璃艺术设立了一个强大、坚实的学术背景，有效地指引了今后国内玻璃艺术市场的前景。多年来他建立的国际交流网络体系为刚刚起步的中国玻璃艺术提供了相对宽广的国际合作平台，迅速地提升了中国当代玻璃艺术的水准，他在该领域中的经验和前瞻性使中国的玻璃艺术少走了许多弯路，缩短了我们的探索之路。他主张的开放、互利的多样性合作交流原则使伍尔弗汉普顿大学玻璃工作室成为培养第一批中国当代玻璃艺术实践性人才的摇篮，可以说，中国当代玻璃艺术的发展是站在巨人的肩膀上开始的。

走过了筹备、创建初期的艰辛，中国的玻璃工作室运动又面临着怎样的挑战，今后的发展道路将何去何从，中国的玻璃艺术应该以怎样的姿态和面貌在国际玻璃艺术的舞台上占有一席之地，并以它独特的发展道路在国际玻璃艺术园中熠熠生辉，众多的问题始终盘绕在中国有志于投身玻璃艺术事业的艺术家以及布华顿先生的思绪中。如今他正一如既往地在幕后默默指导并支持着中国玻璃艺术的发展，试图将艺术家、策展人、学院、艺术机构、博物馆、画廊、收藏家等编织成一个完整的网络体系，希望从彼此的合作与交流中吸取养分，滋润中国玻璃艺术这棵大树，并期望在不久的将来，羽翼丰满的中国当代玻璃艺术能推动整个国际玻璃工作室运动的继续发展，形成一道颇具特色的风景线。

薛吕

## 妙人·趣文·愚译·悦读

　　初识安德鲁·布华顿（Andrew Brewerton），是在一个晴朗冬日的下午。他打开上海大学延长校区乐乎楼客房的门，伸手示意我们进入。回想起来，就在那一刻，他也打开了一扇通向玻璃艺术的大门。

　　记得冬日暖暖的阳光照在客厅的沙发上，满头银发的他斜倚着，神采飞扬地谈论他的思想，回答我的问题，兴之所致还在纸上涂涂画画，眼睛里闪烁着睿智的光芒。令人想起八个字：翩翩君子，温润如玉。

　　是啊，这是一段多么妙趣愉悦的经历啊！

　　布华顿其人妙。

　　他的人生很奇妙。

　　幼时有诵读困难的人却读了剑桥文学硕士，成为诗人。剑桥毕业后却去做玻璃制造业工作。成为经理后，又回归伍尔弗汉普顿大学，主持和管理玻璃艺术，横跨玻璃、文学、艺术评论和管理。

　　他与中国的机缘很奇妙。

　　他曾经谈到过他从很小的时候就对中国的艺术、诗歌、哲学和政治历史等等充满喜爱，这或许可以看作是一种直觉，一种预感，一种可遇而不可求的缘分。

　　20世纪末，在中国经济迅速发展的时代背景中，布华顿凭借着敏锐的目光和教育者的直觉将注意力投向了上海。他只身来到中国，开辟贯穿中西兼容通达的中国玻璃工作室运动之路。其间遭遇、克服了种种困难，诸如语言交流障碍、文化差异的互识，以及建立长期合作关系中遇到的挫折等，最终获得了成功。说他是中国当代玻璃艺术的先驱也不为过。

　　布华顿其文更妙。

　　妙在其趣，妙趣横生。

　　他的文字包罗万象，涉及哲学、宗教、历史、考古、文化、社会风俗乃至数学等领域。然而其文远远超出了简单的知识堆砌，而是以他自己的智慧，融会贯通。他的每篇评论都是从独特敏锐的视角切入，恰到好处地运用其渊博学识来分析，探讨了当代玻璃领域的方方面面和人类灵魂层面对生命、人生以及世界等宇宙万象的求索。

　　与作者面对面的交流和探讨，是每个译者梦寐以求的宝贵时光。我却有机会与

布华顿一起工作了几个星期，何幸之如！

然而事到临头，还是犯愁：如此美妙却也晦涩的文字，该如何用中文恰当地表达出来呢？

其文中反复谈到各类矛盾与辩证，也难怪其文字将矛盾与辩证身体力行。

他的行文富有诗意，善于运用长句，所涉及的广泛领域的知识，须仔细通读琢磨和查找资料，并加以细细品味才得以理解文中的含义。由于中西文化差异等因素，又为理解及翻译增加了许多困难。

例如，在《玻璃之路》一文中，他引用了"The road that can be followed is not the true way"，这出自早期詹姆斯·理雅各（James Legge）所译的英文版《道德经》第一句，亦即《道德经》首句："道可道，非常道。"不过这句话直译为"可以遵循的道路并非正确的道路"，与译者本人对《道德经》原文的理解，差距不小，因而翻译时颇费周折。

而在表达上，采取直译或是意译更是两难的选择。直译或许更容易从直观上理解，但是可能存在的文化差异会使理解变得困难，意译或许读者更容易明白，却不免带上翻译者本身的理解偏差。而出版社则希望在保持本书学术性的同时，亦要保证其可读性。通读全文，仔细推敲无数次，译者权衡利弊，只能尽所能忠实表达原义。

安德鲁·布华顿是一位大师，亦是一位智者，他打开了一扇明澈的琉璃窗，引领我们步入其后所隐藏的神奇绚烂而又美丽通透的世界。让我们一起来"悦"读本书，于虚实间沐浴其澄澈，领略其奥妙吧！

<div align="right">赵炯蔚</div>

# 第二章 艺术教育

# 布华顿与中国玻璃艺术教育

"如果说人类发明的历史至今已历经石器时代、青铜时代、铁器时代的话，那么我们的新千禧年——21世纪，或许就是玻璃时代了……玻璃大概是我们的第一种合成材料，本身充满了矛盾和不拘：玻璃是坚硬的，也是易碎的；是柔软的，也是脆弱的；可以是肌理粗糙的，也可以是精致光滑的；可以是透明的，也可以是朦胧的；是一种固体，同时也是一种液体。我们就栖居在吸收、过滤、折射着光线的玻璃建造物中……玻璃在物质上照亮了我们的生活，同时也隐喻地启发了我们的生活。"

与汪大伟在上海大学新校区美术学院大楼工地上

这是一位玻璃艺术家的文字，也是一位诗人的文字。他就是英国伍尔弗汉普顿大学艺术及设计学院院长安德鲁·布华顿（Andrew Brewerton）先生。在他各种文章的字里行间，你可以看到海德格尔、多默、老子、庄子、梅尔维尔、庞德等诸多文学家、哲学家的影子，他关心的领域涉及手工艺、实用工艺、建筑学、哲学、文学、地质学、音乐等，而且在各个方面都取得了相当的造诣。剑桥大学文学硕士的底蕴，塑造了他儒雅温润的言谈、内外兼修的涵养和丰神俊朗的气质。

有幸同游黄山，当看到他蓝灰色的眼睛、含蓄的笑容和花白的银发，身姿矫健地漫步于山阴道上、青山绿水之间，愉悦地爬上石级山道、轻松地翻过石梁与山坡，你会觉得他与自然映衬、融合得如此完美。那时候，素食主义的他似乎浑身不沾染烟火气息，好像他一直自由风行于天地之间，一切都能举重若轻。

的确，他在各个身份之间的游离转换看似那么轻松随意：剑桥文学系毕业之后，他来到一家玻璃工厂做起了艺术总监，然后又调入伍尔弗汉普顿大学，主持和管理玻璃艺术，成为一名教育管理者和艺术品传播推广者。所有的身份于他都游刃有余。虽然他可能不是一位精明的商人或经营家，你会觉得他偶尔大智若愚、不谙规则，但他眼中时而闪烁的光彩和机灵，分明告诉你，这绝对是一个敏感智慧、想象力超群的人。

## 一、第一次访问上海大学美术学院

冥冥中总有某种机缘，或者这个世界上有些人总会相遇。布华顿与上海大学美术学院结缘，源于1996年，当然还是因为玻璃艺术牵线的契机。他当时作为伍尔弗汉普顿大学玻璃艺术系主任，通过英国文化委员会的介绍，来到上海大学美术学院

做一次学术访问。当时我们正好接下了地铁一号线黄陂南路站的玻璃壁画，在对玻璃艺术一知半解的情况下，一边跑各大玻璃工厂，一边学习玻璃制造工艺，勉为其难地迈出了走向玻璃艺术道路的第一步，而其中的艰辛与困难，真是如人饮水，冷暖自知。

所以，布华顿的到来，为我们打开了一扇明亮的玻璃艺术的窗口。当时由布华顿牵头，我们通力合作，一起在新建成的上海图书馆举办了改革开放以来国内第一个系统的专业玻璃艺术展，并由英国的玻璃艺术家们制作了一个中国书简的玻璃艺术作品，捐赠给上海图书馆。在落成仪式上，我们的钱伟长校长也亲自出席，并且吁请全国的玻璃企业家们都到这里参观学习。而当时的境况是，全国很多玻璃企业濒临倒闭，整个玻璃行业一片萧条。布华顿和英国玻璃艺术团队的到来，无疑翻开了玻璃艺术在中国发展的新篇章，为中国玻璃艺术的崛起与推广做出了重大的贡献。

布华顿之后还策划、组织了好几个专业访问团到访中国，并邀请我们的师生回访英国的相关院校与玻璃博物馆。现代英国玻璃制造的复兴，涉及从生产设计产品到吹制工房玻璃器皿、从新型建筑玻璃装置到合成玻璃家具、从压铸玻璃珠宝饰物到与窑制技术同属一类的小型雕塑作品等种类。过去的三十年，就英国"玻璃经济"而言，目睹了一个时代的发展，同时也记述了一场重大的转变：从久负盛名的晶质玻璃品牌的传统产品设计和制造，日益向横跨更为广泛的玻璃设计实践的小型和微型行业的工房玻璃经济转变。布华顿正是见证并参与实践了这一历史性过程，并把相关的理念与技术引进到中国，极大地推动了两国玻璃事业的发展。

当时我们一起参观了伍尔弗汉普顿最古老的玻璃艺术工厂的遗址。伍尔弗汉普顿的英文原意是"狼窝"、人迹罕至，是当时产煤、烧煤的场所，就在这样的地方，经由布华顿等人的不懈努力，使当地的玻璃工业欣欣向荣起来，让我们也见识和学习了原汁原味的英国玻璃艺术工艺，并学习引进、推广到中国。

## 二、玻璃艺术工作室的发生和发展

早在2000年，英国伍尔弗汉普顿大学和上海大学美术学院两家就合作建立玻璃艺术工作室，而当时国内的美术院校还没有玻璃艺术专业。

1999年，上海大学美术学院专门组织一批优秀教师，由我带队，访问英国，全面考察了玻璃专业的课程设置、教学方案和师资培养，打下组建专业工作室的第一步。紧接着开始师资人才的培养：学院选派庄小蔚、张海平老师以及相关学生赴伍尔弗汉普顿大学进修学习，为玻璃工作室的师资培养跨出关键的一步。在上海大学新校区建设期间，在布华顿院长的关心和指导下，玻璃工作室硬件设备规划和师资培养同时起步。新校区建成后，玻璃工作室同时落成，专业教师也同步到位。

我们玻璃工作室的主要研究方向为现代玻璃造型艺术和玻璃艺术材料，是中国高等院校中第一所真正意义上的玻璃艺术工作室。工作室自创建以来一直承接国家级艺术礼品的设计与制作任务，工作室将进一步扩大国际间的交流与合作，保持在中国高等院校中玻璃艺术专业的教学科研领先地位。其课程设置有玻璃艺术语言、玻璃艺术发展史、玻璃材料特性、玻璃铸造原理、温度控制与退火、冷加工工艺等。专业上要求学生系统了解玻璃艺术的发展历史与理论、熟悉玻璃工艺过程；熟练掌握工艺技能和表现手法，能独立创作玻璃艺术作品，并处于在国内领先地位。

作为技术后援，英国伍尔弗汉普顿大学与上大美院工作室一直保持着密切的交流与联系。中英两校联手，开始招收玻璃专业研究生。我们也委派优秀学生去英国学习、进修，先后有多名学生在伍尔弗汉普顿大学攻读了硕士、博士学位。两地联手的同时，也加强同国内艺术院校的联系，以求共同发展。

上海大学美术学院名副其实地成为中国玻璃艺术的前沿阵地，在上海大学美术学院的影响下，清华大学美术学院、中国美术学院、南京艺术学院、山东工艺美术

与汪大伟在西湖边

2008年在黄山

在上海大学美术学院

学院、西安美术学院、广州美术学院等都相继受到影响，纷纷建立自己的玻璃艺术工作室。

如清华大学美术学院把在读研究生推荐到上海大学美术学院学习、训练，再回到清华进行论文答辩，得到双优的成绩。同时也输送优秀学生到伍尔弗汉普顿大学学习玻璃艺术，并引进那里毕业的研究生归国创建玻璃工作室，成为国内玻璃艺术专业的基地之一，还热忱邀请布华顿去清华讲学。南京艺术学院则邀请我们的毕业生去组建玻璃工作室。中国美术学院则选送优秀学生到上海大学美术学院进修，学成后回去建设他们的玻璃工作室。山东工艺美术学院这几年玻璃艺术也发展得非常红火，致力于把玻璃艺术和中国民间的艺术相融合，取得了良好的成绩。近年来，由清华大学美术学院、上海大学美术学院、西安美术学院、南京艺术学院以及山东工艺美术学院等联手，每年举办一次中国现代手工艺术学院展，今年已是第四届了。此展览旨在搭起一个国内外当代手工艺术交流的专业学术平台，并且给予五个学院内外的教师或职业艺术家参与交流的机会，从而促进学术提高及手工艺术的推广。其中玻璃艺术是展览项目中耀眼的亮点。

## 三、布华顿与文化艺术的推广

布华顿对中国玻璃艺术的推动和发展是显而易见的。几乎是他一个人的力量，引领了中国玻璃艺术的燎原之火。几年来，国内各大艺术院校普遍开设了玻璃工作室，玻璃艺术机构、作品形式、品种皆趋于多样化。从玻璃艺术的自身语言来看，有吸收国外的形式，中西合璧的；也有汲取国内民间艺术养分和民间造型语言，本土化特征强烈的；也有和现代雕塑、装置艺术相结合，作品呈现多样化的。

更大的成果在于，艺术门类的多样化从此迈开大步。在材料语言的运用上，除了陶瓷、木头、泥土、铁艺等传统材料之外，一向不受重视的玻璃从此给人们带来了无限的天然之趣和丰富的想象力。玻璃艺术在与中国当代社会发展的不断碰撞中发展，将会无愧于祖先"天工开物"的荣耀。玻璃艺术将从容面对现代对传统的要求，并通过艺术化的方式开启新的现代手艺之门。这一切成绩的取得，我们是要深深感激布华顿先生的。

可以说，布华顿对整个中英文化艺术教育的交流和传播做出了卓越贡献。布华顿先生后来从伍尔弗汉普顿大学调任达汀敦艺术学院（一级学院）当院长，更进一步加强了玻璃艺术教育的推广，并致力于大文化的沟通和交流。说起达汀敦大学，早就与中国结缘：在上世纪二三十年代，我国著名诗人徐志摩就曾留学该校，达汀敦至今还保留有他的多封书信。该校的艺术专业除了设计，还兼及戏剧等，布华顿从中担当了更大的艺术推广者的角色。他曾经请现代舞蹈家金星去英国讲学，促进戏剧的交流。达汀敦大学培养出来的一批优秀的中国学生，回到国内后，纷纷成为艺术机构的中坚力量。比如从达汀敦学成归来的李小菁，现在是今日美术馆的主要策展人。布华顿非常乐意也尽己所能地担当着文化传播使者的角色，他把中英文化传播交流作为一种神圣的责任，一生为之不懈努力。他自己也亲力亲为，欣然担任了中国美术学院与清华大学美术学院的兼职教授，同时是复旦大学视觉艺术学院的艺术咨询顾问。

布华顿经常往返于中英两地，带着纯真敏锐的艺术心灵与自由如风的性情，用自己的智慧和热忱开拓中国玻璃艺术的未来。他本身就是一位学者、诗人，这也是他最终的归宿和诗意的栖居，是他永恒的精神家园。

汪大伟
2008年11月于上海大学美术学院

# 新玻璃经济

当代英国玻璃展（Contemporary British Glass）意在向当代中国观众介绍关于今日英国新玻璃艺术和手工业玻璃设计的种类、品质、活力以及其独创性，这在中国尚属首次。

现代英国玻璃制作的复兴，涉及从生产设计产品到吹制工房玻璃器皿，从新型建筑玻璃装置到组合玻璃家具，从压铸玻璃珠宝饰物到与窑制技术同属一类的小型雕塑作品等等诸多范围。这次复兴在很大程度上反映了英国为数不多的艺术院校学生作品的特色。而这些院校自从20世纪60年代后期就一直致力于此，把玻璃设计作为一门高等教育学科来发展。

1999年，与钱伟长、汪大伟在上海图书馆新玻璃经济展览开幕式上

就英国"玻璃经济"而言，过去的三十年目睹了一个时代的发展，同时也记录了一场重大的转变：从久负盛名的水晶玻璃品牌的传统产品设计和制造日益向小型和微型行业发展的工房玻璃经济转变。这种发展横跨了更为广泛的玻璃设计实践。

这里还有一条与此相关的当代英国社会的有趣注脚尚待详述。1984年，我去斯托尔布里奇的斯图亚特父子有限公司担任熔炉经理一职。这是一家二百年前成立的水晶玻璃餐具和礼品制造的龙头企业。事后想来，就历史的角度而言，我庆幸能拥有这段经历。

作为一名英美文学专业的学生，我还在读书时，就对19世纪美国作家赫尔曼·梅尔维尔（Herman Melville）的作品极为关注。他最为著名的作品《白鲸》（Moby Dick，or The Whale）（1851）[①]，可以被解读为一曲对南塔基特沿海海面上传统捕鲸业的不朽挽歌。之后，机械捕鲸鱼叉的发明终结了整个捕鲸文化。

1999年，与钱伟长在上海图书馆新玻璃经济展览开幕式上

在我看来，我在工作中同样亲身经历了英国手工制作玻璃传统的最后几年。这一传统几乎是注定要被品质日益精良的机器制造水晶玻璃制作工艺所取代。而我见证了这一文化的消亡。

但可喜的是，鉴于我在新近产业和艺术与设计学位教育方面的经验，我觉得自己的上述想法是错误的。虽然如此，我还是要有意地继续将这些对社会和产业的观察所得联系起来，从而树立自己的论点。

我的论点是：今天有幸在上海展出的这些玻璃作品都是对一种强大、公认及持续的传统的继承。这一美学传统由威廉·莫里斯（William Morris）、约翰·拉斯金（John Ruskin）以及工艺美术运动发展而来。并且在不同时期或多或少地反

1999年，与钱伟长等在上海图书馆

1999年，与钱伟长在上海图书馆新玻璃经济展览开幕式上

1999年，新玻璃经济研讨会上

新玻璃经济（画册封面） 1999年

映在更为广泛的社会、政治和哲学范畴中。接着它又贯穿于英国上世纪二三十年代手工艺制作的"家庭现代主义"（引自塔尼娅·哈罗德Tanya Harrod）中；随后又通过陶工伯纳德·利奇（Bernard Leach）——其主要著作《陶工手册》（A Potter's Book）自1940年首次面世以来一直被工房制作奉为圭尺——具有深远影响的思想吸取了东方哲学之精华。

或许可加以论证的论点还有，一种虚伪的理想主义不时地显现出更为激进的主张，要求"忠实于材料"或要求手工制作过程、先进工艺造诣之精妙，以及优质手工艺品所带来的满足感和认知价值。而已经得到论证的论点则表明，这实际上只是中产阶级的事情，以此来逃避工业革命所带来的社会、经济和环境剧变。

如果说这种极少艺术的批评看起来似乎对生命和作品极为轻视，亦似乎对沿袭至今的这一传统的规模和持续性描述不当，那么今日英国手工业的教育的确面临着严峻考验，其教育成果越来越表现在那些客观的经济指标上，比如大学毕业生的就业能力、艺术与设计毕业生的创业情况、小型企业的发展以及传统制造业的经济复兴。

当然，这些指标确实为我们提供了观看这次展出的玻璃新作的基本视角。1993年手工艺理事会调查（Crafts Council Survey）表明，手艺业的估计成交量大约为四亿英镑，而在过去七年中这一成交量已大幅上升。

这里陈列的所有作品都代表了某一时期的艺术家、设计师、设计师导师们的专业素养。他们以学生、研究人员、讲师或访问讲师的身份与伍尔弗汉普顿大学艺术与设计学院的玻璃学科（于1989年和以前的斯托尔布里奇玻璃学科合并）发生联系的艺术家、设计师、设计师导师们的专业素养。

与此同时，伍尔弗汉普顿大学的国际合作也显现出了初步成果，尤其是1996年以来与上海大学美术学院的同行们的合作，也到了享受其初步成果的时候。

这次展出可以说是艺术与设计学院中单一学科的精选作品，并且以此提供了独一无二的个案研究。在这一研究中，展览以及随后的目录短论和展品，也引出了许多的独立命题：

确定所研究的作品在可确认的传统中的位置，这种传统通常被称做威廉·莫里斯传统，即工艺美术运动和随之而来的20世纪发展的传统；

确立高等教育在20世纪60年代后期以来英国手工艺复兴中起到的作用，以及艺术与设计毕业生对小型企业发展和手工业经济复兴作出的贡献；

为玻璃设计的发展在学术和商业两方面的国际性合作提供新机会。

这次展览并不意味着结束，而是标志着新的开端，正因如此我才有机会在这篇导言中再次表达我的荣幸。

---

① 译者按：《白鲸》完成于1850年，出版于1851年。

# 玻璃之路

"玻璃之路"(Glass Routes)展览表现了丝绸之路上的一种硅石变异形式，并与其专题研讨会"创造之路"(Creative Pathways)一起绘制了一幅横跨40载的当代玻璃教育发展的画卷。这些发展是在各不相同的道路上发生的，正如《道德经》中所写："道可道，非常道。"①

1995年，我自愿参加了在中国南方举办的英国文化委员会教育展，这使我能利用两次展会之间原定为香港购物的三天时间访问上海。当我的前任，当时伍尔弗汉普顿大学艺术设计学院院长沃恩·格里尔斯问我为什么选择上海时，我非常坦率地说我答不上来，但我的直觉告诉我，上海有重要的机会在等待着我们。

可能就在同一个星期，我告诉过沃恩，一位已在我们学院玻璃艺术系工作了几周的研究精铸技巧的艺术家夏洛特·德·西勒斯(Charlotte de Syllas)刚刚获得了哲尔伍德珠宝设计大奖(Jerwood Prize for Jewellery)。当时，沃恩还不认识她，她在学校里还没有正式职位，因此不仅未加入学校的健康和安全保险，而且实际上还未办理手续。

沃恩的鼓励和支持加快了我们在中国的工作进程，否则缓慢的程序很可能会减弱甚至摧毁我们最初的信心。

令我感兴趣的同样是当前玻璃学术和艺术发展所面临的问题——生活体验的问题。正如丹麦哲学家索伦·克尔凯郭尔(Soren Kierkegaard)在其1843年的日记中所写"生活必须向后理解，这是完全正确的"，但是他忘了另一点，即生活必须向前继续。

我所谓生活体验，指的是关于人类文化、社会、思想、认同和生态的问题，以及时间碎片之间的历史得失。在一个数字指纹泛用的时代——我这样说是因为人类身份认证仍然多以触摸方式实现，我感兴趣的是那些无法窃取却可能缺失的同一性。

我的想象在之前就已驰骋：在道路（请引申其隐喻）至今还难以辨识的时刻；在只能用直觉到前方似有若无的回声、召唤、指引或仅是前行的冲动时刻。我们移到新环境时所产生的不安的本能，而又凭借这种本能跨越了蔓延此处和彼处间无可躲避的地域。因为发生和未发生之间的差距有时是非常微小的，然而这一差距通常包含了某种非同寻常的人类行为。

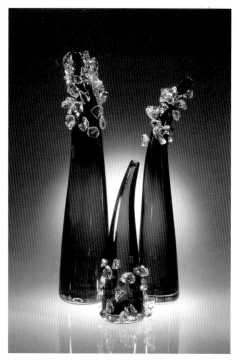

冰族 斯图亚特·嘉伏特（Stuart Garfoot） 长
420mm，宽300mm，高470mm，2005年

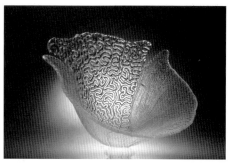

头脑风暴 斯图亚特·嘉伏特（Stuart
Garfoot），直径390mm，2005年

艺雕竹简，科林·里德（Colin Reid） 长
1500mm，高3500mm，1999年

这样抽象的哲学背景或许是有益的，却引起了目前的西方艺术教育，尤其是手工艺教育弱点的真实担忧。然而，由斯图尔特·加伏特（Stuart Garfoot）筹划和策展的专题研讨会"创造之路"以及"玻璃之路"的展览恰如其分地详细描绘了这样一个时刻。

它们关注的是玻璃艺术家中领军人物们各不相同的创作道路，并力图概述过去四十年来与伍尔弗汉普顿大学（之前与斯托尔布里奇学院玻璃课程）互有合作的玻璃团体的发展历程。这次展览意在以例阐释，而不在面面俱到。

这些活动相互联系，对于拓展和更新发端之倡议大有裨益。这一发端由史无前例的1999年7月的新玻璃经济展（New Glass Economy）而起。新玻璃经济展将散失四十年来伍尔弗汉普顿大学玻璃艺术[2]之成果引入上海，并于同年在英国赫特福德大学（University of Hertfordshire）的阿特里尔姆美术馆（Atrium Gallery）展出。

新玻璃经济展由萨拉·鲍勒（Sarah Bowler）策划，其标志性事件为一个高3米、重1.75吨的钢铁和水晶玻璃雕塑《竹简》的揭幕仪式。该雕塑作品由科林·里德（Colin Reid）[3]创作，并作为上海图书馆入口大厅的永久性装置。

玻璃雕塑《竹简》项目历时约三年协商完成，它已经成为我们合作伙伴关系中最为直观的公共标志。其概念以中国古代书写制品，即编联起来并可卷成卷轴的刻字竹简为出发点。我相信这个创意来自于1996年4月我首次访问在建的上海图书馆时布满竹脚手架的建筑工地的启发。凸起并抛光的汉字浮雕与透明的水晶玻璃铸块浑然一体，呈现出手写体文字的晶莹剔透，作品由古铜色平行带状钢结构体固定。

该雕塑中的汉字取自原版刻字，通过制模工艺反转成浮雕，再由随意排列的一系列文字组成，表现了人类和自然的本真。它们本身并不连贯成文——因为文字排列间并无叙述关联——但文字的分层布局无疑影响了作品的整体构成。这是里德首次将书写符号作为"拾得物"（found objects）进行创作，强调的是这些符号的视觉力量而不是其语言学上的意义。无论其外在形式还是内在的隐喻，这些符号素材重于涵义，制作先于认知。

里德对于该作品放置场所的关注，对于选定上海图书馆作为其装置场所及其文化意蕴的反应，以及最终将作品放置在入口处大厅中央的底座上，使其沐浴在大片的日光中，这些无不展现了他的创造才华。他的才华轻松地游曳挥洒，淡然地传递学识，创作出这件巧妙地融合中西文化的上乘佳作。

在7月酷暑的十天里，新玻璃经济展共吸引了一万八千多名观众前来参观，并引起了无数人对《竹简》这件奇特作品的好奇和喜爱。在一次公开的研讨会上，曾经有人问过我这样一个问题：展览中的所有作品确实都是由玻璃制作的吗？

在20世纪的最后四十年中，工房玻璃经济替代了衰退中的英国手工艺制作传统。而新玻璃经济展恰恰见证了英国艺术院校在发展工房玻璃经济中所发挥的重要意义及真实作用。

在已出版的《新玻璃经》展览目录导言中，我曾经提到过一段轶事，虽然当时此轶事因为跑题未能逃过策展人萨拉大笔一挥的删除，但我相信她会原谅我在这里旧事重提。

我对自己在斯托尔布里奇度过的历史性时刻（也就是担任玻璃暖房经理的经历）的理解就像我对19世纪美国作家赫尔曼·梅尔维尔的理解一样。他的名作《白鲸》（1850）[4]，可以被解读为一曲对南塔基特沿海海面上传统捕鲸业文化的不朽挽歌，后来以机械捕鲸鱼叉形式出现的新技术发明毁灭了传统捕鲸业文化。梅尔维尔不仅生活在当时仍被称做"新大陆"的土地上，而且还记录着它的消逝，记录着人类脆弱的生态环境，他以已灭绝的美洲土著部落来命名小说中的捕鲸船"佩科特人"（Pequod）就暗示了这一点 。[5]

而我曾在斯图亚特水晶玻璃公司担任玻璃暖房经理，最后担任生产经理，因

此有着相似的感受，这在刹那间深深地打动了我。正如这次展出的与白星级大西洋客轮泰坦尼克号船长所用的雕刻水晶玻璃碗分毫不差的复制品所蕴涵的缱绻怀旧之情，对上海观众来说确是一件引人入胜的展品。巧合的是，凯特·温丝莱特（Kate Winslett）和里奥纳多·迪卡普里奥（Leonardo di Caprio）主演的电影《泰坦尼克号》正在上海热映。这个巧合在两年前创作电影剧本时又怎能预料到呢！

就在新玻璃经济展举办三年后的2002年3月，创建于1776年的红房子玻璃厂和毗邻白宫的斯图亚特水晶玻璃厂结束了玻璃生产并关门停业。

上海的诸多项目是由始于1996年1月的伍尔弗汉普顿大学玻璃课程与上海大学美术学院之间的密切合作发展而来的。1994年，我很荣幸地继基思·卡明斯（Keith Cummings）之后成为伍尔弗汉普顿大学玻璃学科带头人。不久之后，由于玻璃艺术家杨惠姗及其工作室琉璃工房的慷慨协助，我们又与北京的清华大学建立了同样的联系。目前琉璃工房已成为当代中国玻璃最为重要和最富创新精神的品牌。

在此之前，我们与南非比勒陀利亚理工大学（Technikon Pretoria）（现茨瓦尼科技大学（Tshwane University of Technology））在玻璃学习设施和课程方面已开始合作发展，还获得了康瑟尔玻璃制造商（Consol Glass）的大笔工业资助，因此得以在比勒陀利亚进行了两天多的协商。伍尔弗汉普顿大学的玻璃课程及其工业联系被英国设计委员会列为优秀实践个案，并在2003年度英国政府《兰伯特企业与大学合作观察》（Lambert Review of Business-University Collaboration）最终报告中详加研究，希望这能证明，我们不断发展的设计理念是由我们的卓越眼界所决定的。

我们与上海大学的合作有着长期发展的前景，其中包括：研究项目、公共艺术项目、中国玻璃新课程和设施建设、工业联系以及策展等。合作之所以成效卓著，有着很多原因，尤其是因为我和上海大学美术学院的同事汪大伟教授是充满活力的伙伴关系，以及我的同事艾·王国丽（1962—2008）的理解和巨大奉献。她长期受疾病困扰，于今年3月逝世，这次的展览和研讨会也是对她的纪念。

当英国大学纷纷以招收短期学生为目标时，我们却以澎湃的激情和信心来规划一个长达三十年的项目，以培养新一代中国玻璃艺术家，并开创跨越各自文化的富创造性和学术性的崭新对话和共享。

这一项目至今不过十二个年头，此次玻璃之路展览恰好提供了一个机会来观察其至今的发展。

展览有两个重要特征：首先是四十多年来基思·卡明斯作为玻璃艺术家和教育家传递给我们的创造精神；其次是来自上海大学和清华大学的作品所体现的当代中国玻璃艺术的新发展。这两所大学的玻璃工作室主任庄小蔚和关东海都是各自创作领域中素有名望的艺术家，并都获得了伍尔弗汉普顿大学的玻璃艺术硕士学位。

"玻璃之路"展览共分三个展厅。展厅前厅陈列了伍尔弗汉普顿大学的研究项目成果，包括吉莉安·伯迪特（Gillian Burdett）和薛吕的作品，以及马克斯·斯图尔特（Max Stewart）关于阿马尔利克·沃尔特（Amalric Walter）的研究。在我看来，基思·卡明斯对伍尔弗汉普顿大学艺术与设计学院的研究的影响是巨大而深远的，以上三个不同项目多年来在玻璃素材和应用研究方面的广度和深度就完全可以证明这一点。

第一展厅展示了卡明斯自己和一些重要艺术家的作品，包括已故的乔治·艾略特（George Elliott），英国皇家艺术学院学生、德国艺术家杰拉德·里贝克（Gerhard Ribke），以及基思在斯托尔布里奇学院任教时的学生、澳大利亚的莫林·卡希尔（Maureen Cahill）、戴维·里克（David Reekie）和科林·里德（Colin Reid），而现在他们都已成为知名的艺术家。

第二展厅则展示了玻璃制品在珠宝、建筑、织物、产品、装置以及手工艺等

竹简 科林·里德（Colin Reid） 长1500mm，宽1500mm，高3500mm，1999年

玻璃珠宝 约·纽曼（Jo Newman） 2008年

海岸线 约·纽曼（Jo Newman） 长80mm，宽10mm，2000年

王朝时代 基思·卡明斯（Keith Cummings）

古音 李富彪 长380mm，宽100mm，高600mm，2008年

夏季的水果——樱桃，熊嘟嘟 长200mm，宽200mm，高80mm，2006年

关东海 长470mm，宽110mm，高250mm，2006年

多种领域中的应用，它们各以其不同方式从卡明斯博大精深的教育思想中衍生出自己的特色和影响。伍尔弗汉普顿大学和今年的英国玻璃艺术双年展之间有着明显的相关之处，例如凯瑟琳·霍克（Catherine Hough）、露丝·斯帕克（Ruth Spaak）、瓦内萨·卡特勒（Vanessa Cutler），尤其是2007年刚从伍尔弗汉普顿大学毕业的乔安娜·曼诺希斯（Joanna Manousis）的作品。

第三展厅展览的是来自上海和北京的当代玻璃艺术作品，这些作品继续表达并重新定义着伍尔弗汉普顿大学玻璃学科以及基思·卡明斯，尤其是作为艺术家和作家，在教育和研究领域所获成就的国际影响。

中国艺术家关东海的杰出作品就是其中的典型。"城门"（City Gates）是其首次个人玻璃雕塑展，于2006年在香港盖弗尔工房玻璃画廊（Gaffer Studio Glass）举办，标志着他创作生涯的重要开端，并见证了他作为当代玻璃艺术家的飞速成长——从七年前首次接触玻璃这种艺术到2006年展出一系列优秀原创作品。

关东海首次个展的主题应该是关于"门口"和"开端"的，它们既是进入点又是止步点，这并不出人意料。在更为广阔的当代国际玻璃艺术背景中，这些作品饱含意蕴也历尽风霜。《门》系列作品表现了入口或门的空间，这些入口或空间缺失的门框，跨越了引领我们进入当代中国玻璃的独特领域并抵制所有纯粹以"别处"衍生而来的事物的视野。这些本质上以其他方式探讨中国建筑作品想象中的城市纬度，也是令人瞩目的——这些"门"以消失或转喻"无形城市"的缺失形式而阻止我们进入。

关东海的"城门"将入侵者抵挡在外，却将奥秘处保护在内，似乎是恰到好处，引发了关于力量、保护、隔绝和孤立文化上的想象。这些"城门"探索着界限的实践性概念，包括整套简单玻璃制作工序自我强加的局限性。但是它们又是现代的，纵然像过往一样高深莫测，却表现了古代中国和现代中国。

玻璃的粗糙质感似乎也恰如其分——分明是原砂铸和窑铸的结构，却呈现出精心处理的表面和细腻色彩的感受性。关东海在此追求一种完成的质感，他称之为"简单纯正"，但事实上，除了关东海对玻璃技术的精通之外，这种质感还不自觉地流露出一种可持续的艺术和技术构成，这种构成常见于呈现完成质感的织物设计、水彩画以及笔触精确的制图法中。

门上各种各样的饰钉星罗棋布，方形和圆形的浮凸交替变换，间有岗台、拱道和门窗。它们的形态像雕刻的图章或是中国人练字用的小方格那样富有张力。从门上不时探出古代的人头，瞪视着观众——这些人像是岗哨，还是被割下示儆的战利品？这样的作品不需要直言不讳地叙述，因为其意义是心照不宣和不言而喻的，足以表达其自身。

同样，《兵器》（Weapon Series）系列作品的形态是将古代仪式所用的青铜和玉制兵器置入全新的建筑柱型，继续运用制作古代兵器的模铸和冷磨技术来创作出具潜在纪念形式并按比例缩小的完整模型。其纪念意义来自于作品的重要性和强烈性，也来自于作品交替的纪念和对于失落的文明，或某种无名却高度发达的仪式及手工艺文化的辉煌历史遗产的思考。同时，这些作品并不只是文化考古学或史学的某种浅薄方法的衍生物，在我看来，这些富有强烈实体感、质感和色彩的作品萦绕着一种创造性的矛盾心理。

这种矛盾心理，如果确实存在的话，或许与关东海个人经历中的两件小事密不可分：1966年关东海出生于中国东北的黑龙江省牡丹江市，五岁时他跟父亲去过北京天安门广场，这令当时上小学的他非常自豪。这个细节摘录自香港盖弗尔工房玻璃画廊艺术家目录中的关东海简介。

生机盎然的玻璃艺术新作以当代的表现方式回顾并再现了往日的形态、过去的经历和形式的研究，从古代玉器、青铜器或石器中吸取灵感，从礼仪、军事和手工艺文化中追溯其形式上的来源。

任何象征性的人类元素，就如同大型建筑设计中的细部那样，在程度和定义上总是从属性的，这也同样赋予了《城门》和《兵器》系列作品的纪念意义。例如，在象征古代人类存在没有身体的人头这一主题的相关作品中，刀刃上的窗口（如《兵器》系列1和2），又如作品《制度》（Régime）中，由玻璃铸成的一节H形钢梁轨道，上面嵌列着有顶髻的半透明玻璃人头，一模一样的脸上涂着红、蓝、白和黑色的氧化物颜料。

每个人头都于颈部嵌入水平的C截面不透明熔融玻璃滑道上，排成密集的队列，就好像冷器时代的西安兵马俑通勤玻璃版本似的。将这样的表现手法与另一位出色的图样设计家——英国玻璃艺术家戴维·里克的作品进行比较是很有意思的。他的作品关东海或许也很熟悉。在他们的作品中，我们都能够找到精确性、优雅的形式、颠覆的幽默、隐秘的游戏以及对人类生存状态的真实描写，有着报刊漫画或讽刺短诗的那种简练和直接。但在《制度》中里克所探索的单人戏剧，即独白的所有脉迹都被抹去了——这种探索是里克所特有的——呈现出一种不同的政治敏感性，专注于力量形式的表现。我很期待这一作品的新发展。

关东海的雕塑语言有着高度的创造性和想象力、对表面质地的密切关注，丰富的色彩感受性、技术上的游刃有余，以及对古代青铜和玉器制作技术方面的中国手工艺传统的敏锐观察意识。它可以是活泼的、富含幽默或政治意味的，又可以是自信、审慎而从容的。

关东海的作品是出色的，也是典型的，然而所有来自上海和北京的玻璃新作都同样各抒己见，各展风采。这是我们合作的首批出色成果。我相信，今后我们之间的合作将继续深入发展。

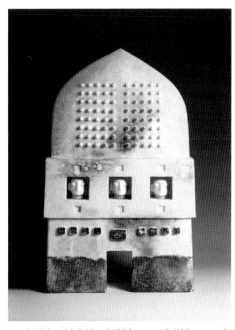

白城门 关东海 长380mm，宽100mm，高600mm，2008年

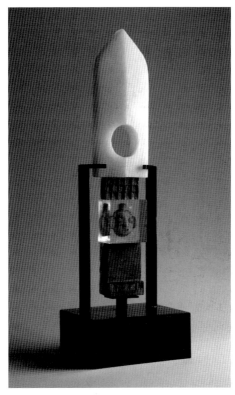

武器系列7 关东海 长120mm，宽60mm，高645mm，2007年

① 译者按：这句话源自早期詹姆斯·理雅各（James Legge）所译的《道德经》英文版第一句，作者巧妙地在本文的语境中对其进行了自己的借喻和解读。原文直译为"可以遵循的道路并非正确的道路"。

②见安德鲁·布华顿（BREWERTON，A.J.）：《新玻璃经济》（New Glass Economy），《新玻璃经济：伍尔弗汉普顿大学的当代英国玻璃艺术》（New Glass Economy：Contemporary British Glass from the University of Wolverhampton）（1997年7月英国文化委员会上海展目录），1999年，第9—12页，ISBN 0 9536057 0 1。再版于《中国艺术玻璃》（Chinese Art Glass）第一期，2004年7月，第8—11页。

③见安德鲁·布华顿（BREWERTON，A.J.）：《黑与白：科林·里德新作》（In Black and White：Recent Work by Colin Reid），《新玻璃》（Neues Glas/New Glass），1999年第4期，第9—22页，USPS 011—475。

④ 译者按：《白鲸》完成于1850年，出版于1851年。

⑤1638年，梅杰·约翰·梅森（Mason，Major John）写了一篇叙述清教徒灭绝佩科特人部落的文章，佩科特人当时控制了在现美国康涅狄格州密斯提克地区的宝贵的海上捕鱼权。见http://www.pthompson.addr.com/moby/mason.htm。[见梅杰·约翰·梅森著；艾德蒙德·克拉伦斯·斯特德曼（Edmund Clarence Stedman）和埃伦·麦凯·哈钦森（Ellen MacKay Hutchinson）编：《攻占密斯提克城堡》（The Taking of the Fort at Mystic），《殖民地早期至今美国文学丛书》（A Library of American Literature from the Earliest Settlement to the Present Time），第一卷，纽约：查尔斯L.韦伯斯特出版公司，1890年，第180—184页。]

<h1 style="text-align:center">玻璃缘</h1>

安德鲁·布华顿（Andrew Brewerton）是一位把现代玻璃艺术教育引入中国的英国艺术家。因为他在十二年前一次偶然的上海之行，孕育了英国现代玻璃艺术教育在中国的艺术教育园地里生根、开花，取得了累累硕果，并对中国的当代艺术发展产生了重要的影响。

中国有一句古话叫"谋事在人，成事在天"。布华顿把英国现代玻璃教育的思想与实践完整地移植到中国，并在中国的土地上茁壮成长，成为艺术教育领域中一个成熟的学科，其规模业已超过英国本土的玻璃艺术教育。曾有专家认为，按此速度发展下去，中国有望成为世界现代玻璃艺术教育的中心。

2008年，与吕坚在黄山

布华顿把艺术教育学科中的一枝奇葩——现代玻璃艺术教育，从英国引入中国是从上海大学美术学院开始的。在短短十二年的时间里，现代玻璃艺术作为一个艺术学科，在教学规模、师资培养、教学实践、产学研结合等各个方面都得到稳步的发展，并已经辐射到全国的其他美术学院，譬如中国美术学院、清华大学美术学院都在上海大学美术学院之后，分别开设了玻璃艺术这一学科。这种中外合作创办艺术教育学科，在短时间能取得如此的成就，可能在国内的艺术教育领域中是不多见的。在与布华顿的交谈接触的过程中，我逐渐领悟到其中的原因所在，那就是布华顿本人的中国情缘：真情、友情、热情。正是此情缘，促成了这次成功合作，使现代玻璃艺术教育在中国这一古老文明的土地上重新焕发出绚丽光彩，并赋予玻璃材质新的内涵——铸造玻璃艺术。

## 一、读《马可波罗游记》 结下深深中国情

布华顿把现代玻璃教育带入中国，并取得成功，可谓是水到渠成。在编辑这本书的过程中，我与布华顿进行了多次深入的交谈。布华顿的个人经历使我逐渐产生了这样一种感觉——布华顿与中国有不解情缘。布华顿与中国的这份情缘，似乎是冥冥之中注定的。

譬如，布华顿在与我的交谈中，曾经谈起过这样的一段往事。早在1988年，布华顿在英国斯特布里（Stourbridge)地区的斯图尔特父子公司(Stuart&Sons Lts.)玻璃车间担任设计主管期间，工作非常繁重，但他仍每周的星期四晚上，驾车到伯明

翰（Birmingham）的中文学校学习中文，足足坚持了六个月。

这段不起眼的往事，对我来讲正是一个很好的佐证，或许可以揭示布华顿与中国长达十二年友好往来和能取得如此丰硕成果的原因。出于这一原因，我曾详细地询问布华顿那时学习中文的动机是什么？以探究他中国情缘的由来。

关于到伯明翰学习中文，布华顿是这样回忆的："我对中国的兴趣可以追溯到儿童时代，当时读了一本名为《马可波罗游记》的儿童读物，书中对中国精彩的描写，唤起年幼的我对古老而神秘的中国的浓厚兴趣与无限想象，从那时起我一直期待着能亲身到古老而神秘的中国去看看。《马可波罗游记》成为我儿童时代最喜爱读的一本书。还有一本名为《中文象形字是诗歌的媒介》（Ernest Fenellosa, 'The Chinese Written Character as a Medium for Poetry'）的书也对我产生了很大的影响，这本书从非常有趣的角度阐述了中国水墨画与中国古典诗歌对现代主义产生的深远影响，并使我对中国的象形文字艺术之美有所了解。另外，中国的道教与佛教，以及从中国古典诗歌英译本中领略到的王维、李白与杜甫的优美诗句，这些都不断加强了我对中国文化的无限敬仰。能用中文直接体会中国诗歌原汁原味的优美一直是我的一个梦，也是我想学习中文的原因……还有一个重要的原因是，1988年我的第二个女儿翰娜出生了，家庭中增加了新的成员。这时我在心里萌生了另一个与中国有关的宏大计划，即十年后带上全家到中国完成'人生之旅'。我打算用十年的时间学习中文，十年后实现这愿望。这一时期，在斯图尔特玻璃工厂的工作非常繁重，每天下班回到家后都感到精疲力尽，需要做一些有意义的事情来充实自己的头脑，从而减轻体力上的疲劳。所以，学习中文是成为我充实头脑的唯一选择。"

通过布华顿的这一段自我表述，我们可以清晰地看到他的中国情缘是建立在自己对中国文化深深的热爱之上，并带有浓郁的浪漫主义色彩。

现实生活往往与理想世界是有一定距离的，不久，由于工作的需要，布华顿由斯图尔特玻璃工厂（Stuart Crstyal）转到达汀敦玻璃工厂（Dartington Crystal）担任管理工作。由于达汀敦地区没有中文学校，现实情况使他学习中文的计划就此搁浅。六个月的中文学习看似短暂，但正如现今人们常说的"过程比结果重要"，布华顿学习中文的过程是短暂的，却是他中国情缘的真切流露。同时，也可以说是为十年以后他将在中国的土地上从事玻璃艺术作出了一定的准备。

## 二、上海之行遇知己 多年夙愿得实现

八年后，实现夙愿的机会终于到来了。1996年1月，布华顿作为伍尔弗汉普顿大学（University of Wolverhampton）艺术与设计学院玻璃学科主任，参加1996年香港与广东举办的英国教育展。香港与广东的英国教育展结束后，布华顿即产生了造访上海的强烈愿望，他改变了原先计划的行程，决定到上海走一趟。当伍尔弗汉普顿大学艺术与设计学院的院长得知布华顿这一临时计划时，显得非常诧异。问布华顿为何要到上海？布华顿的回答说自己不能百分之百肯定将会在上海发生什么，但是凭直觉，这次上海之行，对伍尔弗汉普顿大学艺术与设计学院来说一定是一个机会，院长被布华顿的自信说服，同意了他的上海之行。

就这样，布华顿与同事王国丽从广东来到上海。王国丽是伍尔弗汉普顿大学香港办公室的工作人员，通过她与时任上海大学美术学院副院长的汪大伟取得了联系。两人第一次见面，却一见如故，大有相见恨晚的感觉。

艺术玻璃成为了两人友谊的纽带。在上个世纪90年代，上海开展了大规模的城市基础设施建设。上海大学美术学院凭借着雄厚的艺术设计的实力，以及"艺术教学与社会需求"相结合的传统办学理念，直接参与上海市大型市政工程的建设。汪院长带领着他的设计团队为上海地铁一号线黄陂南路站内制作玻璃壁画，由于当时

上海大学美术学院没制作玻璃艺术品的能力，只能寻找玻璃企业来制作作品。汪院长带着设计团队跑遍上海所有的玻璃生产企业，没有一家单位能够接下这一艺术玻璃制作任务。通过这件事，汪院长产生了在上海大学美术学院设立玻璃艺术专业的想法。这不但能完善学院的学科建设，而且能满足社会对艺术多样化的需求。

布华顿不期造访，可谓天赐良机。汪院长的想法与布华顿的愿望不谋而合，在上海大学美术学院建立玻璃艺术教育学科成为了两个人共同的理想与追求。这时文化与语言上的差异已不是交流的障碍。两个人在这次会谈中畅谈未来，共同描绘玻璃艺术教育合作发展的宏伟蓝图。一条沟通的渠道就这样筑成了。

同年4月与7月，布华顿又两次来到上海。他和汪院长两人首次见面时是畅想未来，而这第二次见面，已经开始讨论玻璃艺术教育长期合作，以及如何实施的具体方案。效率之高、速度之快，可谓是在两个不同的文化背景、思维方式与行政运作管理模式的教育机构中通力合作的奇迹。布华顿与汪院长的真情、友谊与热情，是创造这一奇迹的源泉。正如布华顿在《玻璃时代》一文中所描述的："如果说人类的文明史至今已历经石器时代、青铜时代和铁器时代的话，那么我们的新千禧年——21世纪，或许就是'玻璃时代'了。"布华顿与汪院长的三次会面，预示了中国"玻璃时代"的到来。

1999年7月，被喻为具有"突破性"的新玻璃经济展览在上海图书馆隆重开幕。上海市领导、上海大学校长钱伟长以及社会各界人士出席了展览的开幕式。玻璃艺术品的无限魅力，第一次全面展示在上海公众面前。开幕式结束后，市领导与钱校长亲切接见了布华顿，对展览予以高度评价。在七月炎热的十天中，新玻璃经济展览共吸引了一万八千多名对新事物好奇和渴望的参观者。这次展览标志着现代玻璃艺术教育得到了社会各界的认可。

布华顿在开幕式上致辞时说："这次展览并不意味这件事的结束，相反，这只是一个开端。"这次展览以后，上海大学美术学院在上海大学新校区建立了国内首个具有世界一流水平的艺术玻璃工作室。随后，中国美术学院、清华大学美术学院都分别建立了玻璃艺术工作室。布华顿还应邀到国内著名的艺术高校讲学，并被聘任为特聘教授。同时各大美院还派了一些优秀的教师到英国伍尔弗汉普顿大学留学，学习现代玻璃艺术及其他专业艺术。这些教师学成回国后，成为了我国玻璃艺术教育的中坚力量。

布华顿曾经不无自豪地告诉我，时至今日，他的护照上已有十七个中国的入境签证。这些签证不仅记录了这些年布华顿频繁来往于中国与英国之间的次数，而且是布华顿专注投入于中英交流的见证。令布华顿欣慰的是，他的付出终于有了丰厚的回报，他的中国情终于修成了正果。在现代艺术教育思想指导下，一个教育科研与艺术实践完美结合并与国际接轨的玻璃艺术教育学科，在中国建立并不断壮大。玻璃艺术或许真的能让布华顿在中国完成"人生之旅"。

## 三、诗人抒发心中情 五彩玻璃显旖旎

著名的玻璃艺术家基思·卡明斯（Keith Cummings）在文章中是这样描述布华顿是如何成为一位诗人的："安德鲁·布华顿的评论写作无疑是源自其独特的背景，结合了他在许多各有差别却相互联系的领域的亲身经历。例如，他必须要在大学里学习绘画或是文学之间做出选择。当然，他选择了后者，并在此期间成为了发表多部作品的诗人。"布华顿在1977年剑桥大学尼苏塞克斯学院攻读英国文学，1980年获得学士学位；1983年在剑桥沃里克大学学习意大利文艺复兴诗歌，1984年获硕士学位；1995年出版了第一本诗歌集《天狼星》。

布华顿所学的专业是文学，用文字来抒发个人情感是布华顿的特长。社会是一所没有围墙的大学，社会实践的经历，使他获取了更多书本上学不到的知识。诗人

天狼星 1995年 布华顿著

所具有的文学修养与浪漫气质，赋予他对世间万物气象敏锐的观察力。"评论家的教育和阅历积累了语言和知识，从而形成见解"；知识修养与个人气质，形成他独特的写作风格。

布华顿曾经对我说过："视觉艺术家是通过创造具体视觉形象，来抒发情感，而我是通过语言描绘视觉形象来抒发情感，语言是我进行艺术创作的媒介。"可见，布华顿把自己看成一个用文字作为媒介的视觉艺术家，这使他具有对于形象无限的创造力与想象力，布华顿的文章本身就是一件艺术作品，他创造了一种全新的艺术评论写作风格。卡明斯又在文章里写道："从某些方面来说，安德鲁的文章记录了他所评论的创作和活动，从而成为了半独立的存在。布华顿正在尝试写作一种全新的关于手工艺的评论。一种把最终作品以及在一定程度上创作该作品的艺术家仅仅看作是深层文化潮流的表面现象的评论。"并赞叹布华顿的写作是"所有这些历程都明显地反映在他的文章和诗歌中，就像一整套灵敏（且极为锋利）的外科手术器械一样互为配合，可以用来剖开也可以用来缝合。对哲学的兴趣、对文学的了解、对手工艺活动的默契特质的认识和同情，通过诗人的感性和用词淋漓尽致地表达出来"。

布华顿用他哲学家的头脑、诗人的浪漫、文学家的笔墨、艺术家的想象结合社会实践的丰富经验，创造出了一种全新的艺术写作方法。这一创造性的写作方法，把现代技术的理性与艺术的浪漫有机地结合起来，从而挖掘出古老玻璃艺术的现代韵味。使玻璃艺术在当今数码时代里，焕发出迷人的艺术生命力。

玻璃艺术写作不仅显示其文学的魅力，而且揭示出玻璃艺术家创作的人文涵义，帮助艺术家审视艺术表现的实质，提升玻璃艺术创作的艺术性。现在布华顿艺术写作已经不仅是玻璃艺术，而且延伸到了其他当代艺术领域，譬如当代油画、行为艺术等。

正是这种对艺术的宏观思维方式，打破了学科的边界，使艺术不再局限于材质的物理特性上，而是在理性思维的基础上充分发挥人的想象力与创造力，从而赋予艺术无限的表现力。

这种思想正是当代艺术教育的实质，也是布华顿能与中国同道们合作的基础。在十二年精心耕耘下，玻璃艺术教育这枝艺术奇葩，在中国艺术教育园地里正焕发出绚丽的光彩。由于玻璃缘，使布华顿为我国当代艺术的健康发展作出了巨大的贡献。

<div style="text-align:right">

吕坚

2009年7月

</div>

第三章 艺术观念

# 玻璃时代

如果说人类的文明史至今已历经石器时代、青铜时代和铁器时代的话，那么我们的新千禧年——21世纪或许就是"玻璃时代"了。在为人类使用了五千年后，作为一种材料，玻璃真正迎来了属于它的时代。玻璃大概是我们所接触到的第一种合成材料，是一种充满了矛盾特质的材料。它既是坚硬的，也是易碎的。它既是柔软的，也是脆弱的；既是肌理粗糙的，也是精致光滑的；既是透明的，也是不透明的。它是一种固体，同时也是一种液体。

我们栖居在有着吸收、过滤、反射和折射光线的玻璃建筑物中。在我们新建的环境中，在这些多样玻璃"皮肤"的庇护下，我们安全地生活在家庭、公司和公共的各类建筑物里，它们保护我们免受极端气候的危害，提供我们所希望的开放自由和私密安全的环境。

玻璃重新定义了我们对"内在"和"外在"环境的通感。我们越来越频繁地通过玻璃透镜来观察我们的世界，并且把所观察到的世界投射到玻璃屏幕上。我们用玻璃器皿来保存食物、酒类和昂贵的香料，也用它们作为吃吃喝喝的生活用具。玻璃可以坚韧到阻挡飞射中的子弹，也可以精细到在最复杂的显微外科手术里发挥一技之长。现在玻璃纤维又构建了一条遍布全球的信息高速公路。透过玻璃，我们在物质上照亮了生活，也同时在隐喻上启发了生活。

玻璃似乎世世代代都在不断地进行自我再创造。而属于我们的时代，2002年台湾新光三越国际玻璃艺术节上的艺术家们就用新颖而富于表现力的方式对玻璃进行了这种再创造。聚集在此的玻璃艺术作品将带领我们深入探索玻璃这种令人惊叹的材料所建立起的有无限想象可能的空间。这是它们的舞台。这次展览中的每一件作品都是真正的神妙之作。

# 安东尼·勒彼里耶：流动的半透明不明液体

本文是塞夫勒国家陶瓷博物馆（Musée National de la Céramique Sèvres）举办的安东尼·勒彼里耶（Antoine Leperlier）四十多载作品回顾展专题目录（巴黎，2007年3月，法英文对照）中的主题短论。此前，法国的国家级博物馆从未举办过任何回顾展来表达对其他当代玻璃艺术家的认可。

本文探索了勒彼里耶发展和包容的创作诗学中的玻璃艺术，作为一种对材质的成形想象和认知纬度以及其制作方法和工艺的物质性，意在为当代玻璃认识和理解贡献一份绵薄之力。本文挑战了当代以产品为中心的"应用"艺术中关于思想与作品之间关系的公论，并试图将当代玻璃写作的视野拓展至与西方哲学以及其他艺术形式之间关系的范畴。

本文是应邀而写的专著目录的扩展版，源自作者与艺术家之间的对话体讨论：《安东尼·勒彼里耶》（巴黎／南塞：卡帕扎艺廊，2006年），ISBN 2-915241-22-8，法英文对照。后又应《新玻璃》（Neues Glas）编辑之邀写过评论《安东尼·勒彼里耶在塞夫勒博物馆》（《新玻璃》2007年1月号，德英文对照）。文章也谈到了早期布华顿在《触摸虚空》中关于正负空间（存在和虚无）概念与海德格尔、道和玻璃脱蜡铸造法之间关系的思考（《形式》第1期／创刊号，西澳珀斯，2004年12月）。

> 我觉得思想可能是永恒的。你知道，它们流传下来的方式……
> ——理查德·朗（Richard Long）[①]

> 当绘画抹去其思想的时候，就是它完成的时候。
> ——乔治斯·布拉克（Georges Braque）[②]

从表面上看，受邀[③]为我的朋友安东尼·勒彼里耶的新作品写评论是令人愉快的，却也着实令我左右为难：我既不想重复早已富含思想和关注的开放性叙述，也不想立刻证明从其作品本身跑题的单调和乏味，那么，对于这位当代最具思想性和表达力的玻璃艺术家，我还能做什么来锦上添花呢[④]？

即使只是大致欣赏一下安东尼·勒彼里耶的作品，你都会立刻发现其自相矛盾之

大盘 安东尼·勒彼里耶（Antoine Leperlier）
长310mm，宽115mm，高225mm，1982年

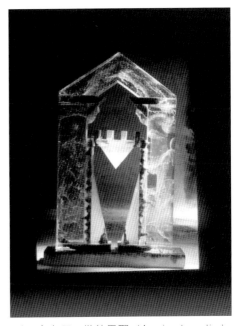

门 安东尼·勒彼里耶（Antoine Leperlier）
长380mm，宽150mm，高550mm，1990年

记忆的影响 1 安东尼·勒彼里耶（Antoine Leperlier）长600mm，宽170mm，高600mm，1993年

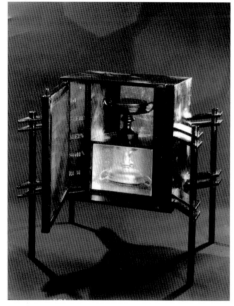

瞬间的记忆 2 - 密室 安东尼·勒彼里耶（Antoine Leperlier）长480mm，宽480mm，高580mm，1993年

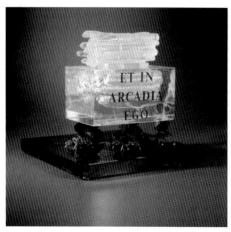

马奈特先生的墓碑 安东尼·勒彼里耶（Antoine Leperlier）长400mm，宽400mm，高350mm，1994年

处，那就是你越试图（以思想、传记和趣闻轶事的形式）确定这些精制的玻璃雕塑作品的"隐藏主题"，似乎就越无法弄清其真正的动机，因为这些作品都强调其外在形式及其在工艺技术上的细致表达。因此，正如本文开头的两条引语所说："作为以语言为媒质来进行创作的作家，我在文中想要探讨的是安东尼·勒彼里耶的玻璃作品中蕴涵的作品和思想之间的关系，无论是可以言说的还是不可言说的。"

第一条引语中理查德·朗的话事实上是2005年10月他在达汀敦与其同行"大地艺术家"克里斯·德鲁里（Chris Drury）一起发表的一次公开演讲后对一位听众的提问的答复。问题大概是这样的："您认为在艺术中有什么是永恒的，如果这种永恒确实存在的话？"而当时朗的回答是出人意料却又简明扼要的，甚至有着座右铭式的风格，几乎打断了德鲁里冗长的回答。

我想问的是，既然朗长期以来一直从事例如圆和线等几何学现象的研究和创作，那么他所说的"思想"到底是指其纯理论"形式"的哲学内涵还是其他完全不同的含义呢？我想留住那一刻，以进一步探究他的想法，可惜那一瞬间早已过去，听众已经继续提问了。

我之所以在一开始就援引理查德·朗的话，是因为这件趣事是引发对安东尼·勒彼里耶的作品中许多可以确定的正题或反题探讨的恰当开端：永恒是相对流动，瞬间的本质会在时光中流逝，结构艺术形式和耐受材料制成的标志及姿态的重要性和真实性，思想的共鸣，记忆以及人类的死亡宿命，形式的继续存在和无可奈何的绝望。

显然，正如这次展览所揭示的那样，这些雕塑并不仅仅是思想的结果，其目的远非说明和阐释。它们与思想领域的关系是错综复杂的，几乎无法被归化成言语和理论。同时，对于一名专注于研究以历史和印刷形式表述的语言的艺术家来说，这种关系又是自相矛盾的。这些作品盘踞在自己唯一而又流动的瞬间，以致在时间上的任何媒质的复制，不管是玻璃、语言还是思想的复制，都不可能发生。

"我们踏入而又没有踏入同一条河流。我们存在而又不存在。"⑤

哲学家赫拉克利特在其哲学著作《残篇》中有三处都提到了这一前苏格拉底的万物皆流以及我们在时间中的存在的本质的观点。

"人不能两次踏入同一条河流，也不能两次触摸到同样状态的凡物。但是，由于变化的突然和迅速，它散开又集合，（或者它既不是集合又散开，也不是集合再散开，而是同时集合和散开），形成和分解，接近和离开。"⑥

那么，这样的观点是如何渗透到安东尼·勒彼里耶的作品中去的呢？或者说得更确切些，因为制作总是先于认知，艺术家的材质智慧和制作方法（或诗学）作为一种独特的感知和思考世界的方式又是如何发生作用的呢？在这些关系中，什么是可以言说的？而什么又是不可言说的呢？

就勒彼里耶而言，肉体和精神力量爆发时的张力对照，即保持和变动的压力，早已成为其选择的媒质——流动的"半透明的不明液体"的本质的专题探讨了。我们可以在老普林尼（Pliny the Elder）所著的《自然史》（Natural History）中找到关于这种流动媒质的起源的记载：

在与朱迪亚⑦以及腓尼基接壤的叙利亚地区，坎迪贝尔湿地以迦密山为界。人们相信这里是伯罗斯河的源头，流经五英里后汇入托勒密附近海域。在伯罗斯河岸上，只有退潮时才能看到沙子。只有经过浪淘，海水去除杂质后，沙子才会闪闪发光……一次，一艘运载着苏打的商船停靠在这里，于是故事就这样开始了。他们在河岸上分散开做起饭来。由于没有石头架放锅子，他们就从船上搬来大块的苏打放在锅子下面作支架。苏打变热后与沙滩上的沙子融合在一起，一种不明液体到处流淌，这就是玻璃的起源。⑧

那么，无序状态下的玻璃究竟是一种液体还是一种固体呢？对于一位像安东尼·勒彼里耶这样的艺术家来说，这种模棱两可的状态又有什么重要意义呢？

对于"玻璃是固体还是液体"这个问题，我们无法给出明确的答案。从分子动力学和热力学方面来说，我们完全可能证明各种不同的观点都是正确的，玻璃是一种高度黏性液体，亦是一种非晶质固体，或者就是既非液体又非固体的另一种物态罢了。⑨

从分子动力学方面来看，玻璃严格说来是有别于结晶固体和液态的，因为玻璃分子呈一种无序却固定的黏合排列，既有液体的属性（尽管坚固地结合在一起），也有固体的属性（尽管没有有序的点阵结构）。事实上，勒彼里耶将他的首选创作媒质定为玻璃的原因就在于它的黏性。黏度被定义为流体阻力的程度，其测量单位为泊（poise）。

至于其状态，作为一种物理物态，玻璃或许体现了古希腊哲学中赫拉克利特关于液体和流动与巴门尼德（Parmenides）关于固体、永恒和包容的相互对立的哲学动力学。安东尼·勒彼里耶从他在巴黎索邦大学学习哲学和雕塑的求学时代起就对这些非常感兴趣。思想和材质之间的关系是具有无限潜力的，是一种冥想本质或是想象工艺的形式。然而，他的素材在本质上并没有像那些视描述或定义玻璃本质为己任的哲学家那样阐释了前苏格拉底哲学思想。

勒彼里耶于1968年开始在其祖父弗朗索瓦·戴克奇蒙（Fran ois Décorchemont）的指导下学习熔融玻璃制作，然而在十年后一段时期对戴克奇蒙文章的整理后，他才开始自己在工艺技术方面的研究。从1982年起，他在全球各地开展览会，其作品成为三十个主要国际玻璃美术馆的收藏，并获得了多项国际大奖。于2005年入围庞贝蓝钻大赏（Bombay Sapphire Prize）决赛。

勒彼里耶已创作出一种关于雕塑形式或主题的独特而古典的语言，并建构了三维场景以探讨含有动物或人类形象的匣子、台阶、穹隆、宝座、橱柜、金字塔、书本、石碑、杯子、框架等的塑性造型。如跳跃的剥皮野兔、鱼群、文艺复兴风格的人体图和象征长寿的龟等。我说"古典"是指，自从勒彼里耶早期创作中将有机形式化为圆拱结构开始，塞尚（Cézanne）对几何图形，如"圆柱体、球体和圆锥体"⑩以及正方形、圆形和三角形的偏好就对他的作品产生了一种几何学的潜在影响。例如《2051109》（2005）和《2030120》（2003年，入围庞贝蓝钻大赏决赛）这样的作品似乎浓缩了整个宇宙，即以无限重复的语言为标志的混乱和秩序的原始游戏，其中蕴涵着含糊不明的观众的状态（或许是有条不紊的，但可能是一片混乱的）。玻璃碎片嵌入并散布在不透明的立方体上，其上显现出一个雕刻的球体，嵌入一块正方形玻璃砖内。

对勒彼里耶而言，玻璃是一种艺术媒质，同时也是人类文化中最早的合成材料。因此，他通过并跟随玻璃的性质来思考，并以开启或隐藏其意涵的新发展方式来探索其天然现象学。他的方法主要采用复杂的铸造工艺，并在不同阶段伴以各种表面处理和修整工序，由此创作而成的作品会达到一种蕴涵着立体玻璃媒质中内外纬度间形式张力的结构平衡感，表现出透明、半透明和不透明的不同质感，明澈的薄纱、文字和背景悬浮其中，其作品强调粗糙和抛光的表面肌理，并凝练或折射出不同浓度的不透明色彩。

作品的表面和边缘很好地表现和包容了这些复杂的张力。正如安德鲁·格雷厄姆·狄克逊（Andrew Graham Dixon）就英国画家霍华德·霍奇金（Howard Hodgkin）作品中的"框"所说：

雕塑家总能理解边缘的重要性，因为边缘明确界定了形式是如何容纳空间的。一幅画的边缘是其最为脆弱之处；是艺术作品结束之处，也是其世界开始之处；是绘画完成之处，或正好相反，是绘画宣布其未完成之处；是绘画与其边界交涉之处；是艺术家本人进入和退出之处；是其能力和信心的标志，是对其能力和信心的掌控或缺乏。绘画之成功或失败取决于其边缘。⑪

勒彼里耶的新作，如《延续生命/河流与石碑I》（Still alive/Fleuve stéle）

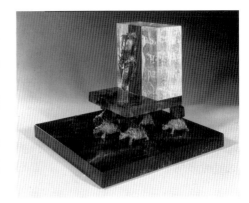

同时幻影5 安东尼·勒彼里耶（Antoine Leperlier） 长400mm，宽400mm，高380mm，1994年

玻璃状的文字1 安东尼·勒彼里耶（Antoine Leperlier） 长120mm，宽150mm，高180mm，1996年

秘密空间－混乱2 安东尼·勒彼里耶（Antoine Leperlier） 长280mm，宽210mm，高280mm，1997年

浮夸的野兔1 安东尼·勒彼里耶 (Antoine Leperlier) 长550mm，宽250mm，高650mm，1999年

浮夸的野兔2 安东尼·勒彼里耶 (Antoine Leperlier) 长1050mm，宽250mm，高680mm，1999年

延续生命－河流和石碑22 安东尼·勒彼里耶 (Antoine Leperlier) 长650mm，宽250mm，高1100mm，1999年

（2005年）和《安息的浮华II/河流与石碑》（Vanité au repos II/Fleuve stéle）（2006年）呈透明和流动的"框"架结构，表现了其物质平衡与存在，以及把握保持和流动间黏度的深思熟虑的瞬间。"poise"既表示形式与思想的平衡，也表示流体阻力的程度，即动态黏度的单位。而将"fleuve"和"stéle"的字母顺序打乱拼成"FSLTEE/ULVEE"，组成流动的带有阴性后缀的合成词，则记录了关于河流与石碑、流动与固定这一相对主题的变换的碑文。

这些作品与人的颅骨以及不透明的变色水果凝结而成的瀑布的形象有着深刻而古典的关系，令人想起尖锐嘲讽和完美工艺调制而成的辛辣的鸡尾酒。作为碑文的文字，即"au repos"（安息）的委婉语，提供以死亡形式体现的舒适，但又收回了以死亡形式体现的休息，在这里只是一个促进因素。而英语中的"静物"（still life）则被讽刺地表现为"延续生命"（still alive），从而为法语中的"自然死亡"（nature mort）②的阴影所笼罩。就其本身而言，该作品表达了一种对人类死亡宿命的关注，富于启发意义。这种死亡宿命是无法避免的时间流逝和物质衰退，也是艺术、记忆和幽默的常青。

安东尼·勒彼里耶并非唯一关注记忆、纪念、死亡宿命和时间不可重复的真实的艺术家。但与众不同的是他对于材料品质的强烈注重以及其在作品思想成形时允许触觉美感存在的独特方式。这种探寻记忆的方式与霍华德·霍奇金截然不同。关于霍华德在十七岁时创作的早期油画《回忆录》（Memoir），科尔姆·托宾（Colm Toíbín）写道：

《回忆录》中蕴涵了今后五十多年他会一直关注的元素。促使他创作这幅油画的最重要因素来自于记忆和记忆所承载的情感。在人们记忆中关于他作为画家的事件会激发比所有经历的事件更为重要、微妙和复杂的情感。

与之截然相反的是，对勒彼里耶来说，记忆中的事件似乎绝对无法凌驾于经历过的事件之上。记忆更应该是一种总有一天会消逝的状态，受到不可抗拒的流动和衰退，以及关于永失的深刻觉悟和绝望的影响。因此，他的作品是一曲深刻的哲学挽歌，超越了所有个人失落或私人记忆的感受，其内心关注的是流逝的时光和时间洪流中真实瞬间的本质。在这里，安东尼·勒彼里耶创造力的黏度，即流体阻力，流露出一种对于消逝那一刻的哀惋和留恋。这不仅包括了一种追忆的感悟，还包括了玻璃铸造工艺的独特运用，将特定表面的所有痕迹、印记、特征和质感精确地进行转印并以确定玻璃造型上的细致浮雕的形式表现出来，这样就能减轻时间毁损的程度。

这种复杂的转印工艺的两个特别范例是《有两个把手的壶》（Vase deux anses）系列作品——一只蜥蜴直立着栖息在残蚀的浮雕上，这些动物和文字的形象悬浮在一个固体壶造型中，这个壶配有一个位于重心之下并毫无作用的环状把手。我曾经委婉地问过艺术家这些文字从何而来③，他透露说是从他读过的最为古老的书籍，即祖父弗朗索瓦·戴克奇蒙所有的1559年拉丁文版的《宇宙志》（Cosmographia）上摘录下来的。《宇宙志》为塞巴斯蒂安·明斯特（Sebastian Münster）所著，初版于德国，1544年。

这些文字的碎片由一位工业雕刻师手工转印，随后酸蚀刻到一块厚锌版上，从该版上制作一个橡胶模，再由此制作一个石膏模型，最后是定型的包括蜥蜴形阳模的复合石膏模型。

蜥蜴形象的来历与其制作过程同样复杂。勒彼里耶的朋友，艺术家伯纳德·德容格（Bernard Dejonghe）发现了这条死去的蜥蜴并将它肚皮朝天地放入石膏中，然后丢到蚁丘中让蚂蚁将它吃掉，最后由吃空的阴模制作出这个胶质的蜥蜴图案，并寄给勒彼里耶作礼物，就好比是无形思想的一个有形成分似的。

从这只石膏蜥蜴和文字的复合模型制作出最终的橡胶阴模，然后在耐火石膏中铸成蜡模，最后用脱蜡法窑铸成玻璃作品。

很明显，当勒彼里耶一步步历经这一极度艰苦的过程时，他从未走过捷径，他在阴阳模型中前行，在立体成品的有和无⑬中穿梭，从形状到铸模，然后再回到原点重新开始。这就好像是为了能守护某些令人想起理查德·朗所说的"流传下来"的思想，比如说，照相网版和沙雕即时的省力和方便。"流传下来"（handed-down）这个词组在英语中暗示着手与手的接触，是经由触摸而延续的智慧。

在这里，印记的永久性或直接来源似乎被工艺转印时的直接肢体接触所证实：印记的特性源于物质感觉的延续以及指引这些感觉的手的稳定性。这是一种有形脉迹，而非数字记录，必须认真热情地进行创作。其延续使得每道工序持续的时间浓缩并增加其黏度。即便如此，无论其过程如何艰苦，每个阶段仍然经历了许多的变化，其清晰度每次都会遭受轻微的损失——就像记忆那样。

记忆的影响10 安东尼·勒彼里耶（Antoine Leperlier）长250mm，宽250mm，高250mm，2000年

而在包括了系列作品中的小海龟形象则更可能是这种思路更为浓缩的范例，一种"不忘的形式"的典型。其海龟原型，那种至今还能在远东传统药房里买到的风干标本的小型海龟，是勒彼里耶的叔祖父从利比亚带回来的。勒彼里耶还记得小时候看到这些小龟被放在他祖父的老式收音机上的样子。他说其实是他姐姐恰好发现了它们，才激发了他的灵感。这暗示着其他的标本，不管有多么相似，都不可能合他的意。这个小小的玻璃造像也是由蜡模铸造而成的，而蜡模又是由直接取自其原型的橡胶模制成的。对我这个评论者而言，这段历史的繁琐细节至少与将海龟寓为力量与长寿象征的解读一样意味深长。同样，蜥蜴也有其寓意，在作品中表现出其爬虫特有的尾巴拖曳过的印记，象征人类知识的碎片。在这里我们遇到了典型的模棱两可：在这个玻璃宇宙志中，玻璃蜥蜴是否怀着恶意窃取或是嘲弄我们世俗智慧的浮华呢？或仅仅是自然科学中的偶然事件，即蚂蚁的食物？也许这两个猜想都不对？

艺术家引发了以上那些对其作品的解读，却并不引导观众对其作品进行特定的诠释。但是对勒彼里耶来说，通过以上所述的一丝不苟的模塑和铸造工序来进行的记忆转印技术，是一种会意与蓄意的浮华。因为就在其进行复制的那一时刻，艰苦的劳动也意味着其原型的作废和在时间中的消失。取而代之的则是作品（l'oeuvre）。用乔治斯·布拉克笔记中的话来说就是"当绘画抹去其思想的时候，就是它完成的时候"，即本文的第二条引语。

浮夸的兔子－跳跃 安东尼·勒彼里耶（Antoine Leperlier）长380mm，宽200mm，高550mm，2001年

这一抹去的行为需要一种创造性的转变，一种赫拉克利特式的契机，在失去的瞬间以艺术作品的形式创造全新的事物。画家霍华德·霍奇金曾记录下与之相似的完成的意义：

我问他，你怎么知道一幅画已经完成了呢？他的回答对我来说似乎是完全清晰明了的，但又是非常玄奥神秘的。他说："当主题回归，当激发创作一幅画的灵感作为对象回归时，这幅画就完成了。"⑮

但对勒彼里耶而言，对于其作品中思想的领悟不仅伴随着完成的行为，还伴随着开始的最初时刻：

首先，我的每一个设计都源自于我脑海中的一种记忆。就好像它们出现在我想象中的那一刻，我就早已熟悉它们了。想法是突然出现的，但总是伴随着不可错认的"似曾相识"感。作为对象，它们在我内心的想象中早已完成。我能够从各个角度审视它们。如果它们异常强烈地出现，那么总会伴以一种当我们极力想要记起的单词突然浮现在脑海时的那种感觉。就在那一刻，我知道我得把它创作出来。当我完成这件玻璃作品时，这种感觉又会回来，它一回来我马上就能感觉到。⑯

一件新作品开始和完成的那刻总是伴随着强烈的几乎是不自觉的认识。而在这两个时刻之间，思想的印象随着时间的前行，通过铸造过程中阴阳形式和黏性玻璃媒质内与外的触摸而延续。作品和世界在不随时间流逝而变化的对象的物理限制中，在永恒与流动、秩序与混乱、存在与虚无这些矛盾中遇见又告别。

在勒彼里耶看来，作品无法模仿，也无法再现或重复其由来的形成过程或思

想。它至多是"流传下来"的，怪异的熟悉，同样的新奇。作品本身也是无法重复的，永远无法以描写或评论的语言来复述。

我们踏入而又没有踏入同一条河流。我们存在而又不存在。

延续生命30－可爱的塔希提岛女孩2 安东尼·勒彼里耶 (Antoine Leperlier) 长370mm，宽370mm，高220mm，2000年

立方体中的球体 安东尼·勒彼里耶 (Antoine Leperlier) 长183mm，宽183mm，高183mm，2003年

有两个环形把手的花瓶 安东尼·勒彼里耶 (Antoine Leperlier) 长350mm，宽80mm，高300mm，2003年

① 理查德·朗（Richard Long）2005年10月18日在达汀敦一次公开演讲后的谈话中所说。

② 原文为Le tableau est fini, quand il a éffacé l'idée. L'idée est le ber [berceau] du tableau. 意为"当绘画抹去其思想的时候，就是它完成的时候。思想是绘画的摇篮。"见乔治斯·布拉克（Georges Braque）：《乔治斯·布拉克笔记，1917—1947》（Cahier de Georges Braque, 1917—1947）巴黎：玛格出版社，1948年。斯坦利·阿普尔鲍姆（Stanley Applebaum）译：《乔治斯·布拉克插图笔记，1917—1955》（Georges Braque Illustrated Notebooks 1917—1955），纽约：多佛出版社，1971年，第80页。

③ 本文早期版本《安东尼·勒彼里耶》（Antoine Leperlier），巴黎/南塞：卡帕扎艺廊，2006年，第4—16页。ISBN 2—915241—22—8。

④ 见《安东尼·勒彼里耶》，奥拜斯：HD尼克艺廊，1999年——与埃诺洛特（Jean-Marie Lh  te）的访谈；亦可参见《安东尼·勒彼里耶》中他的"不合时宜的见解"的声明，巴黎/南塞：卡帕扎艺廊，2002年，ISBN 2—9516344—5—5；亦可参见丹·克莱恩（Dan Klein）：《庄严的表达》（'Expressions of Gravitas'）中对其迄今为止的艺术生涯的适时而又有益的概述，《国际手工艺艺术》（Craft Arts International），2005年第63期，ISSN 1038—846X，第26—30页。

⑤ 赫拉克利特（Heraclitus）著；T.M.罗宾森（T.M.Robinson）译注：《赫拉克利特著作残篇译注》（Fragments: A Text and Translation with a Commentary by T.M. Robinson），多伦多：多伦多大学出版社，1987年，ISBN 0—8020—6913—4，残篇49a，第35页。亦可参见残篇12中"当他们踏入同一条河流时，流过他们的是不同而又不同的水"；以及注释6。

⑥ 同上，残篇91a [91b]，第55页。

⑦ 译者按：古代罗马所统治的巴勒斯坦南部。

⑧ 老普林尼（Pliny the Elder）：《自然史》（Natural History），第36册。原文如下：

190 Pars Syriae, quae Phoenice vocatur, finitima ludaeae intra montis Carmeli radices paludem habet, quae vocatur Candebia. ex ea creditur nasci Belus amnis quinque milium passuum spatio in mare perfluens iuxta Ptolemaidem coloniam. lentus hic cursu, insaluber potu, sed caerimoniis sacer, limosus, vado profundus, non nisi refuso mari harenas fatetur; fluctibus enim volutatae nitescunt detritis sordibus.

191 tunc et marino creduntur adstringi morsu, non prius utiles. quingentorum est passuum non amplius litoris spatium, idque tantum multa per saecula gignendo fuit vitro. fama est adpulsa nave mercatorum nitri, cum sparsi per litus epulas pararent nec esset cortinis attollendis lapidum occasio, glaebas nitri e nave subdidisse, quibus accensis, permixta harena litoris, tralucentes novi liquores fluxisse rivos, et hanc fuisse originem vitri. [http://penelope.uchicago.edu/Thayer/L/Roman/Texts/Pliny-the-Elder/36*.html]

⑨ 菲利普·吉布斯（Philip Gibbs）：《玻璃是液体还是固体？》（Is glass liquid or solid?）[http://math.ucr.edu/home/baez/physics/General/Glass/glass.html]

⑩ 保罗·塞尚（Paul Cézanne）给埃米尔·伯纳德（Emile Bernard）的信，艾克斯，1904年4月15日。

⑪ 安德鲁·格雷厄姆·狄克逊（Andrew Graham Dixon）：《霍华德·霍奇金》（Howard Hodgkin），伦敦：泰晤士和哈得逊出版社，1994年，第74页。

⑫ 译者按：法语中的'nature morte'意为"静物"，作者在这里进行了一场文字游戏。科尔姆·托宾（Colm Toíbín）：《我不喜欢绘画》（I Hate Painting），《卫报》（《周六评论》），The Guardian, Saturday Review，2006年5月15日，第12—13页。

⑬ 安东尼·勒彼里耶与本文作者的通信，2007年1月。

⑭ 安德鲁·布华顿：《触摸虚空》（Touching the Void），《形式》（FORM）第1期/创刊号，西澳珀斯，2004年12月，第2—7页。ISSN 1832—388X [www.form.net.au/form1.pdf]。文中详细论述了海德格尔、道和脱蜡铸造法的关系。

⑮ 托宾，见前引书。

⑯ 安东尼·勒彼里耶与本文作者的通信，2007年1月。

混乱8 安东尼·勒彼里耶（Antoine Leperlier）长300mm，宽260mm，高550mm，2003年

曾经8 安东尼·勒彼里耶（Antoine Leperlier）长180mm，宽180mm，高200mm，2003年

延续生命－河流和石碑3 安东尼·勒彼里耶（Antoine Leperlier）长300mm，宽150mm，高600mm，2005年

# 楼梯的灵魂：安·沃尔夫"观察"展

安·沃尔夫（Ann Wolff）在瑞典的家中

K In Suite 安·沃尔夫（Ann Wolff）1989年

外与内构成了辩证法的分界线，当我们将其引入形而上学的领域并发挥其作用时，其明显的几何形令我们眼花缭乱。它和决定一切是非的辩证法一样尖锐。如果你不小心，它就会成为掌控所有阴阳思想的形象基础。哲学家们面对外与内这样的概念时会就存在与虚无之间展开思考。所以，深奥的形而上学其实源于内隐的几何学——不管我们是否愿意承认——几何学赋予思想以空间性；如果形而上学学者不会勾画空间，那么他还能思考什么呢？①

在这篇短文中，我并不打算详述拉斯特出版社（Raster F rlag）最近出版的关于艺术家安·沃尔夫（Ann Wolff）的专著②所取得的详细而杰出的成果，而是打算以讨论现象或个人经验的形式来进行写作。为了避免这种"细读"被不经意地误解为"描写"，我想从一开始就援引乔治斯·布拉克典型而深刻的评论，这会是一种明智的做法：

写作并非描写，绘画亦非描画。现实只是一种幻象。（Ecrire n'est pas décrire. Peindre n'est pas dépeindre. La vraisemblance n'est que trompe-l'oeil.）③

尽管这一观点非常任性，但当我目睹安·沃尔夫迄今为止所有作品时所感受到的那种强大、坚定或是发自内心的召唤，为其提供了最好的佐证。这种召唤超越了任何纯粹的具象意义：未加修饰却充满活力的空间人体；强烈的性征和他性的官能存在；关于肉体、材料以及同一的"内"与"外"的形而下和形而上的辩证法；作为开放和封闭的现象，或者说作为遮蔽、反映和边界的表面；人类栖居的物质与梦想纬度；以及作为思维过程和存世模式的艺术创作本身。

然而，本文也有越界之处：我有幸目睹了除安·沃尔夫所有已发表作品之外的一件最新作品，在我写作本文时，该作品尚未进入公众视野。可以这样说，《楼梯房子》（Stair House）是一个尚未离家的孩子，在安·沃尔夫的柏林公寓的家里——其实我更想说是母爱——等待着独立的机会。今年1月的几天里，我与它在光影不断变化的冬季里，已变得亲密无间了。它与这次名为"观察"（Observations）的回顾展中的两件作品——《球屋II》（Ball House II）和《球屋III》（2004），还与展览中安·沃尔夫的早期作品《女神》（Goddess）（2002）和《女人》（Femme）（1999），有着形式上的联系。

《楼梯房子》有着凝聚的原始力量：长方形平面的紫色水晶铸块，渐升至尖顶，它由两个经过打磨抛光的斜面相交而成，代表了透明或缺失的屋顶坡度。浓淡一致的紫色玻璃体内部嵌入了规则的阶梯——负空间中凹凸的楼梯形状。

从上往下看，由于光线在其完整连续并未经磨光的微结构表面上反射，内部的虚空仿佛是实体。级级升高的阶梯向上轻微地折射、放大和扭曲，填满了斜面的视野——透明的玻璃媒质看上去是虚空，实质是内外纬度的相互颠覆中的彩色凹面体。它根据外部光源作出变化，因而转浓转暗，在不透明表面粗暴地阻挡了凝注的视线，作品的光深变得朦胧而难以穿透。只是在玻璃中多混合些许锰，这种对称就会被打破了。

K In Suite 安·沃尔夫 (Ann Wolff) 1989年

这种存在与不在、故意的正空间与负空间的游戏绝非只是一道智力题——某种单纯的视觉游戏——而是作品保留的铸模原型的牢固联系，其原型的每个局部印记都像指纹那样细致地留在作品各处，除了那两个屋顶坡面之外，因为那里所有的模痕都被磨去了。

除模铸过程中隐含的阴阳形式的性征意涵之外，这些不透明玻璃肌理也会令人注意到它们作为皮肤的官能性——并非是作为乏味包装的皮肤，而是作为"内"与"外"之间的活生生的分界面的"皮肤"，一种敏感的媒介物，正如生理学家路易吉·卢卡·卡瓦利 (Luigi Luca Cavalli) 所说：

"人体通过皮肤表面与外界发生联系。(El cos es comunica amb l'exterior a través de la seva superficie.)"④

安·沃尔夫对于复杂的玻璃表面工艺，通常表现为半透明、不透明或分层，其关注也带有对生活经验内外纬度之间交流与交换的意识、强调或认知的性质。她的作品将人体作为开放性和呼吸着的器具，作为有温度、对声音有反应、有血色和外形、有内外面和表面的物体，作为我们的居住场所，赋予生气和从中向外观望并最终离开的物质形态，加以探索。

楼梯房子 安·沃尔夫 (Ann Wolff) 长250mm, 宽180mm, 高220mm, 2004年

从这个意义上讲，房子这个形象是她对于人体关注的一种延伸。这种关注在她迄今为止的所有作品中得到了最充分的体现，它以人类栖居所作为存在，作为我们创造并理解艺术的经验。本文关于"内"与"外"思想的空间性的按语作者加斯顿·巴什拉 (Gaston Bachelard)，或许也有这种感觉，所以他说"雕刻中的房子或许会唤起你住进去的欲望"⑤。

显而易见，在关于内部空间亲密涵义的现象学研究中，房子是一种特许的存在。房子向我们同时提供了散开和集合的形象。⑥

作为一种平行阅读或是参照点，巴什拉的著作《空间诗学》(The Poetics of Space) (1958年) 或许的确令人满意地修正了那些关于安·沃尔夫的评论。这些评论满足于空有其名的罗列安·沃尔夫广为人知的有关"表征性"主题部分，或是试图将其创造性成就浅薄地归类为"男女平等主义者"或"家庭"题材，又或是受今日当代玻璃界颇为内省的思维视野所限。然而，在我看来，安·沃尔夫的作品是与其所示完全不同的一类作品。

即便是在此刻，我也无意低估生活经验在沃尔夫艺术实践中的重要意义。相反，我想表明的是，生活经验的本质必然是私密甚至孤独。同样，生活经验追溯的是一条始终如一的道路，而不是命运的偶然轨迹。

就这个意义而言，例如《玻璃房子》这件新作品——本文标题⑦就由此而来——就可以以某种方式与安·沃尔夫非常喜爱的一幅照片联系在一起。在这幅照片中沃尔夫本人坐在其农庄前的一小段阶梯的最高一级台阶上——这是他工作间隙休息时沉思以及遥望的地方——面向花园，花园外就是无垠的波罗的海。该农庄建于1635年，位于哥特兰岛 (Gotland) 上。但是就在此处，本文将要冒险驶入关于描写的浅海区，就在那里我曾经允诺过要继续对巴什拉更富启发性的关注：

"这并非描写房子或列举其特点的问题，相反，我们必须跨越描写的问题以

楼梯房子 安·沃尔夫 (Ann Wolff) 长250mm, 宽180mm, 高220mm, 2004年

楼梯房子模型 安·沃尔夫（Ann Wolff），2004年

屏风 安·沃尔夫（Ann Wolff） 长1200mm，宽120mm，高1300mm，2004年

在工作室中的图片 安·沃尔夫（Ann Wolff） 2004年

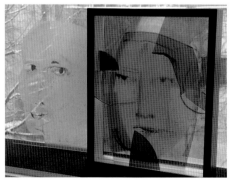
在工作室中的图片 安·沃尔夫（Ann Wolff） 2004年

获得其根本价值，这些价值在某种意义上揭示了一种源自对居住功能的依恋。在每一所房子，即使是最奢侈的房子里，现象学家的首要任务都是发现其原初的贝壳。"⑧

在《楼梯房子》中，楼梯的形象并不是为了在特定结构中连接特定的点而存在的。虚空的楼梯在人类经验所有纬度中含蓄地表达了关于其自身，即阶梯和纯粹的思想。作品以其尽可能简单的形式，抹去除模铸工序中"胎记"之外的所有附带细节，力求达到一种强大梦境般的共鸣，以及极度亲密的效果。

房子的过度美丽会掩盖其亲密性。生活也是如此，而梦想更是如此。因为记忆中真实的房子，使我们在梦中将房子富于不变的梦想，这是难以描画的……原初与梦想中的房子必须保有其藏身处。因为它属于深度文学，即诗歌，所以不需要其他人的故事来解析亲密性的流畅文学（指叙事体文学）。⑨

就在夺目的紫色光线以垂直纬度两极分化时，就在顶部的明亮向下逐渐黯淡时，楼梯这一主题也同样表现了房子的这种极性。据巴什拉所说："房顶提供了与地下阴暗的存在——地窖空间的"无理性"区域——正好相对"理性"的蔽身之处⑩。我所说的《楼梯房子》的"原始"力量在这种蔽护的原本意涵中凝聚了精神、梦幻或想象的力量，这种蔽护的原本意涵就是在想象中"作为垂直存在"的房子：

地窖和阁楼的极性确保其垂直性，两者的分界是如此之深远以至它们在某种程度上，开辟了想象现象学中的两个截然不同的视野。⑪

楼梯表现了连续而亲密的可能空间——地窖、客厅、卧室和阁楼。它首先是沉思与幻想的藏身处，是梦想家的庇护所，是思想、记忆、理想和愿望在其中融合的贝壳，是同一性在其中形成的坩埚。这种同一性，在安·沃尔夫看来显然确实包括了"你还不知道部分的你"。⑫

如果我们以现象学的方法来研究形象的真正发端，它们将具体地证明有人居住的空间和保护我的非我价值。⑬

作品中发生作用的阶梯现象学是既原始模型又极为个人的，就像遗传密码那样亲密：

在我们的记忆之内及之外，我们在其中出生的房子都铭刻在我们身上。二十年后，尽管我们曾走过无数其他的无名楼梯，但脑海中仍然会浮现那"第一段楼梯"的映像，我们不会再绊倒在那高高的台阶上。那房子完整地存在并——展现，忠实于自身的存在。我们将以同样的姿势推开那扇吱嘎作响的门，将在黑暗中找到那通向隐隐约约的阁楼的路。我们的手上还留着触摸即使是最小的门闩时的那种感觉。⑭

在前文人体与房子这一形象的比喻中，以及在本文论述对《楼梯房子》的细读中，关于人体更为明显的表达自始至终贯穿了整个"观察"回顾展，并将在两个方面作为沃尔夫作品中一个强有力的焦点而不断继续下去。它频繁地以雕像形式出现，通常是双双出现的，其回视——人像对艺术家或观众的回视——可以是直率的、掩饰的、隐藏的、回避的、分散的或黯淡的。

这些人头形象，据我看来，反映的远远不止对二元性、"我"与"非我"、"他"性或正相反的冷静思考。它们当然证明了对同一性与二元性、亲密无间与异性伴侣的持续关注，正如"观察"中各"站"⑮所表明的那样。但是其运动却是内向而又外向的：从人体进入某种争议性范畴，其中的内涵与外延以及同一性是在其表面传递的行为结果。

这令我想起沃尔夫对皮娜·鲍什（Pina Bausch）的评论（沃尔夫曾于1989年观察过她的舞团）——皮娜·鲍什"对人们如何移动并不感兴趣，她感兴趣的是什么移动了人们"，这一思想对于一位舞蹈家和编舞家来说是显著而深刻的，并自然而然地成为了一次对沃尔夫大型作品《科隆套房》（Cologne Suite）的解读。这件作品由一系列高度姿态性的图形组成，通常以其未加修饰的炭画技巧与控制得宜的强烈力度而闻名。

即使在因"叙述"内容为特征而著名的沃尔夫作品中，如20世纪80年代的装饰性《碗》系列，其形式也总是显示了对表面，以及对同一性分层的结构关注。器皿的玻璃壁，在其半透明的进深中，提供了这种"阶梯"形式三维的可能性，并拒绝遵守连续时间的经典法则中的叙述性直线运动。

这种与拼贴画密切相关的分层结构趣味，在最近的一次柏林展上以生气勃勃的崭新面貌展示在观众面前：一系列壁挂《人头》看起来仿佛为金属支座的斜影所框，投影出人头的形象和反转的线透视图，强烈暗示着14世纪意大利绘画中的"按透视画法缩小"的正相位。

这种透视画法简单地倒转，将这些正交线的灭点置于观众所处空间的某处——如果其直线排列恰当的话，甚至是观众身体内部——而非画面之外的某个想象中的远处。拼贴画在布满碎片、线条、色块以及污斑的柔和的调色板上出现了这些人头。那么我们究竟是在向画面中看还是从画面中向外看呢？这是关于我们在安·沃尔夫作品中，发现永久而难以和解的对峙，或许最后可以用加斯顿·巴什拉的话来为其作一最佳诠释：

"内与外都是亲密的，它们总是可以随时被倒转，可以随时互换其敌对状态。如果内与外之间存在分界面的话，那么这个分界面是进退两难的。在这亲密的几何学剧本中，我们应该住在哪里呢？"⑯

在工作室中的图片 安·沃尔夫（Ann Wolff）2004年

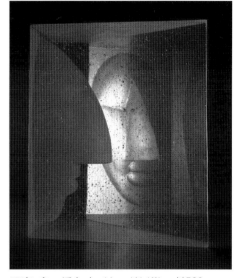

恶魔 安·沃尔夫（Ann Wolff）长500mm，宽300mm，高520mm，2005年

单身 安·沃尔夫（Ann Wolff）长400mm，高500mm，2005年

单身 安·沃尔夫（Ann Wolff）长400mm，高500mm，2005年

住宅 安·沃尔夫 长380mm, 宽180mm, 高250mm, 2006年

住宅 安·沃尔夫（Ann Wolff） 长380mm, 宽180mm, 高250mm, 2006年

阶梯 安·沃尔夫（Ann Wolff） 长690mm, 宽190mm, 高520mm, 2007年

面具 安·沃尔夫（Ann Wolff）

① 加斯顿·巴什拉（Gaston Bachelard）；玛丽亚·乔勒斯（Maria Jolas）译：《空间诗学》（The Poetics of Space），新版，波士顿：灯塔出版社，1994年，第211—212页。ISBN 0—8070—6473—4.

② 海克·伊萨亚斯（Heike Issaias）等：《安·沃尔夫》（Ann Wolff），斯德哥尔摩：拉斯特出版社，2002年，ISBN 91—87215—07—1。收录了丹·克莱恩（Dan Klein）、里克·斯蒂文斯（Riika Stewens）、克斯廷·瑞克曼（Kerstin Rickman）的文章以及与赫尔穆·里克（Helmut Ricke）的访谈。

③ 乔治斯·布拉克（Georges Braque）：《乔治斯·布拉克笔记》（Cahier de Georges Braque），巴黎：玛格出版社，1994年，第43页；亦可参见斯坦利·阿普尔鲍姆（Stanley Applebaum）译：《乔治斯·布拉克插图笔记，1917—1955》（Georges Braque Illustrated Notebooks 1917—1955），纽约，多佛英文版，1971年，第20页。

④ 路易吉·卢卡·卡瓦利（Luigi Luca Cavalli）：《第5届加泰罗尼亚国际奖获奖演说》（Address on receiving the 5th International Catalonia Prize），《加泰罗尼亚文化》（Catalonia Culture），1993年10月。

⑤ 加斯顿·巴什拉，见前引书，第145页。

⑥ 同上，第3页。

⑦ 在法语中，"l'esprit de l'escalier"，即楼梯的精神，描述的是当事后才想到对恶意评论或质问的完美回答时的"转念一想"的瞬间，事后聪明或机智的瞬间。"l'esprit de l'escalier"承载着我将之与安·沃尔夫的艺术实践联系在一起的进行、反思以及继续未完工作的精神。

⑧ 加斯顿·巴什拉，见前引书，第4页。

⑨ 同上，第12—13页。

⑩ 译者按：作者在这里将房子比喻成人体，房顶对应"理性"的头部。

⑪ 同上，第17页。

⑫ 与作者的谈话，柏林，2005年1月28日。

⑬ 同上，第5页。

⑭ 同上，第14—15页。

⑮ 译者按："观察"是安·沃尔夫作品的一次回顾展，展品分组陈列，安·沃尔夫将展览喻为一次旅行并称这些分组为"站"。

⑯ 同上，第218页。

# 如鱼得水：凯文·戈登新作

我漫步于英格兰德文郡海滨的瑟尔斯通（Thurlestone）沙湾，想象地球另一端凯文·戈登（Kevin Gordon）如鱼得水的样子：

我住在西澳大利亚的海边，几乎每天都带着小狗们去海滩，几乎每天都会发现新的东西，像贝壳、小块珊瑚、海草、海胆等，甚至还有被冲上海岸的碎玻璃。[①]

此刻我们共享的沙滩是丰富的，充满着杂质、花样、习惯、偶然和变动。根据古罗马历史学家老普林尼的《自然史》所说，玻璃是一种流动的"半透明的不明液体"，它就是在这样的环境中，偶然被发现的：

"在与朱迪亚与腓尼基接壤的叙利亚地区，坎迪贝尔湿地以迦密山为界。人们相信这里是伯罗斯河的源头，流径五英里后汇入托勒密附近海域。在伯罗斯河岸上，只有退潮时才能看到沙子。只有经过浪淘，海水去除杂质后，沙子才会闪闪发光……一次，一艘运载着苏打的商船停靠在这里，于是故事就这样开始了。他们在河岸上分散开做起饭来。由于没有石头架放锅子，他们就从船上搬来大块的苏打放在锅子下面做支架。苏打变热后与沙滩上的沙子融合在一起，出现了一种不明液体到处流淌，这就是玻璃的起源。"[②]

戈登对他所选的创作媒质特性非常警觉，有自然以及合成的循环特性——从硅砂（作为其逐渐形成的贝壳和珊瑚的残留）到玻璃；从天然矿石到人工制品再到被冲上海岸的漂流物——非常警觉，这对他的新作产生了直接的影响，正如他所说："事实上，这些作品是由它们所表现的东西制成的。"他的话显示出一种反身意识，进行了对艺术表现形式上更为复杂、隐含的探讨。这一反应或许与赫尔曼·梅尔维尔的小说《白鲸》（1851）[③]中的讲述者以实玛利（Ishmael）的反应是相似的，以实玛利用透明的干鱼胶片，鲸"皮的皮"，来读他关于鲸的书。

今天的展出象征着凯文·戈登作品的新起点，有创见有特色，其目的地直指一个当代玻璃艺术中还无人到达的地方。事实上这个起点与某些历史学方面的先例，以及19世纪晚期的科学美感有更多的共同之处。包括：利奥波德·布拉希卡和鲁道夫·布拉希卡（Leopold and Rudolph Blaschka）的非同寻常的玻璃项目（1880—1936）；恩斯特·赫克尔（Ernst Haeckel）的植物和海洋类平版、单色印相插画，以及于1899至1904年间集结出版的《自然界的艺术形态》（Kunstformen der Natur）；威尔逊·A·本特利（Wilson A. Bentley）（1865—1931）在佛蒙特

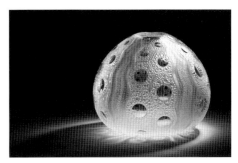

海胆1 凯文·戈登（Kevin Gordon）直径370mm，高300mm，2007年

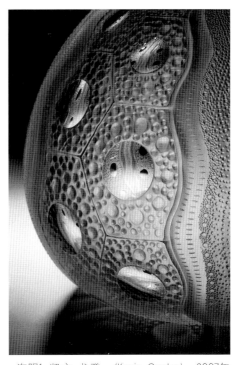

海胆1 凯文·戈登（Kevin Gordon）2007年

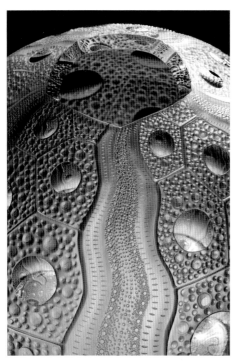

海胆1 凯文·戈登 (Kevin Gordon) 2007年

海胆2 凯文·戈登 (Kevin Gordon) 直径
370mm，高300mm，2007

州拍摄并收集的雪花摄影资料《雪晶》（Snow Crystals）（1931），于其逝世当年出版。而《白鲸》本身或许被看作是同样的鸿篇巨制，从人类生态学的角度来看，是随着机械鱼叉的出现而行将消失的南塔基特捕鲸业文化的一曲不朽挽歌。

戈登曾经谈到埃伯尔托夫特玻璃博物馆（Ebeltoft Glasmuseet）举办的2006布拉希卡海洋作品展——"玻璃水族馆"（Glass Aquarium）[④]，以及赫克尔（1834—1919）和M．C．埃舍尔（M.C. Escher）（1898—1972）对他作品的影响。他与这些艺术家一样着迷于自然和数理形式，这种着迷似乎跨越了整整一个世纪的欧洲美学背景。

利奥波德和鲁道夫·布拉希卡父子在其位于德勒斯登附近的工房里制作精细的烧拉玻璃植物和海洋生物模型，这些植物和海洋生物形式基于如菲利普·戈斯（Philip Gosse）所著《博物学家在德文郡海岸上的漫步》（A Naturalist's Rambles on the Devonshire Coast）（1853）[⑤]等书籍中的博物学插图。德文郡海岸正巧就是本文开始时作者的漫步之处。布拉希卡父子将自己描述为"博物学工匠"，而他们的作品则被其同时代者看作是"科学领域的艺术奇迹和艺术领域的科学奇迹"。他们的设计动力来自于两方面，一是对19世纪初开始的深海潜水技术发展后的惊人发现，二是用以制作当时科学界流行的博物学采集中有机体标本的化学防腐技术的不足。他们为科内尔大学（Cornell）及其他大学制作无脊椎动物模型，1890年开始则专为哈佛大学植物博物馆（Botanical Museum at Harvard University）制作布拉希卡玻璃花（到1936年为止，他们共制作了约四千四百座惟妙惟肖的玻璃模型）。

这两位"博物学工匠"在技术、艺术和科学的断层线里进行创作的意义十分深远，其中鲁道夫（1857—1939）与阿马尔利克·沃尔特（1859—1942）几乎完全生活在同一时代，然而他们父子的成就似乎与法国象征派诗人、散文家保罗·瓦雷里（Paul Valéry，1871—1945）的现代主义思想和对形式的关注格格不入，瓦雷里本身就是一位热衷于生物学和数学的饱学之士。

艺术家们的作品并非取材于其自身的物质存在，他们所追求的形式来自于可以完全脱离其存在的精神特殊应用。

或许在我们称之为（无人追求，有人鄙视的）艺术上，那种完美的境界仅仅是一种在人类作品中渴望或发现技巧的确定性、内在的必然性以及形式和材料之间有着不可分割的联系。所有这些我们都可以在最不起眼的贝壳中找到。[⑥]

如果我们对这种反身的现代主义以及后来的后现代主义精神与存在之间的脱离给予应有的关注，那么我们就会发现力求工艺上的完美，这种审美态度似乎起到了很大的作用，该特质可能会在最终完成的作品中被认为是一种物质形式的必然性而大加赞赏。就这点而言，考虑到凯文·戈登作品中的海洋性形式，瓦雷里的观点或许也一样值得我们注意。

戈登极其精美的作品引起了法国哲学家加斯顿·巴什拉（1884—1962）在《空间诗学》（La poétique de l'espace）（1958）中第五章开始时叙述，就保罗·瓦雷里、戈登极其精美的作品引起了关于贝壳的思考并发出惊叹：

"对这位诗人来说，贝壳似乎一直是一种完全凝固的动物，是一种几何学真理，并因此'鲜明而独特'。这种被创造的物体本身就是这样，神秘的是其形成而非形式。"[⑦]

"人类雕刻的贝壳只有从外部才能获得，是通过一系列无法历数且带有人工雕琢美的特质行为。然而'软体动物分泌其贝壳'，令其成为贝壳的建筑材料并'渗出'、'提炼出它需要的奇妙的东西'。瓦雷里以这样的方式回归赋形的生命之谜、缓慢而连续的形成之谜。"[⑧]

在该争论空间里的，凯文·戈登创作了具有活动与极端表面精确性的发光体：这些玻璃雕塑创造了一种栩栩如生却曲折、静止的海洋性的存在，其大小适合置于

家中。它们的形式和形成令人惊异。它们游于透明媒质的固有二重性之间，其外表的魅力令人忘记思考海胆、珊瑚、河扇或贝壳形式的变形和精致的细节，虽然它们都是完全脱离存在精神的"特殊应用"，却正是从这种变形和亲密的细节中获得的另外感悟。

作为玻璃作品而非有生命的有机海洋生物器皿，就其具象意义而言，它们既是非科学或自然例证，亦非幻想或错觉的行为。在自然现象世界中，玻璃与实物的区别在于它们有"从外部获得"的"即在对象性"，其外观和手感既带有本来的肌理特征，又有像在漫长环境影响中所留下的磨损和伤痕。

在这里，雕刻工具的刃口接触材料，并以另一种理论检验并揭示了其材料亲密特性，这种理论与保罗·瓦雷里对立于渗出和雕刻形式的观点是相近的。因此，在英国艺术理论家艾德里安·斯托克斯（Adrian Stokes）（1902—1972）看来——斯托克斯的写作受到梅兰妮·克莱因的精神分析理论的影响——雕刻不同于制作模型，是一种形式和精神显露的过程，承认并证实了其对象的脱离。

就玻璃材质而言，瓦雷里观点中的两个方面都有助于我们理解凯文·戈登的创作方法，其中液体玻璃材料——经由大卫·海（David Hay）的巧手引导成形——的确是"渗出"的，慢慢地产生或渗出其外表面，随之冷却成为静止的流动形式的半透明贝壳状外观。透明的玻璃媒质打开了深入其内部纬度的窗户，这与海胆自然的不透明性质完全不符。

而在另一方面，每件作品都是"精神的特殊应用"，都是习得手艺与故意设计的作品，瓦雷里极其敏锐地意识到了这一特征：

"贝壳的制造是生命的表现，而非故意为之。还有什么能比我们有目的、有动机有组织的行为更截然相反的呢。"⑨

戈登广泛运用了冷加工精整工艺（砂轮切割、雕刻、喷砂处理、钻孔、刷涂、磨料抛光），强调冷加工玻璃器皿异常精美的造型外表面的装饰性，并雕刻出一种漂浮于其静止流动形式上的细小点阵结构"外骨骼"。他巧妙地利用玻璃材质模棱两可的状态及其亚稳和无序的分子状态⑩——既非液体，亦非固体；并因此流动而柔韧却又同时稳定而坚硬。这在《透明的海胆》（Clear Sea Urchin）这类作品中表现得尤为明显。《透明的海胆》呈现由热塑成形的球体状，经过研磨或平整的表面散饰着抛光而成的透镜，放大了作品内部正对面的纹理和图案，它们在作品内部曲折。无论从哪方面看，这件作品好像都是在水中雕就。

因此，《透明的海胆》中所运用的表现方式并不是文字上的，甚至也不是描写性的。相反，是由几何元素、形式、肌理以一种转喻的方式结合在一起，部分转喻整体，而其自身则包含于这件器皿的内涵中。

对于在海滩上捡东西的迷恋，也许是始于偶然发现珍宝的运气，然而为戈登的海滩散步增添了如此之多的乐趣的正是残骸和漂流物，主要是贝壳或玻璃碎片以及光滑的浮木碎片，它们立即引起了模糊的联想，对每天随着潮水冲上海岸而迷失的所有来自自然或人工世界的物体中——相隔着神秘的时间与空间距离——不明来历的联想。这样的距离标志着我们与自然界的脱离以及在自然界中的寓意。每一片都有其自身不同的特征与价值，透视着现象世界，要么讨人喜欢，要么令人反感，完全取决于机缘。如果恰好不是不规则碎片的话，那么至少能隐约看出其有机或数学种类。

"我研究了分形概念和曼德勃罗理论，这个概念是指一些基本元素以不同的方式而形成，并使用这些不断重复构建完整结构元素的数学公式的形式。在我的作品中，我用透镜来强调这一点，因为透镜告诉我们，无论其比例或分辨率是多少，它的设计都能反映出其背后的涵义。"⑪

戈登对于这些以及其他数学形式，包括斐波那契数列和戈尔登数列的兴趣既表现在其设计方法上，也表现在个人对其表现形式的看法上。他阅读了许多关于这些数学形式的原始参考资料：

珊瑚2 凯文·戈登（Kevin Gordon） 2007年

珊瑚2 凯文·戈登（Kevin Gordon） 直径150mm，高330mm，2007年

珊瑚（组群） 凯文·戈登（Kevin Gordon） 2007年

珊瑚 凯文·戈登 (Kevin Gordon) 直径
140mm，高320mm，2007年

珊瑚 凯文·戈登 (Kevin Gordon) 直径
310mm，高310mm，2007年

"在这件作品中，我并不试图准确和科学地表现珊瑚、贝壳、海胆等等，我想在这些海洋生物中寻找可以运用在我作品中的图案、质地和结构。因为在这样的作品中，我能够使用冷加工玻璃技术，并展示自己创作领域中由累积的经验而所发展形成的许多方法。这组作品要求我发展新的方法来达到一种效果，这不仅将我的作品推到新的领域，还拓展了如何以玻璃媒质进行创作的新的思考和探索。"⑫

在西澳大利亚更为广阔的自然环境中，产生了戈登新作系列，它带来了关于艺术与生态学中表现形式的有趣问题。作品用部分来引发对整体的想象，戈登那些不断走向成熟的作品中可能有这种隐含的转喻因素，通过对物种细节层面上的注重来试图引起对整个（海洋）生态系统的理解和关注。威廉·布莱克（William Blake）想象中的"微观-宏观"关系的变形，他的"在一粒沙中看世界"的才能⑬，傲慢地否定了将碎片看作是有限限度的科学观点——正如布莱克在其《地狱箴言》（'Proverbs of Hell'）中所说："永恒爱恋着时间的作品"。⑭

环境可持续性的潜流只是一种意会，尽管戈登的设计并无意在敲响生态学的警钟，以作尖锐的政治哀悼目的，但推测一下这组新作，还是很有意思的。作为一次最后的演出，作为一块玻璃的珊瑚礁，如果超越其作品的总和，它可能会意味着怎样的结果呢？

① 凯文·戈登写给作者的信，2007年12月12日。

② 190 Pars Syriae, quae Phoenice vocatur, finitima ludaeae intra montis Carmeli radices paludem habet, quae vocatur Candebia. ex ea creditur nasci Belus amnis quinque milium passuum spatio in mare perfluens iuxta Ptolemaidem coloniam. lentus hic cursu, insaluber potu, sed caerimoniis sacer, limosus, vado profundus, non nisi refuso mari harenas fatetur; fluctibus enim volutatae nitescunt detritis sordibus.

191 tunc et marino creduntur adstringi morsu, non prius utiles. quingentorum est passuum non amplius litoris spatium, idque tantum multa per saecula gignendo fuit vitro. fama est adpulsa nave mercatorum nitri, cum sparsi per litus epulas pararent nec esset cortinis attollendis lapidum occasio, glaebas nitri e nave subdidisse, quibus accensis, permixta harena litoris, tralucentes novi liquores fluxisse rivos, et hanc fuisse originem vitri.

[老普林尼 (Pliny the Elder)：《自然史》(Natural History)，第36册，http://penelope.uchicago.edu/Thayer/L/Roman/Texts/Pliny-the-Elder/36*.html]

③ "从鲸的未受损伤的尸体上，你也许可以用手刮下一层非常薄的透明的东西，这东西有点像最薄的鱼胶片，只是它几乎就像缎子那样易弯和柔软；不过这是在晒干前，晒干后它就缩起来变厚了，而且还变得又硬又脆的。我自己就有几片这样的干鲸皮，我用它们在我的鲸鱼书里作书签。我前面说了，这东西是透明的；我相信它，如果放在有字的书页上，会把字放大，这有时会让我觉得高兴。也许就像你说的，不管怎么样，从鲸自己的皮做的眼镜里读关于鲸的书，确实让人高兴。" 赫尔曼·梅尔维尔 (Herman Melville)：《白鲸》(Moby Dick; or, The Whale)，1851年，第68章《毯子》。

④ 见http://www.glasmuseet.dk/english/exhibitions/past/the-glass-aquarium.html.

⑤ 菲利普·戈斯 (Philip Gosse) (1810—1888) 与梅尔维生活在同一时代，在位于纽芬兰卡伯尼尔 (Carbonear) 研究昆虫时，在那里的捕鲸部门偶然工作过很短的一段时间。

⑥ 保罗·瓦雷里 (Paul Valéry)；詹姆斯·R·劳勒 (James R. Lawler) 选编并作导论：《人与贝壳》(Man and the Sea Shell)，《保罗·瓦雷里选集》(Paul Valéry: An Anthology)，伦敦：鲁特莱治和凯根保罗出版社，1977年，第132页。瓦雷里的散文《人与贝壳》(L'Homme et la coquille) 最早发表于《法国新评论》(La Nouvelle Revue Fran aise)，1937年2月1日，鲁道夫·布拉希卡 (Rudolph Blaschka) 停止其创作的一年后。

⑦ 加斯顿·巴什拉 (Gaston Bachelard)：《空间诗学》(La poétique de l'espace)，1958年；玛丽亚·乔勒斯 (Maria Jolas) 译：《空间诗学》(The Poetics of Space)，波士顿：灯塔出版社，1994年版，第105—6页。

⑧ 巴什拉，《空间诗学》，第106页。

⑨ 保罗·瓦雷里：《人与贝壳》，第128页。

⑩ 从分子物理学方面来看，玻璃严格说来是有别于结晶固体和液态的，因为玻璃分子呈一种无序却固定的黏合排列，既有液体的属性（尽管坚固地结合在一起），也有固体的属性（尽管没有有序的点阵结构）。玻璃的特点在于其黏度，黏度被定义为流体阻力的程度，其测量单位为泊 (poise)。

⑪ 凯文·戈登写给作者的信，2007年12月12日。

⑫ 同上。

⑬ 威廉·布莱克 (William Blake)：《天真的预兆》(Auguries of Innocence)，最初由罗塞蒂出版社出版于其版本的吉尔克利斯特 (Gilchrist) 著《威廉·布莱克的一生》(Life of William Blake) (1863年) 中，这首诗是根据布莱克可能写于其在菲尔法姆居住期间的一张保存尚好的手稿编辑而成 (1800—1803)。此处引用徐志摩的翻译：

一沙一世界，一花一天堂。

无限掌中置，刹那成永恒。

(To see a World in a Grain of Sand

And a Heaven in a Wild Flower,

Hold Infinity in the palm of your hand

And Eternity in an hour.')

⑭ 威廉·布莱克：《天国与地狱的婚姻》(The Marriage of Heaven and Hell)，写于1790—1793年。

# 玻璃之门

## ——关东海"城门"玻璃雕塑展

城门系列1 关东海（Guan Donghai） 长420mm，宽170mm，高320mm，2003年

"城门"（City Gates）是中国艺术家关东海的首次个人玻璃雕塑展，于2006年10月11日至11月11日在香港盖弗尔工房玻璃画廊（Gaffer Studio Glass）举办，标志着他创作生涯的重要开端。我很荣幸能为这次意义重大的展览写一篇短论，来见证他从五年前首次接触玻璃这种素材到现在展出一系列优秀原创作品的飞速成长，并重温我从中感受到的那种快乐和满足。

或许是意料之中，关东海首次个展的主题是关于"门口"和"开端"的，它们既是进入点又是止步点。在更为广阔的当代国际玻璃艺术背景中，这些作品饱含意蕴也历尽风霜。《城门》系列作品是入口或门的空间，这些入口或空间缺失的门框引领我们进入当代中国玻璃的独特领域，并抵制所有纯粹以"别处"衍生而来的事物的视野。这些本质上是以其他方式探讨中国建筑作品想象中的城市纬度，其成效也是令人瞩目的——它们以消失或转喻的"无形城市"的缺失形式阻止我们进入。

事实上，将关东海的《城门》系列作品想象成是与伊塔洛·卡尔维诺（Italo Calvino）的小说《看不见的城市》[①]（Le città invisibili）相呼应的会意雕塑作品，这是异想天开的。在《看不见的城市》里，马可波罗一章接着一章地向忽必烈描绘了稀奇古怪的记忆之城、语言之城和游历之城，然而在这些"故事中的故事"最后的大逆转中，所有这些城市原来都是献给马可波罗钟爱的故乡威尼斯的一曲想象中的颂歌。

相比之下，关东海的"城门"无声地将入侵者抵挡在外，将隐秘处保护在内，似乎是恰到好处，引发了关于力量、保护、隔绝和孤立的文化上的想象。这些"城门"探索着界限的实践性概念，包括整套简单玻璃制作工序中自我强加的局限性。但它们又是现代的，纵然像过往一样高深莫测，却戏谑地表现了一个与公认的标准看法或低劣的新闻观点截然不同的古代中国和现代中国。

玻璃的粗糙质感似乎也恰如其分——分明是原砂铸和窑铸的结构，却呈现出精心处理的表面和细腻的色彩感受性。关东海在此追求的是一种完成的质感，他称之为"简单纯正"，但事实上，除了关东海对玻璃技术的精通之外，这种质感还不自觉地流露出一种可持续的艺术和技术构成，这种构成常见于呈现完成质感的织物设计、水彩画以及笔触精确的制图法中。门上各种各样方形和圆形的饰钉星罗棋布，

这种构成常见于呈现完成质感的织浮凸交替变换，间有岗台、拱道和门窗。它们的形态像雕刻的图章，又像是中国小孩练字用的小方格那样富有张力。从门上不时探出的古代人头，凝视着观众——这些人像是岗哨，还是被割下示儆的战利品？这样的作品不需要直言不讳的叙述，因为其意义是心照不宣、不言而喻的，足以表达其自身。

同样，《兵器》（Weapon Series）系列作品的形态是将古代仪式所用的青铜和玉制兵器置入全新的建筑柱形，继续运用制作古代兵器的模铸和冷磨技术来创作出按比例缩小的完整模型。其纪念意义来自于作品的重要性和强烈性，也来自于作品的交替纪念和戏谑形式，以及对于某种失落或无名却高度发达的文明仪式和手工艺文化的辉煌历史遗产的思考。同时，这些作品无疑不只是文化考古学或史学挪用的衍生物，因此在我看来，这些富有强烈实体感、质感和色彩的作品萦绕着一种创造性的矛盾心理。

关东海生机盎然的玻璃艺术新作以当代表现方式回顾并再现了往日的形态、过去的经历和形式的研究，从古代玉器、青铜器或石器中吸取灵感，从礼仪、军事和手工艺文化中追溯其形式上的来源。

关东海的作品中有一种深刻的东西，一种比挽歌或怀旧远为意味深长的东西，因为这些作品总是流露出一种明显的感性，对于经过岁月洗礼的人工制品的物理属性感到本能的兴奋。作为一个画家同时又是一个旅行者，他的水彩画和其他绘画耐心地记录了某些主题，如《小院》和《老工厂建筑》，记录了衰败或倾圮的详细发生，也因此（几乎是偶然地）获得了2003年伯明翰皇家艺术家协会（Royal Birmingham Society of Artists）的绘画大奖。我还记得，那年秋天我们漫步于什罗普郡的乡村小道上，他发现了一堆杂草丛生的废弃农业机械，那因氧化而锈迹斑斑的金属造型令他一下子激动若狂的样子还历历在目。

任何象征性的人类元素，就如同大型建筑设计中的细部那样，在程度和定义上总是从属性的，这也同样赋予了《城门》和《兵器》系列作品以纪念意义。例如以象征古代人类存在的没有身体的人头为主题的相关作品中，刀刃上的窗口（如《兵器》系列1和2），又如作品《制度》（Régime）中，由玻璃铸成的一节H形钢梁轨道，上面嵌列着有顶髻的半透明玻璃人头，一模一样的脸上涂着红、蓝、白和黑色的氧化物颜料。

每个人头都于颈部嵌入水平的C截面且不透明熔融玻璃滑道上，排成密集的队列，就好像冷兵器时代的西安兵马俑通勤玻璃版本。将这样的表现手法与另一位出色的图样设计家——英国玻璃艺术家戴维·里克的作品进行比较是很有意思的。他的作品关东海或许也很熟悉。在他们的作品中，我们都能够找到精确、优雅的形式、颠覆的幽默、隐秘的游戏以及对人类生存状态的真实描写，有着报刊漫画或讽刺短诗的那种简练和直接。但在《制度》中，里克所探索的单人戏剧，即独白，所有痕迹都被抹去了——这种探索是里克所特有的——呈现出一种不同的政治敏感性，专注于力量形式的表现。我很期待这一作品的新发展。

关东海的雕塑语言有着高度的创造性想象力、对表面质地的密切关注、丰富的色彩感受性、技术上的游刃有余，以及对建筑细部、古代青铜和玉器制作技术方面的中国手工艺传统的敏锐观察意识。它可以是活泼的，富有幽默或政治意味的，又可以是自信、审慎而从容的。

这些令人耳目一新的作品在表现当代活力的同时，也折射了一种关于历史和文化传统的明确感受。在关东海目前的创作时期，他似乎满足于探索玻璃材质发光度的局限性，以及玻璃与砂石之间的关系，而不是透明度或表面光泽等更为明显的性质。

关东海本人似乎也是这样。七年前我们在清华大学首次见面时，我为他对玻璃和艺术的狂热（几乎可称之为一种渴望）所深深打动。而今天，他在如此之短的时

城门系列6 关东海（Guan Donghai）
长420mm，宽170mm，高600mm，2006年

城门系列8 关东海（Guan Donghai）
长240mm，宽90mm，高320mm，2006年

间内取得如此之大的成就，可谓是一位既有思想又对自己在当代玻璃艺术界中定位明确的自信标志。显然，今后他还会创作出更多更好的作品。

城门系列 "Biao" 关东海 (Guan Donghai)
长310mm，宽80mm，高420mm，2009年

城门系列 "Xin" 关东海 (Guan Donghai)
长320mm，宽90mm，高420mm，2009年

① 伊塔洛·卡尔维诺 (Italo Calvino)：《看不见的城市》(Le città invisibili)，米兰：埃依纳乌迪出版社，1972年。威廉·韦弗 (William Weaver) 译：《看不见的城市》(Invisible Cities)，伦敦：皮卡多出版社，1979年。

# 触摸虚空

本文关注手工艺实践中"缄默"（silence）定义的本质"虚空"（emptiness），并论及将手与心、素材与理念联系起来的创造性问题。文章意在邀请读者思考其问题，而非指导读者接受其论点，这或许正适合这本新办期刊的创刊号。

就行文而言，我的主题仿佛交织于两段平行的历史中——其中任何一段，对于澳洲乃至太平洋沿岸地区的当代手工艺和设计实践的发展来说，都可能有着同样的重要性——分别谈到了欧洲和东亚传统的创意和智慧遗产。

本文继而对"悬而未决的现代主义"作为20世纪的遗留问题以及作为当代应用艺术和设计的争议焦点作了进一步的阐述和探讨，并涉及哲学领域，即已故的彼得·多摩尔（Peter Dormer）或称之为"实践哲学"的领域：

大智 杨惠姗（Yang Hui-shan） 长400mm，宽400mm，高180mm，1998年

"之所以将手工艺称为实践哲学，是由于几乎与之相关的所有要点都无法用语言或是命题来表达，手工艺与理论正如水油一样不相溶……

然而，经过训练的手工艺是一种知识体系，其价值观复杂而多元。其体系的拓展及其价值观的表现和检验是通过实践而非语言来实现的。这就使得我们难以清晰连贯地记录甚至是谈论手工艺了。"①

多摩尔在其《手工艺的语言和实践哲学》一文中确立了这种默契（tacit understanding）的重要性。默契是能立刻感受到的，绝不是应用艺术领域所独有，有多摩尔在其《制造者的艺术》一书中所作下列表述为证②：

"我无法系统地阐述知识体系的深度，我也无法描述自己是如何告诉一位病人他即将死亡的。在我的知识体系中最为重要的部分是通过与人交往和学习建构起来的。这对我的判断能力至关重要。这是一个不断重复的过程，永远不可能用言语表达清楚，无法通过理论学会，因为这比其他任何事物都更需要'领会'的能力。"③

无言之美（中）杨惠姗（Yang Hui-shan） 长530mm，宽460mm，高900mm，1999年

托马斯·F·加杰（Thomas F. Judge）所著的《江户工匠》（Edo Craftsmen）一书是对当代东京尚存手工艺人（shokunin）的研究。他与多摩尔一样关注"什么是手工艺，以及默会知识（tacit knowledge）因何如此重要"，并通过对东亚教授法传统的阐述进一步拓展了默会知识或默契这一问题。他与我们刚刚读到过的那位医生一样，强调"领会"和内隐学习的重要性：

"不提供正式训练也同样有助于表明：即使仅仅是触摸工具也是一种特殊待

莲花藏 杨惠姗（Yang Huishan）
长650mm，宽650mm，高810mm，2001年

百花如意 杨惠姗（Yang Huishan）
长750mm，宽700mm，高450mm，2002年

莲花 杨惠姗（Yang Huishan）
直径700mm，高250mm，2004年

遇。这逐渐培养了一种发自内心的求知欲望……师傅并不通过解说来教导学徒。只有完成的作品才重要；不达标的作品被退回，而学徒被丢在一边让他自己思索问题出在哪里。从本质上来说，学徒是通过模仿，或者如日本人所说：'通过观察和偷师来习得手艺的。'"④

手工艺制作的实践哲学与更为广泛的哲学论述之间存在的理论性及语言学歧异，可以言说和必须保持缄默之间的鸿沟，在20世纪德国哲学家马丁·海德格尔（Martin Heidegger）关于"物"的本质的一篇文章中进一步扩大了。在文中，他就一件简单的手工制容器，即陶罐的本质进行了思考：

陶罐是作为器皿存在的物——它能够容纳某些物体。虽然这件容器必须被制作出来，但是陶罐被陶匠制作出来这一状态决不能构成其作为陶罐的独特性和恰当性。陶罐并不是因为被制作而成为器皿，相反，正因为陶罐是器皿，它才必须被制作出来。

当我们将葡萄酒注满陶罐时，我们认识到它容纳的本质。显然是罐底和罐壁承担了容纳的工作。但是，别忙着下结论！当我们在陶罐中注满葡萄酒，我们是将酒注入罐壁和罐底吗？我们至多是将酒倒在罐壁之间和罐底之上吧。自然，罐壁和罐底是器皿中无法渗透的部分，然而无法渗透的部分并不是起容纳作用的部分。当我们注满陶罐，是倾倒的液体流入空的陶罐，正是这种虚空完成了器皿的容纳。正是这种虚空，这种陶罐的无，成就了作为容纳器皿的陶罐。

但是，如果容纳是由陶罐的虚空来完成的，那么在转盘上塑造罐壁和罐底的陶匠，严格说来，就并不是在制作陶罐，而只是在把黏土塑造成形。不！他只是在塑造虚空。为创造虚空，在虚空之中，从虚空而来，把黏土塑造成形。自始至终，陶匠把握了虚空并且将其创造出来，使之成为有容纳作用的器皿的形态。陶罐的虚空决定了其制作过程中的所有行为。器皿的物性绝不在于其构成的材料，而在于其容纳的虚空。"⑤

这大概是迄今西方哲学与陶器最亲密的一次接触了吧！海德格尔在巴伐利亚美术学院（Bavarian Academy of Fine Arts）所作的演讲中进而界定了独特的容纳和保持——陶罐的本质。这是由倾倒宗教仪式祭品而获得并完成的：奠酒祭神，天地合一。

不过，海德格尔仅仅是以陶罐为例来印证其学说罢了。而奇怪的是，对于一位如此执著地认为诗可以"言说"真理、揭示存在，人可以诗意地栖居、诗意地思考的哲学家来说，海德格尔竟然没有思考其制作过程或诗学。事实上他隐瞒了其思考的源起，即《老子》或《道德经》的第十一章。《老子》或《道德经》是中国道家哲学的早期经典著作，编撰于约公元前三至四世纪的战国时期。

"三十辐共一毂，
当其无有，车之用也。
埏埴以为器，
当其无有，器之用也。
凿户牖以为室，
当其无有，室之用也。
故有之以为利，无之以为用。"

海德格尔曾读过理查德·威尔海姆（Richard Willhelm）翻译的1911年德文版《老子》第11章，里面说道："陶罐的作用在于其无有。"

海德格尔在整个20世纪20年代都与现代日本哲学界中一些最有智慧的哲学家保持着直接联系，直接导致了1927年《存在与时间》（Being and Time）这部被普遍誉为自尼采以来对西方形而上学冲击最大的哲学性著作的出版。

而我们从赖因哈德·迈（Reinhard May）的研究⑥中获知，1930年海德格尔曾参阅过马丁·布勃（Martin Buber）翻译的1910年版《庄子》。《庄子》是另一

部道家经典著作。他也读过冯·斯特劳斯（von Strauss）1870版和威尔海姆1911年德文版《老子》。1946年夏天，他与中国哲学家萧师毅合作翻译《老子》，然而翻译工作进行了八章后，应海德格尔的要求中止了。仅四年之后的1950年，他就发表了我刚刚引用过的《物》（'Das Ding' / 'The Thing'）一文。

我之所以就这一点加以解释，是出于几个原因。首先，因为我相信我们仍应正确看待东亚对西方现代主义，包括20世纪的纯艺术和应用艺术、诗歌、哲学、音乐和建筑等各领域的影响。

在这里我指的是主流的现代主义，是常从对东亚文化的误读中获取灵感的创造力和智力的发展：高更（Gaugin）对日本版画复制术的关注，高迪埃·布泽斯卡（Gaudier Brzeska）对中国表意文字的雕刻性解读，伯纳德·利奇（Bernard Leach）对日本陶瓷传统的形式化体验，美国诗人以斯拉·庞德（Ezra Pound）对汉学家欧内斯特·弗诺罗塞（Ernest Fenellosa）之研究[7]的挪用（欧内斯特将其研究成果著成《作为诗歌媒介的中国文字》一书出版，为英语现代诗歌的发展开拓了新的方向），海德格尔思想的"隐秘来源"，哲学家威拉德·奎因（Willard Quine）思想中公认的东亚影响，以及约翰·凯奇（John Cage）、弗兰克·劳埃德·赖特（Frank Lloyd Wright）、罗伯特·马瑟韦尔（Robert Motherwell）等众多大师的作品。

我第二个观点是，尽管东亚文化的影响的确无处不在，西方文化得以从中吸取多元价值观并将之转化为其思想体系的各个层面，但它们却并未因此而动摇西方文化之根本。

与手工艺有关的这种情形可以作为一个特殊的例子。流行理论历来有痛惜当代应用艺术缺乏成熟理论或评论标准（当然是严格以西方标准来界定的）并贬低其文化价值的趋向。

我的第三个论点实际上完全是我个人的观点——我认为当代手工艺实践继续被悬而未决的现代主义的诸多问题所困扰。这正好也包括了我前面提出的关于东亚影响的问题。而在更为广泛的文化背景中，一种被破坏了的文化传播模式则继续制约着手工艺实践，同时也边缘化着像伯纳德·利奇这样的重要人物。

《无相无无相》（Formless, But Not Without Form）是中国玻璃艺术家杨惠姗创作的一组非常重要的作品。其连续的模塑和窑铸过程本身似乎就是一次对存在和虚无，以及正负空间、形式和姿态在想象中可能性的持久冥想。

作品无论在材质还是想象方面都与佛像有着显而易见的联系，朦胧而又清透的媒质的内部和外部维度、物质和非物质的光学游戏，蕴涵着简单力量从而引起观众共鸣，这一切都掩盖了其每一制作阶段所投入的艰辛劳动。

脱蜡铸造法和雕刻陶模的装饰性运用是中国青铜器铸造的常规方法。那么，关于铸造工艺作为人类想象的载体、正负空间在理论上的重要性以及形式与造型的冥想究竟能遨游多远呢？

德国著名的欧洲罗曼语言学家埃里希·奥尔巴赫（Erich Awerbach）在其1938年撰写的文章中认为，是卢克莱修、特土良、西塞罗和奥古斯丁对拉丁文的使用衍生了forma和figura这两个词的含义，使之超越了其原先在联系语源学中技术层面的用法。这可能会令玻璃制作者们感到惊奇和有趣。

"严格说来，forma的意思是'模子'，对应法语moule，与figura的关系就如虚空形式与由此衍生出来的造型之间的关系。"[8]

有自无中生。奥尔巴赫通过追溯这些古代手工艺人对拉丁语词汇forma和figura的用法，证实了其抽象含义的迅速发展：

"在柏拉图和亚里士多德时代的语言中，morphe和eidos表示'告知'(inform)事物的形式或理念，schema则表示纯粹感知的形状。"[9]

在拉丁文中，forma的含义可解释为morphe和eidos，意为"形式或理念"

为自己祈祷 杨惠姗（Yang Huishan）
长350mm，宽180mm，高360mm，2001年

光辉翱翔 杨惠姗（Yang Huishan）
长200mm，宽170mm，高670mm，2001年

千手观音 杨惠姗（Yang Huishan）
长80mm，宽810mm，高810mm，2001年

在水一方 杨惠姗 (Yang Huishan)
直径600mm，高220mm，2004年

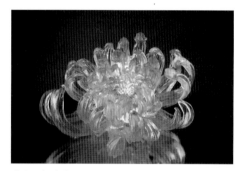

菊舞 杨惠姗 (Yang Huishan)
长850mm，宽780mm，高440mm，2008年

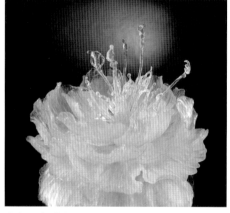

春舞 杨惠姗 (Yang Huishan)
长760mm，宽620mm，高620mm，2008年

（idea），而figura则可解释为schema，意为外部形状。这些词语最初的"造型"含义与铸模工艺息息相关，但很快就衍生出在语法、教学、修辞、逻辑、音乐，甚至是舞蹈艺术等形式领域的新意涵。随后，更多涵义，包括"像"（portrait）、"蜡上的戳记"（the impression of a seal in wax）开始出现。词语figures诸如"模型"（model）、"副本"（copy）之类的用法也出现了。卢克莱修发现该词语还可用来表示"虚构的事物"（figment）、"梦中的形象"（dream image）和"幻象"（ghost）。

但丁则认为，"喻象"（figura）一词在神学上的发展，作为可以感知的预言，在神父们的著述中获得了一种新的富有诗意的复杂性语义。该词在关于基督化身的历史真实中的运用以及"道成肉身"都证实了这一点。

在可以感知的预言中，喻象既具有历史真实的性质，又同样具有它所预示的历史应验的性质。喻像与应验因此在真实的预兆中发生了关系，而抽象的宗教真实因此成为了历史。

奥尔巴赫并不清楚在中世纪艺术中形象概念能在多大程度上决定审美观念，例如，他写道："艺术作品在大多程度上仍然被视为现实中不可企及的应验的喻象。"⑩

不过，我在这里的观点则是，所有这些语义的演变及其产生的富于想象的工艺，同其语言学起源一样，都包含着阴性与阳性形式以及模制与铸造的原始造型意义，也包含着正负空间——人类创造力的源头：有和无。

① 彼得·多摩尔（Peter Dormer）：《手工艺的语言与实践哲学》（The Language and Practical Philosophy of Craft）、《手工艺的文化》（The Culture of Craft），曼彻斯特大学出版社，1997年，第219页。

② 彼得·多摩尔（Peter Dormer）：《制造者的艺术：技巧及其在艺术、手工艺和设计中的意义》（The Art of the Maker：Skill and its Meaning in Art，Craft and Design），伦敦：泰晤士和哈得逊出版社，1994年，第16页。

③ I.约瑟夫森（I. Josefson）：《语言与经验》（Language and Experience），B.戈伦松（B. Goranzon）和M.弗雷文（M. Flavin）编：《人工智能、文化与语言：关于教育与工作》（Artificial Intelligence，Culture and Language：On Education and Work），柏林和海德尔堡：施普林格出版集团，1990年，第73—74页。

④ 托马斯·F·加杰（Thomas F. Judge）：《江户工匠》（Edo Craftsmen），纽约：韦瑟希尔出版社，1994年，第10页。

⑤ 马丁·海德格尔（Martin Heidegger）：《物》（Das Ding），1950年6月6日在巴伐利亚美术学院（Bayerischen Akademie der Sch nen Kunste）的演讲，艾伯特·霍夫施塔特（Albert Hofstadter）译：《物》（'The Thing'），《诗·语言·思》（Poetry，Language，Thought），纽约：哈珀和罗出版社，哈珀科拉芬版，1971年，第168—169页。

⑥ 赖因哈德·迈（Reinhard May），格雷厄姆·帕克斯（Graham Parkes）译（并为之写了一篇补充文章）：《海德格尔思想的隐秘来源：论海德格尔作品中的东亚影响》（Heiddeger's Hidden Sources：East Asian Influence on his Work），伦敦：拉特利奇出版社，1996年，书中各处。

⑦ 欧内斯特·弗诺罗塞（Ernest Fenellosa），以斯拉·庞德（Ezra Pound）编：《作为诗歌媒介的中国文字》（The Chinese Written Character as a Medium for Poetry），旧金山：城市之光书店，1969年，最初刊载于《煽动》（Instigations），1920年；亦可参见钱兆明：《东方主义和现代主义：庞德与威廉斯对中国文化的继承》（Orientalism and Modernism：The Legacy of China in Pound and Williams），达勒姆和伦敦：达勒姆大学出版社，1995年。

⑧ 埃里希·奥尔巴赫（Erich Auerbach），拉尔夫·曼海姆（Ralph Mannheim）：《喻像》（Figura），1938年，《欧洲文学戏剧场景》（Scenes from the Drama of European Literature），纽约，1959年，第13页。

⑨ 同上，第14页。

⑩ 同上，第62页。

大菩提心 杨惠姗（Yang Huishan）
长490mm，宽170mm，高350mm，2008年

无形 杨惠姗（Yang Huishan）
长490mm，宽170mm，高350mm，2008年

# 迈克尔·帕特利

传染 迈克尔·帕特利 (Michael Petry)，2000年

本文选自一部专著中的部分章节。该书受美国装置艺术家迈克尔·帕特利 (Michael Petry) 委托所著，是对于其在挪威、美国及英国的一系列装置作品的观察与评论。这些作品均运用了吹制、模铸、套色等方法，并以有色玻璃为主要材料。论及的作品包括：一、联合命名为《笑看光阴》('Laughing At Time') 的两件相互衔接的装置作品（《记忆的珍宝》[The Treasure of Memory] 和《被遗忘的吻》[The Forgotten Kisses]，加上《珍珠MAP单元》(Pearl MAP Unit) ——这三件作品都是为位于挪威南部北海海边的斯塔万格附近的哈伊自治区的艺廊和谷仓改建的综合性艺术中心而创作；二、《传染》(Contagion)，2000布赖顿节上展出的加德纳艺术中心 (Gardner Arts Centre) 的委托制作；三、《流动的人》(The Fluid Man)，为德克萨斯州休斯顿的德文伯顿海勒姆巴特勒艺廊 (Devin Borden Hiram Butler Gallery) 制作。

成书同时，《记忆的珍宝》正在美国俄亥俄州的托利多博物馆 (Toledo Museum)、普福尔茨海姆的珠宝首饰博物馆 (Schmuckmuseum)、纽约哥伦布圆环的艺术与设计博物馆 (Museum of Arts and Design)、纽约州罗彻斯特大学纪念艺廊 (Memorial Art Gallery of the University of Rochester) 以及意大利和荷兰的阿拉巴马地区的莫拜博物馆 (Mobile Museum of Art) 作巡回展览 (2007年9月)。

本文试图拓展关于玻璃这种当代艺术媒质的评论语言和文化背景，并将帕特利的装置作品放入更为广泛的评论语境中加以观察和探讨。文章研究了艺术家对于男性人体（在传染性人类免疫缺陷病毒，即艾滋病病毒的背景中按阿尔伯蒂"标准"）的表现，还从玻璃媒质的流动和反射属性的角度出发，解读了与成像这一无回应的行为有关的希腊神话那西塞斯 (Narcissus)。文章探讨了艺术家在玻璃和珍珠的物质状态、血液、精液、汗液以及尿液作为有机与无机存在的物质连续统一体中的物质证迹方面的创作，并且在概念上连接了作为认识过程的自我陶醉和炼金术。

"当我们看一样事物时，我们将它看作一件占用了空间的物体。画家会将这个空间周围框起来，并称之为勾画外形，更为恰当的说法是划定范围。然后，当我们再看时，我们就会看出该物体的几个可见面是如何组成一个整体的；而当艺术家将这些表面的组合按恰当的关系画下来时，便称之为构图。最后，当我们观看时能更

清楚地感知观察表面的色彩以及画这个方位时的表现形式，因为它接收了来自光的所有变化，可适当地称之为光线的接收。"

对于迈克尔·帕特利的玻璃新作的一篇相关短文，莱昂·巴蒂斯塔·阿尔伯蒂（Leon Battista Alberti）的《论绘画》（Della Pittura）（1436年）[①]初看起来似乎是一条有点深奥，甚至是令人误解的引语。《笑看光阴》由两件相互衔接的装置作品组成，为哈伊自治区的艺廊和谷仓改建而成的综合性艺术中心设计并创作，它们位于挪威南部北海海边的斯塔万格附近。

不过事实并非完全如此：因为这两件作品都表现了对数字、度量、比例、线条、空间、持续性以及时间的关注。阿尔伯蒂无疑将这些概念看作是划定范围或是构图的原理，并认为它们在维特鲁威人制定的比例中是显而易见的。

因此，可能阿尔伯蒂所说的手臂（braccia），作为一种测量单位，通过比方说错误的词源说明，在帕特利的前臂中被"重新记起"，帕特利的前臂本身就是在更早之前的MAP（艺术家的姓名首字母缩写）项目中经常使用的标准或度量。从某种程度上来说，MAP项目共同组成了帕特利的所有作品。

阿尔伯蒂的另一个测量单位是人体高度，这正是帕特利在1999年的MAP装置作品《流动的人》中使用的，并在后来的另一件MAP单元《珍珠》（高178厘米）中再次使用。介于策展的需要，这件作品被单独安放在哈伊自治区的综合性艺术中心的屋顶空间内。

不过，我暂时还不打算在这两者之间作进一步的比较，当然他们对表面所共有的关注除外。因为阿尔伯蒂所说的"光线的接收"（the reception of light）这一用语不仅明白易懂，而且非常恰当，几乎是说明性的，因此完全可以用来描述《传染》。这是一件早期受加德纳艺术中心委托制作的装置作品，并作为了2000年5月间布赖顿节部分活动内容。

《传染》由一百四十四颗悬挂着的玻璃"心脏"组成，它们是由玻璃艺术家卡尔·诺德布鲁奇（Carl Nordbruch）无模吹制而成，看上去就像是医用血袋似的。从表面上看，它们血红色玻璃膨胀的形状仿佛是由其本身液体体积的悬挂重量而造成的。事实上，它们是由套色铅晶质玻璃制成，近似人的心脏大小，相互之间在色彩和色调上有着细微变化——从几乎一致的纯色到接近透明。

这些心脏按照剧场门厅的平面图进行排列，恰好在艺术家本人齐胸的高度悬挂成弧形。这是一次出入悬浮迷宫的心到心的旅行。参观者们小心翼翼地漫游其中，轻轻触摸着这些物体，他们为铅晶质玻璃在其手中的实际重量而惊讶，不由自主地身陷迷宫而不可自拔。他们给予这一脆弱易碎的玻璃心脏集合如此的尊重，以致整个互动活动中只打破了两颗心，是一位好奇的参观者尝试用它们相互敲击而碎裂的，真可谓是心碎之人了。

作品受到来自一边的定向红色光线的照射，其环境于昼夜转换时会发生色彩和亮度层次上的巨大变化。昼间是半透明的心脏，黄昏之后，则因其对投射的红色光线的光学反应而变得色彩饱和而不透明了。这时，红色光线渗透在整个门厅，从外面看来，给人一种像是一张笼罩建筑物玻璃外墙的发光血色帷幕的感觉。这种感觉是迷人的，如玻璃般闪亮和浓丽的色彩，然而却令人联想到如世界末日般的大屠杀。剧院或影院的观众如果白天到来，观看晚上的演出，就会感受在黄昏后出现的为血红色灯光所浸染的同一个空间里的气氛。

人的心脏，作为情感的栖处和血液循环的器官，是一种袒露而脆弱的存在。它的生命原理即病毒的传染途径。艾滋病病毒的主题在这样一件作品中，以一种无人打破的静默方法表现出来，正是在处理这一主题时，帕特利很清楚自己"并不想讨论死亡的科学"。因此其方法既非争论亦非传记，并不希望获得个人的偏爱。相反，这个创造出来的环境将一些严肃的问题悬于半空中，沐浴在变化的光线里，观众不得不找到自己的路线来穿过这个迷宫的道路。

传染 迈克尔·帕特利 (Michael Petry)
2000年

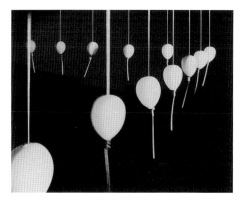

传染 迈克尔·帕特利 (Michael Petry)
2000年

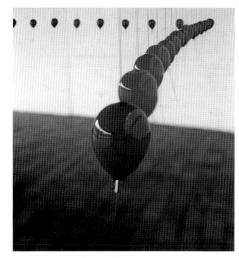

传染 迈克尔·帕特利 (Michael Petry)
2000年

传染 迈克尔·帕特利 (Michael Petry),
2000年

记忆的珍宝 迈克尔·帕特利 (Michael Petry)
2000年

我在文中尤为关注这方面的探讨，即装置艺术家迈克尔·帕特利以玻璃为媒质进行创作的独特方法。这种方法与"玻璃艺术家"的方法，或与那些通常被认为是与相似的或易碎媒质相关的类似方法的相对也许是不言而喻的。有没有人提到过戴尔·奇胡利 (Dale Chihuly) 呢？

他的艺术是煽动买风者、赶超崇拜者、新货币以及忸怩的暴发户的完美艺术。换句话说，是适合在财富上早熟却在文化上稚嫩的新西北人的艺术。玻璃是被博物馆和美术馆正式认可的艺术形式，而同时又极具纯粹的装饰性（如奇胡利所创作的那样）——令人喜悦地不受威胁、含糊或其他意味所累。"你不需要很聪明，也无需精通艺术史就能理解这些作品"，在一部关于奇胡利的纪录片中，他的助手这样说道，"它们只是非常美丽"。玻璃也很适合一个像西北部这样的醉心于金钱和科技的地方。它炫丽而奢华，像珠宝那样闪亮，却比珠宝大一百倍。②

对这类艺术进行猛烈抨击的学者们，可以在石板 (Slate) 网上看到这篇笔触辛辣的新闻报道全文，其网址附在文后的注释中。其余人则可能只是注意一下几个严厉却不出所料的贬低性假设——关于玻璃的"装饰"性、所有的闪光物品、奢侈品、单单好看以及不可思议的巨型珠宝——然后就一带而过了。

《笑看光阴》包含的两件作品则装置在毗邻的场所，分别叫做《记忆的珍宝》和《被遗忘的吻》。作品的装置地点就像特隆·博根 (Trond Borgen) 的强烈呼唤所表达的那样，有着不可抗拒的气氛。在露天海滨特有的光线下，一种暗示的力量使人浮想联翩——那些散布于海岸线上、始于石器时代的墓丘里许许多多的考古发现；北部旷漠的日光照射在这些人类制作的石器上，带着一种无法追忆的久远而持续的基调。

一根来自罗马的玻璃珠链和布满卵石的海滩，一起构成了这两件姊妹作品想象中的启航点，它们将欢笑、记忆和遗忘连接起来，并用爱与情欢愉这些脆弱的人类价值观，同人类宿命、前景以及人类和地质时期的自然环境对立起来。

出于好奇，我很想知道更多关于这条拾得的罗马项链的情况，其玻璃珠复杂的编排设计、其制作年代和原产地（尽管我已经意识到这种专业知识对于我眼下的探讨来说是完全多余的），因为艺术家本人并不关心甚至并不认可任何历史的说明，他关心的是作为一种死亡状态的时间而不是作为历史的时间；也因为帕特利的姊妹作品想表达的或许正像美国诗人卡明斯 (e.e.cummings) 曾经说过的那样："吻是一种比智慧更好的命运。"

就结构而言，《记忆的珍宝》在空间和时间上延伸并扩展了罗马玻璃珠链这一意象，每颗"珠子"都是一个自由吹制的套色玻璃泡泡，直径约在30-35厘米，共有三个形状：椭圆、菱形以及"头形"。这些泡泡在两端开口，切除并磨去铁杆留下的痕迹，以作穿线用。

三十二个膨胀的玻璃珠以一根黑色的游艇用绳穿起，悬挂在大致人体颈部的高度，组成了一串海洋主题装饰作品，部分是玻璃珠，部分是渔用浮标，因其自身重量形成了一道弧线，脆弱地从画廊的一头伸展到另一头，每个珠子都由其两端的水手结固定着。

帕特利对于以拾得的罗马玻璃项链形式出现的华丽墓葬品的兴奋处理构成了一种创作，这种创作与爱尔兰诗人谢默斯·希尼对于类似的斯堪的纳维亚原始资料的关注是完全不同的。这些资料得自其对P.V.格洛勃 (P.V. Glob) 的研究《沼泽中的尸体》(The Bog People)（1970年）的解读。希尼的诗《图伦男子》(The Tollund Man) 摘自其1972年的诗集《冬游》(Wintering Out)，诗中将绞索比作项链，强调潮湿的有机组织，这与帕特利作品中坚硬干燥的玻璃质无机珍宝形成了鲜明的对比：

"赤裸，除了
帽子、绞索和腰带

我将固守很久
献给女神的新郎

她在他脖上收紧她的颈环
打开了她的沼泽③

希尼的诗句似乎与大岛渚（Oshima）的电影《感官世界》（Ai No Corrida）
（1976）④一样带着直接而热烈的性欲暗示，但同时在写作上也对铁器时代的祭典
表现出浓烈的兴趣，他与众不同地将人的性欲与克制联系在一起，这与帕特利对人
体装饰的那种充沛而欢乐的关注（以及轻微的物恋）截然不同。将帕特利戏谑的转
喻（身体装饰转喻成不存在的身体）与希尼蓄意的隐喻进行对比未必十分恰当，但
却揭示了某些特质：漫不经心的闲谈，而不是收紧的金属颈环；高级女子定制时装
设计，而不是园艺。⑤

记忆的珍宝 迈克尔·帕特利
(Michael Petry) 2000年

这串令人喜爱的有盗取或破坏价值的玻璃珠链，被设计和改造成为富含编码涵义
的巨大有力的念珠串，私密却并非遥不可及，对于自认为无所不知的新手来说或许也
是神秘的。普拉达玻璃珠、古驰玻璃珠、蓝色和黄色的埃及玻璃珠、苏美尔玻璃珠、粉
红色的穆拉诺玻璃珠、深绿色的渔用浮标，在毫无遮挡的日光中闪烁幻变。

作为一件装置作品，《记忆的珍宝》占据并改变了这一特定的艺廊空间，表现
了光线接收的多重表面——流动的玻璃质外壳、虚空的深度、绳索所构成的图形线
条、白色的墙壁、窗户的隙缝，引导着我们的注意力穿过一系列流动的色彩关系，
回应着日光、定向聚光、反射、折射的连续平面或立体相位和均衡。

其内部空间通过这些结合元素的直接互动进行了重构，外部空间则获得许可进
入内部。在这里，窗户就好像是固定透镜那样透入强烈的来自海洋的光线，海浪冲
刷的多石的地方有着闪烁流动着的海水，这些海水的反射则更加强了这些光线。

在这个被侵蚀的世界边缘，我们透过窗看到更多的是大海而不是陆地。我们占
据了这个新的空间，并顺着绳索追溯，仿佛是在钢丝上保持平衡。

记忆的珍宝 迈克尔·帕特利
(Michael Petry) 2000年

这个被改造的空间正是作品本身。作品在工艺方面的一个重要实现，就是工房
玻璃吹制，以及玻璃作为合成材料与其展览环境的静态或动态元素之间的关系，只
构成作品的二维，就光线的接收而言只是工具性的。因此，尽管其概念初看时显得
巧妙而迷人，我还是认为《记忆的珍宝》作为玻璃艺术来说，与代表并束缚了当代
玻璃领域的以物体为中心的艺术创作相去甚远。

帕特利作为创作者的立场同样暗示我们，尽管技术上的精确性就艺术而言可能
确实是一种既定事实或先决条件（即使某个想法可能要求极高的技术难度），但是
作品的技术方面仍然只是"需要克服"的部分，本质上，艺术家对物体本身并不感
兴趣。

如今，迈克尔·帕特利自己制作的玻璃作品并不比戴尔·奇胡利更多。相
反，他委托其他艺术家，比如《记忆的珍宝》就是委托伦敦的玻璃艺术家伊恩·
汉凯（Ian Hankey）制作的，就像奇胡利委托包括声名远播的里诺·泰格亚派特
（Lino Tagliapietra）在内的威尼斯大师们那样。身为创作者却不亲手制作，这是
一种自由，由此，帕特利成功地抗拒了纯粹精湛技艺的浅薄诱惑，并从而防止了技
术本身在玻璃创作中僭取一种替代性的物体身份或实质。

记忆的珍宝 迈克尔·帕特利
(Michael Petry) 2000年

然而，这并不是说，对于帕特利的艺术而言，诱人或肤浅的技术是毫无帮助
的。事实上，当需要技艺的时候，它们是能发挥很大作用的，只是需要慎重地选
择。碰运气的创造性决定其实并不多见。也许就是因为这些原因，任何进一步将帕
特利与奇胡利的作品相比的努力都将有可能是徒劳无功的。

相关《笑看光阴》的另一件作品《被遗忘的吻》则被放置在哈伊自治区的一个
谷仓内。《被遗忘的吻》由两千颗手工制纯铅晶质玻璃"石头"组成，呈两个相接
的半圆形，以其垂直轴为界并且由加高的木质走廊分隔开来，高处的半圆就放置在

被遗忘的吻 迈克尔·帕特利 (Michael Petry)
2000年

被遗忘的吻 迈克尔·帕特利 (Michael Petry)
2000年

MAP单元 迈克尔·帕特利 (Michael Petry)
2001年

那里。高处的石头上打的是侧光，石头投射出强烈清晰的侧面阴影。而与之对应的低处的半圆则投以垂直的聚光，玻璃石头雅致地散落在低处开阔的砾石地面上，一池的光彩夺目。缕缕细长的日光从木墙的缝隙中洒进来，完成了这件光的雕塑。

这些玻璃石头的表面经过仔细的处理，喷砂的表面使它们呈不透明状，看上去像海滩上的卵石，然而又是经过变化的发光石头，就像被海水卷上沙滩的玻璃碎片那样吸收着光。这两千颗石头是英国玻璃艺术家卡尔·诺德布鲁奇（Carl Nordbruch）制作的，每一颗都独一无二。

如果说《记忆的珍宝》创造了一个有高度张力、充溢着明亮延展光线的视觉环境，那么《被遗忘的吻》则在昏暗朦胧的光线中，以比珠宝"大一百倍"的玻璃作品（据埃里克·西格利安诺在《石板》上的讽刺）替代冰冷的矿物残余，这些矿物残余不可思议地伴随着那些沉淀的岩石、海岸上留下的人类眼泪和吻以及多石的地形，难以数清却因遗忘而无法被纪念。

在被玻璃石子一分为二的圆中，泪水和吻的情感洋溢，仿佛经由炼金术转变成了坚硬的玻璃物质。

如果说这件作品的整体效果颇有点童话式的戏剧风格，或是矫揉造作的话，那么帕特利关于《被遗忘的吻》的个人主页入口处[6]的一段短短的文字却也带着这种萧瑟的味道，仅一句话就能立即引起情欲的想象，带着不顾一切的绝望，然后分散成不可遏制的绝望笑声。

尽管如此，该主页的名字似乎也正好呼应了这种复杂的笑声。这种在痛苦的渴望和绝望、绝望和渴望之间反复纠葛的情感张力的游戏，与《被遗忘的吻》在那些自我模仿的优雅浮华的浅薄被发现后的脱离和救赎殊途同归。

顺便提一下，这些玻璃的吻是引人注目的，也同样是便于携带的，拿在手里凉爽舒适，这显然引起了保安部门的焦虑。因此他们作了周密的安排，也因此人们可以带着恰到好处的腼腆在艺廊的商店里以一次10挪威克朗的代价正当地交换一个吻。

就这样，通过《被遗忘的吻》的扩散和传播，该项目获得了有趣的延伸。我不知道那些购买者在拥有这些光滑的矿石恋物时有怎样的感受，也不知道有多少个吻以其他方式被轻率地带走了，但我猜想，无论何时品尝，偷来的吻的滋味都应该比买来的更甜美、长久。

《被遗忘的吻》中所探索的自恋和炼金术的活性组分在《珍珠MAP单元》中得到了更为公开的表达，《珍珠MAP单元》构成了《哈》项目在第三个地点的装置，完全独立于《笑看光阴》。

《珍珠MAP单元》由一串笔直串在蚕丝上的珍珠组成，其高度为艺术家本人的身高。珍珠看来似乎是直立着的，但事实上是由看不见的装置从顶梁上悬垂而下。在变暗的屋顶空间中，捕捉并拥抱着以聚光照射的珍珠，并发出珍珠特有的光芒，令人想起以前在该处曾大量发现的天然淡水珍珠。丝线的两端各有一个标准纯银吊环来固定，整串珍珠都可以取下作为表演饰品，比如项链。可以这样说，在迈克尔的牡蛎中，珍珠引领我们更进一步地认识了沙砾的意义。

当然，如同所有的《MAP单元》那样，该作品是一幅自画像。自画像在一定程度上寄予了对自我的关注，这就像你在帕特利的作品中所寄予的那样。作品在本质上蕴涵的自恋，尽管极端，却又是经过仔细斟酌和控制的。为准确起见，我或许得就该字眼的当代意涵进行延伸。"自恋"（Narcissism）的通常定义为"对自己或自己外貌的过度喜爱或爱欲"，源自那西塞斯（Narcissus）的神话故事。那西塞斯是希腊神话中的一位美少年，他爱上了自己映在水中的倒影。大部分的词典都是这样说明的，然而事实上该词的现代用法却是最常被忽略的，其意为自体性欲。

有趣的是，那西塞斯所得到的惩罚，由于蔑视而拒绝同性与异性追求者的求爱，神宣判他永久地承受爱情得不到回应的痛苦。更有趣的是，他爱上的并不是他自己，而只是一个影像。事实上，这是光的幻术，是在水面上晃动、反射的半透明

影像。这至少与迈克尔·帕特利这位视觉艺术家有着异曲同工之妙：他们的热情，除非通过转换，都是得不到回应的；他们都对影像有着极度的偏爱。

帕特利在其最近的ＭＡＰ作品中更为明确地将珍珠比拟成体液的流动，"珍珠项链"意指射出体外作为爱人身体装饰的精液。

现在，至少自从马塞尔·杜尚1946年的作品《任性的风景》（Paysage fautif）开始，精液在自画像中也已不能算作是一种新媒质了。《任性的风景》是一幅以黑绸为衬的赛璐珞上的画作，包含在他赠与玛丽亚·马丁（Maria Martin）的《旅行箱中的盒子》内，四十三年后，其作画媒质经化学分析鉴定为是射出的精液[⑦]。

相比之下，帕特利作品的主题则似乎是羞怯而转换的，在流动性、化学熔剂以及数理论证中进行创造。他是通过珍珠创造性地思考，正如他通过玻璃思考一样，以一种既直觉又理性的方式思考，这种方式实际上同詹姆斯·埃尔金斯（James Elkins）最近发表的优秀论文《何谓绘画》（What Painting Is）[⑧]中的观点，以及伊丽莎白女王时代的微图画家尼古拉斯·希利亚德（Nicholas Hilliard）[⑨]准备纯微图颜料时，细心研磨贵重宝石的方式非常接近。

更早的一件MAP玻璃作品《流动的男人》（The Fluid Man, 1999）是为德克萨斯州休斯顿的德文伯顿海勒姆巴特勒艺廊制作的。其更为复杂的数理和线性结构是由人体比例决定的，由线条以及线条间的空间构成的，而这些空间亦是按艺术家本人的身高来安排的。四个由无模人工吹制而成、容积各异的套色玻璃球体，分别是乳白色、黄色、红色和蓝色，对应精液、尿液、血液和汗液，并精确地按照地面、阴茎、心脏和前额的高度进行装置。这些体液在炼金术中有着重要作用，无论是作为材料还是隐喻，它们都能不断地流动并变化。

在迈克尔·帕特利的玻璃作品中，冷矿物元素的刺激并不能理所当然地反映艺术家对炼金术的关注，而是更为紧密地通过玻璃的流动性和发光性来进行创作，以达到"光线的接收"，同炼金术一样致力于以材料和过程来进行思考。玻璃是人类最早的合成材料，也是恒久流动的过程。

当物质熔合时，它们变得更纯净、强大、珍贵，正如灵魂变得更圣洁。点金石是精神完善的标记，几乎达到超然的状态，所有杂质都被中和、燃烧、熔解或熔合，灵魂喜悦而宁静。炼金术士密切注意坩埚，观察物质的混合和离析，在某种程度上是思考尘世的斗争和污秽，并最终思考他们自己的灵魂和精神。[⑩]

他将思想置于技术期望的边缘，这种技术期望并非艺术上的熟练技巧，而是相对赋予现有新方法的可能性。技术上的挑战总是等待着被打破，然后被免除和克服，其后并不会留下对作品本身丝毫的兴趣。或许他为玻璃承载光线、反射、折射和发光的特性所倾倒；或许他陶醉于这些特性，就像成瘾（narcotic，"麻醉；吸毒成瘾"，派生于Narcissus，意为水仙花，以及其化学效应）似的；或许他着迷于如套色之类技术的二重性，连续的玻璃层创造出虚幻的色彩或深度，尽管这根本只是假象而已。

无论迈克尔·帕特利的玻璃作品在界限、构造和表面上是多么复杂或矛盾，它们直接运用光线来创造变化或超越的努力，可以说是非常成功的。因为就像莱昂·巴蒂斯塔·阿尔伯蒂所写：

"他们称之为美的人体，其和谐和优美来自于表面的构成。"[⑪]

① 莱昂·巴蒂斯塔·阿尔伯蒂 (Leon Battista Alberti) 著；塞西尔·格雷森 (Cecil Grayson) 译；马丁·肯普 (Martin Kemp) 作导论并注释：《论绘画》 (On Painting)，伦敦：企鹅出版集团，1991年，第64—65页。

② 埃里克·西格利安诺 (Eric Scigliano)：《玻璃心：当人们在西雅图谈"艺术"，他们谈的是奇胡利的艺术》 (Heart of Glass: When folks say 'art' in Seattle, they reach for their Chihuly)，1999年6月9日，[http://slate.msn.com/LetterFromWa/99—06—09/LetterFromWa.asp]

③ 谢默斯·希尼 (Seamus Heaney)：《图伦男子》 (The Tollund Man)，《冬游》 (Wintering Out)，伦敦：费伯和费伯出版社，1972年，第47页。

④ 《感官世界》 (Ai No Corrida) [tr. The Realm of the Senses]，在1976年纽约电影节上首映时被禁，导演：大岛渚 (Oshima)。

⑤ 译者按：原文为Haute couture in place of horticulture，作者在此延续了上一句中的押韵，并无实际意义，只是兴之所致下的音律游戏。

⑥ 迈克尔·帕特利 (Michael Petry)，《笑看光阴》 (Laughing at time) 地点2，[www.manornet.com/MPetry/index.htm]

⑦ 卡尔文·汤姆金斯 (Calvin Tomkins)：《马塞尔·杜尚传》 (Duchamp, A Biography)，伦敦：兰登书屋，皮姆利科版，1998年，第354—355页。

⑧ 詹姆斯·埃尔金斯 (James Elkins)：《何谓绘画：如何以炼金术的语言思考油画》 (What Painting Is: How to Think about Oil Painting, Using the Language of Alchemy)，纽约和伦敦：拉特利奇出版社，1999年。

⑨ 尼古拉斯·希利亚德 (Nicholas Hilliard) 著；R.K.A.桑顿 (R.K.A. Thornton) 和T.G.S.凯因 (T.G.S. Cain) 编：《论线描艺术》 (A Treatise Concerning The Arte of Limning)，约1600年，曼彻斯特：卡坎内特出版社，1992年，第81—95页。

⑩ 埃尔金斯，同上，第4页。

⑪ 莱昂·巴蒂斯塔·阿尔伯蒂，同上，第71页。

# 富丽珍奇的瑰宝①

化石经受无法抵御的压迫和持久的化学作用而慢慢形成，这是一种类似制模过程的自然现象，这一过程记录了有机和无机生命之间的相互作用和影响。当我们还是孩子时，我们敲开石头，急切地将其中寒武纪原始海洋生物化石和其虚空的模子撬离开来：那样完美地呈现，每一个细节都带着沉积而成的美。那样精密的形式，饱含岁月的磨砺之美，带着史前时期的流痕，作为有机的存在：不朽。

或许这种孩提时代对化石的认识总是在生物化学中增长而深刻起来的——"他的眼睛变成了珍珠"，莎士比亚戏剧中的爱丽儿唱道②，"他的骨头化成了珊瑚"。

正是在这种神秘的代数中，任何与基思·卡明斯（Keith Cummings）玻璃作品的邂逅都将会遇见其自然的平衡：奇美的瑰宝，迷人的材质，复杂的结构，娴熟多样的技巧，精美的局部细节，隐含着漫长历史或忍耐。这些窑制的玻璃和金属艺术品似乎带着某种神秘莫测的印记。正如爱丽儿在歌中最后的吟唱："他的全身都没有消失，而是受到海水的变幻，化成富丽珍奇的瑰宝。"

《残骸》（Wrack）（1994）的灵感正如其名所示，的确来自《暴风雨》，意味着被冲上海岸的失事船只残骸、海藻和垃圾，毁灭和灭亡。这件含有青铜和紫铜的小型玻璃作品遍布绿锈，有着长期受盐水浸渍后从海底挖掘而出的质感，伴以堆积衍生而出的水晶贝壳，就像种子破土而出那样劈开其角状的外壳。那么，这到底是化石还是种子呢？是有机的还是无机的？是沉没的器具、礼器还是政治机构的标志呢？

而更早期的作品《水手》（Mariner）（1987）也同样具有含糊不明的形式特点，体现了鹦鹉螺化石、船舶和器具的典型结合形式。《水手》开一系列"器具性"标题（1989年的《快艇》[Cutter]，1993年的《冰触发器》[Ice Trigger]，1996年的《沉睡者》[Sleeper]，1997年的《谷仓》[Garner]，1998年的《缆索》[Rigger]）之先河，暗示其功能是潜在或被超越的，模棱两可的措词则激发了我们对作品的想象。Cutter可以是快艇或是切刀；Sleeper可以是沉睡者，同时又是有机座垫和小耳环；Garner意味着收获、采集和贮藏；Rigger既是索具也是黑貂毛画笔。

作为小型装饰玻璃和金属艺术品，这些作品所运用的雕塑语言看上去显得含

水手 基思·卡明斯（Keith Cummings）
1987年

Barc 基思·卡明斯（Keith Cummings）
1995年

沉睡者 基思·卡明斯 (Keith Cummings)
1996年

颈环 基思·卡明斯 (Keith Cummings)
1996年

谷仓 基思·卡明斯 (Keith Cummings)
1997年

糊、自省、奇特和专注，本质上却又是私密的。它们似乎与当代玻璃艺术主流背道而驰，与更透明、巨大、外向甚至更闪亮的作品风尚格格不入。相反，它们是不透明的，内省的，其可亲（或正好相反）之处依赖于对其复杂表面的精妙解读。正如卡明斯在1993年的一次访谈中所说：

"我认为手工艺品是终点，是冥想的产物。这就是为什么手工艺者总是热衷于表面质感的微妙神韵。在我看来，手工艺品也最适合于家庭环境。我想要创造的就是房间内的核心装饰品。"③

卡明斯独具风味的玻璃作品如今已成为当代英国玻璃艺术中最为高深的秘密之一。

自20世纪50年代后期开始，卡明斯在达勒姆大学师从理查德·汉密尔顿 (Richard Hamilton) 和维克托·帕斯莫尔 (Victor Pasmore) 学习艺术，从而形成了形式构建和综合运用多元材质的创造性风格，这在他迄今为止的雕塑实践中得到了充分的体现。

"我选择和发展窑制玻璃作为主要方法，用来创作造型、结合、浇铸青铜和组合金属部件。这使我创造出一种持久和多级的制作方法，由此带来了许多获得创意反馈的机会。可能使关于形式的指导贯穿在多道工序中，从蜡模到总装。我意识到自己常常以延迟作出决定来等待作品发生最大限度的进化，我有意地追求这种方法。克利 (Klee) 的观点：'形成比形式更重要'，对我来说似乎一直是尤为正确的……我采用的方法持久、复杂而缓慢，这种创作方法非常适合我，但是，我一年只能创作几件作品。"④

如果上面这段话可以理解为类似诗学的声明的话，那么显然，在卡明斯的作品中，流动着一种与材质和工序的漫谈以及充满着的想象和沉思，随处活跃着关于构造和组装的决定。这种技巧是"有计划的冒险"而非"无忌惮的侥幸"。用他的话来说，如果这件完成的"手工艺品"是一种旅行的终点，那么在途中开启了一连串动态的起点正是作品形成的过程本身。当遇见这件完成的作品时，我们会通过对工艺和想象的默想来重现这些可能。同样，制图担任的好像并不是蓝图的角色，而是定位或探向的工作。

前人创作的手工艺品，比如牛津艾许莫林博物馆 (Oxford's Ashmolean Museum) 收藏的《阿尔弗雷德宝石》(Alfred Jewel) 或古代礼器、金属项圈和身体装饰品，也同样只提供了创作的出发点而其明确的鉴定价值 (如《颈环》[Torc], 1991年；《颈环》, 1996年)。

就卡明斯的作品而言，只有非常肤浅的解读才会将其视觉语言误认为当代"科幻"的语言，有时这两者确实被浅薄地相提并论。就其材质之富丽和工艺之造诣的偶像性而言，我认为这些玻璃雕塑作品是手工艺偶像传统的当代、异端和立体的表现。

偶像 (ειχων, 意为画像) 是东方正教会教义中，方便进行沟通的冥想术语和器具。它们打开了通向精神感知的门窗，我们通过精神感知在冥想中凝视或前行。它们以层层的釉料、矿物性颜料、蜡 (而后是蛋彩画)、金箔、红色的高岭土、石膏、亚麻和木质结构的形式出现，成为神的恩典和人需要的有形入口，引领我们开始精神生活的重复旅程。我们却给予其物神、商品或"艺术史"的性质，从而损害了这种复杂分层的偶像功能。同时我们也通过虚情假意的诱哄掩盖了这种偶像功能。

《缆索》(1998) 则表达了身体通过其表面与外界发生联系 (el cos es comunica amb l'exterior a través de la seva superficie) 这一观点⑤。稀疏铜线缠绕的脉络中，借用身体装饰、船上索具和植物种壳等语言，几乎将不透明水晶主体容纳其中，主体就像是其外部骨架的玻璃分泌物一样。从表面上看，作品中体现的意涵来自于隐秘的由来和莫测的内在。

作品有着高度平衡、完整的结构以及经过深思熟虑创作而成的静止的三维形

式，有着含在眼眶中的一滴泪般的匀称和表面张力，虽没有流下但仍有意保留了一滴泪的结构。

那么究竟是什么将所有这些局部细节结合在复杂表面上的呢？又是什么阻止作品流于低级趣味，堕入华丽、甜蜜却又空洞的精美宝石的堆积呢？

或许这样的问题更适合留给观众去解答。那么艺术家对此又会有怎样的回应呢？

"我为自己而创作，因此当有人喜欢我的作品时，我总是为此大感惊奇。"[6]

楔子 基思·卡明斯 (Keith Cummings)
1997年

缆索 基思·卡明斯 (Keith Cummings)
1998年

① 译者按："富丽珍奇的瑰宝"（something rich and strange.），引自莎士比亚喜剧《暴风雨》（The Tempest）。

② 《暴风雨》（The Tempest），第一幕第二场，P399—405。

③ 《当代英国玻璃》（Contemporary British Glass），伦敦，1993年，第24页。

④ 《观点》（Point），第3期，1996年冬，第52页。

⑤ 路易吉·卢卡·卡瓦利（Luigi Luca Cavalli），生物化学家，第5届加泰罗尼亚国际大奖（International Catalonia Prize）获奖演说，刊登于《加泰罗尼亚文化》（Catalonia Culture），1993年10月。

⑥ 引自给作者的一封短笺，1998年12月。

# 试金石

从1996年伦敦、汉堡和旧金山的个展，到2000年5月华盛顿莫林利特尔顿艺廊（Maurine Littleton Gallery）展，英国玻璃艺术家科林·里德（Colin Reid）并没有沉醉于"个人"艺术展览所带来的独一无二的愉悦感受，而是不断致力于开创其创作的新方向。值得注意的是，这里说的是"开创"，而非发展、推测，或决定。本文将对里德近十年间的创造性发展加以审视，这一主题，从某种意义上说，也就是研究里德的开创才能。

里德的发展道路，也就是他走出美术馆等封闭空间并进入公共环境后，将公共领域作为更大型作品的装置场所的过程。最近，他又在英国的风景区创作了露天景观作品《河岩》（River Rocks），这一作品是为兰开夏郡新建的月牙河千禧公园（River Lune Milleniun Park）创作的公共艺术作品。

看着目录中展示的这件最新的装置作品，我们很难想象还有比此处更合适的当代艺廊空间的地点或环境了，作品在这里暴露的特质有着崭新而惊人的效果。里德将三块喷砂处理的光学水晶玻璃放置在河边露出的岩层上，并通过二十毫米长的钢钉和化学黏合剂将其固定在基岩上。这些水晶有着喷砂的不透明表面，却又遍布着研磨和抛光成透明的脊状，突起效果明显。

到此处散步的人们将这件装置作品看作是公园的景观设备，他们会坐在这闪耀折光的艺术品上休憩。但当河水猛涨时，作品则会淹没到水下三米深，此刻，这些作品就像沉入水中的珠宝那样闪耀，而河流也就成为了延续"制作"过程的辅助物和途径。随着时间的流逝，河流也会改变作品的形态，碰撞、侵蚀、岩屑、海藻增生等都能改变作品的形态，最后也许还会使其破裂或完全毁灭。

在某种程度上，《河岩》也标志着里德艺术新近发展的巨大突破。

里德更早期的作品似乎受到外部驱动因素的影响也更多，如艺廊规定的截止时间或玻璃艺术市场供求情况对艺术家的创造性所造成的束缚和影响，然而现在，其全新的地标性作品却被赋予了询问、发现或认识的特质，通过崭新的创作语言来处理想象中难以了解的规模、技巧和风险等潜在问题，所以有时这种崭新的创作方式，是在艺廊背景下与面向市场精致优雅的风格背道而驰。

但这并不意味着里德已经退出了展览界。事实上，整个20世纪90年代期间，他通过参加欧洲各国、美国和日本少数艺廊举办的群展来维持其国际影响力，用他的

话来说就是"与我尊敬并喜爱的所有艺廊人"合作。然而前十年间，新的委托作品开拓了里德雕塑创作的新局面，它们打破了追求单一方向的内省性创作力，从而得以创作出"不只是另一个科林·里德"的作品。这些重大的委托为里德提供了休息和思考的时间，不仅拓展了他的技术层面，也拓宽了其材质运用中光学性能和规模的潜力，并为图像尝试提供了很大的支持。

科林·里德早期在滴铸桌上雕塑、香水瓶或更小型的器皿等方面取得了很大的成功。这些作品以其自持的抽象形式探索了艺术家对于原始人类、天然几何图形主题——圆、螺旋、锥体和十字形或本质为火山地质特征和素材的持续关注。这次展览中包括了一组1992年的作品，如R460和R659，正是其新近创作中通向图像创作目的地的启航之处。

显然，人类对矿物在视觉方面有着截然不同的旨趣或缔合，然而在图像创作中却比我们随意假设的要严谨得多。即使在浏览最为古板的地质学教科书时，你也能立刻体会到这种火成物质的图像和跨越不同领域的影响力。以我们称之为火山毛（Pele's Hair）的玻璃质玄武岩细丝结构为例：

"这些玄武岩玻璃细丝是由火山熔岩喷发时的颗粒在风中拉长而形成的。夏威夷原住民相信火山毛是传说中居住在基拉韦厄火山（volcano Kilauea）的一位神女。"①

里德从未有意在作品中建立详细或慎重的符号性联系，但诸如此类明显的视觉偏好，从表面上看来，好像界定了一种创作美学，并为玻璃铸造工艺的可持续发展制定了形式参量。他在作品的诠释或暗指意涵方面一贯的缄默在极其简洁的标题中体现得淋漓尽致。

除了《河岩》或《竹简》（Bamboo Scroll）之类的委托作品之外，其作品的标题主要采用以字母R开头的缩略序号形式。这标示着作品的创作顺序，完全无法进行诠释，也无法发现作品以外丝毫的语言暗示。至于这里的R是否代表了艺术家本人的姓，我们也不得而知。假如确实如此，那么我们至少看到了艺术家的署名，确认了艺术家的身份，并欣赏了每件以编码方式呈现里德的艺术品。

里德早期的典型作品从形式上来说似乎是学习并吸收了日本江户时代浮世绘（Ukiyo-yi）流派海景画中的所有版画能量。例如，葛饰北斋（Hokusai）画作中波浪状的黑色轮廓线与泡沫状的空白鲜明对立以此确定波浪的边界——完全抹去了透视感，线条在画面上拉紧平展。里德早期的三维作品也经常将外层裂状结构与内部流动空间的卷曲纹理以及染色褶皱进行对比，内部彩饰亦透出精细研磨和抛光而成的窗状平面。

葛饰北斋的轮廓并不完全是波浪的存在，而是在一定程度上记录波浪的猝然缺失，给人一种突然断裂之感。另外，里德的小型雕塑作品也同样是格外的立体，结构性强，玻璃磨砂轮廓和立体的形式形成鲜明对比，内部明亮的透视形式和简单的色彩中同样蕴涵着张力。艺术家将这些复杂因素在作品表面和边界处完美融合。如R659，正是以这种方式在其边缘获得了成功，独立自持同时又富于变化。正如安德鲁·格雷厄姆狄克逊在对英国画家霍华德·霍奇金作品中的"框"的评论中所说：

"雕塑家总能理解边缘的重要性，因为边缘明确界定了容纳空间的形式。一幅画的边缘是其最为脆弱之处；是艺术品结束之处，也是其开始之处；是绘画完成之处，也是绘画尚未完工之处；是绘画与其边界交涉之处；是艺术家本人进入和退出之处，是其能力和信心的标志，是对其能力和信心的掌控。绘画的成功与否取决于其边缘。"②

作为一个选择半透明或透明媒质作为其创作素材的雕塑家，里德经常在极为粗糙不透明，或抛光的平面框架中充满活力地同时运用内部色彩、线条或纱幔等元素。当我们能从完成的作品中明确地感受到其表面张力时，这种能量与包容也就达

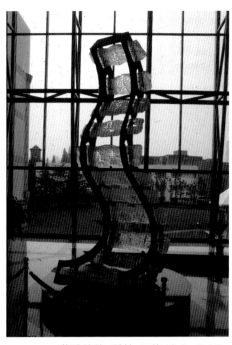

艺雕竹简　科林·里德（Colin Reid）
上海图书馆　长1500mm，高3500mm，1999年

艺雕竹简　科林·里德（Colin Reid）
上海图书馆　1999年

艺雕竹简　科林·里德（Colin Reid）
长1500mm，宽1500mm，高3500mm，1999年

镶玄武石的光学水晶 科林·里德
(Colin Reid) 高670mm 1995年

光学水晶 科林·里德 (Colin Reid)，
长1380mm，宽190mm，高370mm 1995年

到了最佳平衡。

里德的作品中很少出现碗的形式，但其碗状的作品和现在可收集到的香水瓶系列，都带有这种成形的特质，因其最为轻微的容纳形态而背离了其自持的主要用途。作为早期的实验性作品的器皿，如结合了铸造玻璃和板岩的R848，以及之后进一步发展的作品，如R911（铜绿表面的光学玻璃和白金）、R937（光学玻璃结合玄武岩）的灵感即来自于对铣床特性的技术兴趣，对拾得矿石碎片的美学兴趣，也同样来自于对碗的形式的意识。此刻，碗已经简化为最为纯粹的，也绝非虚空的姿态。

有人认为，这些作品就其速写性而言带有浓郁的日本风格。当然我在这里并不想在科林·里德的当代玻璃作品和日本浮世绘流派的版画制作或霍华德·霍奇金的绘画之间进行严格比较。如果直接参照地质学资料，尤其是火山题材，那么关于里德作品的偶然评论也并未超越批评印象主义的层面。然而有趣的是，我们注意到里德的某些审美爱好其实是早于日本造型经验的，而其他方面亦是紧密地与自然界或多元人类文化中的出发点联系在了一起。

1990年至1991年，里德在新西兰奥克兰的卡林顿理工学院（Carrington Polytechnic）做了一年的常驻艺术家，这段经历为我们提供了强有力的佐证。那里纯美天成的自然环境、明净清爽的光线以及波利尼西亚的浓郁风情在各方面为里德造就了一个全新的创作环境，但我们又无法在其作品中找到明确的参考。

奥克兰建于玄武质熔岩高地上，它为里德提供的不是研究的正式场合，也没有博物学的文字资料，但它却为里德展示了通过熔化和冷却制作的玻璃和纯天然的玄武岩，并给他提供了新材质，即玄武岩和沙砾来创作的机会。

玄武岩呈现出反差很大的黑色，有着玻璃碳酸钠的密度及独特的耐光方式，是一种试金石。玄武岩（Basalt）源自希腊语Basanos，意为"试金石"（'Touchstone'）。

里德的创作方法中有一种自然经济法，以环境的极度自由开放来交换精神方面的另一种满足。正如他所说："我并不留心意义，我关心的是形式：即我如何回应它。没有明显的主旨。"在他的创作手法中，蕴涵着活跃、探询和创造性的智慧，却又明智地避免"发现太多"。根据满足的程度确定转效点，过度的信息反而阻碍创作，因为他坚持"玻璃才是我的领域"。

诸如此类的声明使其他人将科林·里德归入传统手工艺者的范围。在传统手工艺中，制作的行为先于理解的过程：制作过程本身就提供了一种认知方法。思想通过三维模型或拾得物得到表达和发展。绘图在这一过程中的作用非常有限，因为该过程与探询、警觉或三维创作的关系比与设计的关系密切得多。即使这还不属于参与世界的一种方式，那也至少是观察世界的一种方式。在这个世界里：

"艺术家相信手工艺传统，认为自己是制作者而非创造者，是必需品的提供者而非不被认可的创造者。"③

作为必需品的提供者接受委托制作，是里德作品的一种新挑战。1996年里德接受委托为位于伦敦的东印度公司大楼制作了大型雕塑《标准生活》（Standard Life），他从该公司与印度和中国的贸易联系历史中汲取灵感，创作了两件结合玻璃与染色木材的新作品。关于印度的作品以黑白莲花为主题，由水晶铸块嵌入弯曲的细木合板框架构成；而关于中国的作品则取材于一种简单的用于搭建直角木构架的细木工艺元件，也同样采用黑色木材和白色光学水晶铸块的对照。

这两件作品解决了里德创作中一个阶段出现的关于比例与结构的问题，其主题通过单纯的两相对比而逐渐展开：木材与玻璃、明与暗、黑与白、正与负。但这里并没有明确地显现出象征阴与阳的相互作用。

里德还通过接受制造业委托来拓展其大型铸造工艺，例如为苏格兰国家博物馆（National Museum of Scotland）的古代巨石阵（Standing stones）制作铸造玻

璃柱基。也许有人将这看作是技巧的锻炼，但这显然也是里德一次重新引发对玻璃与石头的相近属性的关注的实践性改造。表面上看来这只是一次例行工作，然而这件不起眼的委托作品却凝结了里德创作中的多种专长和方法。

这些方面包括对主导制作过程的技术关注、对材质光学属性的自觉探索、玻璃与石头的对照、苏格兰西部群岛（埃利安锡尔）的早期基督教文化，以及对经常被整合入完成作品的拾得物的重大兴趣。

里德关于拾得物的作品，主要是木材或石头，这是认识或观察的行为："首先要发现拾得物是非常困难的，看出其可能的作用方式也很难。"他的方法既不像毕加索那样俏皮，也不像杜尚那样具有颠覆性。其意旨也与另一位当代英国玻璃艺术家黛安娜·霍布森（Diana Hobson）有着根本上的区别。

自1997年开始，里德连续创作了一系列以拾得木条板为素材的作品，这些木质残片长高达一米，取自拆除的伊丽莎白女王时代的篱笆断片，栎木上的伤痕和钻孔记录了几百年来人类不断地使用和英国天气的变化。这些风化的栎木废料是从沃里克郡埃文河畔斯特拉特福附近的查勒科特庄园（Charlecote House）修复工程中抢救出来的。

这些物体被里德拾得，然后被运用、组合、调换到一个全新的结构中。重新创作成浇铸的玻璃作品，或是与双重的正负玻璃形式重新整合，与人的关系简单、平凡：只是制作和应用。

例如R803，这件作品的铸型来自于木材的原始形态，一个被制成榫接的巨大硬栎木节疤，木材两面较模糊的纹理处都被磨损了。有证据表明这根木材早已翻造过，在早已故世的无名木工手中被制作成数种形状，最后在科林·里德的作品中获得了全新的意义。作品的主体为铜绿斑斑的铸模玻璃，是有机纤维质原型发光流动的无机复制品。

榫头部分嵌入木纹很深颜色很暗的原栎木中后，作品便大功告成。这一设计体现了对比属性的境遇、配合或交集，讲述了处理的经历，并创作出不为时间所动的精妙作品。

相比较而言，在黛安娜·霍布森1994年的青铜红松枝作品《发言杖》（Talking Stick）中，拾得的树枝就像幽灵似地徘徊于精细的浇铸青铜细部，以个人经验为主，虽然最终还经过了改造。但这里最初的媒质被超越和丢弃了，因为艺术家的注意力穿透并跨越了其成为艺术品的创始时刻。

所以，霍布森改造拾得物，而里德则诠释，或再诠释拾得物。霍布森的艺术似乎在召唤一种存在，或是在确立一个开端，然而里德却全心投入定位及运用。正如维特根斯坦（Wittgenstein）在其《哲学研究》（Philosophical Investigations）中所写："让字词的使用告诉你它们的意义。"

1999年夏天，另一件重大的委托制作随着高4米的玻璃和钢铁雕塑《竹简》作为亚洲第三大图书馆、世界最大的公共图书馆之一——上海图书馆新馆入口大厅的永久性装置落成而结出硕果。这一刻，和伍尔弗汉普顿大学艺术与设计学院商谈长达三年的项目达到了最高潮，而里德那时正在伍尔弗汉普顿大学任客座教授。

该雕塑的概念以古代中国书写制品，即编联起来并可卷成卷轴的刻字竹简为出发点。这种刻字竹简是西周（公元前1045—770年）时书吏所刻的作为记录俗世生活的档案的简牍，与装饰铸青铜器内面意在与精神供奉的铭文相对应。

作品的灵感或许来自于1996年4月该项目萌芽阶段时在建的上海图书馆布满竹脚手架的建筑工地。凸起并抛光的浮雕中国文字阳文与喷砂的光学水晶玻璃铸块浑然一体，呈现出通向明亮媒质的手写体文字透明视窗，并由火切古铜色平行带状钢结构体固定。

雕塑中的中国文字取自原版刻字，通过制模工艺翻转成浮雕，由随意排列的一系列文字组成，表现了人类和自然的本真。它们本身并不连贯成文——因为文字排

光学水晶 科林·里德 (Colin Reid)
长170mm，宽140mm，高780mm，1997年

光学水晶 科林·里德 (Colin Reid)
长1380mm，宽190mm，高370mm，1999年

列间并无叙述关联，然而文字的分层布局无疑影响了作品的整体构成。这是里德首次将书写符号作为"拾得物"进行创作，强调这些符号的视觉力量而不是其语言学的意义。无论就其外在形式还是内在隐喻而言，这些符号在白昼明亮而闪耀地悬浮着，素材重于涵义，制作先于认知。

里德对于该作品放置场所的关注，对于选定上海图书馆作为装置场所及其文化意蕴的反应，以及最终将作品放置在入口大厅中央的抬高底座上，使其沐浴在大片的日光中的决定，无不展现了他的创造才华。他的才华轻松地游曳挥洒，淡然地传递学识，这件巧妙地驾驭中西文化的一流作品，立刻赢得双方一致的高度评价。

这次展览横跨了科林·里德十年创作发展之路的黄金时期，但并没有"回顾"的意味。所有这些作品更多地揭示了远超艺廊范畴的罗经点所确定的"前行中的创作"观念，意味深长而又无拘无束，令人心悦诚服，继续前行。

① W.S.麦肯齐（W.S. MacKenzie），C.H.唐纳森（C.H. Donaldson）和C.吉尔福德（C. Guilford）：《火成岩及其纹理图集》（Atlas of Igneous Rocks and their Textures），哈洛：朗文出版社，1982年，第6页。

② 安德鲁·格雷厄姆－狄克逊（Andrew Graham-Dixon）：《霍华德·霍奇金》（Howard Hodgkin），伦敦：泰晤士和哈得逊出版社，1994年，第74页。

③ 加布里尔·夏希波维希（Gabriel Josipovici）：《论信任：艺术与怀疑的诱惑》（On Trust: Art and the Temptations of Suspicion），纽黑文和伦敦：耶鲁大学出版社，1999年。

# 论制作：关于玻璃诗学

2003澳洲玻璃大会（Ausglass 2003 conference）的合作与孤立的对照，可能是在截然相反的隐含等级体系姿态之间提供了一个简单的选择（例如，合作是"好事"，孤立对你而言是坏事）。但这并不意味着这两种姿态是相互排斥的，因为正如英国浪漫主义诗人、空想家威廉·布莱克（William Blake）所说："没有矛盾就没有进步。"①

本文所附插图选自伍尔弗汉普顿大学当代玻璃艺术在工业、国际和学术背景下的合作作品，也包括我在担任达敦水晶玻璃有限公司设计与发展部主任时期的作品。

这篇作为我在2003澳洲玻璃大会上演讲的精简版文章中要说明的是，在实践中，这个辩证或对立的过程对于创造性地学习和发展来说是至关重要的，对于我们，作为当代玻璃艺术的制作者和使用者、观赏者或解读者来说都同样适用。更有甚者，"反省实践"性的作品包括了创造性解读的连续或同时的行为，而这种解读构成的并非制作理论或评论纬度，而是制作的诗意纬度。就玻璃而言，这或许发生在对作品表面、线条和变化、边缘和界限、温度、结构和维数、改变或变形的解读中，而这种解读是始终贯穿在创作发展过程中的。正如诗人罗伯特·谢帕德（Robert Sheppard）所说："诗学不可避免地令其实践者成为有创见的读者与作者。"②

我想要发展并为这一诗学观点辩护，尽管其与理论或评论背道而驰。那么，不妨让罗伯特·谢帕德继续成为我的首个证人吧：

诗学是次要的叙述法，但并不是"事后"的；诗学并不仅仅回应制作。制作能够改变诗学，同时诗学也能够改变制作。③

对我来说，这里的关键要素在于改变或变形。我认为，改变也是所有学问的根本特征：任何值得称之为学问的范畴，都会引起其学习者身上某种形式的可辨识改变。

我的同事基思·卡明斯（Keith Cummings）将玻璃称做是"变色龙材料"，因为玻璃能够在所有这些条件下，在多于三维的维度中发生极度活跃的变化，这包含了其外部和内部形式，并拓展了其他材质无法轻易比肩的知觉深度和想象潜能。

而"反省实践"，法国诗人保罗·瓦雷里或许会称之为"精神的特殊应用"，

一直持续不断地将制作行为中接收到的信息与思想、思维意象或意向通过直觉进行比较，并从中学习。请谨记：没有矛盾就没有进步。

因此，本着这样的精神，请允许我暂时扮演魔鬼代言人，提出相反的看法来描述一下"当前的明显危险"，即当代玻璃界，相对隔绝于其他当代艺术形式或艺术实践，以及更广阔的文化或跨文化领域，正处于满足于其已经掌握范畴的危险之中。满足于那些已经完全被证实为是成功的范畴。亦即当代玻璃界正处于抑制状态，或更糟的是陷于一种自我欺骗的危险之中。约两百年前，意大利诗人贾科莫·利欧帕迪（Giacomo Leopardi）曾这样写道："掩饰自己学识不足的最正确方式就是不要跨越其界限。"④

这里所说的风险是消极的隔绝，内视而封闭，像玻璃那样华美而诱人，是欧洲神话中那西塞斯的反射镜文化：漂亮得惊人的美少年，沉溺于对映射在镜一般的水面上自己影像的迷恋中。

考虑到本文关于当代玻璃艺术合作与孤立的主题语境，可以确定存在着一种危险：在恐惧走出其已知范畴的固步自封的评论文化中，会产生关于制作的掩蔽、幼稚或虚假的描述。或者一种内省或利己的文化会造成批评的缺失，制作会成为其自身终结，或夸张的姿态、回避批评的手段，或还是"狡诈的"思维诡计。

说白了也就是当代玻璃艺术所面临的危险，在某种程度上是隐藏其技艺（ars）中（拉丁语ars，artis：阴性名词，意为由于知识和实践而习得的技能、手艺、科学或学识。也表示诡计、谋略，以及欺骗）。我坚持认为没有所谓的"绝对制作"。

当然还有比夸张姿态更糟糕的事。例如，还有比拙劣的诗坏得多的东西。拙劣的诗产生于拙劣的诗学，poetics一词源自古希腊。由于本文宣称的主题就是诗学，也许我以一条谨慎的忠告来给出该词的定义会有些帮助，即立体派画家乔治斯·布拉克的尖锐陈述：定义某事物就是以其定义来取代它。⑤

我援引poetic一词是想要恢复工艺和创作过程的初始意义，并揭除现今该词使用中的常见讹误：以其形容词形式来表示"含糊的"、"夸大的"、"装饰的"或"纯粹多愁善感的"。

做诗一词中隐含的"诡计"和诗歌一词中隐含的"制品"意涵在这里是含蓄的。事实上，就学术来看，这也正是Poet一词最初的含义，其希腊语词根poiētēs的意思，同时也是Poetry(poiēsis)的含义：都源自poiēin，即"制作"。诗人的字面意义是制作者。因此，精神病学者用Autopoesis一词来表示自我创造，音乐学家用Poietics一词来指音乐的作曲范畴⑥。正如美国诗人罗伯特·邓肯（Robert Duncan）在《音乐诗学：斯特拉文斯基》（'The poetics of music：Stravinsky'）一文中所写：

诗学是对形式意义的思索：为绘画、雕塑、音乐与诗歌所共有。斯特拉文斯基告诉我们：Poiein的意思是制作。我们或许还记得，在威廉·邓巴（William Dunbar）所处的时代，诗人被称为Makeris。⑦

Makeris即制作者，是以15世纪包括威廉·邓巴（约1456–1515）的宫廷抒情诗传统为主的苏格兰行吟诗人闻名的称谓。

这一概念在20世纪的著作以及已故的维罗妮卡·福里斯特-汤姆森（Veronica Forrest-Thomson）所著的《诗的欺骗》⑧，这样的批评类著作中开始被广泛使用，但是这个概念是根本（即固有）性的，因此不能像其初始时看来那样被约简成单纯的技术或工匠的忠诚的问题。就个人投入而言，其风险可能是很高的。这里可以以诗人保罗·策兰（Paul Celan）为例，其德语原名写作保罗·安彻尔（Paul Antschel），出生于罗马尼亚犹太家庭，在浩劫余生后以压迫其种族者的语言从事写作：

"手工艺，就像一般而言的干净，是所有诗法的状态。这种手工艺无疑不能带

来金钱上的回报，它包含着深刻与深渊。"

手工艺是关于手的问题。这双手必然属于一个人，也就是以其语声与沉默来探寻其道路独一无二、终有一死的灵魂。只有诚实的双手才能写出真正的诗歌。我认为握手与诗歌之间没有本质上的区别。

不要跟我谈poiein等等。我怀疑该词，以其亲密和疏远，表达的是与其目前通用的语境截然不同的涵义。⑨

因此，我们在这里谈到了poiěin，即制作、诗学：引起亲密和疏远的过程，并通过素材真理的理念，带着其深刻和深渊——就策兰的情况而言，是指经历奥斯威辛集中营之后，使用德语作为其创作媒质。

我们注意到，在这里策兰对"关于手的问题，诚实的双手"的关注，也就是说，通向以及在于制作行为的真理问题。他对于手工艺的真实性和完整性的信仰是确切又务实的，发展成为一种对签名的关注，一种带人类共有的脆弱性标志的评论，甚至是对伦理的关注。

这是关于手的问题，关于习得知识的问题，关于通过触摸而创造意义的问题。这令我想起大部分的英国白镴器皿都带有制作者的个人印记，称为其"戳记"。

希腊词(poiěin)的流传，在两千五百年来发生了词义和涵义上的变化，跨越了所有的亲密和疏远，然而诗人还是制作者，其方法——有别于理论——还是其诗学。

但是，如果如我所示，关于制作过程的狭隘或盲目的说明，长期以来被证明是完全不堪一击的话，如果现在我们已经看穿了制作作为其本身终结的那张天真虚伪面具的话，那么现在该赋予我们的信任怎样的评判价值？在其特征与特性相互独立的有利状态下，在更为广泛和自由的视觉文化的合作语境下，我们又能够以哪种诗学来表现和告知当地玻璃艺术实践呢？在这里我想引用加布里尔·夏希波维希(Gabriel Josipovici)的话来回答这些问题：

"由于相信手工艺传统，艺术家视自己为制造者，而非创造者；为必需品的供应者，而非未获承认的人类立法者。"⑩

带着这样批判性的洞察力，作家加布里尔·夏希波维希从英国浪漫主义诗人雪莱的关于诗人是不被认可的人类立法者，这一高度浪漫的主张里抽身而出，但是又保留了雪莱在其《为诗辩护》（1821）中，强调诗人是制造者⑪的观点。夏希波维希发现了后现代主义的特殊张力与困难，而这种后现代主义是将当代艺术家作品简单直接地与手工艺传统联系起来时发生的，并在20世纪末西方向制作者们提出了一些根本性的问题：

"有时，怀疑的态度不得不屈从于信任的态度——对素材、对我们的才能、对制作这一行为本身的信任。而问题在于如何阻止怀疑转变为愤世嫉俗，如何阻止信任转变为轻率浅薄。毫不怀疑的信任是治疗虚伪和浮夸的艺术的良药；而毫不信任的怀疑则是改变浅薄和空洞的艺术的秘诀。"⑫

夏希波维希拒绝那种随心所欲的后现代主义，因为这种后现代主义擅用所有的传统。而在当代应用艺术中，这些传统可能使得人们认为手工艺的要旨再好也不过是一种疗法，再坏则不过是感伤或者放纵。夏希波维希保留了一种失落的纯真感，这种感觉迫切而无处不在。这也正是1919年爱尔兰诗人W.B.叶慈（W.B. Yeats）在其《库尔的野天鹅》⑬一诗中所表达的观念：

"希克：我要找到我自己，而不是一个映像。
伊勒：那是我们在现代的希望，藉由其光亮。
我们照亮了温柔敏感的心灵，
却丢失了古老的手的冷漠；
无论我们选择了凿子、鹅毛笔还是画笔，
我们都不过是评论家，空虚而羞愧。"

如果现代，更不用说后现代，不再有那"古老的手的冷漠"，那么，手工艺传

统的单纯祈求似乎就会以拒绝接受的形式出现，这是一种逃避现实的幼稚行为，华而不实，也是裹着糖衣的虚伪感情。是一种空洞的诗学。

同时，"没有信任的怀疑"可能是治疗浅薄艺术、传播或挑选重要性的良药。换句话说，既是纲领性的工作，也是概念性的俏皮话。是一种拙劣的诗学。

几乎恰好与叶慈的诗歌同时代，乔治斯·布拉克在其1917至1947年间的私人笔记本早期的一页上，用文字和绘画表达了就此进退两难困境的领悟。在他用普通写法记录下的骨架形式的潦草提纲下面，文字和图像各占了半壁江山：

"画家以形式和色彩来思考，作品就是他的诗歌语言。"⑭

布拉克对于绘画作为一种思考过程的绘画关注，对于形成诗歌的物体，例如骨骼、水罐、风景的关注，都决定了一种关于现实的复杂创作，而这种创作远非模仿行为或单纯的形象叙述工艺可企及。

你不应该模仿你想要创造的东西。

作品是创作行为中关注、思考和发现的深思熟虑的过程——艰难而不单纯。

写作不是描写，绘画也不是描绘。现实只是一种假象。⑮

如果，就像加布里尔·夏希波维希所说，我们，作为从事玻璃艺术的反省实践者，确实失落了"古老的手的冷漠"的话，那么，在堕落的纯真里我们现在所面临的危险，就是通过艺术来表达毫无价值的伤感或愤世嫉俗的扭曲。这正是设计与制作艺术行为中的不真实性。

① 威廉·布莱克（William Blake）：《地狱箴言》（Proverbs of Hell），《天国与地狱的婚姻》（The Marriage of Heaven and Hell），1790年，第3页。

② 罗伯特·谢帕德（Robert Sheppard）：《诗学的必然性》（The Necessity of Poetics），利物浦：愚人船出版社，2002年，第6页。

③ 同上，第3页。

④ 贾科莫·利欧帕迪（Giacomo Leopardi）：《札记》（Zibaldone），1817—32；J.G.尼古拉斯（J.G.Nichols）译：《思想》（Thoughts），伦敦：金星出版社，2002年，第60页。

⑤ 乔治斯·布拉克（Georges Braque）：《乔治斯·布拉克笔记，1917—1947》（Cahier de Georges Braque，1917—1947），巴黎：玛格出版社，1948年，多佛版：斯坦利·阿普尔鲍姆（Stanley Applebaum）译：《乔治斯·布拉克插图笔记，1917—1955》（Georges Braque Illustrated Notebooks 1917—1955），纽约，1971年，第31页。

⑥ 谢帕德，参见前引书，第18页。

⑦ 引自爱克特·法斯（Ekbert Faas）：《青年罗伯特·邓肯》（Young Robert Duncan），圣芭芭拉：黑雀出版社，1984年，第335页。ISBN 0-8768-5488-9

⑧ 维罗妮卡·福里斯特-汤姆森（Veronica Forrest-Thomson）：《诗的欺骗：20世纪诗歌理论》（Poetic Artifice：A Theory of Twentieth Century Poetry），帕格格雷夫-麦克米伦出版社，1979年。ISBN：0312617984。亦可参见丹尼斯·赖利（Denise Riley）编：《诗人谈写作，英国，1970—1991》（Poets on Writing，Britain，1970—1991），麦克米伦出版社，1992年。ISBN 0-333-47130-X

⑨ 保罗·策兰（Paul Celan）给汉德尔（Hans Bender）的信，1960年5月18日；罗斯玛丽·沃尔德罗普（Rosemary Waldrop）译：《散文集》（Collected Prose），纽约：绵羊草原出版社，1986年，第25—26页。ISBN 0-935296-92-1

⑩ 加布里尔·夏希波维希（Gabriel Josipovici）：《论信任：艺术与怀疑的诱惑》（On Trust：Art and the Temptations of Suspicion），纽黑文和伦敦：耶鲁大学出版社，1999年，第273页。

⑪ 珀西·比希·雪莱（Percy Bysshe Shelley）：《为诗辩护》（A Defence of Poetry），1821年，大卫·李·克拉克（David Lee Clark）编：《雪莱散文集，或预言的号角》（Shelley's Prose，or The Trumpet of a Prophecy），伦敦：新闻界出版社，1988年，第276—297页。

⑫ 夏希波维希，1999年，第2-3页。

⑬ W.B.叶慈（W.B. Yeats）：《我是你的主人》（Ego Dominus Tuus），《库尔的野天鹅》（The Wild Swans at Coole），1919年，《诗集》（Collected Poems），伦敦，1977年，第180—181页。

⑭ 乔治斯·布拉克：《乔治斯·布拉克插图笔记》，第11页。

⑮ 同上，第12页。

# 火精：给斯洛维奥·维里阿图罗

事实上，光泽会随着观众的走动在物体表面移动，减轻表面光泽以强调更为明朗和稳定的色彩结构；甚至放弃表面光泽以获得内部的闪耀，在色彩中具化无光泽的透明。[①]

本文引语出自保罗·希尔斯（Paul Hills）的《威尼斯的色彩》一文。在这篇引人入胜的散文中，保罗·希尔斯引用了美术史学家詹姆斯·阿克曼（James Ackerman）的话来评论15世纪晚期意大利绘画美学中发生的变化"从阿尔伯蒂（Alberti）将色彩看作是一种物体属性的观点到列奥纳多（Leonardo）认为色彩是在眼睛里生成的看法"，并认为阿尔伯蒂关于绘画模仿的观点是"以对象为中心"的，然而：

对列奥纳多来说，绘画是对主体看到事物的记录，取决于观察角度以及眼睛与所看到表面之间的环境。但是这一文艺复兴初期和盛期之间在关于模仿的观点方面，这一典型变化没有充分考虑到非叙述性的色彩在具象艺术语境中是如何表现，并由此将单纯的可见事物转化成有意义的客观世界的物质。[②]

好吧，我得承认对于一篇探讨斯洛维奥·维里阿图罗（Silvio Vigliaturo）玻璃雕塑创作的短文来说，乍一看这个开头好像非常奇怪。但是这段短短的评论——关于威尼斯的色彩，关于看的行为，关于眼睛在何处并如何倾祥于玻璃的表面光泽和内在透明之间的光度交流——所有这些见解，似乎在我看来，都提供了对维里阿图罗作品的洞察和领悟。这种洞察和领悟要比其作品与现代主义大师，如夏加尔（Chagall）、毕加索（Picasso）或米罗（Miró）的作品在形象方面的任何偶然相似之处都更为敏锐和集中。

保罗·希尔斯继续把文艺复兴初期柔和色彩的运用（以表现绘画中的立体感），或细微渐浓或渐淡色彩的运用（以表现物体的边缘和角度）与图像界限之外的背景色，即从描绘对象的任务中解脱出来的色彩进行对比。这一鲜明的色彩"领域"正是威尼斯玻璃的本质，将会改变其象征状态：

正如在贝利尼（Bellini）和提香（Titian）的作品中，玻璃器皿的色弧和鲜明色块的创造是完全不以线透视法来划分和表现的，充满着曲线能量的空间。[③]

要从这些方面来对维里阿图罗的作品作出适当的解释，必须要一篇继续引申的文章来更全面深入地探讨艺术家的创作过程，现象学中自然出现色彩的重要意义，

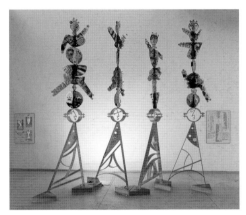

走钢丝的人 斯维欧·维利亚托柔
(Silvio Vigliaturo) 高4500mm 2005年

天使 斯维欧·维利亚托柔（Silvio Vigliaturo） 长4000mm，高2200mm，2007年

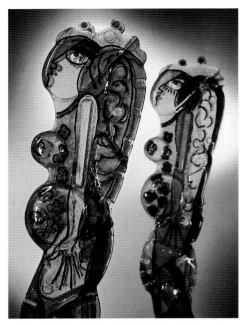

天使 斯维欧·维利亚托柔 (Silvio Vigliaturo)
长4000mm, 高2200mm, 2007年

斯巴达勇士——声音 斯维欧·维利亚托柔
(Silvio Vigliaturo) 高2470mm, 2008年

该创作过程即其独特的创作诗学。然而，眼下这些关于乔凡尼·贝利尼的评论却似乎要引领我们去直接面对维里阿图罗造型玻璃雕塑的直接视觉冲击。

当然，我是指去感受融入其本身光辉中的色彩。

同时作为"图像"和"场域"来绘制的色彩，而非描绘或装饰用途的色彩和"事物本来面貌"的内在属性中的色彩。

借用莫里斯·布朗修（Maurice Blanchot）的话来说，这种色彩似乎：

"以作品搭建一条通向灵感之路——守护和保持灵感纯净之路——而非以灵感搭建一条通向作品之路。"④

斯洛维奥·维里阿图罗的作品是天马行空的，有着半透明的外形，提供了观察我们身处世界纠结难懂和璀璨光辉的符号透镜，并通过人类关注、想象和叙述的神话形式透射出来。如小丑、将军、音乐家、情侣、孕妇、天使、魔鬼、牧神潘任何我们依稀记得的故事中的主人公。

我们好像偶尔还能在光天化日之下感受到这类形象中蕴涵的原始力量——或许在科库洛（Cocullo）的蛇节游行（Processione dei serpari）⑤上，在巴巴吉亚（Barbagia）的假面狂欢节上（Mamuttones），在罗伯特·卡拉索（Roberto Calasso）的著作、电影中。

我以前曾冒昧地说过，维里阿图罗作品的表现意义有着更为持久的价值，期待着我们对艺术家的创作过程——即其本质诗学——的天然现象学的继续探索，这种探索可以通过他一直关注的熔融玻璃媒质的强烈光辉、色度、外形和灵魂来进行。而艺术家本人又是什么样子的呢？

我在脑海里想象着斯洛维奥在其位于基亚里（Chieri）的工作室中的样子，他专注而投入地通过打开窑门看看里面的铸像，并思考其成型后的形式和效果，或许准备添加些金属箔，而铸像似乎会回视着他。这是一种火精，《牛津英语词典》是这样定义Salamander这个词的："应该是住在火里的神灵或妖精（1657年）；永远在火里，永不毁灭；火焰所象征的恒久的标志。"

我想我大概是把艺术家的形象和其流动熔融的作品本身混淆了起来。

能住在火中的伟大精灵。一种熊熊烈焰象征的永恒。

① 保罗·希尔斯（Paul Hills）：《威尼斯的色彩：大理石雕刻、马赛克镶嵌、绘画和玻璃，1250—1550》（Venetian Colour：Marble，Mosaic，Painting and Glass，1250—1550），耶鲁大学出版社，1999年，第131页。ISBN 0-300-08135-9。
② 同上，第105页。
③ 同上，第125页。
④ 莫里斯·布朗修（Maurice Blanchot）：安·斯莫克（Ann Smock）译：《文学的空间》（L'Espace littéraire 1952）（The Space of Literature），林肯和伦敦：内布拉斯加大学出版社，1982年，第186页。
⑤ 译者按：意大利阿布鲁佐的科库洛村的宗教节日，每年5月的第一个周四举行。村民抬着真人大小的游满活蛇的圣德梅特里奥雕像绕村游行。

# 2003雷纳莫克玻璃奖

两年前重设为雷纳莫克玻璃奖（The Ranamok Glass Prize）的RFC玻璃奖已走到了第九个年头，它无疑是当代国际玻璃界最讳莫如深的秘密之一。收藏家们的眼睛就像雷纳莫克现今为人熟知的喜鹊标志的眼睛那样晶亮，在他们看来，这一明亮闪耀的巡展聚集了由四位眼光敏锐的评委组成的评判小组成员，他们一致认为是澳大利亚和新西兰的作者能获当年最佳的当代玻璃作品奖。今年，他们再次表现出其卓越独到和值得信赖的眼光。

2003雷纳莫克奖以盲审方式在一百二十四位强有力的参赛者中产生了三十七位入围决赛的艺术家，提出了四十二件决赛作品。我认为我在珀斯的克莱夫特威斯特艺廊（Craftwest）观看的去年的展览是一次出人意料的惊喜：绝对是很长时间以来我亲眼目睹的最为有趣和多元的当代玻璃展。而2003雷纳莫克奖足以与其相媲美。

这次展出的作品都同样是最优秀的，在其种类和多样性、美学追求、开放性和包容性以及技术造诣等方面都显示出了不同层面真正的活力和激昂。这种共享的领域和多元性，在去年的展览上也显露无遗，2003雷纳莫克奖保持着一种惊人的凝聚和一致，确实蕴涵着大于其组成部分之总和的全新趣味。

也就是说，2003雷纳莫克奖似乎代表了南半球玻璃趣味那独特却又被公认的创作共性，依次受到莫林·卡希尔（Maureen Cahill）和玻璃艺术家艺廊（Glass Artist's Gallery），尤里卡投资公司（Eureka Capital Partners,）的安迪·普拉默（Andy Plummer），以及众多发起人的支持和资助，其范围之广着实令人印象深刻。

高等教育院校中的玻璃系在其发展过程中也自始至终发挥着很大的作用；艺术家和手工艺协会则实际上相当于评判小组——如今两者都将被越来越多地称之为"创意产业"的部分引入了这一生气勃勃的领域。

2003雷纳莫克奖是一场玻璃的真正视觉力量的庆典。这次展览洋溢着素净却丰富的内容，充满了色彩细节和发生于形式与表面上最为深奥微妙关系的视觉活动，仅一件作品中就运用了通常还是对立的多种工艺。

最为成功的作品是一种有力的形象存在，并同时创造或组织着其占据的物质空间。关于这是否是最简易的人类手工艺品的特性这一点尚无定论，但在这里确实如此。因为这些作品有着一种超越其真实物质存在形式的共鸣，这种现象甚至经得起

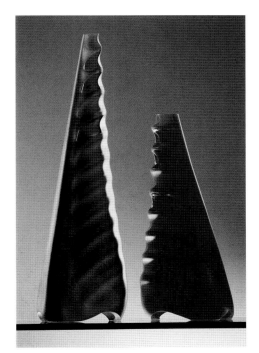

科鲁尼亚风景 查尔斯·布奇 (Charles Butcher)
直径180mm, 高410mm, 2001年

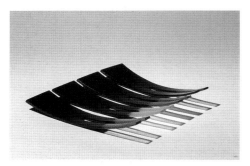

花饰 柯斯蒂·雷亚 (Kirstie Rea)
长580mm，宽480mm，高70mm，2001年

夏威夷人 劳丽·杨 (Laurie Young)
长500mm，宽70mm，高450mm，2002年

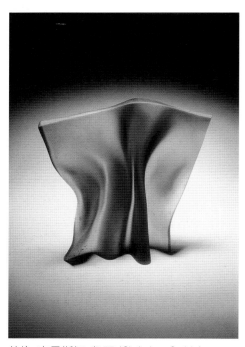

转换 克里斯汀·凯西 (Christine Cathie)
长350mm，宽100mm，高350mm，2001年

通过扫描输入计算机处理的数码影像来进行的进一步研究。

在某种程度上，一件作品中的分裂处或是其组元连接的对位处经常会创造出新的空间。比如柯斯蒂·雷亚（Kirstie Rea）的窑制及砂轮切割作品《花饰I》（Rosette I）将白色光线引出其中心明亮的琥珀色光轮，其简单的构图是由按一定布局放置的玻璃尖齿的顶端所形成的。

或是查尔斯·布奇（Charles Butcher）的吹模冷铸作品《科鲁尼亚风景》（The View from Corunna）的饰边产生了一种光的柔和的沟壑，切割成风帆的形状，形成了三角形流动虚空的无有，有着安全剃刀那样的锋。

又或是劳丽·杨（Laurie Young）的浇铸作品《夏威夷人》（Kamaaina）和《最佳种类》（Da Kine），出乎意料的浓稠，动摇了我们与衣服之间的关系。这些作品愈加厚重、复杂，最终形成了发光的衣服，光线的衣服，永不是编织而成，永不能用以穿着。

正是在这些方面，克里斯汀·凯西（Christine Cathie）的作品，作为一薄层玻璃材质中的空间感官明觉，是不言而喻的。如果你对此哪怕只有片刻的怀疑，目录中收录的作品《S》也能用其比苏希拉·拉曼（Susheela Raman）唱《相信我》[1]（'Trust in me'）时还要蜿蜒曲折的谐和音和S音来纠正你的看法。

我可以一直继续谈论下去，因为事实上，今年的每件作品都令人深思。例如达妮埃拉·塔林（Daniela Turrin）的窑铸水晶壁面装置作品《彷徨》（Hover），在三维空间中创造出一种"踌躇"感，穿透并超越了现象世界，并实现了法国哲学家莫里斯·梅洛·庞蒂（Maurice Merleau Ponty）就凹面和凸面之间关系所说的"它形成的三维穹隆和空洞"，就像是灵魂与肉体之间的联接。

其实有各种炼金术对2003雷纳莫克奖施加着影响，以玻璃材料的流动发光的灵魂来发挥作用的实践炼金术，就像阿尔伯蒂说的那样"来接收光线"[2]。其创作方式与炼金术一样致力于全面深入地思考材料与工艺。而这一次是将玻璃看作人类最早的合成材料以及不断变动的过程来加以探索。

当物质熔合时，它们变得更纯净、更强大、更珍贵，正如灵魂变得更圣洁一样。点金石是精神圆满的标记，几乎达到超验的状态，所有杂质都被中和、燃烧、熔解或熔合，灵魂喜悦而宁静。炼金术士密切注意其坩埚，观察物质的混合和离析，在某种程度上总在思考尘世的斗争和污秽，并最终思考他们自己的灵魂和精神。[3]

2003雷纳莫克奖所代表的玻璃艺术水准似乎是难以用语言表达的，或许确实到了评论性感受或解读，或是当代玻璃诗学纬度大为改观的时候了。

因为就像我在另一篇文章[4]中曾主张的那样：是诗学，而不是评论或理论，为制作提供了自由发挥的空间。然而，在许多关于当代应用艺术的评论中，文字与形象，或作品与文字的抱负之间存在着明显的张力。

我只想说关于2003雷纳莫克奖还有许多可谈之处，小小一本目录远不能满足其需要。这里有一个奇妙的悖论。

我很怀疑澳大利亚与新西兰的国内市场是否足以吸收或容纳文中谈到的即使只是三十七位艺术家的系列作品，更不用说那些今年没有入围决选或没有参加评选的艺术家的重要作品了。在我看来，这一水准的作品完全可以与当今国际玻璃舞台上的任何作品相媲美。

除了在国际收藏家市场上个人形象与声望的稳步发展之外，高素质与高水准的当代玻璃艺术实践的可持续发展之路或许也在于国家，关键通过提高在海外展会上的曝光率，对当代西澳大利亚玻璃艺术出口方面有更大支持与努力。

或许该是雷纳莫克奖展翅高飞的时候了，带着它奇特的喜鹊纹章，飞越广袤的疆界。

① 苏希拉·拉曼 (Susheela Raman) ：专辑《盐雨》 (Salt Rain) ，纳拉达唱片公司，2001年，第6首。

② 莱昂·巴蒂斯塔·阿尔伯蒂 (Leon Battista Alberti) 著；塞西尔·格雷森 (Cecil Grayson) 译；马丁·肯普 (Martin Kemp) 作导论并注释：《论绘画》 (Della Pittura, 1436年；译作On Painting) ，伦敦：企鹅出版集团，1991年，第64—65页。

③ 詹姆斯·埃尔金斯 (James Elkins) ：《何谓绘画：如何以炼金术的语言思考油画》 (What Painting Is: How to Think about Oil Painting, Using the Language of Alchemy) ，纽约和伦敦：拉特利奇出版社，1999年，第4页。

④ 安德鲁·布华顿 (Andrew Brewerton) ：《论制作：关于玻璃诗学》 (On Making: Towards a Glass Poetics) ，《国际工艺艺术》 (Craft Arts International) ，第59期，2003年10月，第2—4页。

和谐 大卫·黑 (David Hay)
直径200mm，高4800mm，2001年

线之间 梅·道格拉斯 (Mel Douglas)
直径450mm，高530mm，2001年

# 走出黑暗
## ——2004英国玻璃双年展

星形收藏品（Star）查理·麦克（Charlie Meaker）达汀敦水晶馆的精品 1990年

玻璃花瓶 雷切尔·伍德曼（Rachael Woodman）达汀敦水晶工坊 1991年

如果我们认为玻璃的历史存在于已知或可以言说的领域，包含所有可获得、所有被保留和收集的、众所周知的事物的话，那么英国玻璃双年展（British Glass Biennale Exhibition）——最广泛的当代英国玻璃艺术十年间所记录的开幕遵循了同样的假定，而且总体而言并非是偶然的家谱。

这次玻璃展不同于1993年手工艺协会巡回玻璃展（The Glass Show），是首届双年展，其目的并不是就当今玻璃舞台作一历史性的概览。玻璃展及其里程碑式的目录期刊《当代英国玻璃》（Contemporary British Glass）[1]对英国近三十年来的工房玻璃艺术进行了综合性的回顾，而这次双年展的目的，不论是在概念方面还是在策展方面，都截然不同。

英国玻璃双年展的首次展览是在前韦伯·科贝特／前皇家道尔顿玻璃工厂（Webb Corbett/former Royal Doulton）空置的厂房中举办的，并成为一次艺术家新作评审比赛的策展活动。

在这样的情况下，该展览必然是不全面的，其意味深长、深思熟虑且争议性的目的也是如此——正如所表现的那样，把握当代英国玻璃最新成就的脉搏或节拍，并在后工业遗产的内在范畴中展示其广泛的创造性。

因此所有提交的作品都被要求在2002年3月1日之后完成。本着兼容并蓄的精神和远大慷慨的抱负，比赛采用公开邀请的形式，坦率地说，只有一位艺术家被特别排除在外。[2]

评审小组想对康迪斯－埃莱娜·埃文斯（Candice-Elena Evans）致以特别的谢意，尤其是她一丝不苟的准备，准确无误地确保了二百二十八名参与者（总计约一千幅影像）提交作品的非盲审和不具名作品的数码图像文件，因此在4月，评审员花了两天多的时间挑选了八十一位艺术家和设计家的一百五十余件作品并进行展出。

五名来自玻璃界，有着完全不同背景的评审委员组成的小组从一开始就采用了严格的评审规则，采纳多数意见，不允许弃权。因此绝对不可能发生非一致性决定或废票的情况——但也会提供他们称为的"珍贵时间"来再三考虑并进行经过周密思考的辩论。

我们的方法偶尔也包括突如其来的（越来越超现实）的幽默——那种当一小群人在一个封闭空间内长时间极度专注时所爆发出来的幽默，几乎是无意识的。

这里我要为我们辩护一下，在这种状态下，我们通常都很激动，因此不由自主地就一些讨论中的作品的常见（总是可喜的）方面或性质表现出一种调皮的智慧。这并不完全是当今英国玻璃界的特点。奇怪的是，完整的情感变化——从赛会的闹剧到尖刻的讽刺再到悲伤的反语——对于玻璃这样如此引人注目的媒质来说，竟仍然是一片处女地。

我们的评选方法还包括对第一轮删减时所作的每一个决定做至少一次的回顾思考，以求每件作品在最后决选前都可以得到我们所认可的特有价值。

反映了当代玻璃全方位实践的创造性想象和技术性成就的最高水准——从建筑、装置和雕塑作品到基于对象的作品，包括以玻璃为主要或重要材质的产品设计。

我们的任务暂时告一段落，但这标志着康迪斯－埃莱娜相当庞大而难以应付的策展工作才刚刚开始，接下来我们还要对共同选择的作品进行整理安排，从而确保在前韦伯·科贝特玻璃厂粗犷却鲜活的环境中举办首届英国玻璃双年展。

该场所的历史情形和现代处境都对评审小组成员产生了一定的影响。漫步于这栋废弃的建筑物中，伴随着数以千计富有直接视觉冲击和创作活力的当代玻璃艺术作品幻灯片的更新图像，在经过漫长的两天的讨论后，我们突然失语了。

一边散步一边回忆那段生动的经历，作为评委之一，我突然觉得筋疲力尽，要构造出现今英国玻璃的现实状况是困难的，这其中也有黑暗的一面，就好像是从幻象中拔苗助长一样。尽管我们每个人散步时都以自己的方式共同关注着这一点，但我仍然可以很有信心地说，我们对过去并不留恋。

我们评审的作品无疑是足够真实的。

这其实是我们后工业时代地方性制造业经济的困难、矛盾，或许还是对难以处理的现状问题的一种承认。

也就是说，一方面承认在很大程度上，英国手工水晶玻璃业无法（通过设计或工艺革新来）对20世纪80和90年代其他欧洲竞争者产品的连续风潮——从东部国家较低成本的手工工匠制作到来自西部的品质不断提高的机械水晶玻璃生产——作出有效的回应。而另一方面，则见证了我们展望未来双年展的创作渴望和技术成就对立的丰富性、创造性，以及仍有待发展的潜在可能性。

创作渴望、经济现实和共同要素之间的差距正是抱负与现实的特征，在我看来也正是这样的差距，使这次展览成了一种如此紧迫的检视。稍后在本文中我还会再谈到这一矛盾之处，现在，让我们回到这次展览。

首届双年展表现了玻璃作为吹制、铸造、熔融、热模、锻造、离心成形、淬火、切割、雕刻、打磨、抛光、镀层、镌刻、电铸成形、镜面、构成和动态玻璃形式的主要材质——作为器皿、珠宝、物体、雕塑、室内建筑、照明和装置的特征，许多作品应用了多种工艺并大胆地横跨了多种风格。

在1993年手工艺协会展览中参展并在《当代英国玻璃》刊物中占有一席之地的六十五位指定艺术家中，有十二位参加了这次的展览。[③]而后来在策展人亚历山大·贝雷斯琴科（Alexander Beleschenko）和蒂姆·麦克法兰（Tim Macfarlane）为1997年手工艺协会玻璃、光和空间（Glass，Light & Space）展[④]选择的十一位艺术家中，只有哈里·西格（Harry Seager）出现在这次双年展中。

这些艺术家交叠的现象，尽管是有趣的，却也在另一个惊人却重要的数据面前黯然失色：首届英国玻璃双年展参展艺术家中有百分之八十四，都是在十一年间脱颖而出的。

这十一年确实是一个充满了变化和过渡的时期：在此期间，斯托尔布里奇传统的手工水晶玻璃制造业进入了一个几乎是终结的阶段。也是在此期间，高等教育领

彩盘 雷切尔·伍德曼（Rachael Woodman）
达汀敦水晶工坊 直径500mm 1991年

硫磺烈火 基思·卡明斯
(Keith Cummings) 2002年

密码石1 科林·里德（Colin Reid）
长2100mm，高2000mm，2003年

无题 科林·里德 长45cm 2004年

域的玻璃学科开始逐渐却显著地拒绝，例如玻璃和陶器等应用艺术和三维设计科目的本科课程的国家申请。1993年雷·弗拉维尔（Ray Flavell）曾就此院校传统写过文章。也是在同时，在全国范围内，这些科目在学校课程中变得越来越边缘化，变成了空间缺乏和资源密集型成分，对政府的全民识字和识数的目标几乎没有明显的贡献。

因此，以这十年框架为背景的双年展铺设了一张极为宽广和多元的画布，然而，就像我们所注意到的那样，这还不能称做是今日英国玻璃的综合性调查。

因为制作者在人数上占据了支配地位。不出所料，工房玻璃对双年展作出了强烈的回应，然而作品提交截止时我们却好奇地发现建筑和雕刻玻璃、照明和家具设计领域的新作似乎数量不足，制造产品设计方面的作品也是一样。

发展中的玻璃艺术实践在重要领域中的作品数量是如此微少，这对于那些欢迎因选择进入此领域的并因其缺席而值得注意的设计师和艺术家的作品的评审委员会全体成员来说，显然是非常令人失望的。

在2004年手工艺协会展所取得的优异成绩的鼓舞下，2006双年展或许能够留下向地方和国际观众展示英国玻璃舞台更综合性的印象。然而，目前已经有足够的迹象显示出规模方面日益增大的雄心，对室内建筑、场所和位置的更开放和更直接的关注，在室内作品较为封闭的环境方面的突破，以及对制作首要地位的不变坚持。

如果当代英国玻璃想要在国际舞台上、地方发展中、出口数值上、冒险委托中、规划部门和"艺术百分比"计划中、风险投资家、商业培育项目等等方面，以及我们院校中朝气蓬勃的创作抱负方面获得更强大、更持久的影响力的话，这一点是非常必要的。

更确切地说：如果最近的斯托尔布里奇水晶玻璃业的不幸历史将不会在后工业时代重现或者笼罩着这些前玻璃工厂的阴影最终将被埋葬的话。那么我看到，走出这样的黑暗，迎接我们的是一片光明。

① 琳达·西奥菲勒斯（Linda Theophilus）等：《当代英国玻璃》（Contemporary British Glass），伦敦：手工艺协会，1993年，第103页。ISBN 1-870145-11-9

② 我相信基思·布劳克勒赫斯特（Keith Brocklehurst）会原谅我提到其首届双年展评审委员会会员身份所导致的无法参加展览的谦虚行为。

③ 即：鲍勃·克鲁克斯（Bob Crooks）、基思·卡明斯（Keith Cummings）、安娜·狄金森（Anna Dickinson）、黛博拉·弗拉德盖特（Deborah Fladgate）、雷·弗拉维尔（Ray Flavell）、凯瑟琳·休（Catherine Hough）、艾丽森·金奈尔德（Alison Kinnaird）、彼得·雷顿（Peter Layton）、戴维·里克（David Reekie）、科林·里德（Colin Reid）、卡林·拉什布鲁克（Karlin Rushbrooke）和雷切尔·伍德曼（Rachael Woodman）。基思·布劳克勒赫斯特（Keith Brocklehurst）也在玻璃展中发挥了重要作用。

④ 亚历山大·贝雷斯琴科（Alexander Beleschenko）和蒂姆·麦克法兰（Tim Macfarlane）等：玻璃、光和空间：在建筑中运用玻璃的新建议（Glass, Light & Space: New Proposals for the use of Glass in Architecture）展，伦敦：手工艺协会，1997年，第64页。ISBN 1-870-145-712

# 喻象

湖水结成了冰，冻得结结实实的，冰面上延伸出一条小径。就连湖底都结满了白霜，上面又覆盖着厚厚的坚冰。阔如剑形的树叶、细细的麦秆、树上落下的种子和碎屑、一只棕色的叉开腿走路的蚂蚁，一切都凝入了冰中，与形成的气泡交相辉映。阳光照射其上之时，如珠般晶莹。湖边滚落的光滑的黑色石子也同树皮脱落的树枝一起被冻在冰中。弯曲的欧洲蕨立在冰中，宛如幅幅精美的图画。

乌恩躺在地上凝望着，为之迷醉；这可比任何童话故事都要神奇吧。①

我很钦佩这次展览的远大抱负以及策展者所冒风险的明确界限，因为展览集中展出了如此多样的当代玻璃作品，同时这些作品又都表现了对人类形式在玻璃这一无与伦比的合成媒质内外维度中成形的关注。

因为这种冒险令我在期待中百感交集。

例如总体而言，我们对这些作品分别体现、象征、再造、扮演、揭示或意味着什么的感觉可能是浅薄或单一的，或者个别的作品可能会被埋没或附会于肤浅贫乏的叙述期望中。

如此形式各样的玻璃作品可能无法在广泛的人类尺度上得到比较、发展、延伸或检验，或许这确是一种冒险的方式；或者最糟的是，这些汇集到此的人物形象可以说是拒不开口的。

有趣的是策展方似乎承担着很高的风险。在这种情况下，我们或许会无可避免地在艺术家的说明中徒然无益地寻求自信、关键、线索，或是坦白。因为我们的所有发现事实上都是与之相反的。这些声明无一例外地远离作品，诱使我们误解其主旨与本质，就如同许多喧嚷的云雀飞出以保护其丛中的筑巢免受危险。

在我看来，这正是这样。如哲学家路德维格·维特根斯坦（Ludwig Wittgenstein）所说，当我们定义词语时：

让字词在使用中告诉你它们的含义。②

词语如此，艺术也同样如此。因为视觉艺术家关注的自然主要是材料和工艺，思索其道，这种特别的应用能预先表达其涵义。

艺只有当他们使用、透过以及对照玻璃媒质来创作时，他们才会了解其旨趣，才能远见其全新内涵，铸造的自我投影也许会突然消失，从而深深迷失在新鲜出炉的作品中。

七日的预言 Raymond Martinez
长250mm，宽250mm，高600mm，1992年

轮廓 Mari Meszaros
长540mm，宽250mm，高980mm，1994年

诱惑 Mari Meszaros
长680mm，宽350mm，高1000mm，2000年

她平躺在冰面上，还未感觉到寒冷。她纤细的身体在冰底投下了一个歪曲的人形倒影。然后，她在这发光的玻璃镜面上改变了下姿势。精致的欧洲蕨仍然挺立在闪闪生辉的冰块中。

令人恐惧地崩落……

乌恩动了动，影子也随着她滑动，恰好滑入裂口之中，如同被吞噬一般迅速消失了，乌恩退缩了。然后她明白了。

当她躺在那儿时，身子微微地颤抖着；仿若躺在清澈的湖水中。乌恩觉得有阵短暂的晕眩，而后重新意识到她正安全地躺在一块厚厚的钢铁般坚硬的冰上。[③]

看来，制作先于了解。在我为"隐形人"（The Visible Man）撰写展览目录短文时，我本人的"云雀癖好"（见本文引文）表达了对挪威诗人和小说家塔尔杰依·维萨斯（Tarjei Vesaas）（1897—1970）的阈下崇敬之情。或许我该解释下原因。

在我所阅读过的作品中，没有任何其他作家在感性的纯粹深度和细微神韵方面能够达到像维萨斯的高度。他以这样的感性重新创作了——通过两个年轻的女学生，希思和乌恩的创造性的注视或想象——难以穿透的物质距离（半透明，甚至透明：如钢铁般强硬），同时将我们与自身在世界中的生活经验和认识感知隔离并联系起来。

仔细体会本文引语，我们可以发现，玻璃是人类想象的令人惊叹的视觉表现媒介。更进一步说，在其1963年的小说《冰宫》中，维萨斯就已经为"隐形人"预先塑造了非凡的主旨。

这个形象或标志就是小说中的小主人公乌恩，在一挂巨大冰冻瀑布——也就是小说标题中的冰宫——四面围墙的冰室及其繁复的光影交织中迷了路。乌恩开始是想象，继而是身处于这玻璃般的环境中，这是一个迷失、冰冻并悬挂在冰瀑布内的小女孩的人物形象：

快要下山的太阳仍然保持着惊人的能量。阳光穿透了厚厚的冰墙，射入了每个角落和裂隙中，阴霾的冰室荡漾着璀璨光芒，五彩缤纷。天花板上垂挂的和地面上竖起的冰柱和滴落的水滴，都在涌入的阳光中起舞。水滴闪烁着光芒每滴一滴，这狭小的空间就小一点。很快冰室就会充满了水。[④]

这景象蕴涵着令人吃惊的，事实上也是令人不安的，力量。它在我们眼前精巧地建立了其自身的感性认识。实际上，图像似乎总是与生理感知机能联系在一起：在那些半透明内部维度中，物体和看的行为融合成水、冰和玻璃，与人类眼睛中的玻璃状液体有着同样的黏性：

满是水滴的房间。玻璃墙中的光线非常微弱，在半明半暗中整个房间仿佛处处滴滴答答的。房间里还未漫起水来，水滴从顶上轻轻溅落，融入了一个个小小的水池。[⑤]

下面我还会继续引用更多的《冰宫》中的描写，以展现其与本次展览关于幻梦的对应之处。而本文标题Figura的语源则完全不同，借用自德国欧洲罗曼语言学家埃里希·奥尔巴赫（Erich Auerbach）1938年撰写的文章。他也知道并理解"字词的使用"教会我们其含义这一观点，而他的论点则可能提供了另一种方法来欣赏在埃贝尔托夫特举办的"隐形人"展览中展出作品。

因为我们在这里关注的是人类形态和人类形象。奥尔巴赫认为，是维罗（Varro）、卢克莱修（Lucretius）、特土良（Tertullian）、西塞罗（Cicero）和奥古斯丁（Augustine）对拉丁文的使用延伸了forma和figura这两个词的含义，使之超越了其在联系语源学中原先技术层面的用法。这可能会令玻璃制作者们感到惊奇和有趣：

严格说来，Forma的意思是"模子"，对应法语Moule，与Figura的关系就如虚空形式与由此衍生出来的造型之间的关系。[⑥]

奥尔巴赫通过追溯这些古代手工艺人对拉丁语词汇Forma和Figura的用法，证实了其抽象含义的迅速发展：

在柏拉图和亚里士多德时代的语言中，Morphe和Eidos表示"告知"（Inform）事物的形式或理念；schema则表示纯粹感知的形状。[7]

在拉丁文中，Forma的含义可解释为Morphe 和Eidos，意为"形式或理念"（Idea），而Figura则可解释为Schema，意为外部形状。这些词语最初的"造型"含义与铸模工艺息息相关，但很快就衍生出在语法、教学、修辞、逻辑、音乐，甚至是舞蹈艺术等形式领域的新涵义。随后更多的涵义，包括"像"（Portrait）、"蜡上的戳记（The impression of a seal in wax）"这些词开始出现。词语"形状"（Figures），以及诸如"模型"（Model）、"副本"（Copy）之类的用法也出现了。卢克莱修发现该词语还可用来表示"虚构的事物"（Figment）、"梦中的形象"（Dream image）和"幻象"（Ghost）。

但丁则认为"喻象"（Figura）一词在神学上的发展，作为可以感知的预言，在神父们的著述中获得了一种新的富有诗意的复杂性语义。该词在关于基督化身的真实历史中的运用以及"道成肉身"（'The Word made flesh'）都证实了这一点，这是建立在特土良现实主义的强硬基础上的。在可以感知的预言中，喻象既具有历史真实的性质，又同样具有它所预示的历史应验的性质。喻象与应验因此在真实的预兆中发生了关系，而抽象的宗教事实也因此成为了历史，成为了肉身。

奥尔巴赫并不清楚在中世纪艺术中形象概念能在多大程度上决定审美观念，例如：

"艺术作品在很大程度上被视为现实中仍然不可企及的应验的喻象。"[8]

不过，我在这里的观点是，所有这些语义的衍变及其产生富于想象的工艺，同其语言学起源一样，都包含着阴性与阳性形式以及模制与铸造的原始造型意义。很显然，Figura凝缩了真实人类存在的物质特征方面的遮盖、分层或隐藏的涵义，包括精神的、道德的、诗意的、隐喻的、心理的、寓言的涵义。

好了，我们回到"隐形人"展览，这些展品预先描绘了怎样的完满；它们究竟是如何（在词语之外）表达涵义的；它们的半透明纬度中又是什么满足了我们的创造性目光以及感知体验呢？

本次意味不明的展览中展出的这些喻象艺术品中体现了什么？又赋予了什么？作为观众，我们又该如何解读本次展览？希思是如何做的呢？

她沿着透明的冰洞向下爬，阳光照耀在冰洞上，闪烁出各种各样的光芒。

她边爬边拼命喊叫：因为乌恩在那里！透过冰墙往外看，就在她面前。

有一瞬间她觉得自己看到乌恩在深深的冰层里面。

三月的阳光直射在她身上，因而她被闪烁的光芒所环绕，各种闪亮的光线和光柱、奇特的玫瑰花饰、冰花结和冰饰物，一如节日庆典般的艳丽盛装。

在流动的冰墙后，乌恩看来远比真实的她巨大。其实只能看清她的脸；身体的其余部分十分模糊。

看不见的裂缝和角落中射出锐利的光线切割着这幅景象。乌恩周身笼罩着灿烂的光芒，令人无法逼视。[9]

来自不可见的裂痕和角落的锐利光芒，切开了画面。令人晕眩的华丽，使人无法凝望乌恩。

在展览中略逛一会儿之后，文章开头时我所提到的模糊的风险感很快就消失了。"隐形人"展中用玻璃素材来塑造人类形态，就像是一次关于富于想象内涵的半透明人物形象的庆典，无论在整体还是细节上都获得了成功，圆满实现了其举办者的雄心壮志。

它的成功足以使这些形式和材料的性质开始引起相对思考和逆向认识：有形化于无形，黑暗湮没光明。

冰冻时光 Mari Meszaros
长470mm，宽310mm，高760mm，2001年

解放 Mark Bokesh-Parson
长510mm，宽200mm，高550mm，2000年

无题 Gerhard Ribka
长230mm，高160mm，2002年

萨乐美的篮子 Jens Gussek
长380mm，宽280mm，高350mm，2003年

车轮上的人头 Jens Gussek
长500mm，宽220mm，高190mm，2003年

可见人 Bertil Vallien
长1600mm，高1500mm，2003年

所以，敬爱的读者：尽管"光线逐渐变暗"，还请坚持读完本文，让我们以塔尔杰依·维萨斯的佳作来结束本文吧：

在这空旷朦胧清寒的春夜，狂野的躁动，毫无情由地从松动的最深处崩溃。当这死亡的冰宫释放力量从而必将消失时，最后时刻的巨响轰然回荡。它挣扎着发出铿锵的声音，似乎在说："它的内在是黑暗的……"

冰大块大块地崩塌，凌乱地滚向较低的湖面，在人们惊醒看到之前就散落在湖面各处。分崩离析的冰块漂浮其上，冰凌刺出水面，漂浮，融化，直至消亡。⑩

① 塔尔杰依·维萨斯 (Tarjei Vesaas) 著：《冰宫》(Is-slottet)，挪威金色峡谷出版社，1963年；伊丽莎白·罗坎 (Elizabeth Rokkan) 译：《冰宫》(The Ice Palace)，伦敦：彼得欧文出版社，1966年，平装版1993年，第42—43页。

② 路德维格·维特根斯坦 (Ludwig Wittgenstein)：《哲学研究》(Philosophical Investigations)，1953年，第220页。

③ 塔尔杰依·维萨斯 (Tarjei Vesaas) 著：《冰宫》(Is-slottet)，挪威金色峡谷出版社，1963年，第43页。

④ 同上，第59页。

⑤ 同上，第52—53页。

⑥ 埃里希·奥尔巴赫 (Erich Auerbach)：拉尔夫·曼海姆 (Ralph Mannheim) 译：《形象》('Figura') 1938年，《欧洲文学戏剧场景》(Scenes from the Drama of European Literature)，纽约，1959年，第13页。

⑦ 同上，第14页。

⑧ 同上，第62页。

⑨ 维萨斯：见前引书，第124—125页。

⑩ 同上，第175—176页。

# 贝壳

艺术家们的作品并非取材于其自身的本质，他们力求的形式是源自其心境的特化运用，因此可以用来完全摆脱其存在的束缚。

或许我们称之为完美的艺术（并非所有艺术家都会努力追求这种完美，有些甚至对之不屑一顾）只是一种想要在人类作品中渴望去发现方法的正确性、内在的必然性以及形式和素材间不可分离的凝聚力。这里，素材却是以最朴实的贝壳模样出现在我们面前的。①

这篇文章简单地谈及了四位英国当代玻璃艺术家——基思·卡明斯（Keith Cummings）、萨拉·麦克唐纳（Sara McDonald）、戴维·里克（David Reekie）和科林·伦尼（Colin Rennie），探讨他们这些展出作品的诗学纬度。

我的文章本身自然亦是一种语言的工艺品、内容的结构体以及文字组成的客体。如果你观察一下语言的素材，就会发现任何文本本质上都是由绵延不断的网状组织。"text"这一英语单词源自拉丁语中的"textus"，意为组织或薄的织物，衍生自动词"texere"，意为使组合或编织②。这个语源方面的细节非常之重要，与写作本身也有着直接的联系：

"就像编织者一样，作者总是在素材的背面进行写作。他关注的只是语言，而正因如此，他会发现自己被意义所围绕。"③

因此，如果我的文章正巧是一种描述这些英国当代玻璃艺术家们的作品和手法趋势，请谨记以下法国画家乔治斯·布拉克（Georges Braque）的"忠告"：

"写作并非描述，绘画亦非描绘。现实主义只是一种假象。"④

或许我还可以接着给"poetic"这个词下个定义，这样应该会有些帮助；或许还应该小心地提起布拉克的另一个敏锐而深刻的观点，即"定义某事就是用其定义来替代它"。⑤

我打算将"poetic"一词的原义稍作恢复，用其来表示一种技术与创造的过程，同时去除那些似乎目前常见的传讹含义，如"不精确的"、"言过其实的"或是"多愁善感的"。

"诗学"一词意为"巧妙的办法"，"诗歌"一词则表示"（手工艺）制品"，此处都是隐含暗指。事实上，从学术角度来看，这正是"诗人"（poet）一词最初的含义，也是它希腊语词根的意思："诗人"的字面意义正是制造者。

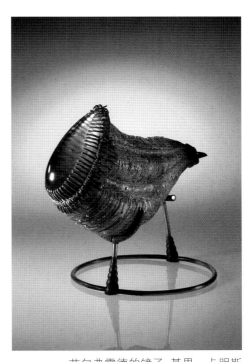

艾尔弗雷德的镜子 基思·卡明斯
（Keith Cummings） 2005年

"出于对手工艺传统的信任，艺术家视自己为制造者，而非创造者；是必需品的供应者，而非未获认可的人类立法者。"⑥

带着这样的批判性的洞察力，作家加布里尔·夏希波维希（Gabriel Josipovici）从英国浪漫主义诗人雪莱"关于诗人是不被认可的人类立法者"这一高度浪漫的主张里抽身而退，但是却又保留了雪莱在《为诗辩护》（A Defence of Poetry）（1821年）中强调诗人是制造者⑦的观点。夏希波维希发现了，当代艺术家作品简单直接地与手工艺传统联系起来时所发生的后现代主义独特张力与困难，并向20世纪末西方的物体制作者们提出了根本性的问题：

"有时，怀疑的态度不得不屈从于信任的态度——对素材、对我们的才能、对制作这一行为本身的信任。而问题在于如何阻止怀疑转变为愤世嫉俗，如何阻止信任转变为轻率浅薄。毫不怀疑的信任是治疗虚伪和浮夸艺术的良药；而毫不信任的怀疑则是改变浅薄和空洞艺术的秘诀。"⑧

夏希波维希拒绝那种随心所欲的后现代主义，因为这种后现代主义会运用于所有的传统中。而在当代应用艺术中，这些传统可能使得人们认为手工艺的要旨最好也不过是一种疗法，最坏则不过是感伤或者放纵。夏希波维希保留了一种失落纯真的、迫切而又普遍的感觉。这正如1919年爱尔兰诗人叶慈（W.B. Yeats）在其《库尔的野天鹅》⑨（The Wild Swans at Coole）一诗中所表达的观念：

"希克：我要找到我自己，而不是一个映像。

伊勒：那是我们在现代的希望，凭借其光亮。

我们照亮了温柔敏感的心灵，

却丢失了古老之手的冷漠；

无论我们选择了凿子、鹅毛笔还是画笔，

我们都不过是评论家，空虚而羞愧……"

如果现代不再有那"古老的手的冷漠"，那么手工艺传统的单纯祈求似乎就会以否认的形式出现，这不仅是一种逃避现实的幼稚行为，也是裹着糖衣的虚伪感情。这种情况也不只是"温柔敏感的心灵"，而是拙劣的诗学。

似乎恰好与叶慈的诗歌同时代，乔治斯·布拉克从1917至1947年间的私人笔记本中，早期的一页上用文字和绘画表达了对进退两难困境的领悟。在他用普通写法记录下骨架形式的潦草提纲下面，文字和图像各占了半壁江山：画家以形式和色彩来思考，物体就是他的诗歌语言。⑩

布拉克关注于作为一种思考过程的绘画以及作为诗歌的形成，比如说骨骼、水罐或者风景的物体认识，都决定了他对现实的复杂创作，而这种创作远非模仿行为可企及（"你不应该模仿你想要创造的东西"）。作品是创作行为中关注、思考和发现的一个深思熟虑的过程——艰难而不天真。

2001竹堑国际玻璃艺术节（Hsin-Chu International Glass Arts Festival）上的四位英国玻璃艺术家，就是在这样困难的批判或文化语境中进行创作的。他们中的每一位——基思·卡明斯、萨拉·麦克唐纳、戴维·里克和科林·伦尼——都通过自己迥异的作品对当代玻璃艺术困境作出了个人独特的回应。

他们的作品之间当然也有相似之处。四位艺术家在时间上都从两个完全分离的视角和两个创造性的意向进行创作：一方面，运用已获得手工艺的传统知识，另一方面又将技巧、知识和理解结合成新的整体。从而制作出令人耳目一新又独具创意的作品。

每个艺术家都选择玻璃作为创作的主要素材，但又都采用微妙的方式避免明显的表现技巧，这种技巧正是一些玻璃艺术家创作方法的特质。有没有人提到过戴尔·奇胡利（Dale Chihuly）呢？

他的艺术是煽动买风者、赶超崇拜者、新货币以及忸怩的暴发户。换句话说，是在财富上早熟却在文化上稚嫩的新西北人的艺术。玻璃是被博物馆和美术馆正式

认可的艺术形式，然而几乎是完全装饰性的（如奇胡利所创作的那样）——令人喜悦地不受威胁、含糊或其他意涵所累。"你若不是很聪明不精通艺术史也能理解这些作品，"奇胡利的一位助手在一部关于奇胡利的纪录片中这样说道，"它们只是非常美丽"。玻璃也很适合像西北部这样沉醉于金钱和科技的地方。它炫丽而奢华，像珠宝那样闪亮，却比珠宝大一百倍。⑩

对于猛烈抨击这类艺术的学者来说，可以去石板（Slate）网上看这篇笔触辛辣的新闻报道，其网址附在文后的注释中。其余人则可能只是注意一下几个严厉却不出所料的贬低性假设——关于玻璃的"装饰"性，所有的闪光物品、奢侈品、好看又巨大的珠宝等，然后就继续读本文了。

基思·卡明斯的作品富有雕塑风格，是室内规格的装饰玻璃和金属艺术品，看上去显得含糊、自省和奇特，本质上又是私密的。它们似乎与当代玻璃艺术的流行趋势背道而驰，与过滤的透明相比可是更巨大、更外向甚至更闪亮的作品风尚格格不入。相反，它们是不透明的、内省的，与其可亲（或正好相反）之处取决于对其高度复杂表面的精妙解读。正如卡明斯在1993年的一次访谈中所说：

"我认为手工艺品是终点，是冥想的产物。这就是为什么手工艺者总是热衷于表面质感的微妙神韵。在我看来，手工艺品也最适合于家庭环境。我想要创造的就是房间内的核心装饰品。"⑫

如果上面这段话可以理解为类似诗学的（意为：创造性的制作法）声明的话，那么显然在卡明斯的作品中，流动着一种与材质和工序的漫谈以及随之而来的充满想象和沉思的可能，随处活跃着关于构造和组装的决定。这种技巧是"有计划的冒险"而非"无忌惮的侥幸"。如果这件完成的"手工艺品"，是一种旅行的终点，那么在途中开启一连串动态起点的正是作品形成的过程本身。当遇见这件完成的作品时，我们会通过默想工艺和想象来重现这些可能。同样，制图者担任的好像并不是蓝图的工作，而是定位或探向的工作。

卡明斯创作的作品是奇美的瑰宝，结合了迷人的材质、复杂的结构、娴熟多样的技巧、精美的局部细节和漫长而隐含的历史，或者说是磨炼留下的痕迹。这些窑制的玻璃和金属艺术品似乎带有某种神秘莫测的炼金术印记。它们遍布古翠，带着长期受盐水浸渍后从海底挖掘而出的质感，伴以堆积衍生而出的水晶贝壳，就像种子破壳而出那样劈开其角状的外壳。它们不可思议地在有机和无机之间存在，准确地引领我们进入对一些古老而熟悉问题的冥想和再熟识中。它的起源是什么？是谁创作的？为什么制作？又是如何制作而成的呢？

初看之下，戴维·里克与基思·卡明斯的作品似乎全然不同。他一直以一种立时可辨并具一贯象征性的雕塑语言进行创作，而我们见证了这种努力的最终成果。我们注意到其作品中的一些偏好和旨趣：黯淡或者说是黑色的幽默、富于哲理的讽刺以及政治的批评。里克的三维窑制玻璃作品与始于12世纪的英国民间传统石刻——那些装饰在古老的礼拜堂或大教堂的屋顶和屋檐上，向我们横眉怒目的讽刺偶像甚至偶尔可憎的塑像——有着很深的渊源。

其作品的另一个根源同样具有丰富的内涵，滋养于新近的书画传统，即具有社会评论和政治讽刺精神的漫画传统。事实上，他的作品非常强调图画这一探索与思考的过程，就其方法而言与基思·卡明斯颇有关联，尽管其结果截然不同。二维的平面设计，如边框或是窗户，似乎令人马上联想到漫画边框或建筑特征，并提供了仿佛是二维与三维之间的入口或是隙缝，震惊与意外的人们跳着相反或不齐的舞蹈，带着紧张、愤怒或迷惑，透过其间窥视着。

里克对这个模棱两可的空间——让我们称之为"二又二分之一次元"——进行了巧妙而又意味深长的探索。其1996年名为《舞者VIII》（Dancer VIII）表现了一个半蹲坐着的卡通人物，在一块依轴旋转的木板上保持平衡。人物短而伸展的手臂末端是巨大的手掌，脸部表情流露出一种带着困惑的讶异，就好像是卡通画人物突

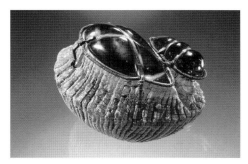

王朝时代 基思·卡明斯 (Keith Cummings)
2006年

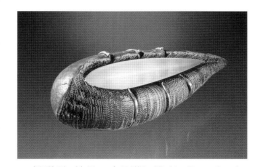

掷弹兵 基思·卡明斯 (Keith Cummings)
2006年

舞者VIII 戴维·里克 (David Reekie)
长460mm，宽260mm，高380mm，1996年

杂耍 戴维·里克 (David Reekie)
长370mm，宽190mm，高520mm，1997年

住在狭窄的空间里II 戴维·里克 (David Reekie)
长290mm, 宽290mm, 高630mm, 1998年

无法用言语表达——自己的肖像画5
戴维·里克 (David Reekie)
长170mm, 宽180mm, 高350mm, 1998年

盘子 萨拉·麦克唐纳 (Sara McDonald)
直径600mm 1998年

然醒了，发现自己住在三维空间里，在努力保持平衡的同时也在掂量并适应着自己这庞大的双手。

作品是直接而正面的，从而掩藏了人物平坦的背面。该作品由注满开放式的窑模铸成。其表面装饰的熔融色彩保留了图画般的外观，这是别样而不朽的玻璃语言中的绘画标志。

里克新近的多数系列作品都致力于在二维和三维空间中探索相似的形式张力。在《生活在有限空间》（Living in Confined Spaces）这一系列中，两个或更多脱蜡铸造的玻璃人物通常以木制底座形式出现在有限的平面上。通常地面被绘制成棋盘状，以强调戏剧场景中古怪的游戏性质，暗指在异常情况下监禁俘虏的非公开限制规则。里克在这些作品中将人类生存状态描述为，不管多么荒谬，人类的本质、罪恶与价值仍然坚持基本的无知或困惑状态。

里克最新创作的《自画像》（Self Portrait）系列似乎也同样如此，将语言和数字的不安定性与铸造玻璃形式对立起来，将人物形象与底座结合起来，构成一个个"严肃的"雕像头部：这将会是你今年所能看到的最原原本本的心灵和肉体分界的形象了！

萨拉·麦克唐纳也创作窑制艺术品，同样注重形式与布局，采用不同的色彩、原料及技术范畴，但创作结果却完全不同。她至今最为独特的作品是由相当浅的、直径很大的熔融、凹陷和层叠的碗组成。其特点是微妙甚至精细的色域是由熔融金属层决定的，这些金属包括金、银箔、铝、铜和铜锌合金。

尽管其规模令人印象深刻，但这些作品的色调仍然高度严谨、精巧和微妙。其有限色域是有意为之的。这是焦点的问题，而此处的焦点向内定位。这些奇妙作品的熔融表面以几何学的精密度来进行细致的分层和层叠。它们捕捉、保持并反射光线，就如同透过了一层层纱幔。

凹形光线形成版画似的玻璃帷幕，时刻变化着的色调和色彩相互补缀、交织、缝合起来，这些色调和色彩却又是随着光源的明暗而移动变幻。观众可以透过横隔在眼前的复杂表面或连绵的遮蔽物、半遮蔽物以及柔和的金属电阻屏蔽物来欣赏作品。

如此形成的存在于具有高度的图案感和连续性，与数字、度量以及比例都有关联，遵循着与音乐和容器同样相关的规则。麦克唐纳说，正是由于这些复杂性，"作品才变得连贯"。[13]

那么，以这样的方式连贯起来的究竟是什么呢？对我来说，连贯的既是工艺、又是美学和沉思的作品。虽然这需要极度慎重的几何学和精致素材的复杂的物理需求，然而却又并未包括计划性的安排和可辨识的寓意。

麦克唐纳的作品象征性地创造了深思熟虑的家庭内部空间，毫无疑问地容纳了日光和欣喜。这就好像作品进展得非常缓慢，尽管素描本上的想法已经成熟——标记、观察、设计、措辞、声音、转录、记忆和冥想——但似乎要到显露出其基本的抽象姿态、韵律或重要意义时，焦点才会出现并且扩大。

正如这种描述性语言所示，我们很难反对以下看法：这些非同寻常的作品正在耐心而坚持地探索着作为光之媒介的容器形式的实质和精神层面。

在技术上却与之完全相反，科林·伦尼的作品是用炉口以色彩融合的铅水晶吹制锻造而成。每一件作品都是多次重复加热、持续扩大材质的操作，待其温度范围直至达到平衡为止的工艺的成果。在此期间，完整的形式达到了赋予其生命力的平衡，组成部分则似乎以某种目的进行着有机的相互连接和形成。成品通常会引起加斯顿·巴什拉（Gaston Bachelard）在其《空间诗学》（La poétique de l'espace）（1958年）第五章开篇时就保罗·瓦雷里（Paul Valéry）关于贝壳的思考所发的惊叹：

"对这位诗人来说，贝壳似乎一直是完全凝固了的动物几何学真理，并因此

'鲜明而独特'。这种被创造的物体本身是极其明白易懂的，神秘的是其形成而非形式。"⑭

如果说科林·伦尼好像以这种"动物几何学"的语言进行创作的话，那么这些高度发光的外表可能只是其作品中最为浅薄的方面。伦尼将形式与形成的可能性运用到极致，通过熔融玻璃媒质的外表面不断限制、释放和塑造达到最终的形式。每件作品从冷却的表面看上去几乎不能凝结或冷铸其蓬勃炙热的内在能量。因此，最终形式是作为内外空间与内外能量之间交锋的成果而出现的。巴什拉在对瓦雷里的解读中追求着这种卓越并探寻着这一秘密：

"人雕刻的贝壳只有从外部通过一系列无法历数的、带有人工雕琢的以及美的特质的行为才能获得；然而'软体动物分泌贝壳'，它使贝壳的建筑材料'渗出'，'提炼出它需要被覆盖的奇妙'。瓦雷里以这样的方式回归赋形的生命之谜，缓慢而连续的形成之谜。"⑮

瓦雷里类比中的两个方面都有助于我们理解伦尼的热铸玻璃工艺，其中液体玻璃材料的确是慢慢地产生或渗出其表面，随之冷却成含有静止流动形式的半透明贝壳状外观。而在另一方面，每件作品都是"精神的特殊应用"，更确切地说，都是习得手艺与故意设计的作品，瓦雷里极其敏锐地意识到了这一特征：

"贝壳的制造是生命的表现，而不是故意为之：还有什么能与我们有目的、有动机和有组织的行为更截然相反的呢。"⑯

科林·伦尼创作了就在这个博弈空间内活动和作用的绝妙作品，构造出静止却又栩栩如生的雕塑玻璃作品。它们令人惊奇于其形式和形成，并令人好奇于它内在的意图。它们外在的美丽更像是阻碍其私密居住形式的思考屏障。它们无疑是手工艺品，而非活生生的海洋生物的有机外壳。

在其玻璃创作生涯早期，伦尼的作品似乎就这些主题展开思考：制作行为，即玻璃制作行为，是诗学本质；工具和器械，无论是有形的还是无形的，无论是锤子还是爪钩，也是诗学本质；内在与外在形式之间的关系。

对我来说，这四位艺术家的作品始终默默地前行，不断地发展，越来越好并越来越有深度和内涵，对今日浮华的玻璃界产生着微妙的影响。

盘子 萨拉·麦克唐纳 (Sara McDonald)
直径550mm 2001年

原始人类 科林·伦尼 (Colin Rennie)
1997年

原始人类 科林·伦尼 (Colin Rennie)
1997年

① 保罗·瓦雷里（Paul Valéry）：《人与贝壳》（Man and the Sea Shell），詹姆斯·R·劳勒（James R. Lawler）选编并作导论：《保罗·瓦雷里选集》（Paul Valéry: An Anthology），伦敦：鲁特莱治和凯根保罗出版社，1977年，第132页。

② 文本（Text）："文字按顺序组成的结构……初始写作的字词"。编织（Weave）："藉由纱线或连续网内某种物质的细丝交织而形成或制作（材料或原料）"引申为"精心设计、构建或创立（精神产品）"。（《牛津英语词典》）

③ 莫里斯·梅洛-庞蒂（Maurice Merleau-Ponty）：《间接语言与沉默之声》（Indirect Language and the Voices of Silence），理查德·C·麦克利里（Richard C. McCleary）译：《符号》（Signs），西北大学出版社，1964年，第45页。

④ 乔治斯·布拉克（Georges Braque）：《乔治斯·布拉克笔记，1917—1947》（Cahier de Georges Braque, 1917—1947），巴黎：玛格出版社，1948年，多佛版，斯坦利·阿普尔鲍姆（Stanley Applebaum）译：《乔治斯·布拉克插图笔记，1917—1955》（Georges Braque Illustrated Notebooks 1917—1955），纽约，1971年，第35页。

⑤ 乔治斯·布拉克：《乔治斯·布拉克插图笔记》，第31页。

⑥ 加布里尔·夏希波维希（Gabriel Josipovici）：《论信任：艺术与怀疑的诱惑》（On Trust: Art and the Temptations of Suspicion），耶鲁大学出版社，1999年，第273页。

⑦ 珀西·比希·雪莱（Percy Bysshe Shelley）：《为诗辩护》（A Defence of Poetry），1821年，大卫·李·克拉克（David Lee Clark）编：《雪莱散文集，或预言的号角》（Shelley's Prose, or The Trumpet of a Prophecy），伦敦：新闻界出版社，1988年，第276—297页。

⑧ 夏希波维希：《论信任》，1999年，第2—3页。

⑨ W.B.叶慈（W.B. Yeats）：《我是你的主人》（Ego Dominus Tuus），《库尔的野天鹅》（The Wild Swans at Coole），1919年，《诗集》（Collected Poems），伦敦，1977年，第180—181页。

⑩ 乔治斯·布拉克：《乔治斯·布拉克插图笔记》，第11页。

⑪ 埃里克·西格利安诺（Eric Scigliano）：《玻璃心：当人们在西雅图谈"艺术"，他们谈的是奇胡利的艺术》（Heart of Glass: When folks say "art" in Seattle, they reach for their Chihuly），1999年6月9日，[http://slate.msn.com/LetterFromWa/99—06—09/LetterFromWa.asp]

⑫ 《当代英国玻璃》（Contemporary British Glass），伦敦，1993年，第24页。

⑬ 麦克唐纳（McDonald）：作者注记。

⑭ 加斯顿·巴什拉（Gaston Bachelard）：《空间诗学》（La poétique de l'espace），1958年；玛丽亚·乔勒斯（Maria Jolas）译：《空间诗学》（The Poetics of Space），第105—106页。

⑮ 巴什拉（Bachelard）：《空间诗学》（The Poetics of Space），第106页。

⑯ 保罗·瓦雷里（Paul Valéry）：《人与贝壳》，第128页。

# 第四章 评论与访谈

## 人类尺度

—— 何云昌行为艺术

与水对话 何云昌 (He Yunchang) 1999年

河道文件 何云昌 (He Yunchang)
上海 2000年

解构你喜爱的事物——这总是一场开放性的游戏——但你无法解构这一点：我们生活中行为的痛苦、愉快与信仰。①

就常驻北京的行为艺术家何云昌 (He Yunchang) 在纽约的初次登场而言，以上引语稍显拐弯抹角。何云昌的初次登场与该引语都同样源自于英国已故的诗人道格拉斯·奥利弗 (Douglas Oliver) (1937—2000) 的《双重的真实回忆和冥想》，以及法国激进无政府主义者、1871年巴黎公社的女英雄路易丝·米歇尔 (Louise Michel) (1830—1905) 之口。

然而在这种情况下，这样的文字或许意外地提供了关于行为的评论性观点：如果人类生命经验的连续是有限的，结合而言的直接含义（以及与此结合的本质区别），这种人类生命经验超越了批评理论，由痛苦、愉悦与信仰的守护神一路伴随，并与我们所玩的游戏纠结难分。这是承认存在并属于我们生活中行为构造覆盖物的文字。事实上，以下这些措辞中的每一条都在何云昌的激进艺术中获得了连续的重要性：游戏、行为、生活、痛苦、快乐、信仰，连同其涉及的深刻持续和忍耐的世俗意义。

在西方后现代艺术批评语境里，奥利弗的话有着诗法和激进主义的狂草意味：

"我们生命中每时每刻的行为都是我们好与坏（或好与坏的艺术）可能性发生的时刻，尽管我们有着关于人类思想或灵魂的行为方式，关于诗法和形式的杰出观点。"②

在遭遇何云昌行为艺术作品时，可以通过许可的方式来接受这样的思想，但这肯定不是一种规定来思考这样的观点。近年来，著作和评论③谨慎保守地提供了其行为作品的摄影记录，伴以最为贫乏的书面说明——关于它的准确日期、时间和地点。这种同列出时间与空间的做法并未体现出其精心的准备，这里有两个例子：

摔跤：一和一百

行为艺术

时间：2001年3月24日

地点：昆明

过程：何云昌连续不断地与一百个人摔跤。最终记录显示何云昌赢十八次，输

八十二次。整个进程持续了66分钟。

视力检测

时间：2003年3月27日

场所：中国北京

事件：何云昌注视一万瓦灯光60分钟令其视力有所下降。

素材：1．一块干净的反射镜，2．两百五十六盏灯，3．一把铸铁椅，4．一张视力检测表。④

何云昌的这些以及其他更为极端的行为艺术作品中所共有的肉体忍耐力的特征，众所周知是其艺术的共性。然而，这种特性可能是他作品中最次要的方面，目前这些掩盖了其对于持续性更深刻的行动性关注。因为这些作品都是经过深思熟虑，有时甚至是痛苦的，因为它们被有意要求并延长时间跨度。它们在时间上被考虑、组织和持续的各方面都是经过仔细斟酌的。在它们引发内部空间——其行为开拓并随后在生命中愈加维持的空间——其范畴和精神维度内也是合乎标准的，正如本文引语所说："必然会引起痛苦、愉悦和信仰"。

这些危险的游戏或许与其自身的忍耐力程度、地点和背景并无多大关系，却有着不同的风险。

2006年3月11日17点45分开始，比通知的晚了十五分钟，何云昌开始了二十四小时的《龙鱼》。来自阿米诺（Amino）的李·卡拉汉（Lee Callahan）将一根二十米长的红绳一端系在阿昌锁骨下方已被穿刺的铁球上，另一端则系在一根穿过中央广场建筑物中庭的钢索上。

系牢后，阿昌赤身裸体地大步走进行为空间中央，那里已经有两张纸固定在地上。他用一支鲜红色的粉笔快速而随意地写了两个潦草的汉字——龙鱼，然后他漫步到接下来二十四小时内将循行的无形圆圈的边缘。他以一种几乎是满不在乎的方式开始以逆时针方向围绕龙鱼慢跑，慢跑的圆圈直径大约在十米左右，这是一次没有目的地的旅程，将持续整晚和第二天的大部分时间。⑤

正如艺术家在两年前就其另一作品《铸》（Casting，2004年）在别处所说：

"当我的每件作品在继续的时候，它们就变得越来越残酷。所有的游戏最终都可能是致命的。在表现游戏的英雄气概和表面从容的谬论背后，只有有坚强意志的人才能克服恐惧，树立信心并在生命流逝时体会其存在的意义。"⑥

这段话结束句中所表达存在主义的剧痛又令人想起何云昌就"不合作方式"（Fuck Off），即在2000年艾未未和冯博一策划的强硬独立展时所发表的艺术声明：

"我近年来关注的是弱势群体和生命意志的话题。追求和现实的是诗意表达的持久与无畏的对峙。"⑦

何云昌在策展人备忘录《关于不合作方式》（About 'Fuck Off'）中，斗志昂扬的抵抗精神也同样显示了这样的天性：

寓言、直接质问、抵抗、异化、消亡、忍耐、厌倦、偏见、谬论、玩世不恭和自娱自乐既是文化的方面，也是存在的特点。这里艺术家以前所未有的坦率和才智表达了这些话题，留下新鲜刺激的信息和存在的轨迹。⑧

文化是一种存在，是我们在生活中和生活本身的行为。在该展览中，何云昌的"诗意地对抗现实"展现出一种惊人而包容的形式，看起来像是萨满主义，但却并非如此，实际上是诗学：

与水对话

行为艺术

时间：1999年2月14日

地点：中国云南梁河

过程：何云昌倒吊在吊车上。他用一把刀切开这条四千五百米长的河流，产生出三十厘米深的切痕。河流每分钟流速为一百五十米，这一行为持续了三十分钟。

河道文件 何云昌（He Yunchang）
上海 2000年

摔跤1和100 何云昌（He Yunchang） 2001年

铸造舞动的龙 何云昌（He Yunchang）
2002年

视力检测 何云昌（He Yunchang）
2003年

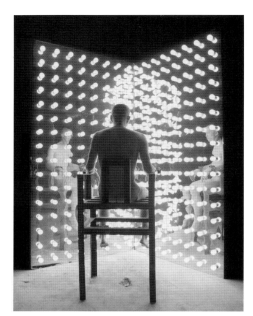

视力测试（1） 何云昌（He Yunchang）
2003年

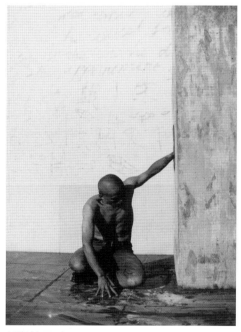

抓紧柱子 何云昌（He Yunchang） 2003年

铸造 何云昌（He Yunchang） 2004年

何云昌的双臂都各有一条一厘米深的伤痕。血沿着他的手臂滴入河里。整个行为艺术持续了九十分钟。

　　甚至在薄薄的目录记载图像中，这件作品都引起了作者的惊人共鸣，切开和流动的相互交换、血与水的交融、有机无机物体和持续时间的分寸。正如何云昌就《铸》（Casting，2004年）所说："时间是行为中的关键要素。行为持续的时间与行为完成的方式，以及行为要求的强度一样重要。"行为就像对话那样保持缄默、无可比拟、几乎不受语言的影响，是无形的作品，总之无法归因于河流形象和倒挂人类形式之外的语境。这是个人意志与作品在其中形成的自然环境的一次和解。

　　在何云昌其他行为艺术作品的出版目录中，语境的问题被适当地弱化了，例如《抱柱之信》（Appointment grasping the Column）（2003年）中再现《庄子》（Zhuang Zi）第十四章的道家寓言；又比如在《空当接龙》（Constructing a Moving Dragon）（2002年）中运用使自身穿过一连串衔接物体的莫比斯尔带概念，并且着重人转体半周，从而反复盘绕和展开那种接龙的普通物质能量：

　　地点：韩国釜山会堂

　　事件：何云昌将一个参与者背在背上、抱在怀里、扛在肩上，并将其带到舞台上，然后该参与者用相同的方式将他带回原地。游戏是与不同参与者轮流进行的。

　　注：《空当接龙》是一种扑克牌游戏。⑨

　　每条目录项都以一句简洁的句子来回顾整个事件，保留了其纪录逐渐减少的行为作品的真实特征，从某种程度上来说与其作品的极度朴素相呼应，这种极度朴素体现在每件作品都使用最少的素材，去除了艺术设计；极度的朴素，几乎没有理论或美学"框架"，以此服务于总要酝酿很长时间的形式思想。

　　作品的简单朴素常常给人以一种有意拖延的假象，因为两年对于一个充分发展而不可简约的概念来说绝不是不寻常的孕育阶段。这要求一种始终如一地进行"技术的减少"，将行为掷出艺术（或升华）的范畴，进入生命经验的领域，他称之为"常态"（"常态"是我在作品中一直使用的一个简单明了的表达方式，将人为因素排除在外⑩）。换句话说：

　　"我早期的作品是极为悦目而理想化的，它们与现实完全无关；而我后来的作品则更贴近生活和社会。它们更残酷，在身体上令人筋疲力尽。我知道这些有力的活动中有些会伤害我的身体，我并不愚蠢。"⑪

　　极端甚至任性的身体限制看起来是这些作品设计中想要超越肉体损耗而获得多种自由的基本先决条件：主要是对艺术家而言"无拘无束"的精神自由。⑫限制是精神上的，例如，在自由意志和心理局限的潜在能量，以及人类存在和本体的自我设限中的限制。

　　随意选择的限制则是在空间（材料、技术和环境）和时间（参与、持续和完成）层面上作用的，通过作品中那种精心计算却仍冗长重复过程的折磨与无用来表现出，就如《龙鱼》或：

　　《上海水记》

　　行为艺术

　　时间：2003年11月3日

　　地点：中国上海

　　过程：何云昌在上海苏州河下游用水桶装了十吨水并将其保存在船舱中，然后将其运至以北四公里处，并在上游将所有水倒入河中，使这些水重新流五公里。整个行为持续了八小时。

　　素材：一条船，一只水桶⑬

　　以弗所的赫拉克利特说："我们走进，但我们无法两次走进相同的河流；我们存在，我们不在"⑭。何云昌将宇宙流动的费力、注定失败及明知无用的倒转，戏弄了中国道家和西方前苏格拉底哲学中重大的古老潜流。作品徒劳地想要打断原始

的流动并将其引入重复的概念：使流动成为再流动，在充满了思想和痛苦、愉悦以及信仰这两种运动之间创造出一个张力的精神空间。

在《上海水记》中，人体的特征并不表现在行为发生的场所上，而是表现在概念的物质延展上。作品标题中的记是精神上的草稿，是一种非常真实和鲜活的精神欲望，是为之工作、意志和游戏的结果。场所和背景提供了行为的地点，从而完成了流动的目的。然而在某些重要方面，实质上，作品本身是无形的，是一种内在的过程：

"当然，行为是艺术家在某个特定时刻和环境中的身体和心理反应。"[15]

是对人类持续纬度的关注，其关键词并非"时间"或"环境"，而是"当时"。

在《铸》（2004年4月23日至24日）中，这一过程到达了无形的高潮。艺术家独自赤身裸体地被封入一个用二十吨水泥浇铸了十小时的狭小房间内，带着他对黑暗、极度寒冷、炎热以及房间倒塌的想象风险中恐惧地度过了二十四个小时，最终再花些时间凿开水泥房从而获得自由。

"对于其他行为艺术家来说，他们是能够被看见的。但在我的行为中，没有人知道我在里面干了什么。我能说我做了这个，也能说我做了那个；我也可以说谎，因为一切都被掩盖了，行为的意义降低到零。人们能看到我进去和出来，但那并非我行为的一部分，真正的过程是任何人都无法看到的。每个行为都要有意义吗？我并不这样想。"[16]

但是，如我所示，如果何云昌作品中人体并不是行为发生的场所，那么这里打开了哪一种空间呢？

1964年在圣盖伦举办的一次雕塑展开幕式上，马丁·海德格尔（Martin Heidegger）发表了一场简短的演说。他将"技术-物质空间"的地理学范畴与一个更为基本的观点鲜明地对立起来：

"雕塑主体中包含着一些东西。是空间吗？雕塑是一种对空间的占有和占用吗？还是一种对空间的支配？从这些角度来看，雕塑相当于技术-科学对空间的征服吗？

创造空间带来了自由，带来了人类安定和居住的开放性……

创造空间是授予空间或为居住地所准备的场所。世俗空间常像是转回潜在神圣空间的空间。

创造空间是使场所成为可能。

在空间创造中，发生了一些同时揭示和隐藏其自身的事。"[17]

在这个项目中，我想要将我的身体和水泥以更亲密的方式联系起来……[18]

他将人体看作是测量的工具，致力于探索其在内心抗拒方面的肉体局限性和在精神自由、旅程或发现方面的隐含意图。

何云昌至今持续时间最长的行为作品是《带着石头漫游英国》（Touring Round Great Britain With A Rock）（2006年9月24日至2007年1月14日），尽管在肉体形式方面与《铸》截然不同，但也将身体与石头这一素材"以一种亲密的方式"联系起来。他在英国诺森伯兰郡海岸线上的洛克村附近找了块石头，带着它按逆时针方向围着英国主岛走过了三千英里，在一百十二天后将它放回原处，行走过程中必须放弃精密的几何圆周来保持耐力。我们无法在该作品中看到作为指定出发点的地形的空间形而上学的野心，也无法找到人类主权的影子。这不是华莱士·史蒂文斯（Wallace Stevens）在其《坛子轶事》（Anecdote of the Jar）中所表现的形式美学主权：

我放了一只坛子在田纳西

"圆圆的坛子，耸立山巅

它使那散漫的荒野

铸 何云昌（He Yunchang） 2004年

铸 何云昌（He Yunchang） 2004年

铸 何云昌（He Yunchang） 2004年

龙鱼 何云昌（He Yunchang） 2006年

大不列颠的摇滚旅行 何云昌（He Yunchang）
2006年7月

大不列颠的摇滚旅行
何云昌（He Yunchang） 2006年7月

大不列颠的摇滚旅行
何云昌（He Yunchang） 2006年7月

大不列颠的摇滚旅行
何云昌（He Yunchang） 2006年7月

麻将 何云昌（He Yunchang） 2007年

环绕在这小山旁。
荒野向它隆起
四处蔓延，再不荒凉
圆圆的坛子，立在地上
高耸如空中港口。
它统领四方
这光秃秃的灰色坛子
长不出鸟儿或树丛
与田纳西的其他一切都不一样。"⑩
更确切地说，关于该作品中何云昌行为目的的说明却惊人地质朴：
"一、个人生存条件：以无效行为挑战当时的主流价值观，例如效率、健康等。
二、减轻技术元素：行为艺术作品应该是艺术家置身于特定环境时，其身体与灵魂的自然反映，这与电影、戏剧、舞蹈、音乐和其他行为不同。石头漫游记就通过以自然方式行走并耗费极大体力来减轻行为因素的影响。
三、不确定性：如何从艺术、自然地理、运动等方面来尽可能地理解该作品，但是，看来从任何视角都无法完全理解它。
四、多维：从本质上具化这一作品并以此为观众提供多种解读的可能，不同的观众会有不同的观点，因此其概念就获得了延伸。
他对于主流价值观的批判——在这件作品中表现为对"健康和效率"文化以及对身体崇拜和锻炼的明显自恋的批判——再一次鉴明了"专制与天性之间的妥协"或"习惯与本能之间的妥协"。由于文化独裁、物恋和习惯阻碍了天性的存在，艺术家的真实旅程正是这种未经开化的存在状态，与之相对立的是，他以"讽刺"而又坚定的态度将"个人的钢铁意志"投入复杂的权力游戏中，游戏特征仍是长期的肉体困苦和最终的无用。这是废物中的纯净本质。
然而，何云昌通过访谈或记录材料表达这些观点时，他或许是在进行另一个游戏，将其意图隐藏在不带感情的行为之后。在其行为中，真正的诗学实际上更多地表现为巴斯特·基顿（Buster Keaton）而非华莱士·史蒂文斯的诗学，理性的反抗则与路易丝·米歇尔相距不远。
何云昌为其在纽约的首次展出设计了一件长期以来他一直想实现的作品：
该作品的创作主题是温和、正常和坚忍。
《麻将》（Majiang），我们或许可以称之为一种特别再现。该行为作品的物质环境来自一个可以说是有凭有据的故事：值班的官员通过无休止的麻将，来寻求监狱日常工作中的放松。游戏包括囚犯将刻有汉字的沉重砖头搬来搬去，直到他们站不起来为止。
温和、正常和坚忍：该作品中蕴涵着牺牲，掩蔽着内在力量。
一个古老的游戏，对何云昌而言，是其生命的行为艺术。

麻将 何云昌 (He Yunchang) 2007

① 道格拉斯·奥利弗 (Douglas Oliver)：《私语"路易丝"：双重的真实回忆和冥想》(Whisper 'Louise'：A double historical memoir and meditation)，海斯汀斯：现实街版，2005年，第56页。ISBN 1-874400-31-8

② 同上，第56页。

③ 见唐昕：《阿昌的坚持》和《铸：何云昌行为艺术》，北京—东京艺术项目，2004年。

④ 同上，第40页和第26页。

⑤ 何云昌：引自唐昕《为〈铸〉——写在何云昌个展之前》，《阿昌的坚持》（见前引书）。

⑥ 何云昌：www.eastlinkgallery.cn/fuckoff-heyunchang.htm 上的艺术家资料。

⑦ 阿黛尔·谈，见前引书，第34页。

⑧ 何云昌，2007年7月写给作者的私人信件。在此我要衷心感谢李晓潜（音译）协助翻译我们的往来书信。

⑨ "何云昌的行为艺术"，访谈记录，2004年7月9日，见www.crienglish.com

⑩ 何云昌，2007年7月写给作者的私人信件。

⑪ 同上，第22页。

⑫ 赫拉克利特 (Heraclitus) 著；T．M．罗宾森 (T.M. Robinson) 译注：《赫拉克利特著作残篇译注》(Fragments：A Text and Translation with a Commentary by T.M. Robinson)，多伦多：多伦多大学出版社，1987年，ISBN 0-8020-6913-4，残篇49a，第35页。亦可参见残篇12中"当他们踏入同一些河流时，流过他们的是不同而又不同的水"。

⑬ 何云昌，2007年7月写给作者的私人信件。

⑭ 唐昕：《铸》(Casting)，同上，第24页。

⑮ 马丁·海德格尔 (Martin Heidegger)：《艺术与空间》(Die Kunst und der Raum)，1969年，是其最初于1964年10月3日在圣盖伦伊姆埃凯尔画廊 (Im Erker Gallery) 举办的伯纳德·海利格尔 (Bernard Heiliger) 雕塑展开幕式上发表的简短演讲的重写。修改后的文章由埃凯尔出版社 (Erker Verlag) 于1969年10月为欧内斯特·卡斯特纳 (Ernst Kästner) 图片展首日而出版。我有该文新近的德意对照版本：卡罗·安赫利诺 (Carlo Angelino) 译；詹尼·瓦蒂莫 (Gianni Vattimo) 作序：《艺术与空间》(L'arte e lo spazio)，热那亚：苦橙出版社 (Il Melangolo)，2003年，第19页和27页。ISBN 88-7018-285-1．我对此处英文译文负全责。

⑯ 赖因哈德·迈 (Reinhard May)，格雷厄姆·帕克斯 (Graham Parkes) 译（并为之写了一篇补充文章）：《海德格尔思想的隐秘来源：论海德格尔作品中的东亚影响》(Heiddeger's Hidden Sources：East Asian Influence on his Work)，伦敦：拉特利奇出版社，1996年，书中各处。

⑰ 唐昕：《铸》(Casting)，同上，第16页。

⑱ 华莱士·史蒂文斯 (Wallace Stevens)：《坛子轶事》(Anecdote of the Jar)，《风琴》(Harmonium)，1923年。

⑲《石头英国漫游记》(Touring Round Great Britain With a Rock) 由阿米诺 (amino)（纽卡斯尔）和 x 空间 (spacex)（埃克塞特）共同制作。见www.amino.org.uk上的参考文件。

# 欧文·皮科克：物的秘密生活

选择 欧文·皮科克（Irvine Peacock）
长330mm，高280mm 2001年

骨音声 欧文·皮科克（Irvine Peacock）
长500mm，高395mm，2001年

一个戴着日本猫卡通假面的妇女形象浮现于一张油画布上，她的头与双臂被支撑着，轻柔地浮在空中，她的下半身微微斜倚在背景中的积云中。另一幅画中悬浮的前景人物，左掌张开作"慈悲之心"手势，也许是对着观赏者，画中她那天蓝和服自然地飘动。显出拒绝采取叙述性立场的姿态。

而在另一幅画中，许许多多像鲭鱼般的剪刀停在半空中——这些意味深长而又引起共鸣的物体，有张开的，也有合拢的，在碳钢剪材质中发出银质般餐具的光泽，它们同样被细细地描绘出来——还有那些黑色搪瓷手柄上小凸刺的设计是用来定住它们的。

初见欧文·皮科克（Irvine Peacock）画作的人，也许会注意到这篇简短说明的两个引文——在英语词源说明中截取的法语部分；怀特黑德的双关语中类似的绝妙智慧，它预示着我们各自日常生活的常规性本质以及创造性关注的性质，这种关注迫使我们直接经验的细节越发详尽并生活和居住在其中。

皮科克对于极微妙差别细节的精确描绘保证了画中物的逼真程度，这似乎乍看之下像是现实主义，但经过更仔细的观察后，却发现像是在探索如何更为困惑不安地表现不确定、幻觉以及看的原现象学。正如他自己所说：

事实上，事物只有在某种特定角度、光线条件、特定距离下观看时才像它们本来的样子，不然它们看上去根本就不像真的。"①

所以这些充满激情、像瓷器一样精美的画面，其中包含轮廓鲜明的细节，对于粗心的观赏者来说，也许反会成为其不可靠的理由。因为，坦白地说：事物的像并非其本身。

更确切地说，像在意识活动中被"赋予生命"、被"经历体验"、被"重新想象"……②

因此，作为一个想象条件，怀特黑德的告诫中的"第二条观点"："生活于细节中"的自然词语，以及最适宜表达欧文·皮科克画中所蕴涵的那种思考方式的词语是幻想。

这就是说，幻想作为创造力警醒的一种状态——正如克莱特·高登（Colette Gaudin）谈及加斯顿·巴什拉（Gaston Bachelard）时所定义的那样——是一种想象的状态：

"远非自身满足的漂流，而是通过长期读写以及不断的"自省"实践而习得的素养。对于疏于梦想的人而言，像说明不了什么。"③

如果用"绘画"来替代"读写"的话，那么我们就可以体会到皮科克画作中可观察细节的特别之处了，这使得皮科克的幻想和其作为画家的艺术作品，无疑都有别于林内·玛格丽特（René Magritte）、弗丽达·卡洛（Frieda Kahlo）、利奥诺拉·卡灵顿（Leonora Carrington）、拉米迪欧斯·瓦罗（Remedios Varo），或乔治欧·德·奇日科（Giorgio de Chirico）等人的作品。尽管初看之下皮科克的作品与这些艺术家的作品似乎都继承了一种异质的传统或带来了相似的视觉效果。正如巴什拉自己所写的那样，对于皮科克来说"是幻想勾画了我们精神上的最高境界。④

和玛格丽特、卡灵顿等其他画家相比，欧文·皮科克在某种程度上更为关注局部环境中真实现象的丑恶细节，而非典范或理想形式——他似乎为这些现象深感不安。他描绘的男性人物看起来总是巧言令色以致不必花钱接受昂贵的理发服务，他们总是占据着画中最显著的位置，与拉米迪欧斯·瓦罗画中的缥缈轮廓大相径庭。

皮科克富有想象力的作品与其说是梦幻，不如说是现实的幻想，他的风格——用更精妙的笔触耐心地描绘出细节，侧重细节的图画使时间不仅是绘画创作时间，而是成为一种精神空间，连接主观和客观，既是短暂的时间也能得到和谐统一。

皮科克的作品如果是现实主义的话，那么它们是如此地令人沉醉，直面自然世界，其绘画创作是最为实用和先锋的创造性风格⑤。他认为现代美术遗产没有多大用处。相反，由于忠于绘画对象的强烈真实性、历史和当前的存在，使他不再采用由抽象转换而来的弗南德·拉杰（Fernand Léger）的波状花纹。

当我在耀眼的日光中看到加农炮敞着的后膛和白色金属上闪烁着的光芒时，我一下子目瞪口呆了。不需要其他，仅此就足以使我将1912年至1913年之间的抽象艺术抛之脑后。这对于我，作为人和画家而言，是一场完全的革命……我画了无数的画，感受着金属被握在手中的感觉，观察着各部分的几何形状。就是在这"战壕"里，我真正地抓住了物的真实。⑥

皮科克幼年时就对印刷复制作品有着强烈的爱好，如布歇（Boucher）为路易斯·奥莫菲（Louise O'Murphy）所作肖像画中斜躺着的裸体或是杨·斯蒂恩（Jan Steen）风俗画场景⑦中对性的直白描绘和对画中肉体的期望——在某种程度上将对物的本能感觉与单纯创作色彩性质的技巧鉴赏力结合起来："我只是不明白他是怎么画金属的，那种铜般的光泽……我仍然喜欢物体上的光泽。"⑧

强烈的惊讶——轮流表现为荒谬可笑的、欢欣的、颠覆的、顽皮的、情欲的或是暗中的恐吓——在皮科克创作的直接体验中存在，而观赏者在观看中再生，在"当你画某样东西的时候，它看起来就是那样东西：突然回视着你"时发生。⑨

这样看似率直的评论却掩藏着复杂的契机，画家极度投入对技巧的控制并尽情发挥创造性的幻想，对画家来说，新创作的人物形象再现了一个独立的灵魂，它自己就能决定下一步的发展。

由此，幻想引领我们进入了一个用文字无法表述的叙述性空间，伴以不断重复的主题下，将穿衣的或裸体的、蒙面或不蒙面的人物，进行了一场不可思议的游戏，而游戏的规则早已失窃、遗忘，或是尚待考虑。

历史学家 欧文·皮科克（Irvine Peacock）
长760mm，高760mm 2002年

早上好 欧文·皮科克（Irvine Peacock）
长865mm，高395mm 2003年

Kimono 欧文·皮科克（Irvine Peacock）
长645mm，高940mm 2003年

等待早餐 欧文·皮科克 （Irvine
Peacock） 长620mm，高910mm 2003年

警告 欧文·皮科克 （Irvine Peacock）
长310mm，高290mm 2008年

① 欧文·皮科克 （Irvine Peacock） 与作者的对话，2004年8月。

② 加斯顿·巴什拉 （Gaston Bachelard）；克莱特·高登 （Colette Gaudin） 译并作序：《论诗学的想象与幻想》 （On Poetic Imagination and Reverie），达拉斯：春天出版社 （Spring Publications），1987年，1998年第3版。

③ 同上。

④ 加斯顿·巴什拉 （Gaston Bachelard）：火的精神分析 （La Psychanalyse du feu） 巴黎：格利玛出版社 （Gallimard），1938年，第215页。

⑤ 见罗伯特·斯道 （Robert Storr）：《不问现代主义的现代艺术》 （Modern Art despite Modernism），纽约：现代艺术博物馆 （Museum of Modern Art），2000年："认为任何时期的现实主义其本质上都是保守的观点是错误的……现实主义一直以来都反对学术教条。抱持着同样的精神，现实主义不断违反现代主义抽象艺术的规则，这些规则的制定者认为抽象艺术原理与实践是通用与绝对的。" 第32页。

⑥ 弗南德·拉杰 （Fernand Léger），引自彼得·弗朗西亚 （Peter de Francia）：《弗南德·拉杰》 （Fernand Léger），纽黑文：耶鲁大学出版社，1983年，第31页。

⑦ 弗朗索瓦·布歇 （Fran ois Boucher）：《躺着的女孩》 （Fille allongée） （路易斯·奥莫菲肖像），1752年，慕尼黑老美术馆 （Alte Pinakothek, Munich）；杨·斯蒂恩 （Jan Steen）：《晨起梳洗》 （The Morning Toilet），1659—1660年，海牙莫瑞泰斯皇家美术馆 （Mauritshuis, The Hague）。

⑧ 欧文·皮科克 （Irvine Peacock） 与作者的对话，2004年8月。

⑨ 同上。

# 格架层：戴维·琼斯烧制陶器新作

不久之前，我很荣幸地在什罗普郡郊区一个美术馆举行的"定影—封火"开幕式上发表了演说。什罗普郡位于英格兰与威尔士接壤地区的英格兰边境。"定影—封火"这一展览由戴维·琼斯（David Jones）的烧制陶器和罗德·多林（Rod Dorling）风景照片构成，这次展览将黏土这一最为平凡世俗同时又最为缥缈幽雅的艺术创作材料和光影结合在了一起。

该美术馆位于不列颠群岛上最重要地质层之一的西部地带。这里有很长的悬崖，被称做温洛克边界（Wenlock Edge），由大约四亿年前志留纪浅海中压碎的贝壳、珊瑚虫、海绵以及海百合的骨骼化石所形成的古珊瑚礁构成，位于赤道以南约六十度。而现在我们能看到的则是长满了树木的石灰岩山脊和较为平缓的粉砂岩及页岩的并行山谷。

这是一个令人惊异的多元地质地貌带，堆积而成的暗礁坐落在底部的奥陶纪岩石上，在北面则是由前寒武纪变质岩和火成岩所构成的郎明德山脉。

这就是现在"定影—封火"开幕式的所在地了，就在我们站着的地方：处于地质断层线的深地壳缝合上面，在经过许多代的提升、褶皱、熔化、堆积、分解、断裂、穿刺等，处于巨大的构造运动、剧烈的火山活动、江河海洋的溶解作用以及冰川的压力运动下形成的火山岩、火山灰、古代淤泥滩、泥沙沉积矿床所构成的岩石地幔上面。

而就在这里，栖居在漫长的矿物历史的外壳上，手工烧制的陶器作品被安置在提高的金属网格上。某种程度上，这些作品作为手工艺，调动并运用了与上述地壳运动相同的自然力——热力、压力、运动力、化学和矿物的悬置力。它们所关注的核心是人类长久以来作为手工艺品的容器的本质。因此它与记忆有着更为密切的关系，甚至与炼金术也有关联。稍后我会更加详细地就这一点展开讨论。

1950年6月6日，马丁·海德格尔（Martin Heidegger）在巴伐利亚艺术学院的一次演讲中对一件简单的手工制容器——陶罐作了如下的精彩阐释：

"陶工在转盘上塑造罐壁和罐底，严格说来，他并不是在制作陶罐，而只是在把黏土塑造成型。不，他只是在塑造虚空。为创造虚空，在虚空之中，从虚空而来，最终将黏土塑造成型。自始至终，陶工把握了不可把握的虚空并且将之创造出来，使之成为容器并进入有容纳作用的器皿形态。陶罐的虚空决定了制作过程中的

窑制容器 戴维·琼斯（David Jones）
2001年

两件窑制容器 戴维·琼斯（David Jones）
2001年

容器（破碎的心） 戴维·琼斯
（David Jones） 2001年

容器 戴维·琼斯（David Jones） 2001年

容器俯瞰图 戴维·琼斯（David Jones）
2001年

暗塔 戴维·琼斯（David Jones） 2001年

所有行为。器皿的物性绝不在于其材料，而在于其所容纳的虚空。"①

这是迄今西方哲学与陶器最亲密的一次接触了吧！海德格尔在其演讲中进而界定了陶罐的本质——"独特的容纳和保有"。这是通过倾倒宗教仪式祭品所获得并完成的"奠酒祭神，天地合一"。

不过，海德格尔仅仅是以陶罐为例来印证其学说罢了。奇怪的是，对于一位如此执著地认为诗可以"言说"真理、揭示存在，人可以诗意地栖居、诗意地思考的哲学家来说，海德格尔竟然没有思考其制作过程，或者是诗学（poesis）。然而，事实上是他隐瞒了其思考的源起，即《老子》或《道德经》的第十一章：

三十辐共一毂，

"当其无有，车之用也。

埏埴以为器，

当其无有，器之用也。

凿户牖以为室，

当其无有，室之用也。

故有之以为利，无之以为用。"

海德格尔曾读过理查德·威尔海姆（Richard Willhelm）翻译的1911年德文版《老子》第十一章，里面说道，"陶罐的作用在于其无有"（The work of jugs consists in their nothingness）。他之所以对其可能的思想来源讳莫如深，从好的角度理解是出于某种原因不详的疏漏，而更具争议的说法则是"默会知识"，即"既然如此就保持缄默的知识"。而赖因哈德·迈（Reinhard May）的研究②显示，1930年海德格尔曾参阅过马丁·布勃（Martin Buber）翻译的1910年版《庄子》。他也读过冯·斯特劳斯（Von Strauss）（1870年版）和威尔海姆的德文版《老子》（1911年版）。1946年夏天，他与中国哲学家萧师毅合作翻译《老子》，然而翻译工作进行了八章后，应海德格尔的要求中止了。仅四年之后的1950年，他就发表了《物》（'Das Ding'）一文。

尽管戴维·琼斯对哲学和文学的兴趣为时甚久，但在陶器制作中，他一直都小心翼翼地避免盗用理论或文化增加叙述性解读的负担。他被收藏于韦斯特瓦尔德博物馆（Westerwald Museum）的新作进一步发展了其较早的展览，即"定影—封火"中对于材料的强调，同时愈加关注史前阶段，或者说关注记忆——人类的，甚至个人的，那些以矿物质形式出现的记忆。作品被分层安置在矩形网格上方，就好像考古遗址的示意图，去除了可能曾经埋藏这些坟墓内物品的泥土，形成了有意建构的虚空。

作为手工艺品，这些容器本身显现出一种有和无之间的平衡，这种平衡存在于材料中，存在于虚空中。正是围绕着虚空，容器才获得了形状。

但是，詹姆斯·埃尔金斯（James Elkins）在其名著《何谓绘画》中提出，艺术家在创作新的作品时是通过材料来进行思考的。因此作品并不描述其他的主题、素材或是目的，因为它们自己本身就是目的。

用埃尔金斯的话来说，艺术家就像炼金术士，通过材料，通过持续不断的熔融过程进行思考：

"当物质熔合时，它们变得更纯净、更强大、更珍贵，正如灵魂会变得更圣洁。点金石是精神圆满的标记，几乎达到超验的状态，所有杂质都被中和、燃烧、熔解或熔合，继而灵魂会是喜悦而宁静的。炼金术士密切注意其坩埚，观察物质的混合和离析，某种程度上他们总在思考尘世的斗争和污秽，并最终思考自己的灵魂和精神。"③

① 马丁·海德格尔（Martin Heidegger）:《物》（Das Ding），1950年6月6日在巴伐利亚美术学院（Bayerischen Akademie der Schönen Kunste）的演讲，艾伯特·霍夫施塔特（Albert Hofstadter）译:《物》（'The Thing'），《诗·语言·思》（Poetry, Language, Thought），纽约:哈珀和罗出版社，哈珀科拉芬版，1971年，第168－169页。

② 赖因哈德·迈（Reinhard May），格雷厄姆·帕克斯（Graham Parkes）译（并为之写了一篇补充文章）:《海德格尔思想的隐秘来源:论海德格尔作品中的东亚影响》（Heiddeger's Hidden Sources:East Asian Influence on his Work），伦敦:拉特利奇出版社，1996年，书中各处。

③ 詹姆斯·埃尔金斯（James Elkins）:《何谓绘画:如何以炼金术的语言思考油画》（What Painting Is: How to Think about Oil Painting, Using the Language of Alchemy），纽约和伦敦:拉特利奇出版社，1999年，第4页。

光与火的展览 戴维·琼斯（David Jones）
2002年

光与火的展览 戴维·琼斯（David Jones）
2002年

火的考验 戴维·琼斯（David Jones）
2006年

# 流动的地平线

人们常说，"东方是东方，西方是西方"。然而，在这篇文章里可不是这样。

自本文标题开始，文中其所呈现的一切均无以证实。因为你一旦踌躇斟酌，观念和事物就开始移动、漂流，不再是静态的。我们把这理解为"流动现代性"的加速状态。"流动现代性"（liquid modernity）一词是由定居利兹的波兰裔流亡社会学家齐格蒙特·鲍曼（Zygmunt Bauman）创造的，他用它来描述引起知识和金融瞬间全球移动的现代性对人类产生的影响，并认为所有人类熟悉的事物，如时间、空间、工作、个性和社会都全然是流动的，包括人类解放，甚至是自由本身的可能。

鲍曼关心的是人类伦理和责任的消退，这是伴随"人类相互关系的许多基本契约关系中"金钱关系的首要地位而来的。作为一名社会学家，鲍曼的论点与技术现代性相符合，而这种现代性正是决定流动性的基本力量：

"力量能够随着电子讯号的速度移动，因此其基本组分运动时间缩短到了顷刻间。就其所有现实目的而言，力量真正成为治外法权，而不再是被束缚的，甚至也不再为空间阻力所延缓。"[①]

在这样一个等式中，价值不再处处存在，而是具体化了。相反它还可以买卖，横跨人类几乎感觉不到的空间、时间运动的时刻。不再需要全面爆发全球金融危机来弄清楚这样的方式是多么短暂：

"流体可以说既不固定空间也不束缚时间。在某种程度上，固体取消了时间；而对液体而言，正好完全相反，基本上正是时间才重要。"[②]

本文提到的不断运动的空间也正是这样短暂地被这些关于西澳大利亚玻璃的流动反思所占据，以人类、地质和真实时间为主要内容，以一种明显的海洋对陆地的包围和鲸吞的方式来探讨素材、地点、方位，甚至同一性的潜在可能。在物质空间的移动过程中，其中"所有固体的都化为烟云"[③]，沉积、分层和固定事物中最古老可靠的，甚至地方和本体都被动摇了。就连罗盘的意义也被摧毁，正如一位早期的评论家所说：

"对陆居者而言，'东方'和'西方'只是地方，然而对水手来说，它们都是他要去的方向。"[④]

巴克明斯特·富勒（Buckminster Fuller）[⑤]在《流动的地理学》（Fluid

贝壳碗 凯文·戈登（Kevin Gordon）
直径440mm，高120mm 2007年

Geography）（1944年）一书［该书与其《戴麦克森投影世界地图》（World Map on Dymaxion Projection）一起出版］中提供了纠正麦卡托（Mercator）投影的地域主义者失真的制图法，明确表示地球表面只有百分之二十六是陆地，对人类定位历史产生了深远的意义：

"水手对于洋流是很警觉的，他们能够看出历史的流动，而关注静态的历史学家则完全不能。他看到人如何将不幸转化成技术优势，如何逐渐减少道路的局限，以及他们实际上又是如何加速运动。

陆地上的活动通常是在八小时工作日的基础上进行的，八小时后办公室和工厂就关闭了，然而海洋永不关闭。惰性和缺乏挑战会带来草率的哲学。"⑥

在富勒的分析中，人类对地形记录的历史残留事实上仅限于连绵不绝的海底山脉和高原，是地球的表面环境，而地球的根本状态又是流动的。《流动的地理学》（Fluid Geography）出版于1944年，深刻地认识到现代飞行技术给整个城市带来的灾害，留下一片狼藉，就好像广阔的海洋洋底上留下的人类失事船只残骸那样，只不过这里的"海洋"是地球的大气层，是环绕着地球的气态流体。格尔尼卡或德勒斯顿，接着是广岛，都是活生生的例子。

因此鲍曼认为实质现代性所具有的这种流动的力量或许一直都是我们的时间、地构、地理学和哲学的真实状态：决定了人类迁移方式、技术和因而产生的文化海生气味，并架构了矛盾的空间：

"水手心目中的一体化海洋为其尤为关注的海岸线片断所组成。"⑦

由此我们与地方最深厚的联系获得了解放。

尽管现在我的思绪萦绕在澳大利亚西部，然而我却在威尔士边界写这篇文章，抬头就能看见名为温洛克边境（Wenlock Edge）的悬崖。温洛克边境是一处著名的景观，也正是豪斯曼（A.E. Housman）在其诗歌《什罗普郡一少年》（A Shropshire Lad）（1896年）中所讲的"记忆中的蓝山"。《什罗普郡一少年》由拉尔夫·沃恩-威廉斯（Ralph Vaughan-Williams）、乔治·巴特沃斯（George Butterworth）、亚瑟·布利斯（Arthur Bliss）和伊沃·格尼（Ivor Gurney）等人配乐，这些名字本身就能唤起一种纯英国风格的魅力。

然而，去掉这些附加表面，温洛克边境本身既是时间的边界，也是时间的眼界：南太平洋沿海水域的温暖浅水下由四亿年前压碎的贝壳、珊瑚、海绵以及海百合的骨骼化石形成的古珊瑚礁，位于志留纪赤道以南约三十度，正好与西澳大利亚的珀斯处于同纬度地区。

我说的是地质断层线的深地壳缝合，坐落在经过许多代的提升、褶皱、熔化、堆积、分解、断裂、穿刺等等，在巨大的构造运动、剧烈的火山活动、江河海洋的溶解作用以及冰川的压力运动下形成的火山岩、火山灰、古代淤泥滩、泥沙沉积矿床所构成的岩石地幔上面。而现在我们能看到的则是长满了树木的石灰岩山脊和较为平缓的粉砂岩及页岩的并行山谷。

好吧，感谢你脑海中正浮现的明信片风景，但所有这种流动的冥想和西澳大利亚当代玻璃艺术又有什么关系呢？

我的推论是：或许所有的人类身份，无论是文化、国家、地区、精神还是个人的身份，都是更多地取决于我们将视野投向何处而不是边界碰巧定在何处。是地平线而非分界线决定了地方的本质是动态而非静态的，决定了所有的远洋航行后初见陆地在被确定为出发（或不出发）的固定地点之前都只是活动的彼岸。

当然，关于地方、归属感和边界还存在着更固定，甚至是保守的意识形态，预示着在经济和社会发展方面，文化硬化和无力不可避免的后果。对个人和艺术家而言：他们是内省的，培育出一种排外的地域性情绪或影响，有时还带着一种对本质的敌意，最后接近被富勒称做孤立主义的"谬论"。约翰·多恩（John Donne），在1623年因"危险的疾病"隔离时，听到敲响的钟，因而写道："没有人

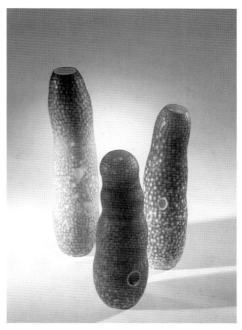

菌类 凯文·戈登（Kevin Gordon） 2007年

红河扇 凯文·戈登（Kevin Gordon）
直径400mm，高130mm 2007年

珊瑚灯 凯文·戈登（Kevin Gordon）
2007年

海星 凯文·戈登 (Kevin Gordon)
直径240mm，高410mm 2007年

沃伦·兰利 (Warren Langley)
米德兰工作室的记忆之塔

会完全是一座孤岛。"然而对于富勒来说：

"孤立主义是更深刻的东西，是静态，是愚昧的惰性。"⑧

这种惰性"因缺乏挑战而致，会带来草率的哲学"。然而地平线却促使我们行走，引起谨慎的冒险，尽管在鲍曼对后现代状况的液态化分析中，地平线对此时此地而言几乎是不可忍受的：

"生命将是不屈不挠地追赶不断逃避的地平线，你知道，你追赶着地平线，而就在你奔跑时，地平线也在前行。"⑨

当然，地平线的本质就是不断前行。但是此处鲍曼或许是在诊断后现代的健康状况，充满在这样一个变化不定的糟糕社会中：

"欲望并不渴望满足。相反，欲望渴望的是欲望。"

关于地方和身份的当代问题就漂浮在这种瞬间的流动现代性的表面张力，这种令人眼花缭乱的液面上，像眼泪、浮冰块或冰架那样漂浮着。这样的表面张力在玻璃作为一种材质的本质中产生了熟悉的矛盾：玻璃的状态是亚稳和无序的，那么，玻璃到底是液体还是固体呢？

对于这个问题，从来没有明确的答复。从分子动力学和热力学方面来说，我们完全可能证明各种不同的观点都是正确的，玻璃是一种高度黏性液体，是一种非晶质固体，或是既非液体又非固体的另一种物态罢了。⑩

从分子动力学方面来看，玻璃严格来说是有别于结晶固体和液体的，因为玻璃分子呈一种无序却固定的黏合排列，既有液体的属性（尽管坚固地结合在一起），也有固体的属性（尽管没有有序的点阵结构）。事实上，玻璃的特点在于其黏性。黏度被定义为流体阻力的程度，其测量单位为泊（poise）。因此，玻璃的流动性是不断成为其本身的流动性。玻璃作为人类的第一种合成材料，真正是我们这个时代的材料：

"需要成为本真是现代生活的特征，强制性的自我决定。"⑪

那么，今日西澳大利亚的潜在地方是什么？它将寻求哪种自我决定呢？我们又能够将其形成的地平线定位在何处呢？玻璃是流动的现代性中的一种动态存在，在这种现代性中，正如所有艺术家都知道的那样，强迫性的制作是本体和地方的一种活性剂。

米德兰工作室（Midland Atelier）新玻璃工房的建立带来了艺术家引导的重要大型玻璃开发项目"一生只有一次"的机会。这些项目一旦实现，将形成一个独特应用于公共和建筑的广泛领域的国际当代玻璃艺术中心，能够提供其他任何澳大利亚艺术中心都无法提供的，米德兰铁路工房现有结构和工作室设施，因为它们是为大型作品量身定做的。

然而对如此突然崛起的抱负而言，其工作范围或限制是多少呢？其地平线又在哪里？当2004年8月鄱若素（Ross Garnaut澳大利亚驻中国大使），谈到拓展与中国的贸易联系是西澳大利亚的"天命"时，他回忆起中澳在历史的相互影响的长期传统以及最近在贸易上的发展关系。西澳大利亚经济的快速增长在很大程度上是得益于其就中国、印度和东南亚而言的有利地理位置。

因此，决定地平线的开放性，与中国合作伙伴关系的外向型战略承诺，以及泛太平洋地区的创意经济，将会通过玻璃的衔接，在高等教育、创意产业发展、文化和艺术规划以及大型公共艺术项目领域中的发端，形成新的伙伴关系。这与西澳大利亚政府对"文化的丰富与多元作为一种建立西澳大利亚艺术与文化市场的主要方式"这种战略舞台上国际合作的优先考虑不谋而合。

通过完全就国内而言的合资企业协作伙伴关系，这也将支持延伸的"创新西澳"政策的目标：改革作为经济和技术革新的驱动力、教育和研究领域的能力建设，着眼于工业的研究所产生的想法的商业化，创造新的就业机会和扩大国家的出口潜力。

鲁伯特·默多克（Rupert Murdoch）在其2008年博耶系列讲座中，将当代澳大利亚的同一性看作是将会被改变和形成的人工制品和自我决定，并强调了在澳大利亚人面对不断扩张的，以中国和印度日益激烈、规范的竞争为特征的全球市场的国际化背景下，以及在现代多元社会自信的"开拓精神"语境中教育、技术和培养人类资本的重要性。

在他看来，东方更多的是一种"趋势"而不是一个"地方"，这将我们带回到文章开始时的巴克明斯特·富勒及其戴麦克森（Dymaxion）投影：

"通过实验，我们可以从这幅地图中看出为什么水手会嘲笑'东方是东方，西方是西方，两者从不会相遇'的说法，因为他认为，人类作为个体随着时间的推移不仅已经走遍了地球的四面八方，而且他们根本都是从一个主要文明流域，即印度支那中移居国外的。这么来说的话，东方和西方其实原来是一体的。只是从这个主要流域中发展出了两个分支，我们却粗心地认为它们之间是毫无关联的。东方和西方的两个支脉分裂在其最终环绕地球一周的过程中成为了正好相反的世界方位。"⑫

黑德兰港马修哈丁雕塑工坊

① 鲍曼（Zygmunt Bauman）：《流动的现代性》，剑桥：普利提出版社，2000年，第10－11页。
② 同上，第2页。
③ 马歇尔·伯曼（Marshall Berman）：《所有固体的都化为烟云：现代性体验》（All That Is Solid Melts Into Air: The Experience of Modernity），伦敦：乌萨出版社，1983年。伯曼该书的标题当然是取自于卡尔·马克思（Karl Marx）和弗里德里希·恩格斯（Friedrich Engels）：《共产党宣言》（The Communist Manifesto）（哈蒙斯沃斯：企鹅出版集团，1967年），第83页上写道：一切固定的东西都烟消云散了，一切神圣的东西都被亵渎玷污了。人们终于不得不用冷静的眼光来直面他们的生活地位和他们的相互关系。
④ 理查德·巴克明斯特·富勒（Richard Buckminster Fuller）：《流动的地理学》（Fluid Geography），1944年4月。詹姆斯·梅勒（James Meller）编并作导言：《巴克明斯特·富勒文选》（The Buckminster Fuller Reader），伦敦，1970年，第129页。最初因其《戴麦克森投影世界地图》（World Map on Dymaxion Projection）一书而作发表于《美国海王星》（American Neptune）。
⑤ 富勒一生中曾与各界有才之士，例如建筑师诺曼·福斯特（Norman Foster），雕刻家和设计师野口勇（Isamu Noguchi）以及作曲家约翰·凯奇（John Cage），合作并影响了他们。自他于1983年逝世以来，随着人类认识到地球资源并非无穷无尽，必须极度经济与谨慎使用，其重要发现、发明和建议的现实意义获得日益重视。富勒现同样被各界有识之士，从工业设计师马克·纽森（Marc Newson），到在作品中将其观点付诸实践人道主义设计师，这些作品为人道建筑（Architecture for Humanity）所作，遍布世界灾难地区⋯⋯列为灵感之源。富勒童年去过其祖父位于缅因州海岸线上的岛屿农场之后，他就爱上了船⋯⋯他相信科学知识中最为重要的发展均是航海和到达新彼岸的渴望的直接产物。相比不爱出门的"未曾出过海者"而言，海员必须找到各种挑战的解决方法：利用风力、用星星导航和不断改进船及其导航仪器的性能以应付富勒称之为海洋"流动的地理学"的能力。[http://www.designmuseum.org/design/r-buckminster-fuller]
⑥ 《流动的地理学》，见前引书，第129页、130页和131页。
⑦ 同上，第132页。
⑧ 《什罗普郡——少年》（A Shropshire Lad, XL.）"一阵风吹入我心底，令我着迷／从那遥远的土地／什么是那些记忆中的蓝山／什么高高耸立，什么是那些农场／／那是失落的土地／我看见它发光的平原／我曾走过的可喜大路／再不会来"（"Into my heart an air that kills／From yon far country blows；／What are those blue remembered hills，／What spires, what farms are those？／／That is the land of lost content，／I see it shining plain，／The happy highways where I went／And cannot come again."）
⑨ 与齐格蒙特·鲍曼的对话，《马斯希尔声音期刊》（Mars Hill Audio Journal），第48期：http://www.marshillaudio.org/resources/mp3/MHAJ-48-Bauman.mp3
⑩ 菲利普·吉布斯（Philip Gibbs）：《玻璃是液体还是固体？》，见http://math.ucr.edu/home/baez/physics/General/Glass/glass.html
⑪ 《流动的现代性》，第32页。
⑫ 同上，第134页。

# 安德鲁·布华顿（Andrew Brewerton）访谈

1996年与朋友在家中合影

2008年，与汪大伟在登黄山的缆车上

Q：基思·卡明斯（Keith Cummings）曾经说过，你的文章早已超越了"纯粹的文艺批评"范畴，你实际上是在"尝试创作一种全新的手工艺评论"。然而，当你谈到自己的文章时，几乎是随意地称其为"关于玻璃的写作"，听起来就像是某种涂鸦似的！那么你是否把你的玻璃评论文章看作是一个累积型的项目呢？

A：基思对我的溢美之词是很宝贵的，我对他评价的重视也是难以言表的。无论是作为玻璃艺术家还是作为玻璃教育家，他的成就在英国都是无与伦比的。我结合了玻璃与写作并默默为之耕耘的小小事业被他视为一种崭新的声音。我确实希望这对于中国读者来说，也是全新和有趣的体验，因为即使在西方也确实没有与之类似的作品。

"关于玻璃的写作"这一系列的作品累积起来后，是否产生了更为深远广泛的涵义，只有时间才能给出答案。但我想其中的思路必然是延续不断的，因为每当写了新的文章后，我总是不断想要回顾并修改以前的文章。

Q：诗人的身份对你作为一名艺术评论家有什么影响呢？

A：这是个很有趣的问题，我自己倒是从来没有想过呢！我想语言的"习惯"——读写的体验和其中主要相互作用的声音与行动——对我，不管是作为诗人还是艺术评论家都很重要，并且这种"习惯"在我的文章中必然也是不证自明的。在剑桥读书时，我学会了"实用批评"、"细读"法，这通常应用于历史和所有语境背景的托辞中所剥离的无归属文本。这种文本分析凌驾于所有形式的书面解读之上。我在文章（甚至邮件）中微妙的调整和语言的神韵方面也都花费了很多时间，因此当我写作时，并不一定在开头处开始，也不一定在结尾处结束。随着时间的流逝，文章交织拼凑成形，但我花费了太多时间。"你的文章难道还没有写完吗？"我妻子会装作一副很绝望的样子来问我。

哲学家路德维格·维特根斯坦（Ludwig Wittgenstein）曾经写道："不要忘记，尽管诗是用告知的语言写成，却并不用于告知的语言游戏。"（泽塔尔，第160页）[①]我想我也许总能敏锐地发现语言的戏谑活泼或者说是胡乱盲目的旨趣：在特定语境中突破其狭隘的告知意义，从而发现多元或多层的含义。因此，我无意中就把维特根斯坦关于诗的告诫延伸到寻常语言中去了。有时这就导致了"拾得诗"，或是在仅仅一首诗中发出不同的声音。

Q：你又是如何从玻璃生产经理向玻璃艺术评论家转型的呢？

A：事后诸葛亮吧！在我看来，改变从来就不是渐次的，相反总是彻底而决然的——比如我吧，从文学学术研究到玻璃工厂工作，再到艺术学校，然后回归表演艺术学院（达汀敦）并进行诗歌创作。也在英国、意大利、中国和澳大利亚等地工作过。

在斯图亚特水晶玻璃制品公司从事玻璃制造工作五年之后，我去了达汀敦水晶玻璃制品公司，担任了五年的设计和产品开发部主管。我与很多设计师进行了多方面的合作，也和许多艺术院校的玻璃系建立了联系。一开始，进行玻璃方面的写作是为了推广我们开发的一系列限量版产品，其中一些现已被伦敦维多利亚和艾伯特博物馆收藏。

1994年我离开达汀敦水晶玻璃有限公司，成为伍尔弗汉普顿大学（University of Wolverhampton）玻璃学科的带头人和主讲。同时，由于其他原因，例如《新玻璃》杂志（Neues Glass/New Glass）编辑的约稿，以及各类讲课和研讨会，我的写作就更偏重于学术性了。因此，我对"关于玻璃的写作"采取了一种更为慎重的态度。在伍尔弗汉普顿大学，人们把我看作是对诗歌有着古怪兴趣的工业玻璃专家。而当我后来被聘为达汀敦艺术学院（Dartington College of Arts）的院长时，我则又被看作是对玻璃有着古怪兴趣的诗人了。

Q：那么你觉得作为玻璃生产经理的经历对你后来成为玻璃艺术评论家有什么帮助吗？如果有帮助的话，体现在哪些方面呢？

A：当然有帮助啦，而且帮助很大。许多年前，我和基思·卡明斯与称之为"变色龙材料"的玻璃极为亲近；每天在极其多变的环境中和玻璃工匠们一起工作，研究玻璃制作工序和玻璃工艺。漫长、酷热、令人筋疲力尽的工作时间，每分钟都要作出数个决定。处于这样一种紧迫的状态下，你得很快学会做出敏捷的反应，然后，你会疲倦到只有站着才能思考的程度。

我对于遇到独具特色的玻璃语言和其他各种"语言"（无论是文字的还是非文字的）总是非常敏感的。例如，看一组玻璃工匠工作就好比是在观赏一种舞蹈。这种工作经过精确设计，要求分毫不差的计时和动作，因为在这种情况下时间就是金钱。

你得学会尊重玻璃这种素材，尊重其多变多元的"形"以及独特且富生命力的"神"。它流动的智慧，想做什么，又不想做什么。玻璃熔炉则是奇特而生机勃勃的，它不停地呼吸着的。

我所工作的工厂始建于18世纪90年代，相同家族的几代人都是厂里的玻璃吹制工、切割工。在传统手工水晶玻璃制造业急剧衰退时，我能在这种令人惊叹——尽管有时是野蛮粗暴——的工厂车间文化即将消失的最后一刻得其门而入，就像是一种难得见证历史的特殊荣幸。这家工厂最终还是在2002年，我离开十三年后关闭了。我们完全可以这么说，三百年的手工技艺和制造传统随之消亡了。

所有那些工匠、场所，所有那些历史和手工艺智慧，都在我心中引起了深深的共鸣。我曾是这其中的一部分，而这也已成为我的一部分了。在某种程度上，正是这些造就了现在的我——既是作家，亦是教育家，还是管理者，更是创新的推动者。无疑也正是这些塑造了我对玻璃的态度。对我而言，这些都是鲜活的经历，而非我碰巧研究的某段历史。

Q：你是如何开始在玻璃业工作的呢？

A：完全是个偶然！当时我刚刚放弃了关于文艺复兴晚期英语和意大利语诗歌中隐喻特质的博士学业，就在斯图亚特父子水晶玻璃有限公司的玻璃工厂找了份工作。我是在一个工业小镇上长大的，放假也会在工厂里打工。当时我非常天真地认为，一份容易控制的"日班工作"能让我有充裕的时间来创作。但这种想法简直错得离谱！他们要求我长时间呆在令人精疲力竭的工厂环境中，这样我根本没有写作

1999年与钱伟长合影

中国东方视觉艺术设计大学（筹）
聘书 Letter of appointment, SIVA

**LETTER OF APPEINTMENT**

We have the distinguished honor of appointing Professor *Andrew Brewerton* as the honorable (Guest) professor of Fine arts College of Shanghai University

President of Fine arts College of Shanghai University

Date 2000.11.

上海大学美术学院聘书
Letter of appointment, Shanghai University

上海大学荣誉证书 Honorary Professorship at Shanghai University

Raag Leaves for Paresh Chakraborty，2008年

的时间，也没有写作的欲望。我能做的只是观察、倾听、积累经验、加深理解，并同时继续生活。

Q：你在玻璃业内做过的工作种类可以说是相当广泛。能多谈谈这方面吗？

A：好吧。1989年我离开了斯图亚特水晶玻璃公司。此前，我已是主管生产、销售以及制造等所有方面的经理了。不过我主要还是负责玻璃制作方面——从玻璃暖房经理，最后到生产经理。我带着所有这些专业知识和对工厂及公司运作的全面了解去了达汀敦水晶玻璃公司。在所有的公司里，你都能发现设计、销售和生产职能之间的创造性，同时它们又都处于消极的紧张状态，面临不同的压力和既得利益。但是，我在制造方面的洞察力使我能够迅速切入做出判断，并决定既定产品的要害，而且我也很享受此过程中的团队合作和紧迫之乐。

后来，我在达汀敦水晶玻璃公司的工作从纯设计转向产品和工艺开发，再转向销售。虽然职务变了，但我却把所有这些角色看作是单一、连续及明确思想和行动过程的不同方面。

Q：作为诗人，你想表达的是什么？作为艺术评论家，你想表达的又是什么呢？

A：我的评论性文章基本上是把玻璃看作一种富创造性的媒质和一种与众不同的当代艺术形式，并探寻其评论的新方法。它们是关于制作的诗学，也就是说，通过作为想象媒介的有形素材和属性可能性的思考来探索，并将这些感知和人类体验的不同想法或方面联系起来。

我们将之看作是西方当代玻璃创作评论中所带有趣闻轶事的特质，我很不喜欢这种特质，所以我从不认为自己是个艺术史学家。而与诗歌创作的联系则是出于对语言素材和诗学的兴趣使然——把文本看作语言艺术品来进行创作——尽管我从未将我的诗看作是一种个人表达行为。对我来说，语言、形象和灵魂是迥然不同的现象。

如果可以如此，那么这正是诗本身的表达。做诗，可能更多的是一种倾听——它需要时间、沉静和专注。作为一个诗人，你得努力隐藏自己，正如诗人、鹰猎者海伦·麦克唐纳（Helen Macdonald）对于驯养苍鹰的看法："你得努力隐藏自己。"

我创作的素材是具体的语言以及吞没这种语言的无言。随着时间的推移，这种语言日益厚重，逐渐呈现——它创造着时间，击打其节拍。它富于视觉性、音乐性和示意性。这似乎在中国书法中体现得尤为明确，例如其术语"飞白"，据说就是书法家蔡邕受石匠蘸石灰刷字的启发所创的枯笔笔法。

我对这种书法的感性感到非常之亲切，很可能是我天生诵读困难的倾向所致。这种与生俱来的倾向使我在阅读文字本身之外，还喜欢"解读"页面上的空白处，我对两者的重视或视觉强调几乎是相同的。我创作并付印诗中许多的中断、沉默和空白，在某种程度上来说也正是在探索这样的听觉、视觉和示意的感性。

Q：在你看来，玻璃艺术家们想表达的又是什么呢？

A：我感兴趣的艺术家似乎是通过创作玻璃作品来提出他们所探寻的"问题"。尽管我在这里所称之为的"问题"有时是难以诉诸言语的，但是你却能通过玻璃作品直接感受到。

这样的作品也许是探究解决形式或技术问题——比如说透明介质中"内"与"外"的关系——然而其美感际遇或哲学体验却远远超越了技术基准。

作品的参考资料包含了转化成艺术作品的思想或主题，这通常点明了作品的由来。正如华莱士·斯蒂文斯（Wallace Stevens）诗中所写："在蓝色吉他上，事物改变了本来的面目"。②

Q：那么艺术家更关注技巧还是思想呢？又是如何平衡技巧和思想的呢？

A：这可是个好问题，既有艺术性也有教育意义。技巧当然很重要，对于进行

并实现创作的思考和学习的相互作用来说是不可或缺的，但它只是工具。其本身并不足以成为结果，最终是会机械化的。就这一点来说，技巧作为工艺已不再是复杂的现有知识，而成为了简单而必需的技能。

我认为所有的艺术创作都是一种认知过程：代表了手、眼、心——所有熟悉和陌生的感觉——具体而真实的智慧。这是一种发现、创造或改变思想和个性的思维方式。如果说我对于纯粹的熟练技巧、空洞的表面光华或浅薄学识根本不感兴趣的话，那么正是因为这些东西很少能导致思想和个性的转变。

Q：你认为在诗歌创作和玻璃艺术创作之间有什么相似和差异之处吗？

A：相似之处？两者都采用复杂多变和难度很高的素材，玻璃和语言都是合成材料，其历史都与数千年人类发展密切相关，远胜于艺术家个人。

至于差别可就大了——是人类创造力中最为厚重和最为缥缈的介质之间的差别。不过，我可不确定哪个是哪个哦！

Q：怎样的玻璃才能称之为玻璃艺术呢？

A：自从马塞尔·杜尚（Marcel Duchamp）创作了《泉》（Fountain）之后——《泉》是陶瓷而非玻璃，但这并不重要——任何创建了全新体验、感知、理解以及透明视野的玻璃物品都可称之为艺术。

Q：你认为普通玻璃制品有艺术含量吗？

A：当然有啦。20世纪30年代，英国评论家赫伯特·里德（Herbert Read）曾经谈到，陶器最为纯粹的本质就是抽象派艺术——其意不在指模仿的造型（例如雕塑，三维立体）艺术。对此我思考过一段时间，认为重要的是：我们人类，作为一类物种，本来就有着这种创作作品的确定性冲动。我注意到一位上海的出租车司机用玻璃包装物——一个带螺旋盖的玻璃罐——喝绿茶，这也在某种意义上告诉了我何成其为人之特质。

Q：那当你作玻璃艺术评论时，更关注的是技巧还是表现呢？抑或是你自身的思想、感受？

A：我不知道。在某个特定时间中确定究竟是上述哪一点引导我们去感受作品是很困难的，我只有通过写作才能发现这一点。

Q：在你看来，如果诗人或艺术家无法为人所理解，他们会觉得沮丧吗？

A：如果他们作品的内涵被误解的话，恐怕会更糟。

Q：那么是什么使工业设计不同于艺术呢？

A：嗯，形式上的期望不同——尽管设计和"纯艺术"实践的期望在飞速变化，甚至就在一代人之间也变得很厉害。从表面上看，设计和艺术仍然处于收藏市场的不同分类。关于艺术和设计的分水岭已有许多著述，因此我就不再锦上添花了。我倒是更愿意区分一下人类想象的不同形式。

英国浪漫主义诗人塞缪尔·泰勒·柯勒律治（Samuel Taylor Coleridge）（1772—1834）认为有一类富创造力的天赋，通过不辞辛劳地发展手艺、技巧、创造、方法和实践，在其原有认识的基础上不断进步。这种思想构建、了解以及赖以存在的基础正是体验。

还有另一类富创造力的天赋却似乎不知从何而来：这是一种"体验并理解"全新事物的幻想能力，然而这些往往是不自觉的，或是一种以全新的认识去重新发现现存事物的能力。这种能力没有统一的方法可证，也没有发展的过程可循。其创造性是瞬间的——更多的是洞察而非技巧。我的观点是柯勒律治《文学传记》（Biographia Literaria）（1817）中观点的释义和引申，因此不能算是创新了。

理想的情况是这两种创造力相互扶助，相互辩论——从价值的角度看，两者之间并无等级关系，也绝非创造性范围中相互排斥的正负两极。谈到比例的话，众所周知创造力等于"百分之九十八的汗水加上百分之二的灵感"这一定义看来是非常的搭配！

2008年与汪大伟在黄山

在上海大学美术学院

在上海大学美术学院的雕塑前

上海图书馆作品《竹简》安装工地现场
1997年

1999年《竹简》在上海图书馆安装作品

1999年《竹简》在上海图书馆安装作品

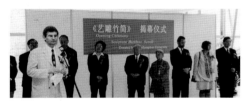

1999年，在《竹简》揭幕仪式上

我认为所有的设计师和艺术家处于创作中的不同节点，事实上是在创作一件作品或一个系列的不同阶段时，都会认识到这两种创造力的作用。

Q：是啊。那么艺术和设计作品以及其市场的区别又在哪儿呢？

A：有时我们说设计作品是终点，而艺术作品则是起点，其实这种说法很对，但是现在这种界线正在变得越来越模糊。显而易见，设计的目的受特定的设计大纲和目标市场的限制更大，对此我同样能举出许多受自身限制或迎合市场期望的当代艺术的例子来。在艺术上能有谁有那样的勇气完全活在当下，做每件事都好像初次那样，从不重复自己呢？

西方设计潮流已经从20世纪七八十年代的以制造、产品为中心的消费者市场转向20世纪八九十年代的以销售型生活方式为中心，后又转向20世纪90年代和21世纪的日益客户化、参与式或互动型的产品文化。消费者不再是简单地"购买"产品或品牌。相反，他们"接受"有个人认同感并贴有商标的产品，从而在某些性质或程度上扩展其自我形象或个人身份。

当然，如果把设计文化的这种"转型"等同于从以物体为中心的抽象艺术创作（20世纪五六十年代）到概念艺术（20世纪七八十年代）再到关系艺术实践的"转型"，包括近期的网络虚拟参与式"第二人生"实验（维他命空间曹斐的《人民城寨》就是一个很好的例子），是过于简单化了。

然而也有重大的当代全球性问题：沟通。区域认同和个体身份、宗教和政治原教旨主义对人类自由的影响、环境的可持续发展、物种多样性面临的威胁和以多种方式超越了艺术——手工艺——设计之间的区分，且令所有艺术家和设计师关注的人类生态学。

Q：你认为设计中什么更重要，是迎合市场呢，还是随心所欲呢？又该如何平衡市场和艺术家个性之间的关系呢？

A：又是一个大问题啊！这大概可以用两个极端的例子来说明吧。就新产品而言，大众市场在看到新产品之前是不知道其自身需求的。而（例如连锁零售店的）采购员多半也不知道在寻找什么——他们想要的是已经在出售的产品——因此设计师必须把握好她或他打算以模仿形式所作的妥协程度。随着降低成本的商业中心区或贸易竞争的压力上升，设计师不可避免地会在品质、直接成本、边际销售等各方面作出更多更大的让步。

事实上，许多商业设计就是已存产品概念的模仿或再造，最糟的情况则是故意违反知识产权和设计权，以低价购物的消费者至上，推动毫无鉴别能力并对商品不加区分的市场。当然，这是一个极端。

另一个极端则体现在最高端的"增值价值"奢侈品牌上，设计标准显得至高无上，逐渐形成其经典风格，以满足精英市场的需求，例如获得一位富足安逸的消费者在品位、气质、审美和价值观方面的认同。品牌的"印记和特征"既要独特又要突出（品位、气质、文化价值等等），设计师必须与之保持积极的联系和一致。

顶级品牌往往有着更具长期性和预测性的规划远景、更具持久性的商业模式和更具凝聚力的体系，这决定了设计团队创作的限定因素、设计敏感度和生产价值。

然而一切都是相互联系的，与世隔绝的话是很难产生好的设计。设计文化是散漫无章的，也是兴趣广泛的，有着充分发展的社会本能。这样说来，或许"艺术家的个性"和"市场"并不像你的问题所示的那样泾渭分明。

真正的原创设计是全然创新和出人意料的——创造先前市场并没有的崭新概念。市场并非是偶然发生的，无论如何，市场是被创造出来的。

Q：作为艺术教授，你希望你的学生从你身上学到什么呢？你认为他们必须知道的最重要的事情是什么？

A：嗯，有两条规则，而且我希望是相互矛盾的两条规则：

第一，渴望（从你观看、倾听、触摸、品味、察觉或在其他情况下碰到的任何

人和事物中）学习一切你可能学到的——无论源自何处，最好是通过直接经验和艺术创作来学习；

第二，要明白可以遵循的道路并非正确的道路。

Q：是什么让你来到了中国呢？

A：好吧，我得说是我大概六七岁时就莫名其妙直觉到的一种缘分吧。我无法解释这种对中国的喜爱从何而来，也无法说清它有多么强烈——反正用我朋友金星的话来说就是，这缘分不是源自这一世吧。当我还在上学时，这种喜爱体现在我对中国艺术、诗歌、哲学和政治、历史的兴趣上，并且这些兴趣在一些老师的鼓励下又扩展到了学校课程之外。

于是我采取了实际行动：1995年，我以伍尔弗汉普顿大学玻璃系主任的身份自愿参加了在中国广东和香港举办的英国文化委员会教育展，这使我能利用广州和香港展会间的三天时间访问上海。当我的头儿时任艺术与设计学院院长沃恩·格里尔斯（Vaughan Grylls）问我为什么选择上海时，我的回答自然而坦率，直觉告诉我说在上海有个有趣的机会在等着我们学院。

值得大加感谢的是，沃恩支持了我颇为俗套乏味的动机。于是，在1996年的1月，我和我的同事艾达·王与汪大伟在上海首次会面，并从而开始了延续至今的友谊和专业合作伙伴关系。开始是偶然的，但由此发展了上海玻璃工作室、1999年的新玻璃经济展、上海图书馆的雕塑装置《竹简》以及宝山玻璃新项目的开发，包括上海玻璃博物馆，当然还有新一代的中国玻璃艺术家。

汪大伟和我都非常清楚，这将会是一个长期的项目规划，意在为上海及其他地区的学生、艺术家和教育者服务。

十三年后，我们似乎是暂时交换了女儿：汪大伟的女儿汪丹现在伦敦学习策展专业硕士课程，而我的女儿露西娅则在上海蒋琼耳处做织物设计工作。

Q：那么谁是你在中国最密切的合作伙伴呢？

A：公开点名是不公平的，因为无论如何都有太多的名字无法一一列举。但是我们的玻璃事业一直都是团体合作项目。这样的团队合作，如果没有艾达·王和陈正颢的帮助，是不可能如此迅速且默契地发生的。

这一团体合作项目，这种伙伴关系的意义以及所有共有的创造力，正是这本书的真正主旨所在。

我很荣幸能与中国玻璃艺术成长期的新兴人物，如上海的庄小蔚、薛吕、杨惠姗、张毅以及北京的关东海等合作。上海大学钱伟长校长、周哲玮校长及其前任壮云乾教授的支持、勉励和领导一直都发挥着积极的影响，上海大学美术学院院长邱瑞敏教授也一直非常支持我们的工作。

在学术界，北京的韩健及范迪安与我相交多年，我一直都很重视他们的想法并与之交流。就更广泛的艺术界而言，我曾与维他命空间的胡昉和张巍、长征空间的卢杰和邱志杰以及刘鼎合作。李晓潜则安排了艺术家链接项目以及参与者在达汀敦驻留期间的活动。

我将继续向以上以及其他许多我有幸成为朋友和同事的人学习。这里没有足够篇幅来一一提及他们的姓名，但是他们知道他们是谁！

Q：那么，你对目前中国玻璃业的状况有什么看法呢？

A：充满热情！在中国，我能看到玻璃制造业设计创新的巨大潜力，与建筑空间相关的玻璃艺术的诱人前景。我将这种崭露头角看作是中国在国际玻璃舞台上的独特存在。

我认为琉璃工房的杨惠姗和张毅对于当代中国玻璃艺术成长发展所作的贡献并没有得到足够的肯定。除了杨惠姗的创作外，她是我评论的艺术家之一，我对于琉璃工房这一品牌在未来几年将如何继续发展也很感兴趣。

但是现在新一代的中国玻璃艺术家，上海大学和清华大学的首批玻璃专业大学

庄小蔚与王国丽合影

与庄小蔚和中国大使馆代表李望荣（左）、宋波（右）在伍尔弗汉普顿大学玻璃工作室
1999年

2006年与关东海在清华大学玻璃工作室

接受赵炯蔚采访

生诞生了，尽管他们还未对中国玻璃制造业产生影响。越来越多的中国艺术院校热衷于开设新的玻璃课程，前景是非常光明的。

世界似乎对中国玻璃与众不同而又鲜为人知的历史再次发生了兴趣，当然这段历史确实是非常吸引人的。上海市宝山区新建的上海玻璃博物馆将和琉璃工房、玻璃博物馆一起为中国玻璃的发展作出重要贡献。

Q：将目前中国工业设计教育，与英国工业设计教育相比，你又有何看法呢？请对中国艺术和工业设计教育提提建议好吗？

A：我认为艺术和设计院校的特质在不断变化，因此其教育传统可以获益于跨学科实践和文化交流。艺术学科和设计学科已不再能够在相互隔绝的"学科仓库"中独立而有效地运作，然而在现代和后代保持传统、专业技术以及通过制作学习的手工艺智慧是至关重要的。现在的学生毕业后马上就进入了全球市场，也正是由于这个原因，使我更感兴趣的是地平线而非分界线，是眼界而非边界。本书中另一篇文章《流动的地平线》更为详尽地谈到了这一点。

Q：你认为在中国成熟的艺术市场和成熟的艺术家群体哪个更重要呢？

A：艺术家创作什么，市场就跟着运作什么，只是迟早而已。

---

① 对维特根斯坦（Wittgenstein）而言，"语言游戏"的概念（Sprachspiel）将语言和语言编织而成的人类活动以及支配这些活动的各种规范和语法规则关联起来。他在《哲学研究》（Philosophical Investigations）（1953年）第二部分写道："让字词的使用告诉你它们的意义。"

② 华莱士·斯蒂文斯（Wallace Stevens）：《弹蓝色吉他的人》（The Man with the Blue Guitar），《华莱士·斯蒂文斯诗集》（The Collected Poems of Wallace Stevens），伦敦：费伯和费伯出版社，1955年，第165页。

艺术简历

**1958年**

2月8日，生于英国伍尔弗汉普顿；十二个月大时，幸存于几近致命的疾病。

**1969年**

就读于伍尔弗汉普顿小学，师从诗人R.F. Langley，学习文学和艺术史。

**1975年**

17岁时遇见了未来的妻子，并计划学习美术。

**1977年**

在剑桥大学西德尼苏塞克斯学院攻读英国文学。

**1979年**

获得瑞士日内瓦大学R.E. Hentsch奖学金。

**1980年**

6月，获得英语学士学位；移居意大利，被戴勒阿古拉（dell'Aquila）大学特聘为英语教师。

**1982年**

回到剑桥，攻读博士学位，业余时间教授英语。

**1983年**

与珍妮特·比弗结婚，并到考文垂；获得研究生奖学金，并在沃里克大学学习意大利文艺复兴诗歌。

**1984年**

被剑桥大学授予文学硕士学位；做出离开文学界的决定；移居英国斯图布里（Stourbridge），加入了斯图亚特王室有限公司。

**1985年**

被任命为斯图亚特水晶温室经理。

**1986年**

第一个女儿出生，取名为鲁思·露西娅。

**1987年**

被任命为斯图亚特水晶业务经理。

**1988年**

第二个女儿出生，取名为汉纳·基亚拉；被任命为斯图亚特水晶制片人。

**1989年**

移居德文郡，作为设计经理加入达汀敦水晶；被任命为达汀敦玻璃博物馆馆长；担任RSA学生设计奖（玻璃器皿）(Glassware) 评委；1989至1996年担任

英国皇家社会与艺术工商协会委员。

## 1990年
被推选为英国皇家艺术学会会员。

## 1991年
限量版系列——《达汀敦水晶版》，在法兰克福赢得了设计大奖，同时受邀为1991年康宁玻璃写评论文章；有五件作品被维多利亚与艾伯特博物馆购买并作为永久收藏。

## 1992年
被任命为达汀敦水晶新产品工艺过程开发部门经理。

## 1993年
被任命为达汀敦水晶市场经理。

## 1994年
继基思·卡明斯后，在伍尔弗汉普顿大学担任玻璃专业主要项目领导人、讲师；在国会演讲，庆祝伦敦维多利亚与艾伯特博物馆新玻璃画廊开张；获得了英国文化学会与马来西亚MARA技术研究所在玻璃艺术上的合作交换；被任命为红屋玻璃博物馆董事。

## 1995年
出版第一部诗歌集《天狼星》（剑桥大学，诗歌史学）；在南非半岛理工大学第二次国际会议上，就发展中国家设计教育学做演讲；在苏格兰爱丁堡玻璃学院开设玻璃文学硕士学位；协商为比勒陀利亚理工大学玻璃制作工艺集资。

## 1996年
1月，与王国丽(Ida Wong)在上海大学会见汪大伟院长；4月和7月又重回上海提倡开发玻璃艺术，并与汪大伟院长展开了长期合作；被任命为斯图亚特水晶设计顾问；把玻璃、电子媒体展览和研究组带入马来西亚设计学会；被任命为伍尔弗汉普顿大学艺术与设计学院院长。

## 1997年
移居什罗普；再度访问中国，计划在上海大学开展公共艺术项目和课程发展；并携手汪大伟院长参观了伍尔弗汉普顿大学玻璃工作室。

## 1998年
获得1998年应用（玻璃）艺术杰伍德奖，并在伦敦手工艺学会发表演讲。

## 1999年
7月，由萨拉·鲍勒组办的新玻璃经济展览在上海图书馆开幕；由科林·里德在上海图书馆揭幕其玻璃作品《竹简》；发表首部中文刊名出版物——《设计新潮（现代设计）》。

## 2000年
被任命为上海大学美术学院荣誉教授；被任命为英国玻璃教育馆馆长；就科林·里德的玻璃艺术在《隆宝》上发表论文；在苏格兰爱丁堡大学就欧洲国内玻璃联盟发表演讲。

## 2001年
被推选为英国艺术学会艺术与设计高等教育的国家行政主管；为台湾新竹国际玻璃艺术节做专题报告；被任命为沃尔索尔新艺廊董事。

## 2002年
被任命为伍尔弗汉普顿大学玻璃专业教授；被上海市教育委员会聘为上海中国东方视觉艺术设计（SIVA）大学（筹）专家咨询委员会委员；在伍尔弗汉普顿会见胡芳。

## 2003年
出版第二部诗歌集《Cade l'uliva》；在澳大利亚玻璃艺术家协会第十三次

会议上发表主题演讲；在伦敦卡姆登人民剧院朗诵诗歌；商业大学合作的兰伯特回顾：玻璃设计与生产——爱丁堡水晶ＭＡ奖学金，被英国设计委员会作为杰出贡献的案例编入英国政府的报告；在上海琉璃工坊会见杨惠姗和张毅；在广州维他命创意空间会见胡凡和张炜；在英国、丹麦和澳大利亚出版当代玻璃艺术的论文。

## 2004年

就任英国玻璃双年展主席；就任伍尔弗汉普顿大学公共讲演教授；玻璃写作：《用诗意描绘当代实用艺术》；被任命为达汀敦艺术学院校长和普利茅斯大学客座教授，并回到德文郡；在 Heidegger and cire-perdue casting上发表《"触摸虚空"中的道教》一文。

## 2005年

被任命为英国战略委员会（商业与社会）高等教育基金协会顾问；成为高等教育统计代理的董事会会员；成为高等教育艺术与设计专业基金会主席；出版的安·沃尔夫的论文目录，就关东海的玻璃艺术做论文；在《装饰（艺术与设计）》杂志5月刊(145)上发表中文翻译的《触摸虚空》。

## 2006年

被任命为高等教育咨询组副主席；在剑桥当代诗歌会议上发表公共演说；在杭州中国艺术学会发表演讲《西方现代主义实体空间》；发表安东尼·勒彼里耶(Antoine Leperlier)的伽勒伊·卡怕萨 (Galerie Capazza)论文目录。

## 2007年

被任命为国家艺术学会会员，英国艺术学会西南地区主席；发表安东尼·勒彼里耶 (Antoine Leperlier)的穆瑟·德·塞威斯(Musée de Sèvres)论文目录和艺术家何云昌表演的纽约论文目录；在达汀敦美术学院和艺术家古斯塔夫·麦特泽格 (Gustav Metzger)等就艺术和伦理学论文进行小组讨论。

## 2008年

为Paresh Chakraborty发表诗歌集Raag Leaves；访问上海大学学者：艺术教育大师；由艾玛·达科和斯图亚特·嘉伏特策划的玻璃之路："从伍尔弗汉普顿到中国"展览，在比尔斯顿手工艺画廊开幕；主题演讲和伍尔弗汉普顿大学创意之路专题报告会；发表澳大利亚玻璃艺术家凯文·戈登的论文目录；与达汀敦艺术学院和法尔茅斯大学联合，并做了研究报告；与琉璃工坊合作，成为珀斯（澳洲西部）顾问。

## 2009年

出版《张开你的嘴》（赫里福，五季刊）；出版《玻璃经典，杨惠姗玻璃艺术》；2月回到萨罗普；被任命为上海玻璃博物馆和上海玻璃科技馆顾问委员会会员；玻璃之路："从伍尔弗汉普顿到中国"展览，在伦敦玻璃艺术画廊开幕；8月在意大利创作新诗集《次序》（Sequence）。

## 2010年

诗集《次序》(Sequence) 由爱尔兰野蜂蜜出版社 (Wild Honey Press) 出版；在北京与艺术家安东尼·勒彼里耶 (Antoine Leperlier)合作创作艺术玻璃装置作品；被任命为普利茅斯艺术学院的院长。

## Something rich and strange. A response

All Art is, by its nature, self-portraiture. As Leonardo da Vinci jokingly put it 'An artist with short legs is doomed to draw his figures with short legs'. To read Andrew Brewerton's description of my work as 'rich and strange' then caused me to ponder this question anew, for I have never thought of myself as either. However, I find his interpretation of my work, methods and motivations to be both accurate and revelatory.

As an artist who fits Tom Phillips'definition as 'simply someone who does not put their toys away at ten years old', I have, over the years, been too engrossed in my practice to unravel its various strands. In any case, I almost certainly lacked the necessary insight and objectivity to define or speculate about them.

Seamus Heaney has defined poetry (and by implication all personally-driven art) as being simultaneously selfish and selfless activities. I take this to mean that, in being driven to celebrate and express one's own existence, the resulting art works may also have the ability to speak to, and for, others. I confess that my work has always been motivated by a need to re-invent selected aspects of the world to create my own version of reality, whether genuine, historical or imagined.

The twentieth century valued originality above all things in its Art. It is very telling that Picasso was its choice as its greatest artist. Attending university when I did in the late 1950s, I accepted this belief avidly, for it offered the chance to extend childhood's search for the means with which to create a personal world. The example set by constructivists like Kurt Schwitters and my tutor Victor Pasmore led me to assemblage as a credible way of making an art in which components retained traces of their original lives, functions, processes and historical contexts. Andrew's article, with its naming of fossils, weapons and jewels, has led me to a realisation of their probable sources.

Brought up in London during the austere post-war years, I spent much of my time in South Kensington, dividing my time between the twin attractions of the Natural History Museum on one side of the road, and the Victoria and Albert Museum on the other. The ancient skeletons and fossils were relics of their original existences in exactly the same way as the swords, jewels and religious reliquaries were. Trapped behind glass, these objects could only be absorbed through the eyes, to re-emerge, decades later, in my work.

My choice of glass and kiln-forming gave me, in addition to a palette of unrivalled richness of material, form, colour and texture to draw upon: a process that by its very nature combined and transformed the elements and fragments of remembered form into a new unity through heat. The forms that inspired me were themselves marked by their history of use, mis-use and, in some cases, burial. This made them, to my eyes, more, not less appealing, and my use of ambiguity of form and title stems, as Andrew has pointed out, from these sources.

I could not and would not have been able to articulate this account of my work as anything other than a response to Andrew's article. It has clarified aspects of my practice that have remained half-hidden for a lifetime.

When the English dramatist and wit, Oscar Wilde, stated that "There was no fog in London until Whistler painted it" he produced much more than just a memorable insight into the nature of Whistler's originality in producing his famous misty Nocturnes. By bringing his own literary skills and knowledge to bear, he also revealed a basic truth about how art functions, in that it shows us aspects of the world that were previously hidden through familiarity or prejudice.

This kind of writing is rare in art criticism, and even rarer when the area under discussion is designated by the term CRAFT. Much contemporary writing, it seems to me, falls into one of two main categories; descriptive or interpretive. By this I mean that writers choose to describe the objects under discussion, both in physical or technical terms, or to attempt to explain what the artist's intentions were. Larger issues like the judgement of quality or cultural context are often avoided.

The essays that make up this collection tackle such difficult issues, but do not attack them head-on, preferring the informed literary scalpel to the dogmatic bludgeon, and are, for this reason among others, doubly effective.

Clearly the education and experience of the observer acts as the reservoir of language and knowledge from which opinions spring, and it comes as no surprise that Andrew Brewerton's writing springs from a unique background that combines direct experiences in a number of different but interlinked fields. He had to make a choice between studying Painting or Literature at University; choosing the latter, and becoming a published Poet in the process.

After graduation from Cambridge he took the highly unusual step of moving into industry as a Design Director in two glass companies that specialised in the production of fine hand made crystal. He followed this by a move to academe as a subject leader, Dean of School at the University of Wolverhampton, and latterly Principal of Dartington College of Arts. All of these strands are evident in his writing, and combine, like a set of sensitive (and extremely sharp) surgical instruments with which he both dissects and constructs. An interest in philosophy, great knowledge of literature, an understanding of, and sympathy for, the special tacit nature of hand driven craft activities are given expression by a poet's sensibility and vocabulary.

The resultant essays, like Wilde's observations, transcend mere criticism. In attempting to introduce them I must avoid, as Andrew does, mere description. Besides, they are here to be read. I will, if I may comment on them obliquely, by association.

The transcription, (as distinct from translation), of one work of art by a new artist has along and distinguished history; Francis Bacon's transcriptions of Velasquez spring to mind. In some ways Andrew's writing transcribes the work and activity he comments on, to become, in their own right, semi-independent entities. They drag craft writing from the shallows to deep water, where undercurrents and tidal movements can be appreciated.

He is attempting nothing less than the creation of a new type of craft writing. One in which the end product, and to some extent the artist who makes it, are only the surface manifestations of deep cultural currents.

Keith Cummings, May-June 2008

## New Glass Economy

Contemporary British Glass* seeks to introduce, for the first time to a contemporary Chinese audience, something of the range, quality, energy and originality of new glass art and craft-industrial glass design and manufacture in Britain today.

The renaissance in new British glass making, ranging from product design-for-manufacture to blown studio glass vessels; from new architectural glass installations to constructed glass furniture; from cast glass jewellery to small-scale sculptural work within the same family of kiln-working techniques; is largely characteristic of the graduate output of a small number of Art Schools in the UK which have been developingglass design as an academic subject at higher education level since the late 1960s.

In terms of the British 'glass economy', these last thirty years describe both a generation and a significant shift: from traditional product design and manufacture within often long established crystal brands to, increasingly, a studio glass economy of small and micro-business development across a wider range of glass design practices.

Within the confines of this discussion, an intriguing footnote to latter-day British social history remains to be written. When, in 1984, I went to work as a

furnace manager at Stuart & Sons Ltd. in Stourbridge, a lead crystal tableware and giftware manufacturing company that had been established almost two hundred years earlier, I experienced what with hindsight I feel to have been a kind of historical privilege.

As a student of English and American literature, I had by that time developed a deep regard for the work of the 19th century American author Herman Melville whose most celebrated work, Moby Dick, or The Whale (1851), can be read as a sustained elegy to the traditional whaling industry off the Nantucket seaboard, before the invention of the mechanical harpoon had terminated an entire working culture.

It seemed to me that, similarly, I was living and working through the last years of a handmade English glass tradition, which the advent of machine crystal production of growing quality and sophistication would almost certainly replace. That I was witnessing a moment of cultural extinction.

In the light of more recent experience in industry and in degree-level art & design education, I now think that, in one very welcome sense, I was mistaken. Even so, I shall continue to link these social and industrial observations quite deliberately in order to make a point.

My point is that these works in glass which we are honoured to present here in Shanghai today are heir to a strong, recognisable, and continuing tradition. It is the tradition shaped by William Morris, John Ruskin, and the Arts and Crafts movement, an aesthetic tradition at various times more or less articulated in wider social, political and philosophical dimensions, which in turn informed the 'domestic modernism' (in Tanya Harrod's phrase) of craft practice in Britain during the 1920s and 30s. It is a tradition that has drawn upon Eastern philosophy through the influential legacy of the potter Bernard Leach, whose key published work A Potter's Book has remained an important benchmark for studio practice since it first appeared in 1940.

It may be argued that a certain disingenuous idealism has from time to time betrayed the more extreme claims for the moral efficacy of 'truth to materials', or for the ethical or cognitive value of the craft-industrial making process, the refinements of advanced technical achievement, and the satisfactions of high quality finished artefacts. It has been argued that this amounted to little more than an affair of the middle classes, in flight from the social, economic and environmental upheaval of the industrial revolution.

If such reductive criticism seems harshly dismissive of both lives and works, and to provide an inadequate account of the scale and persistence of this tradition into the present day, then increasingly the acid-test of craft-industrial education and performance in Britain today consists of cold economic indicators such as graduate employability and self-employment amongst Art & Design graduates; small business development; and economic regeneration in traditional manufacturing sectors.

Of course, these indicators do provide important baseline perspectives in which the body of new work in glass exhibited here can be viewed. The crafts are now accepted as an important sector in the UK small business economy. In the 1993 Crafts Council Survey the estimated turnover for craftspeople was in the order of £400 millions, and this turnover may have grown significantly over the last seven years.

All of the work on show here represents the established professional practice of artists, designers and designer-makers at some time connected, as students, researchers, lecturers or visiting lecturers, to the Glass Subject at the University of Wolverhampton School of Art & Design, with which the former Stourbridge Glass Course amalgamated in 1989.

The exhibition also occurs at a time when international collaboration at Wolverhampton, and specifically links developed since 1996 with colleagues at Shanghai University College of Fine Arts, has reached a point of early fruition.

As the selected output of an individual subject within single School of Art & Design, this work provides a unique case study in which the exhibition, and the catalogue essays and entries which follow, evidence a number of separate theses:

• locating the work in question within an identifiable tradition, commonly referred to as the William Morris tradition: that of the Arts & Crafts movement and 20th century developments which followed

• identifying the role of higher education in the British craft renaissance since the late 1960s, and the contribution of art & design graduates to small business development and economic regeneration in the craft-industrial sector

• providing new opportunities for academic and commercial collaboration in glass design and development internationally

This exhibition marks, not the end of something, but very much a beginning, and so I have an opportunity to record, for the second time in this introduction, a new sense of personal privilege: the privilege of being involved.

**Glass Routes**

A silica variant on the silk road, Glass Routes together with its accompanying symposium Creative Pathways charts the migration, across four decades, of working horizons in contemporary glass, and of glass education in our time – movement arising both within, and at the intersection of, very distinctive individual paths. Necessarily so, for, as it is written in the Dao, the road that can be followed is not the true way.

Perhaps all pathways, and most certainly creative ones, are pathways only in retrospect, untraceable until once they have been trodden, apparent only in the irresistible delusion of hindsight, therefore – and not the uncertain, occasionally wayward or transgressive matter of breaking new ground.

I recall in 1995 volunteering to participate in British Council education fairs in southern China on the basis that I could skip the shopping in Hong Kong and spend three days between fairs in Shanghai. When Vaughan Grylls, my predecessor as Dean of Art & Design at Wolverhampton, asked me why, exactly, I replied in all honestly that I didn't know, except that my intuition told me there was something important to connect with there.

This may have been the same week that I had to inform him that Charlotte de Syllas, someone he did not know but who had been working in the Glass department for some weeks on fine-casting techniques, who had absolutely no formal status within the institution and was not only therefore not insured but de facto in breach of School health & safety procedure, had just won the Jerwood Prize for Jewellery.

Vaughan's encouragement and support helped speed our work in China where procedural inertia might have slowed or damaged initial confidence.

What interests me here – as much, if not more than, the present question of academic and artistic development in glass – is the business of lived experience: as the Danish philosopher, Søren Kierkegaard wrote in his Journal of 1843:

It is perfectly true, as philosophers say, that life must be understood backwards. But they forget the other proposition:

it must be lived forwards.

By this business of lived experience I mean performative questions of human culture, community, ideas, identity and ecology, and the fragile moments in time when such histories are either acquired or lost. In an age littered with digital fingerprints – so-called because so much of human identity still proceeds by touch – I am interested in the kinds of identity that may indeed be lost, but can't be stolen.

My imagination lights up before the not yet: in those moments where the path (to labour the metaphor a little further) is as yet indiscernible; where there is perhaps nothing more to be intuited than a feint forward echo, a sense of beckoning, or direction, or simply the urge to move. That restless instinct by which we migrate to a new place, cross over the inevitable terrain stretching outward between here and there. Because the difference between something happening or not happening is sometimes very slight: a difference usually involving some kind of extraordinary human commitment.

This might appear a useful if abstract philosophical backdrop, framing legitimate concerns however regarding the present vulnerability of arteducation in the West, and of craft education in particular. By way of timely reminder, however, the symposium, Creative Pathways, and this exhibition, Glass Routes, both of which have been devised and curated by Stuart Garfoot, chart in some detail just such a moment in present time.

They concern the various individual creative pathways of leading glass practitioners, and seek to outline the journey undertaken by the glass community linked to Wolverhampton (and formerly to the glass course at Stourbridge College) over the last forty years. The show aims pragmatically to be illustrative where it could not hope to provide a comprehensive exhibition of more than a generation of work.

These linked events helpfully extend and update an earlier initiative, the ground-breaking New Glass Economy exhibition that in July 1999 took thirty years of 'glass at Wolverhampton' to Shanghai, showing in the UK later that year at the University of Hertfordshire's Atrium Gallery.

Curated by Sarah Bowler, that event was marked by the unveiling of Bamboo Scroll, a three metre high, 1.75 tonne sculptural work in steel and glass crystal commissioned from Colin Reid and installed as a permanent feature of the main entrance hall of the new Shanghai Public Library in the year of its opening.

As a project, Bamboo Scroll had taken some three years to negotiate, and became the most visible public icon of our collaborative partnership.

The concept took as its point of departure ancient Chinese literary artefacts, namely engraved bamboo strips bound together and forming a kind of flexible scroll. The brief was I believe unconsciously informed by the bamboo scaffolding which seemed to fill the library when I first visited it as a building site in April 1996. Chinese written characters are incorporated in cast optical crystal blocks in raised and polished relief, providing cursive transparent windows into the light medium. The glass is held in a parallel ribbon structure of flame-cut and patinated steel.

The Chinese characters derive from engraved print originals, reversed out in raised relief through the mould making process, and they comprise a loosely ordered series representing elemental natural and human qualities. This was not a text as such - there is no woven narrative connection between the word sequence - but the layered disposition of Chinese written characters had clearly influenced the overall composition of the piece. This was Reid's first engagement with written symbols as 'found objects', and it is the visual energy of these characters rather than their linguistic meaning, that stands foremost. Physically and metaphorically speaking, the characters hang luminous and illuminated in broad daylight. A work in which material preceded meaning, and making came before knowing.

Reid's attention to the site of this work, his response to the library as a location, its cultural purpose, the eventual elevation of the installation against a great curtain of daylight, and the central well space of the entrance hall, characterise his technique of invention. A technique that travels light, wears its learning lightly, and resulted in a major work which drew deftly upon two cultures, winning immediate acceptance in both.

In the hot course of ten July days, New Glass Economy drew more than eighteen thousand visitors (before the attendants stopped their head-count), such was the curiosity and appetite for this strange new work. Were we sure, I was asked at a public seminar, that everything in the show was made of glass?

New Glass Economy evidenced the fundamental significance and substantive rôle of British art schools in developing the studio glass economy that replaced the declining UK handmade manufacturing tradition over the last four decades of the twentieth century.

In the introductory essay to the published catalogue for New Glass Economy, I had included an aside which on that occasion did not survive Sara's disapproving editorial knife, but which I trust she will forgive me for restoring here. The note made reference to the decade I worked in the glass crystal industry ('sounds like your own private Cultural Revolution?' my Shanghai colleague Pan Yaochang once enquired with the lightest touch of mischief).

I had likened the awareness of my historical moment in Stourbridge – my glasshouse experience – to that of the nineteenth-century American writer, Herman Melville, whose masterpiece Moby Dick; or, The Whale (1850) can be read as a sustained elegy to the human culture of the Nantucket whaling industry before the advent of new technology, in the form of the mechanical harpoon, that destroyed it. In what was still called 'the new world' Melville both lived and wrote its passing, the fragile human ecology of which is encrypted in his naming the fictive whaleboat The Pequod after an extinct Native American tribe
.

My analogous experience – as Glasshouse, and eventually Production Manager at Stuart Crystal – struck me as precisely such a moment. Just as the heavy nostalgia of an exact replica of the cut crystal captain's bowl from the White Star transatlantic liner, Titanic, proved a rather compelling exhibit for Shanghai teenagers in the exhibition that opened just as (in a coincidence that simply could not have been scripted two years previously!) Kate Winslett and Leonardo di Caprio premièred in the Shanghai screening of, well, that film.

Within three years of New Glass Economy, glassmaking at the Redhouse Glassworks (built in 1776) and at the Stuart Crystal factory at the White House glassworks next door, had folded with the closure of the site in March 2002.

The Shanghai projects grew out of a close collaboration that began in January 1996 between the glass program at Wolverhampton, where it was my privilege to succeed Keith Cummings as course leader in 1994, and the College of Fine Arts at Shanghai University. Before long, a similar link was forged with Tsinghua University in Beijing, a program that benefited from the generosity of the glass artist Yang Hui-Shan and her production company Liuligongfang, by far the most significant and innovative brand in contemporary Chinese glass.

These initiatives were preceded by the collaborative development of an academic glass facility and programme at Technikon Pretoria (now Tshwane University of Technology) in the Republic of South Africa, with very significant industrial sponsorship from Consol Glass that we were instrumental in negotiating over two days in Pretoria. Together with industry linkage, subsequently identified by the Design Council as a case study in good practice and featured in the 2003 final report of the British government's Lambert Review of Business-University Collaboration, the glass program at Wolverhampton was keen to prove that our developing identity would be defined more by where we set the horizon, than where we place the boundary.

The collaboration with Shanghai University developed as a long-term vision: involving research; public art projects; the construction of new glass curricula and facilities in China; industry linkage; and curated shows. It worked effectively for many reasons, not least because of the extraordinary energy of the partnership with my colleague Professor Wang Dawei at the College of Fine Arts, and also the exceptional understanding and commitment of my colleague Ida Wong (1962 – 2008), to whose memory the symposium and exhibition are dedicated following her tragic death, after long illness, in March this year.

At a time when British universities were chasing short-term student recruitment targets, we had all the confidence of youth to plan a thirty-year project that would establish a new generation of glass artists in China, and a new kind of creative and academic dialogue and community across and beyond our respective cultures.

That project is still only twelve years old, and Glass Routes offers an interesting opportunity to observe its development to date.

Two significant features of this show chart firstly the creative legacy of Keith Cummings, as an artist and teacher, over four decades; and secondly new development in contemporary Chinese glass, in the work from Shanghai and Tsinghua universities, whose department heads, Zhuang Xiaowei and Guan Donghai – already established artists in their own fields – took Masters programs in glass at Wolverhampton.

Glass Routes is configured in three rooms, preceded by an ante-room exhibiting research projects at Wolverhampton, including work by Gillian Burdett and Xue Lu, and Max Stewart's research on Amalric Walter. Keith Cummings' influence on research in Art & Design at Wolverhampton is, to my mind,

inestimable and far-reaching, as these three very different projects prove by virtue of the range and depth of inquiry into glass as both material and application over many years.

In the first room, Cummings' own work shows alongside that of significant artists, such as: the late George Elliott, the German artist Gerhard Ribke (a fellow student at the Royal College of Art); and also established artists who were Keith's students at Stourbridge, such as Maureen Cahill (Australia), David Reekie and Colin Reid.

The second room opens up an extraordinarily diverse range of glass artefacts in jewellery, architecture, textile, product, installation and craft applications, all in their various individual ways deriving something distinctive, a shade or influence, from the enormous generosity of Cummings' teaching. There are direct parallels between the Wolverhampton and this year's British Glass Biennale – for example I would point to work by Catherine Hough, Ruth Spaak and Vanessa Cutler, and by Joanna Manousis, a very recent (2007) Wolverhampton graduate, in particular.

The third room is dedicated to contemporary work from Shanghai and Beijing – work that continues to register and redefine both the international reach and influence of glass at Wolverhampton and the extraordinary generosity of Keith Cummings' achievement in teaching and research, and as an artist and an author, in particular.

Guan Donghai's exemplary work gives a flavour of this. City Gates – his first solo glass sculpture exhibition at Gaffer Studio Glass, Hong Kong, in 2006 marked, in itself, a important threshold in his work, and witnessed his extraordinarily rapid development as a contemporary glass artist: from his first engagement with the material of glass hardly seven years ago, to the distinguished and original body of work then showing.

That the theme of Guan Donghai's first solo show should have been one of 'gateways' and 'thresholds', as points of entry and exclusion,came as no surprise. In the wider international context of contemporary glass art, these were works that withstood as much as they contained. The gate pieces are portals or door spaces whose absent frames span thresholds both admitting us to a distinctively Chinese contemporary glass domain, and resisting everything which is merely derivative of 'elsewhere'. The imagined civic dimension to these objects, artefacts that otherwise function essentially on a domestic scale, is also notable – in the absent form of the vanished or metonymic 'invisible cities' to which these gates preclude our admission.

That Guan Donghai's city gates lock the intruder without, and the mystery within, seems fitting - in cultural terms invoking ideas of power, protection, seclusion, isolation. They explore practical notions of limit, including the self-imposed confinement or limitation to a rough suite of simple glass forming processes. But these are modern artefacts, albeit inscrutable as the past, offering playful resistance to received ideas or hack journalese perspectives on China, ancient and modern.

The coarse rendering of the glass fabric seems also fitting – these are raw sand- and kiln-cast forms that display, however, highly developed surface and colour sensibilities. Guan Donghai works here for a finished quality that he calls 'unsophisticated' but which in fact betrays, beyond his intensive engagement with glass technique, a sustained artistic and technical formation in textile design, watercolour painting, and touch-perfect draughtsmanship that practically guarantees such qualities.

The gates are variously studded and chequered with squared and rounded bosses, they involve occasional galleries, windows, archways and doors. Their forms are as contained as carved stamps, or the grid squares in which children practice writing characters in the Chinese world. From time to time archaic heads within the gate form confront the viewer – are those figures sentries, or severed trophies, betokening vigilance or warning? These are works that require no explicit narrative, whose significance is tacit, implicit, and whose condition appears to rest sufficient unto itself.

The forms of the Weapon Series similarly take their bronze and jade ceremonial antecedents into a new architectural order – as scaled-down, intimate models of potentially monumental forms that continue employ the mould-casting and cold abrasive technologies that gave form to their ancient precedents. They appear monumental in the sense both of their significance and intensity, and in the memorial sense – playful by turns – that marks the idea of a lost civilisation or the bright technical evidence of some obscure though highly developed ritual and craft culture. At the same time, it is clear that the works concerned are not merely derivative of some shallow process of cultural archaeology or historical appropriation, for these intensely tactile, textured and chromatic objects are to my mind haunted by a kind of creative ambivalence.

That ambivalence, if such it is, might appear inseparable from two related biographical details: that 1966, the year of Guan Donghai's birth, in Mudanjiang (Heilongjian Province, in North East China), was also the year in which Mao Zedong launched, on May 16th, the Great Proletarian Cultural Revolution (1966–1976); and that – as a detail picked out in his short brochure note to the Gaffer Studio Glass artists catalogue bore witness – as a five-year-old, he took primary school pride in having been with his father to Tiananmen Square in Beijing. To the gate of heavenly peace.

And so the child of the cultural revolution has become the artist whose fresh glass œuvre recalls and re-works, in a contemporary idiom, past forms, past references, formal research, deriving from antique jade, bronze or stone artefacts, and the ritual, military and craft cultures from which they trace their formal genealogies. Objects and practices which, throughout that traumatic decade, the makers of the cultural revolution attempted to consign to the waste-skip of imperial history.

The gate and weapon pieces seem monumental also insofar as any figurative human element is always held subservient, in scale and definition, as a small architectural detail of the broader design. For instance, in the disembodied head motif that figures as antique human presence, a windowed inlet within the sword blade section (for example Weapon Series, #1 and #2). Or in Régime, a glass rail cast from a length of H-section steel girder, onto which are threaded cast head-forms in semi-opaque glass, complete with top-knots, their identical faces stained with red, blue, white and black oxide pigments.

Each head is bonded at the neck to a horizontal C-section runner in opaque pâte-de-verre, locked in serried rank like vitreous commuter counterparts, for the machine-age, of the terracotta warriors at Xian. It is interesting to compare this approach to figuration with the work of the English glass artist, David Reekie, another brilliant draughtsman, with whose work Guan may be familiar. In both cases, we witness precision, formal elegance, subversive humour, cryptic games, the stark portrayal of the human condition, with all the terse immediacy of a newspaper cartoon or an epigram. But in Régime, for example, every trace of the individual drama that Reekie characteristically explores is expunged, and a different kind of political sensibility shows itself as an unblinking preoccupation with the forms of power. I look forward to the new direction this single work may inaugurate.

Guan Donghai's sculptural 'language' involves a high degree of plastic imagination, careful attention to surface qualities, a rich chromatic sensibility, technical mastery, and a keenly observant sense of Chinese artisan tradition in terms of architectural detail, and ancient techniques of bronze and jade manufacture. It can be playful, capable of humour or political nuance, and is confident, measured and contained.

Guan Donghai's work is exemplary in both senses of that word, but in similar terms, all of the new glass from Shanghai and Beijing can speak for itself, in its own idiom, and bears the first remarkable fruit of a collaboration that I trust and believe will continue to evolve for many years to come.

**An Age of Glass**

If the history of human ingenuity has so far undergone a Stone Age, a Bronze Age, and an Iron Age, then perhaps our new millennium is the Age of Glass.

After five thousand years of human use, glass as a material has truly come of age. Arguably, glass was our first synthetic material, a material bristling with contradictory qualities. Glass is tough, and it is fragile. It can be both soft and brittle, rough-textured and polished smooth, transparent and opaque. It is by turns a solid, and a liquid.

We shelter within glass structures that admit, filter, mirror, refract and reflect light. These versatile glass skins of our new built environment wrap us safely in the domestic, public and corporate interiors we live and work in, protecting us from extremes of weather, providing us with openness and privacy as we desire.

Glass re-defines the correspondence between our 'inside' and 'outside' environments. Increasingly, we observe our world through glass lenses, and project our world on glass screens. We preserve foods and wines, and rich perfumes in glass containers, and we eat and drink from glass vessels. Glass can be so tough that it can stop a bullet in mid-flight, or so delicate as to assist in the most sophisticated keyhole surgery. Glass fibres now conduct an information superhighway around the world. Through glass we illuminate our lives, physically and metaphorically.

Glass seems to re-invent itself from generation to generation, and in our own time the artists showing here in the Mitsukoshi International Glass Arts Festival in Taiwan, 2002, are re-inventing glass in new and expressive ways. The works in glass assembled here take us deep into the imaginative possibilities of this astonishing material. It is their turn, and every single item in this exhibition is in a very real sense an object of wonder.

## Antoine Leperlier

Keynote essay in the catalogue monograph accompanying a retrospective of Leperlier's work, over four decades, at the Musée National de la Céramique Sèvres (Paris), March 2007 (text in French and English). No other contemporary glass artist has been recognised with a retrospective at a French national museum.

As a contribution to knowledge and understanding of contemporary glass, the essay explores the formative imaginal and cognitive dimensions of glass as a material, and the physicality of production techniques and processes, in Leperlier's evolving and embodied poetics of making. It challenges accepted concepts of the relationship between idea and work in contemporary object-centred 'applied' art, and seeks to extend the scope of writing on contemporary glass in relation to Western philosophy, and to other artforms.

This essay was commissioned as an extended version of a single-authored catalogue*, Antoine Leperlier (Paris/Nançay, Editions Galerie Capazza, 2006) ISBN 2-915241-22-8 (text in French and English), and grew out of a dialogic relationship between writer and artist. A further commission was invited by the editor of Neues Glas as a review, "Antoine Leperlier at the Musée de Sèvres" (Neues Glas/New Glass (1/07), text in German and English). The essay draws upon thinking originated earlier by Brewerton in 'Touching the Void', regarding concepts of positive and negative space (being and nothingness) with reference to Heidegger, Daoism, and lost-wax casting in glass (FORM No. 1, December 2004 (Perth, Western Australia)).

Antoine Leperlier: tralucentes novi liquores fluxisse

I think perhaps ideas are permanent. You know, the way they get handed down…

Richard Long

Le tableau est fini quand il a effacé l'idée.

Georges Braque

At face value, the very welcome invitation to write on the recent work of my friend Antoine Leperlier posed an acute dilemma: what could I possibly add to the existing record of published (if untimely!) positions , by this most thoughtful and articulate of contemporary glass artists, that would neither tamely rehearse an open narrative already rich in ideas and preoccupations, nor quickly prove a tedious distraction from the work itself?

For even the most glancing engagement with the work of Antoine Leperlier soon finds itself involved in a paradox – namely that the more you try to pin down this disciplined, highly crafted body of glass sculpture with 'ulterior motifs' (in the form of ideas, biography or anecdote) the more resistant it seems to become. The more these works seem to insist upon their material presence and their careful articulation of technical qualities. So, as the twinned epigraphs to this brief essay might suggest: as a writer working in the medium of language, I would like here to explore what can, and cannot, be said of the relationship between work and idea in the glass œuvre of Antoine Leperlier.

The words of Richard Long that comprise our first epigraph came as a risposte to a question from the audience, following a public lecture he shared with fellow 'land artist' Chris Drury at Dartington in October 2005. The question had been something like: "what, if anything, would you say is permanent in art?" and Long's sudden, concise, almost lapidary answer seemed to cut through Drury's more laboured response in mid-flow.

I wanted to ask whether, given his long-standing engagement with geometric phenomena such as circles and lines, Long had meant 'ideas' in the philosophical sense of platonic 'forms', or something quite different. I wanted to hold onto that moment – go further into the thought – but the instant had already passed and the stream of questioning had moved on.

My purpose in invoking Richard Long is that this anecdote neatly prefaces, or gives rise to, a number of identifiable themes or antitheses in the work of Antoine Leperlier: ideas of permanence versus flux; of the nature of the temporal moment, and its passing, in the flow of time; of structural artistic form, and the significance or authenticity of marks or gestures made in resistant material; of the resonance of ideas, of memory; and – finally – of the human condition of mortality, the persistence of form, and the mute desperation of irrevocable loss.

Manifestly so, as this exhibition makes clear – these sculptural artefacts do not appear as the mere consequence of ideas. Their purpose is very far from illustrative. Their relationship to the universe of ideas is complex, and – paradoxically for an artist so preoccupied with the material trace of language in its historical, printed form – highly resistant to verbal or theoretical reduction. These are works that so occupy their own unique and fluid moment, that they preclude any possibility of repetition (of replication in any medium: whether glass, language or idea) in time.

We step and we do not step into the same rivers; we are and we are not.

This pre-Socratic notion of universal flux, and of the nature of our being in time, surfaces on three occasions in the philosophical Fragments of the philosopher Heraclitus. Fragment 91a? [91b] reads:

[For, according to Heraclitus, it is not possible to step twice into the same river, nor is it possible to touch a mortal substance twice in so far as its state (hexis) is concerned. But, thanks to ‹the› swiftness and speed of change,] it scatters ‹things?› and brings ‹them?› together again, [(or, rather, it brings together and lets go neither 'again' nor 'later' but simultaneously)], ‹it› forms and ‹it› dissolves, and ‹it› approaches and departs.

So how might it be that ideas as such, and ideas such as this one, find their way into the work of Antoine Leperlier? Or, more accurately – because making always comes before knowing – how does the artist's material intelligence and making method (or poetics) operate as a distinctive mode of perception and as a way of thinking about the world? And what is it that can, and cannot be said, in language, in these terms?

In the case of Leperlier, this tensile counterpoint in time of forces both physical and mental – the pressure of containment and flux – is already a kind of accidental treatise on the nature of his chosen medium, the 'unknown translucent liquid' that flowed (tralucentes novi liquores fluxisse) in the record of whose origin we find in the Natural History of Pliny the Elder:

In the part of Syria adjoining Judea and Phoenicia the Candebia swamp is bounded by Mount Carmel. This is believed to be the source of the river Belus, which after five miles runs into the sea near Ptolemais. On the shores of the River Belus the sand is revealed only when the tides retreat. This sand does not glisten until it has been tossed about by the waves and had its impurities removed by the sea…. A ship belonging to traders in soda once called here, so the story goes, and they spread out along the shore to make a meal. There were no stones to support their cooking-pots, so they placed lumps of soda from their ship under them. When these became hot and fused with the sand on the beach, streams of an unknown liquid flowed, and this was the origin of glass.

So, in its metastable and disordered state, is glass a liquid, or a solid? And why might this ambiguous condition matter to an artist such as Antoine Leperlier?

There is no clear answer to the question "Is glass solid or liquid?" In terms of molecular dynamics and thermodynamics it is possible to justify various different views that it is a highly viscous liquid, an amorphous solid, or simply that glass is another state of matter which is neither liquid nor solid.

In terms of molecular physics, glass is technically distinguished from crystalline solid and from liquid states in that glass molecules configure in a disordered but rigidly bound arrangement, sharing properties of both liquid (although firmly bound) and solid (although lacking a regular lattice form). Indeed glass, Leperlier's preferred medium, is characterised by its viscosity – viscosity being defined as the degree of resistance to flow, whose unit of measurement is poise.

In its behaviour, as a state of physical matter, glass may be held to embody the contrasting philosophical dynamics of Heraclitus (liquid, flux) and Parmenides (solid, permanence, containment) inherent in early Greek philosophy, an enduring interest of Antoine Leperlier since his student days in Paris at the Sorbonne, where he studied Philosophy and Sculpture. The relationship between idea and material is one of open potentiality, a form of meditative substance or imaginative technology. But his material is, of course, in itself no more illustrative of pre-Socratic thought than were these philosophers concerned to describe or define the nature of glass.

Leperlier's apprenticeship in pâte de verre began in 1968, under the eye of his grandfather, François Décorchemont, although it was not until ten years later that he began his own technical research following a period of intensive archival work on Décorchemont's papers. He has exhibited internationally since 1982, is represented in thirty major international glass collections, and won a number of international awards. He was shortlisted for the Bombay Sapphire Prize in 2005.

Leperlier has developed a distinctive, classical vocabulary of sculptural forms or motifs, constructed three-dimensional tableaux exploring the plastic forms of box, step, arch, throne, cabinet, pyramid, book, stele, cup, frame, occupied occasionally by animal or human figures. Flayed and leaping hares; a small shoal of fish; a renaissance medical diagram of a man. Turtles, for longevity. By 'classical' I mean that Cézanne's geometric preference for 'the cylinder, the sphere and the cone' , squares circles and triangles, has provided a subliminal geometry for Leperlier's work since his very early adaptation of organic forms as an overarching schema (in, for example, [030] (198X?) and [034] (198X?)). Works such as 2051109 (2005) and 2030120 (2003, shortlisted for the Bombay Sapphire Prize) appear to compress an entire cosmography – the primitive play of chaos and cosmos, marked by a language of infinite repetition – in which the ambiguity of the viewer's condition (cosmic perhaps, chaotic most probably) is contained. Shards of fragmented material stud and embed an opaque cube from which an engraved sphere emerges into a square, ordered tile of its own element.

Leperlier thinks with and through the intrinsic properties of glass as an artistic medium – arguably the first synthetic material in human culture – exploring the raw phenomenology of its substance in ways that open or fold-in new possibilities of meaning. His method is to work primarily with complex casting techniques, that combine at various stages with a range of surface applications and finishing processes. The resulting artefact arrives at a structured equilibrium involving formal tension between the internal and external dimensions of the three-dimensional glass medium. The work articulates diverse qualities of transparency, translucence and opaqueness; suspends lucid interior veils, texts and perspectives; makes play with textured and polished surfaces; and concentrates or refracts body colour in various densities.

These complex tensions are displayed and contained at the object surface, at its edge limit. As Andrew Graham-Dixon remarks, on the subject of 'frames' in the work of the English painter Howard Hodgkin:

Sculptors have always understood the importance of edges, which define precisely how form contains space….a painting's edge is its most vulnerable point. It is where the work of art ends and the world begins. It is where the painting completes itself or, conversely, declares its incompletion. It is where the painting…negotiates with its limits. The edge of the painting is where the artist makes his own entrances and exits. It is the mark of his competence and confidence, his control or lack of it. Paintings succeed or fail at their edges.

Leperlier's recent works such as Still alive/Fleuve stéle I (2005) and Vanité au repos II/Fleuve stéle (2006) render the figure of the 'frame' structure transparent and fluid, its physical equilibrium and presence a deliberate viscous moment poised somewhere between containment and flux. Poise as the balance of form and idea, and as the unit of dynamic viscosity as a degree of resistance to flow. The disordered lettering of 'fleuve' and 'stéle' as FSLTEE/ULVEE – the synthetic words streaming away with their feminine word-endings – registers a displaced and confused inscription of the opposing motifs of river and stone tablet, flux and fixture.

These pieces invoke strong classical references in the figure of the human skull (vanitas), and the congealed cascade of opaque, discoloured fruit, in an acid cocktail of bitter irony and technical perfection. Language, as inscription, is a contributing element here, with the euphemism of 'au repos' (at rest) at the same time both offering and withdrawing comfort or respite in the form of death. And the English term 'still life' is rendered ironically as 'still alive', thereby haunted by the shadowy French term 'nature mort'. As such, the works embody a kind of luminous preoccupation with mortality – the unavoidable attrition of time, the inevitability of physical decay, and the corresponding resistance of art, memory, and humour.

Recurrent engagement with the place of memory, remembrance, mortality and the unrepeatable authenticity of the moment in time, is not exactly unique to Antoine Leperlier. What is unusual is the intensity of his preoccupation with material qualities, and the distinctive way that technical execution allows a highly tactile aesthetic sensibility to take the imprint of the idea in the moment that it acquires form. As an approach to memory, this could not be more different from that of Howard Hodgkin, of whose early canvas, Memoir, which he painted at the age of 17, Colm Toíbín wrote:

'Memoirs' contained the elements that would interest him for more than 50 years. The overriding impulse to make the painting comes from memory and the emotion that memory can carry. The event remembered for him as a painter is more productive of serious, refined and complex emotion than the event experienced….

In stark contrast, for Leperlier the event remembered certainly does not appear to exceed the event experienced. Memory is rather a mortal condition, subject to irresistible flux and decay, the acute consciousness and despair of unrecoverable loss. His is a philosophical lament reaching deeply beyond any sense of personal loss or private memoir, having at its heart a regard for the nature of the passing moment, the authentic instant in time. In this, the viscosity of his plastic intelligence – its resistance to flow – shows itself as a kind of melancholy, lingering over the authentic mark or signature trace of the very moment in its passing. This involves not only a kind of memorial sensibility, but also a distinctive application of the glass casting technique – which takes the accurate transfer of every trace, mark, imprint and texture of a given surface, and renders it as fine relief on a fixed glass form, a little less subject to the depredations of time.

Two extraordinary examples of this complex transference occur in [2030211 Vase deux anses (?)] (2003) and a series of works including [931109A] (1993) and [941004B] (1994). In [2030211 Vase deux anses (?)], the figure of a lizard rests vertically against the etched relief of a textual fragment, enlarged and unreadable, and these animal and literary figures are suspended within a solid urn form equipped with non-functional ringed handles set below the centre of gravity of the vase. Under mild interrogation , the artist reveals that this text was taken from the oldest book he knew at first hand – a 1559 Latin edition of Sebastian Münster's Cosmographia (first published in German in 1544) owned by his grandfather, François Décorchemont.

This shred of text was hand-transferred by an industrial engraver, and acid-etched deep into a thick zinc plate. A rubber mould was taken from the etched plate and, from this, a plaster model taken. A definitive plaster model was then made as a composite, incorporating a second plaster positive in the form of the lizard.

This figure had a similarly complex history. Leperlier's friend and fellow artist, Bernard Dejonghe, had found the dead creature and set it in plaster, exposing the underside, which he then left in an anthill to be eaten clean. A rubber print was taken from the emptied mould negative, and sent as a gift to Leperlier, arriving like a fully-formed component of a latent idea.

From the plaster lizard/text composite, a final rubber negative was taken, from which a wax model was finally cast in refractory plaster, for the glass to be then kiln-formed through the lost-wax technique.

It is clear that Leperlier allowed himself no short-cuts as the successive stages of this unreasonably laborious process unfolded, moving between positive and negative forms, or being and non-being , as three-dimensional prints, from figure to mould and back again. It is as if the immediate labour-saving convenience of, for example, photographic screens and sand-engraving was disregarded in order to protect something that might recall Richard Long's sense of permanence of ideas as something that is 'handed-down', a phrase that in English implies contact. This is an intelligence that proceeds by touch.

In this case, the permanence or direct genealogy of the mark seems authenticated by immediate physical contact at each point of technical transfer: the character of the mark arises from this sequence of material impressions, and the steadiness of the hand that guides them. It is a physical trace, and not a digital record, that is so intensely to be worked-for. The sequence involves a kind of thickening of time, an increase in its viscosity, as each protracted process serves its required duration. Even so, however painstaking, every stage still incurs a barely noticeable degree of alteration, some slight loss of definition each time – as is surely the case with memory.

The little turtle figures in the series of pieces including [931109A] (1993) and [941004B] (1994) are if anything a more personal, more concentrated example of this line of thought, exemplars of a kind of 'mindful form'. The original turtles – of the tiny kind that can still be bought as dried specimens in traditional medicine shops in the far east today – had been brought from Libya by Leperlier's great-uncle, and as a boy he remembered them sitting upon his grandfather's old radio. It was this memory that drove him to make these pieces. Leperlier says that it was his sister's discovery of precisely those figures that made this possible – the implication being that no other specimens, however similar, would have served his purpose. Once again, the little glass

figures were cast from a wax model made from rubber moulds taken directly from the original figures. This meticulous detail of biography seems at least as significant to this observer as, for example, the more obvious allegorical reading of the turtle as a symbol of strength or longevity. The lizard, too, invites an allegorical reading – in this case dragging its reptilian tail over the printed scrap of human knowledge. And here we encounter a characteristic ambiguity – in this glassy cosmographia, does the vitreous lizard harbour a demonic purpose to steal, or to scorn, the vanity of our earthly wisdom? Or, as a mere accident of natural history, the food of ants, neither of these imaginings?

The artist invites such readings without encouraging any particular interpretation. But the technical element of memorial transfer through the scrupulous moulding and casting processes described above is, for Leperlier, a knowing or deliberate vanitas. For, in the very moment of its replication, the work (travail) also involves a cancellation of the original, its disappearance in time. What emerges is the work (l'oeuvre). In the words of Georges Braque's Cahier that supplied our second epigraph, "Le tableau est fini, quand il a effacé l'idée" ["The painting is finished when it has erased the idea."].

This act of erasure requires a creative transformation – a kind of Heraclitean moment, bringing something new into existence in the form of a work of art in the very instant of loss. The painter Howard Hodgkin reports a similar sense of an ending:

How do you know, I ask him, that a painting is finished? ...His answer seems to me absolutely clear and obvious, but also quite metaphysical and mysterious. A painting is finished, he says, when the subject comes back, when what has caused the painting to be made comes back as an object.

But for Leperlier this awareness – of wholeness or completion of the idea in the object – attends not only the act of finishing, but also the original moment of inception:

To begin with, every one of my projects arises as a kind of memory in my mind. It is as if I am already familiar with them, at the very moment that they occur in my imagination. Ideas arrive unexpectedly, but with always that unmistakable sense of "déjà vu". As objects, they are already complete within my inner vision. I can view them from all angles. If they show themselves with particular intensity, they are accompanied by the kind of feeling we have when a word that we had been struggling to remember springs suddenly to mind. And in that instant I know that I have to make the work. This feeling returns when I am finishing the piece in glass, and I recognise it immediately, the very moment it arrives.

Between these two occasions of intense, almost involuntary, recognition attending both the genesis and the moment of its completion in a new work, the impression of an idea proceeds by touch in and out of the positive and negative forms invoked by the moulding process, and the viscous glass medium, in time. Work and world both meet and take leave of each other at the physical limit of the resistant object in time, the locus of a continual struggle between permanence and flux, cosmos and chaos, being and nothingness.

For Antoine Leperlier, the work does not imitate, nor can it re-live or repeat the formative experience or idea from which it arose. At best, it is 'handed-down', strangely familiar and equally new. In its turn, the work itself cannot be repeated either – certainly not in descriptive or critical language in time.

We step and we do not step into the same rivers; we are and we are not.

## Ann Wolff

Catalogue essay for 'Betragtninger – Ann Wolff – Observations', a one-person international touring retrospective (4 June 2007 – 6 January 2008) of the German/Swedish glass artist Ann Wolff, curated by Glasmuseet Ebeltoft, Denmark. Text in Danish and English. Exhibition toured from the Glasmuseet Ebeltoft (Denmark) to the National Glass Centre, Sunderland (UK); Glashutte Gernheim (Germany); Finnish Glasmuseum Riihimäki (Finland); Holmegaard Glassworks (Denmark); The Mint Museum, North Carolina (USA); and Stadtmuseum Schleswig (Germany). Reviewed in Neues Glas, American Craft, and Craft Arts International.

A 'deep reading' of Wolff's glass sculpture, invoking Bachelard's 'Poetics of Space' and (inter alia) the choreographer Pina Bausch (whom Wolff observed and drew) that explores the artist's technical and phenomenological approaches to embodiment, and the interplay of surface/skin and body/depth across the internal and external dimensions of a translucent medium. The body as vessel, as house, and as sentient surface is articulated in terms of glass casting and surface finishing processes. This essay (together with that on Leperlier, see citation 2) applies thinking originated by Brewerton in an earlier essay, 'Touching the Void' regarding concepts of positive and negative space (being and nothingness) with reference to Heidegger, Daoism, and lost-wax casting in glass (FORM No. 1, December 2004 (Perth, Western Australia) pp. 2-7. ISSN 1832-388X. This was also published under the author's Chinese name, Bu Huadun, as 'Chu Mo Xu Kong' in Zhuang Shi (Art & Design) No. 145 (Beijing, May 2005) pp. 60-2. ISSN 0412-3662), and delivered as a lecture, 'Something and Nothing: Western Modernism and Negative Space', at the China Academy of Art (Hangzhou) in May 2006, extending the thesis to the work of Rachel Whiteread and James Turrell.

Stair Spirit: Observations of Ann Wolff

Outside and inside form a dialectic of division, the obvious geometry of which blinds us as soon as we bring it into play in       metaphysical domains. It has the sharpness of the dialectics of yes and no, which decides everything. Unless one is careful, it is  made into a basis of images that govern all thoughts of positive and negative... ...Philosophers, when confronted with outside and  inside, think in terms of being and non-being. Thus profound metaphysics is rooted in an implicit geometry which – whether we will or no – confers spatiality upon thought: if a metaphysician could not draw, what would he think?

This brief essay does not seek to rehearse the excellent and detailed achievement of the quite recent (2002) Raster Förlag monograph on the artist Ann Wolff but as writing takes, rather, the form of a phenomenological engagement or personal encounter. In case, to the casual glance, this kind of close reading could be mistaken for description, I would be wise perhaps from the outset to invoke a characteristically acute observation of Georges Braque:

Ecrire n'est pas décrire. Peindre n'est pas dépeindre.

La vraisemblance n'est que trompe-l'oeil.

['Writing is not describing. Painting is not depicting. Realism is just an illusion.'].

So wilful an approach feels licensed by the powerful and consistent, sometimes visceral, evocation – quite beyond any merely representational intent – that I experience in witness to Ann Wolff's œuvre to date: the evocation of the human body in raw and vital space; of strongly gendered sexuality, and the sensual presence of otherness; of the physical, and metaphysical, dialectics of 'inside' and 'outside' in relation to the body, to materials, and to identity; of faces and surfaces as both open and closed phenomena – as, variously, veils, mirrors, and thresholds; of the corporeal and oneiric dimensions of dwelling and human habitation; and of artistic labour as itself both a thinking process and a mode of being-in-the-world.

My essay involves, however, an act of transgression: a glimpse – unauthorised, beyond the published body of work – of a new piece that has, at the time of writing, not yet entered the public domain. Stair House is an offspring, as it were, that hasn't left home yet, biding its time still in the domestic – one is tempted to say maternal – sphere of Ann Wolff's Berlin apartment: a work with which I became closely acquainted in the varying winter light of a few days in January, this year. It relates formally to two pieces in this Observations retrospective: Ball House II, and III (2004); and also, in my view, to earlier works such as Goddess (2002) and Femme (1999) that also appear here.

Stair House is a work of concentrated, primitive power: a cast block of amethyst crystal on an oblong plan rising to an apex across two ground-and-polished diagonal planes suggesting the raised pitch of a transparent or absent roof. The solid glass medium is inset with a regular stepped form – the rough figure of a stair in negative space.

Viewed from above, this void appears of substance by virtue of a reflex of light off the unbroken skin of its unpolished micro-surface. The stepped elevation refracts, magnifies and bends slightly upward to meet the eye, filling the diagonal window – the transparent glass medium a seeming emptiness, a tinted hollow in the reverse-play of internal and external dimensions. The optical depth of the work becomes shadowy or impenetrable where the mauve colour intensifies and darkens, where it varies in response to external light sources, or where opaque surfaces abruptly arrest the gaze. Just a shade more of manganese in this glass mix, and the balance would be lost.

This deliberate play of presence and absence, of positive and negative space, is by no means just a cerebral exercise – some mere optical game – but extends to the strong relationship this work retains with the missing original of its mould-form, every local impression of which opaquely finger-prints all except the two pitched surfaces, where all mould marks have been ground away.

Quite apart from the coded sexuality of male and female forms implicit within the mould-casting process, these opaque glass textures draw sensual attention to themselves as skin – skin not as a dull wrapper, but as the living interface between 'inside' and 'outside'. A sensitive medium, as the physiologist Luigi Luca Cavalli makes clear:

> El cos es comunica amb l'exterior a través de la seva superficie.
> [The body communicates with the exterior through its skin surface.]

Ann Wolff's technical attention to complex, often veiled or layered, glass surfaces shares this quality of awareness, insistence or recognition of the physiological basis of communication and exchange between inner and outer dimensions of lived experience. Her work explores the body as an open, breathing instrument; a thing of warmth and acoustic resonance; of colour and contour; of inner and outer surfaces, and faces; as the windowed physical form we occupy, animate, gaze out from and, eventually, vacate.

The figure of the house is in this sense an extension of her preoccupation with the human body. It also brings – perhaps to its fullest expression in Ann Wolff's work to date – the theme of human dwelling or habitation as a question both of being, and of our experience of making and perceiving art. What Gaston Bachelard, the source of our epigraph on 'inside' and 'outside' and the spatiality of thought, may have sensed when he remarked that 'a house in an engraving may invite the desire to live in it.'

> The house, quite obviously, is a privileged entity for a phenomenological study of the intimate values of inside space... the house
> furnishes us with dispersed images and a body of images at the same time.

As a kind of parallel reading, or point of reference, Bachelard's book The Poetics of Space (1958) may indeed provide a useful corrective to criticism that has contented itself with the nominal task of listing 'symptomatic' themes in relation to the known features of Ann Wolff's biography. Or that has sought superficially to pigeonhole her creative achievement in terms of 'feminist' or 'domestic' subject material. Or commentary that co-terminates with the rather self-reflexive intellectual horizon of the contemporary glass community today. Ann Wolff's work is, in my view, of a wholly different order than these categories would suggest.

I have no intention, even for a moment here, to underestimate the central significance of lived experience to Wolff's practice. I am, rather, suggesting the essential nature of this experience to be a necessarily private, even solitary, affair. As such it traces a consistent path, rather than an incidental pattern of biographical circumstance.

In this sense Stair House for example – the new work that provides the title of this essay – relates somehow to a favoured photograph of Wolff herself sitting at the top of the short flight of steps that fronts her 1635 farmhouse on Gotland, a place of reflection and of gazing out in breaks between work sessions – facing onto the garden and, immediately beyond this, immensity in the shape of the Baltic Sea. But here my essay risks straying into shallow, descriptive waters, where I'd promised to pursue a more instructive interest in Bachelard:

> ...it is not a question of describing houses, or enumerating their picturesque features...On the contrary, we must go beyond the problem
> of description...in order to attain to the primary virtues, those that reveal an attachment that is native in some way to the primary
> function of inhabiting...In every dwelling, even the richest, the first task of the phenomenologist is to find the original shell.

In Stair House, the figure of the stair does not serve to connect specific points or places within a given structure. What the hollow stair conducts is the pure idea of itself – of stepped levels – by implication, in almost any dimension of human experience. In the simplest possible form, stripped off all incidental detail other than the birthmarks of the mould-casting process, this work conjures a powerful dream-like resonance, and also an impression of intense intimacy:

> Over-picturesqueness in a house can conceal its intimacy. This is also true in life. But it is truer still in daydreams.For the real
> houses of memory, the houses to which we return in dreams, the houses that are rich in unalterable oneirism, do not readily lend
> themselves to description....   ....The first, the onerically definitive house, must retain its shadows. For it belongs to the
> literature of depth, that is, to poetry, and not to the fluent type of literature that, in order to analyse intimacy, needs other
> people's stories.

So, just as this glowing amethyst light polarises in the vertical dimension – shading from brightness downwards into obscurity – so the stair motif conducts an identical polarity of the house where, according to Bachelard, roofs provide 'rational' shelter in polar opposition to the subterranean, dark entity that is the 'irrational' realm of the cellar space. What I called the 'primitive' power of Stair House concentrates and reposes psychological, oneiric or imaginative force within this primary or original sense of shelter: the house imagined 'as a vertical being' where

> Verticality is ensured by the polarity of cellar and attic, the marks of which are so deep that, in a way, they open up two very
> different perspectives for a phenomenology of the imagination.

The stair conducts the possibility of successive, intimate spaces – the cellar, the living room, the bedroom, the attic. It is above all a sheltering space for daydream, reverie, protecting the dreamer: the shell in which thoughts, memories, dreams and desires integrate – the crucible in which identity is formed. Identity which, to Ann Wolff assuredly, insistently so, includes 'the part of you [that] you don't know yet.'

> ...the real beginnings of images, if we study them phenomenologically, will give concrete evidence of the values of inhabited space, of
> the non-I that protects the I.

The phenomenology of levels at work here is both archetypal and intensely personal, as intimate as genetic code:

> ...over and beyond our memories, the house we were born in is physically inscribed in us...After twenty years, in spite of all the other
> anonymous stairways, we would recapture the reflexes of the 'first stairway,' we would not stumble on that rather high step. The

house's entire being would open up, faithful to our own being. We would push the door that creaks with the same gesture, we would find our way in the dark to the distant attic. The feel of the tiniest latch has remained in our hands.

The human body, in its earlier equation with the figure of the house and the close reading of Stair House that has provided the substance of this essay, finds more overt expression throughout Observations, continuing as a powerfully insistent preoccupation of Wolff's work in two dimensions. Frequently this takes portrait form, often doubled, where the gaze back – the look that the figure returns toward the artist or viewer – can be direct, veiled, masked, avoided, distracted or eclipsed.

These heads reflect, to my mind, something considerably more than a cool reflection of dualities, of 'I' and 'not-I', of 'the other' – gendered or otherwise. Of course they bear witness to a continuing preoccupation with oneness and duality, with togetherness and the gendered couple, as the Observations 'stations' attest. But the movement is both intimate and outward: from the body, into some contested dimension in which interior and exterior meaning and identity are the outcome of action or performance, communicated, critically, at the surface.

I am reminded of a remark of Pina Bausch, whose dance company Wolff observed in 1989, who was, remarkably and acutely for a dancer and choreographer, '…not interested in how people move, only in what moves them' – a thought that could almost of itself provide a reading of Wolff's Cologne Suite of large-scale, highly gestural drawings that date from the same year, works so often noted for the controlled violence of their raw, charcoal execution. Even in works noted or characterised for their apparent 'narrative' content – such as the decorated bowl series of the 1980s – the form has always signalled a structural concern with surface and the layering of identity. The glass wall of the vessel, in its translucent depth, provides this 'stepped' three-dimensional possibility, working against the linear narrative movement that declines to conform with the classical rule of sequential time.

This layered compositional interest, close to collage, has surfaced with new vigour in a recent Berlin show, with a series of wall-mounted 'heads' appearing framed by diagonal shadows thrown by metal supports, projecting both the head forms and a reversed linear perspective strongly reminiscent of the 'foreshortened frontal' phase of Italian trecento painting.

This primitive reversal of perspective locates the vanishing point of these orthogonal lines somewhere in the viewer's space – even, at the correct alignment, in the body of the viewer – and not in some imagined distance beyond the picture plane. The fired collage, in a subdued palette of patches and lines and stains and smears from which these faces emerge, engineers a new ambiguity – are we looking in to, or out from, the picture plane? This is the latest expression of the confrontation, enduring and implacable, that we discover in the work of Ann Wolff – perhaps best articulated in one final word from Gaston Bachelard:

Outside and inside are both intimate – they are always ready to be reversed, to exchange their hostility. If there exists a borderline surface between such an inside and outside, this surface is painful on both sides…in this drama of intimate geometry, where should one live?

## In his element: New Work by Kevin Gordon

Wandering along the sandy bay at Thurlestone, here on the South Devonshire coast of England, I picture Kevin Gordon in his element, on the other side of the globe:

Living near the ocean here in West Australia the coast line becomes part of my life, nearly ever day I go to the beach with the dogs… nearly ever day you find something new that is washed up such as shells, bits of coral, seaweed, sea urchin etc, even bits of glass…

Our shared silicon element is a rich environment awash with impurities, pattern, habit, chance and flux – the very conditions that attended the accidental discovery of glass, an 'unknown/extraordinary translucent liquid' that flowed (tralucentes novi liquores fluxisse) according to the Natural History of the roman historian Pliny the Elder:

In the part of Syria adjoining Judea and Phoenicia the Candebia swamp is bounded by Mount Carmel. This is believed to be the source of the river Belus, which after five miles runs into the sea near Ptolemais. On the shores of the River Belus the sand is revealed only when the tides retreat. This sand does not glisten until it has been tossed about by the waves and had its impurities removed by the sea…. A ship belonging to traders in soda once called here, so the story goes, and they spread out along the shore to make a meal. There were no stones to support their cooking-pots, so they placed lumps of soda from their ship under them. When these became hot and fused with the sand on the beach, streams of an unknown liquid flowed, and this was the origin of glass.

Gordon's alertness to the natural and synthetic cycles that characterise his chosen medium – from silica sand (as evolved shell and coral residue) to glass; from raw mineral to artefact to jetsam – has a direct bearing on his new work, as he puts it, 'in effect these works are made up from what they represent'. His words signal a reflexive awareness, and a more involved or implicated approach to artistic representation, than might at first glance appear. A response akin perhaps to that of 'Ishmael', the narrator of Herman Melville's Moby Dick (1851) , reading his whale books through transparent strips of dried isinglass, through 'the skin of the skin' of the whale.

The present show indicates a fresh and distinctive new departure in Kevin Gordon's work, for which I am aware of no direct equivalent in contemporary glass. Indeed it seems to hold more in common with certain historical precedents, and perhaps with late nineteenth century scientific-aesthetic sensibilities including, for example: the extraordinary glass project of Leopold and Rudolph Blaschka (from 1880–1936); the botanical and marine illustrations of Ernst Haeckel's lithographic and autotype prints, published between 1899 and 1904 as Kunstformen der Natur (Artforms of Nature); or Snow Crystals (1931), the Vermont archive of snowflake photography assembled by Wilson A. Bentley (1865–1931) and published in the year of his death. Moby Dick might itself be regarded as a similarly encyclopædic undertaking and, in terms of human ecology, as a sustained elegy for the dying culture of the Nantucket whaling industry with the advent of the mechanical harpoon.

Gordon has cited the 2006 exhibition of the Blaschkas' marine work at Ebeltoft Glasmuseet, The Glass Aquarium as an influence, together with Haeckel (1834–1919) and M.C. Escher (1898–1972). What he shares with such artists is a rapt attention to natural and mathematical form, a fidelity that might look to have skipped a century in the context of European aesthetics.

At their workshop near Dresden, Leopold and Rudolf Blaschka, father and son, made detailed lampwork replicas of botanical and marine forms based on natural history illustrations in books such as Philip Gosse's A Naturalist's Rambles on the Devonshire Coast (1853) , the very shoreline where, as chance would have it, this essay began. The Blaschkas described themselves as 'natural history artisans', and their work was regarded by their contemporaries as 'an artistic marvel in the field of science and a scientific marvel in the field of art'. Their project was driven by the amazing discoveries that followed rapidly upon the development of deep sea diving technology from the mid-1800s, and by the inadequacy of chemical preservation techniques used with organic specimens comprising natural history collections then in scientific vogue. Invertebrate replicas were made for Cornell and other universities, and from 1890 Blaschka glass flowers were produced exclusively for the Botanical Museum at Harvard University (by 1936 they had made some 4,400 glass facsimile

artefacts).

As 'natural history artisans' working purposefully within the faultlines of craftsmanship, art and science (Rudolph (1857–1939) was an exact contemporary of Amalric Walter (1859–1942)), the Blaschkas' achievement would appear altogether remote from the modernist intelligence and formal concerns of the French symboliste poet and essayist Paul Valéry (1871–1945), himself a polymath with keen interests in biology and mathematics:

> Our artists do not derive the material of their works from their own substance, and the form for which they strive springs from a
> specialised application of their mind, which can be completely disengaged from their being.
> Perhaps what we call perfection in art (which all do not strive for and some disdain) is only a sense of desiring or finding in a
> human work the sureness of execution, the inner necessity, the indissoluble bond between form and material that are revealed to us
> by the humblest of shells.

But Valéry's idea may prove as significant in consideration of Kevin Gordon's glass marine forms, insofar as a laboured aesthetic of technical perfection – a quality that might be identified and appreciated as a kind of 'inevitability' of material form in the eventual object – appears very much at work here, with due regard for that reflexive modernist, latterly postmodernist, 'disengagement' of mind and being.

Gordon's highly finished pieces invite precisely the kind of wonder identified by the French philosopher Gaston Bachelard (1884–1962), in the opening to chapter five of La poétique de l'espace (1958), which he devoted to Paul Valéry's meditation on shells:

> For this poet, a shell seems to have been a truth of well solidified animal geometry, and therefore "clear and distinct"…the
> created object itself is highly intelligible; and it is the formation, not the form, that remains mysterious…

Or again, closer to home perhaps, if not nearer the knuckle:

> …a shell carved by a man would be obtained from the outside, through a series of innumerable acts that would bear the mark of a
> touched-up beauty; whereas "the mollusc exudes its shell", it lets the building material "seep through", "distil its marvellous
> covering as needed"….In this way Valéry returns to the mystery of form-giving life, the mystery of slow, continuous formation.

To my mind, Kevin Gordon creates luminous objects of extreme surface precision that function and perform in exactly this contested space: sculptural glass objects that establish a stilled, though animated and refractive, ocean presence on a domestic interior scale. They invite technical amazement at both form and formation, and open curiosity as to their interior material purposes. They play with the inherent ambiguities of the transparent medium, and their exterior glamour is if anything a barrier to meditation on the metamorphosis and intimate detail of the urchin, coral, fan or shell forms from which they are derived through 'a specialised application' of the mind, ultimately 'disengaged' from its being.

As glass artefacts, not lived organic vessels of marine life, in representational terms these works are neither illustrations, scientific or otherwise, nor feats of illusion or trompe l'oeil. Their glassy differentiation, their 'objectness' in the phenomenal world, 'obtained from the outside', looks and feels however by turns either an intrinsic skin quality, or the worn scar tissue of hard-shelled resistance to lengthy environmental attrition.

The cutting edge makes contact, proves and reveals the familiar otherness of the material in another theory, almost contiguous with Paul Valéry's antithesis of exuded and carved form. Unlike modelling, for the English art theorist Adrian Stokes (1902–1972), writing under the influence of Kleinian analysis, carving is thus a process of formal and psychological disclosure, acknowledging and affirming the object's separation.

In terms of the material of glass, both aspects of Valéry's idea offer useful insights into Kevin Gordon's technique, in which the building material of liquid glass – shaped by David Hay's expert guiding hand – does indeed 'seep through', slowly yielding or exuding its outer surface, which then cools to a translucent, shell-like exterior that then contains the still–liquid form. The transparent vitreous medium opens windows on a further, interior dimension, at complete variance with the natural opacity of sea urchins.

On the other hand, each work is a 'specialised application of the mind', that is to say a work of acquired craftsmanship and intentional design, a distinction of which Valéry was most perceptively aware:

> ….the making of a shell is lived, not calculated: nothing could be more contrary to our organised action preceded by an aim and
> operating as a cause.

Gordon's application of a wide range of cold-finishing processes (wheel-cutting, carving, sand-blasting, drilling, brushing, abrasive polishing) brings an extraordinarily fine quality of decorative attention to the chilled exterior surface of the glass vessel form, inscribing a kind of 'exo-skeleton' that floats as a thin lattice design over the stilled liquid form. He exploits the ambiguous condition of glass as a material, in its metastable and disordered molecular state – neither a liquid, nor a solid; sequentially fluid and malleable and also hard-skinned and resistant. This is especially so with works such as Clear Sea Urchin, a sagging globe, all points of whose grazed, ground or smoothed surface is studded with polished lens cuts that magnify the internal refraction of the textured patterning at the opposite diameter. A piece that looks for all the world as though it has been carved out of water.

So the mode of figuration in play in this work is not literal, nor even primarily descriptive. Rather, geometrical elements, pattern, texture, work in a kind of metonymic way – the part invokes the idea of the whole, itself contained within the span of the vessel artefact.

The fascination of beachcombing may begin with serendipity, but the flotsam and jetsam that so beguiles Gordon's beach walks quickly focuses on shell or glass fragments, smoothed splinters of driftwood, that immediately invoke their unknown origins in whole objects of the natural or manufactured world – and indeed the mysterious distances – that wash up daily on the tide line. Distances that mark our separation from, as well as our implication in, in the natural world. Each fragment has its own discrete character and value as a perspective on the phenomenal world, delightful or repellent in itself, either way authenticated by chance. If not a fractal, exactly, then a fractured glimpse at least of some underlying organic or mathematical order.

> I have studied the idea of fractals and the Mandelbrot theory… the idea of a few basic elements that put into a form of mathematical
> formula with variations that use these elements that keep repeating to build the whole design. In my work I emphasise this with the
> use of lens which shows that what ever the scale or resolution, the design resonates…

Gordon's interest in these and other mathematical forms, including the Fibonacci or Golden Series, operates both as design method and as a personal take on representation. For, whatever they owe to their source reference material:

> In this work I am not trying to make a exact scientific representation of the corals shells sea urchins etc but looking for designs,
> textures and structures with in them that I can use in my work in which I can exploit my skill as a cold glass worker and show many
> of the techniques that I have developed in my experience of my field of work, I would also add that this body of work has challenged
> me to develop techniques to achieve effects that has pushed my work into new areas and has opening up new thinking and approaches to
> how I work the medium.

In the wider context of its native environment in Western Australia, the resulting body of new work gives rise to timely and interesting questions of representation in art and ecology. In its use of the part to invoke the whole, an implicit 'metonymic' ethos might seek, in Gordon's developing œuvre,

through care and attention at the level of the species detail to invoke understanding and concern for an entire (marine) ecosystem. William Blake's visionary transfiguration of this micro «=» macroscopic relation, Blake's gift 'To see a world in a grain of sand', scornfully rejects the scientific view of the torn fragment as a finite limit to provisional knowledge – as Blake put it elsewhere, in his 'Proverbs of Hell': 'Eternity is in love with the productions of time'.

The sub-current of environmental sustainability subsists as no more than an implicit awareness and, though Gordon's project doesn't yet possess the edgy political or elegiac purpose of ecological alarm, it is intriguing to speculate as to what this new body of work may be building incrementally as a longer-term statement. What, as an eventual ensemble, as a glass reef, it might amount to beyond the sum of its constituent works.

### The Glass Threshold – at the City Gates of Guan Donghai

City Gates – his first solo glass sculpture exhibition (Gaffer Studio Glass, Hong Kong, October 11th – November 11th, 2006; www.gafferstudioglass.com) marked, in itself, a important threshold in the work of the Chinese artist Guan Donghai. It was my privilege to write the brief note accompanying this significant show, in which I recalled the earlier pleasure of witnessing his extraordinarily rapid development as a contemporary glass artist: from his first engagement with the material of glass hardly five years ago, to the distinguished and original body of work on show today.

That the theme of Guan Donghai's first solo show should be one of 'gateways' and 'thresholds', as points of entry and exclusion, may come as no surprise. In the wider international context of contemporary glass art, these are works that withstand as much as they contain. The gate pieces are portals or door spaces whose absent frames span thresholds both admitting us to a distinctively Chinese contemporary glass domain, and resisting everything which is merely derivative of 'elsewhere'. The imagined civic dimension to these objects, artefacts that otherwise function essentially on a domestic scale, is also notable – in the absent form of the vanished or metonymic 'invisible cities' to which these gates preclude our admission.

Indeed it would not be entirely fanciful to imagine Guan's City Gates series as a knowing, sculptural counterpart to Italo Calvino's novella Le città invisibili, in which Marco Polo describes, chapter by chapter, for the benefit of Kublai Khan, fantastic cities of the mind, of language and of travel – all of which, in a final twist of these narratives-within-a-narrative, turn out to be nothing less than imaginal hymns addressed to his belovèd, native Venezia.

That Guan Donghai's city gates by silent contrast lock the intruder without, and the mystery within, seems fitting - in cultural terms invoking ideas of power, protection, seclusion, isolation. They explore practical notions of limit, including the self-imposed confinement or limitation to a rough suite of simple glass forming processes. But these are modern artefacts, albeit inscrutable as the past, offering playful resistance to received ideas or hack journalese perspectives on China, ancient and modern.

The coarse rendering of the glass fabric seems also fitting – these are raw sand- and kiln-cast forms that display, however, highly developed surface and colour sensibilities. Guan Donghai works here for a finished quality that he calls 'unsophisticated' but which in fact betrays,beyond his intensive engagement with glass technique, a sustained artistic and technical formation in textile design, watercolour painting, and touch-perfect draughtsmanship that practically guarantees such qualities.

The gates are variously studded and chequered with squared and rounded bosses, they involve occasional galleries, windows, archways and doors.

Their forms are as contained as carved stamps, or the grid squares in which children practice writing characters in the Chinese world. From time to time archaic heads within the gate form confront the viewer – are those figures sentries, or severed trophies, betokening vigilance or warning? These are works that require no explicit narrative, whose significance is tacit, implicit, and whose condition appears to rest sufficient unto itself.

The forms of the Weapon Series similarly take their bronze and jade ceremonial antecedents into a new architectural order – as scaled-down, intimate models of potentially monumental forms that continue employ the mould-casting and cold abrasive technologies that gave form to their ancient precedents. They appear monumental in the sense both of their significance and intensity, and in the memorial sense – playful by turns – that marks the idea of a lost civilisation or the bright technical evidence of some obscure though highly developed ritual and craft culture. At the same time, it is clear that the works concerned are not merely derivative of some shallow process of cultural archaeology or historical appropriation, for these intensely tactile, textured and chromatic objects are to my mind haunted by a kind of creative ambivalence.

And so the child has become the artist whose fresh glass œuvre recalls and re-works, in a contemporary idiom, past forms, past references, formal research, deriving from antique jade, bronze or stone artefacts, and the ritual, military and craft cultures from which they trace their formal genealogies.

There is a kind of poignancy here, amounting to much more than a tendency to elegy or nostalgia, because Guan Donghai's works constantly expose a heightened sensibility – visceral excitement with the physical properties of human objects and artefacts in time. As a painter, and as a traveller, his watercolours and drawings have patiently recorded the detailed incidence of decay or textured dilapidation in subjects such as 'Small Yard', or 'Old Factory Building', for which (almost by accident) he won painting prizes at the Royal Birmingham Society of Artists open exhibitions in 2003. I remember, too, the immediate flurry of photographic excitement provoked by his discovery of an overgrown heap of disused agricultural machinery, oxidised and rust-pigmented metal forms, as we were walking the autumn lanes of rural Shropshire that year.

The gate and weapon pieces that showed at Gaffer Studio Glass in Hong Kong seem monumental also insofar as any figurative human element is always held subservient, in scale and definition, as a small architectural detail of the broader design. For instance, in the disembodied head motif that figures as antique human presence, a windowed inlet within the sword blade section (for example Weapon Series, #1 and #2). Or in the remarkable new work, Régime, a glass rail cast from a length of H-section steel girder, onto which are threaded cast head-forms in semi-opaque glass, complete with top-knots, their identical faces stained with red, blue, white and black oxide pigments.

Each head is bonded at the neck to a horizontal C-section runner in opaque pâte-de-verre, locked in serried rank like vitreous commuter counterparts, for the machine-age, of the terracotta warriors at Xian. It is interesting to compare this approach to figuration with the work of the English glass artist, David Reekie, another brilliant draughtsman, with whose work Guan may be familiar. In both cases, we witness precision, formal elegance, subversive humour, cryptic games, the stark portrayal of the human condition, with all the terse immediacy of a newspaper cartoon or an epigram. But in Régime, for example, every trace of the individual drama that Reekie characteristically explores is expunged, and a different kind of political sensibility shows itself as an unblinking preoccupation with the forms of power. I look forward to the new direction this single work may inaugurate.

Guan Donghai's sculptural 'language' involves a high degree of plastic imagination, careful attention to surface qualities, a rich chromatic sensibility, technical mastery, and a keenly observant sense of Chinese artisan tradition in terms of architectural detail, and ancient techniques of bronze and jade manufacture. It can be playful, capable of humour or political nuance, and is confident, measured and contained.

These new works articulate contemporary energy in the same moment that they invoke a highly refracted though definite sense of historical and cultural tradition. At this stage of his work in glass, Guan Donghai appears content to explore the restrained luminosity of the material, and its relationship to sand and stone, rather than more obvious qualities of transparency or surface brilliance.

And this would seem characteristic of the man himself. When we first met, seven years ago at Tsinghua University, I was struck by his absolute enthusiasm

– almost a species of hunger – for technical and artistic engagement in the glass medium.  Today, for all his achievement in so short a space of time, this aesthetic quality of measured restraint is the confident mark of an artist who seems both full of ideas and sure of his place in the world of contemporary glass.  And from whom there is so clearly very much more to come.

Notes

Italo Calvino, Le città invisibili (Milano, Giulio Einaudi Editore, 1972), translated by William Weaver as Invisible Cities (London, Picador 1979).

## Touching the Void

This essay concerns the defining silence of craft practice, and the essential emptiness of form.  It touches questions of creativity that link hand and mind, materials and ideas.  As may befit the first issue of this new journal, it takes a form of invitation, rather than prescription.

My text seemed, in the writing, to weave between two parallel histories – each of perhaps equal significance to the development of contemporary craft and design practice in Australia, and along the wider Pacific rim – and to invite a respective engagement with the creative and intellectual legacies of our European and East Asian traditions.

It exhibits further issues of 'unresolved Modernism' as a twentieth-century legacy, and as a bone of contention for the contemporary applied arts and design; and it strays onto philosophical ground – or what the late Peter Dormer might have referred to as the place of 'practical philosophy':

> The reason for calling craft a practical philosophy is that almost nothing that is important about a craft can be put into words and propositions.  Craft and theory are oil and water….
>
> …But a disciplined craft is a body of knowledge with a complex variety of values, and this knowledge is expanded and its values demonstrated and tested, not through language but through practice.  It makes craft difficult to write or even talk about with clarity and coherence.

This kind of tacit understanding identified here in Dormer's essay 'The Language and Practical Philosophy of Craft' is immediately recognisable, and by no means exclusive to the applied arts, as witnessed by the following testimony, cited by Dormer in his book The Art of the Maker :

> I cannot formulate the deeper dimension of my knowledge.  I cannot describe how I tell a patient that he is going to die.  I have built up the most important part of my knowledge by meeting people and learning.  That is what is crucial to my ability to make a diagnosis.  It is a question of doing it again and again.  This is always impossible to express in words….  This cannot be learned theoretically; more than anything else it requires an ability to 'see'.

Thomas F. Judge, in his book Edo Craftsmen, a study of surviving shokunin (artisans) of contemporary Tokyo, shares Dormer's concern with 'what craft is and why tacit knowledge matters', extending the question of tacit knowledge, or understanding, by means of an East Asian pedagogictradition, and sharing the insistence that the doctor we heard from placed on 'seeing', and on tacit learning:

> …the withholding of formal training also helped drive home the idea that merely handling the tools was a privilege, and this instilled a natural urge to learn….Masters did not teach by explanation.  Only the finished product mattered; substandard work was rejected and the apprentice was left to puzzle out his mistakes on his own.  Essentially, the apprentice acquired his skills through imitation, or as the Japanese expression has it, "by watching and stealing".

The theoretical and linguistic gulf between the practical philosophy of craft making, and theoretical discourse within a wider philosophical culture - between what can be said and what must needs remain silent - deepens in an essay by the 20th century German philosopher Martin Heidegger, on the nature of 'things', where he meditates upon the essence of a simple vessel artefact, a clay jug:

> The jug is a thing as a vessel – it can hold something.  To be sure, this container has to be made.  But its being made by the potter in no way constitutes what is peculiar and proper to the jug insofar as it is [in its capacity as] a jug.  The jug is not a vessel because it was made; rather, the jug had to be made because it is this holding vessel.
>
> The making, it is true, lets the jug come into its own.  But that which in the jug's nature is its own is never brought about by its making.  Now released from the making process, the self-supporting jug has to gather itself for the task of containing.  In the process of its making, of course the jug must first show its outward appearance to the maker.  But what shows itself here, the aspect (the eidos, the idea), characterises the jug solely in the respect in which the vessel stands over against the maker as something to be made….
>
> …We become aware of the vessel's holding nature when we fill the jug.  The jug's base and sides obviously take on the task of holding.  But not so fast!  When we fill the jug with wine, do we pour the wine into the sides and base?  At most, we pour the wine between the sides and over the base.  Sides and base are, to be sure, what is impermeable in the vessel.  But what is impermeable is not yet what does the holding.  When we fill the jug, the pouring that fills it flows into the empty jug.  The emptiness, the void, is what does the vessel's holding.  The empty space, this nothing of the jug, is what the jug is as a holding vessel….
>
> …but if the holding is done by the jug's void, then the potter who forms sides and base on his wheel does not, strictly speaking, make the jug.  He only shapes the clay.  No – he shapes the void.  For it, in it, and out of it, he forms the clay into the form.
>
> From start to finish the potter takes hold of the impalpable void and brings it forth as the container in the shape of a containing vessel.  The jug's void determines all the handling in the process of making the vessel.  The vessel's thingness does not lie at all in the material of which it consists, but in the void that it holds.

This is perhaps as close as Western philosophy ever gets to earthenware!  In this lecture – delivered in an art school, by the way, at the Bavarian Academy of Fine Arts – Heidegger proceeds to define the distinctive holding and keeping that is the essence of the jug, which is then gathered and fulfilled in the outpouring of a ritual offering: a libation to the gods, uniting heaven and earth.

But Heidegger is merely appropriating the clay jug as an occasion for theory.  And strangely, for a philosopher so committed to poetry as the 'speaking' of truth and of the 'un-concealedness' of being – and to poetry as dwelling and thinking – Heidegger dismisses the making process, or poesis, from a meditation that in fact suppresses its source, in chapter 11 of the Laozi, or Dao de jing, the early classic of Chinese Daoist philosophy compiled during the Warring States period, around 4th – 3rd c B.C.

> Thirty spokes share one hub.
>
> Adapt the emptiness within…and you will have the use of a wheel.  Knead clay in order to make a vessel.
>
> Adapt the emptiness within …and you will have the use of a vessel.
>
> Cut out doors and windows in order to make a room.

Adapt the emptiness within …and you will have the use of a room.

Thus what we gain is Something, yet it is by virtue of Nothing that this can be put to use.

Richard Willhelm's 1911 German translation of Chapter 11 of the Laozi, which was available to Heidegger, reads (in English) as 'The work of jugs consists in their nothingness.' Heidegger's suppression of this likely source is at best a curious omission, and more controversially perhaps a different kind of 'tacit knowledge' – knowledge that in this case just keeps its mouth shut.

For Heidegger enjoyed direct contact with some of the best minds in modern Japanese philosophy throughout the 1920s, that is to say during the period leading to the publication of Being and Time in 1927 – widely acclaimed as the most significant philosophical assault on Western metaphysics since Nietsche.

And we know, from Reinhard May's research , that in 1930 Heidegger had consulted Martin Buber's 1910 translation of the Zhuangzi, another Daoist classic; that he had available to him German translations of the Laozi by von Strauss (1870) and Willhelm (1911); and that he collaborated during the summer of 1946 with the Chinese philosopher Paul Shih-Yi Hsiao, on a translation of the Laozi, discontinued at Heidegger's request after eight chapters. The essay Das Ding ('The Thing') from which I quoted was delivered just four years later in 1950.

I am labouring this point for several reasons. Firstly, because I believe we have yet to take the true measure of East Asian influences on Western modernism, including the fine and applied arts, poetry, philosophy, music and architecture of the twentieth century.

I mean mainstream modernism – creative and intellectual development, often involving techniques of inspired misunderstanding – from Gaugin's preoccupation with Japanese printmaking; to Gaudier-Brzeska's sculptural reading of Chinese ideograms; to Bernard Leach's formative experience of the Japanese ceramic tradition; to the American poet Ezra Pound's appropriation of the sinologist Ernest Fenellosa's study , which he published as The Chinese Written Character as a Medium for Poetry (and the directions this opened for modern poetry in the English language); to Heidegger's 'hidden sources', and the philosopher Willard Quine's acknowledged ones; and to the work of numerous figures such as John Cage, Frank Lloyd Wright, Robert Motherwell…&c. &c.

My second point is that, pervasive as these East Asian influences most surely are, they have not yet unsettled our Western genius for taking the values of diversity and transforming them into a hierarchy.

There is a special instance of this condition with regard to craft, where the lingering default mode for fashionable theory tends to lament the lack of developed theoretical or critical dimensions to contemporary applied art (defined, of course, in strictly Western terms), and to relegate its cultural value.

My third point is an aside, really – that I think contemporary craft practice continues to be preoccupied with issues of unresolved modernism. Including precisely the issue of East Asian influences that I have raised. And that an impaired model of cultural transmission continues both to inhibit craft practice, and to marginalise even so significant a figure as Bernard Leach, within the wider culture.

In Formless, But Not Without Form, a very significant body of work by the Chinese glass artist, Yang Hui-Shan, successive processes of moulding and kiln-casting seem themselves to sustain a long, drawn-out meditation on being and nothingness, and of the imaginative possibilities of positive and negative space, form and figure. A kind of something, arising from nothing.

There is here an overt engagement – in material and in imagination – with the figure of the Buddha, in which the internal and external dimensions of the veiled transparent medium, the optical play of substance and immateriality, is realised in works of simple power, and resonant presence, which belie the intense labour that has attended their production at every stage.

If these works recall the Daoist interest in material and immaterial realities – well… Laozi would 'himself' seem an emblematic figure in these terms – in that he may or may not have existed – some 200 years before the two books that together bear his name were collected. It is not clear whether Laozi created Daoism, or Daoism created Laozi.

If Laozi did exist, this was incidentally during the Spring and Autumn period of the Eastern Zhou dynasty, in the 6th century B.C – a period in which the lost-wax casting techniques that Yang Hui-Shan employs, together with the decorative use of incised clay moulds, had becomeestablished methods of Chinese bronze casting. Though it was of course a much earlier clay technology that is invoked in chapter 11 of the Dao de jing.

How much further might this meditation on casting technology as a vehicle for human imagination, on the theoretical significance of positive and negative space, form and figure, travel?

Well, in a 1938 essay, the German romance philologist Erich Auerbach credits the Latin usage of Lucretius, Tertullian, Cicero, and Augustine in developing the words forma and figura beyond their technical origins in linked etymologies that may surprise and intrigue glassmakers:

Strictly speaking, forma meant 'mold', French 'moule', and was related to figura as the hollow form to the plastic shape that issues from it…

Something, from nothing. From these primitive artisan origins, Auerbach traces the speed and alacrity with which the Latin words forma and figura came to signify abstract meaning:

In…the language of Plato and Aristotle…morphe and eidos were the form or idea that 'informs' matter; schema is the purely perceptual shape.

In Latin, forma translated morphe and eidos as 'idea', and figura translated schema as outward shape. The original 'plastic' signification of these words in relation to mould technology rapidly acquired new meaning in terms of grammatical, mathematical, rhetorical, logical, musical and even choreographic form. Further meanings, including 'portait', and 'the impression of a seal in wax', entered usage.

Verbal 'figures'; and usages such as 'model', and 'copy' arose. In Lucretius, the word is found to signify 'figment', 'dream image', and 'ghost'.

With Dante, the theological development of figura as phenomenal prophesy, in the work of the Church Fathers, acquired a new poetic and semantic complexity, grounded as he saw it in the historical reality of Christ's incarnation, as 'the Word made flesh'.

In phenomenal prophesy, the figure possessed as much historical reality as the historical fulfilment it prophesied. Figure and fulfilment are thus related in the foreshadowing of truth, and abstract spiritual truth had thus become history, human flesh.

In mediaeval art, it is not clear to Auerbach how far aesthetic ideas were determined by figural conceptions, i.e. ' to what extent the work of art was viewed as the figura of a still unattainable fulfilment in reality.'

But my point here is, that all of this semantic evolution – and the imaginative technology it gave rise to – had, as its linguistic origin, the primal, plastic sense of female and male forms, of mold and cast; positive and negative space: a primitive, original source of human creativity. Something and nothing.

**Michael Petry**

Chapter in book-length monograph on American installation artist Michael Petry, commissioned by the artist. Critical examination of a series of installations in Norway, USA and UK invoking the physical properties of blown, cast, cased and coloured glass as primary material. Works considered include (1) two linked installations jointly entitled 'Laughing At Time' ('The Treasure of Memory'; 'The Forgotten Kisses'), plus 'Pearl MAP Unit' – all three made for the gallery and barn complex of the arts centre at Hå, near Stavanger on the North Sea coast of southern Norway; (2) 'Contagion', a Brighton Festival 2000 commission for the Gardner Arts Centre; and (3) 'The Fluid Man', made for the Devin Borden Hiram Butler Gallery, Houston, Texas.

'The Treasure of Memory' is touring (2007-9), accompanied by this book, to: Toledo Museum, Ohio; Schmuckmuseum, Pforzheim; Museum of Arts and Design at Two Columbus Circle, New York; Memorial Art Gallery of the University of Rochester, NY State; Mobile Museum of Art, Mobile, Alabama and venues in Italy and Holland.

The essay seeks to extend the range of critical language and cultural reference for glass as a contemporary art medium, and also to locate Petry's installation work within a wider critical context. It explores the artist's representation of the male body as neo-Albertian 'measure', and in the context of epidemic HIV. The essay also offers an interpretation of the Narcissus myth in relation to the 'unrequited' act of image-making, and in terms of the fluid, reflective/reflexive properties of the glass medium. It explores the artist's engagement with the physical condition of glass and pearls, and with blood, semen, sweat and urine, as material traces in a physical continuum of organic and mineral existence, linked conceptually both to narcissism and to alchemy as processes of cognition.

Some Grit in the Hourglass: Michael Petry's Laughing At Time

'…when we look at a thing, we see it as an object which occupies a space. The painter will draw around this space, and he will call this process of setting down the outline, appropriately, circumscription. Then, as we look, we discern how the several surfaces of the object seen are fitted together; the artist, when drawing these combinations of surfaces in their correct relationship, will properly call this composition. Finally, in looking we observe more clearly the colours of surfaces; the representation in painting of this aspect, since it receives all its variations from light, will aptly here be termed the reception of light.'

Leon Battista Alberti, Della Pittura (1436)

At first glance, Alberti On Painting would appear a somewhat abstruse, even misleading, epigraph for a brief essay on Michael Petry's recent work in glass, Laughing At Time, consisting as this does of two linked installations, designed and made for the gallery and barn complex of the arts centre at Hå, near Stavanger, on the North Sea coast of southern Norway.

Hardly so: for these works share a preoccupation with number, measure, proportion, line, space, duration, time, that Alberti would surely have recognised as principles of circumscription or of composition, and as evident in the ordained proportionality of the Vitruvian man.

Thus, as a unit of measurement, Alberti's braccia might, through false etymology so to speak, be 're-membered' in Petry's forearm, itself a rule or dimension informing earlier MAP [the artist's initials] projects, which collectively comprise, as it were, his body of work.

Another Albertian module, the height of a man, is the exact measure employed in Petry's 1999 MAP installation, The Fluid Man, and is used again in Pearls, another MAP unit (ht.178cm) and a curatorially separate installation in the roof-space at the Hå complex, of which more later.

For now, however, I'm not inclined to push this comparison further, except of course in respect of their shared regard for surfaces for, in Alberti's luminous phrase, 'the reception of light', an acutely apt and almost descriptive term that could be applied to Contagion, anearlier installation commissioned for the art gallery of the Gardner Arts Centre as part of the Brighton Festival during May 2000.

The work was composed of 144 suspended glass 'hearts', free-blown by the glassmaker Carl Nordbruch to resemble medical blood-bags, perhaps, whose swollen forms seem to have been shaped outwardly in blood red by the suspended weight of their own liquid volume. The forms were fashioned in inner-cased lead crystal to the approximate size of a human heart, varying one to another slightly in hue and shade from an almost solid colour to near transparency. The hearts were arranged in hanging arcs following the plan section of the theatre foyer area, hung at exactly the artist's chest height, and providing thus a kind of heart-to-heart itinerary in and out of the suspended maze. Visitors wandering carefully in between and gently handling these objects would register surprise at the actual weight of lead crystal in their grasp, and were physically engaged in the simple maze. Such was the respect accorded to this fragile ensemble, that with inter-action throughout the event only two hearts broke, so to speak, shattering when cracked together experimentally by a some curious heartbreaker of a visitor.

The installation was illuminated by directional red lights projecting from one side, creating huge variations of environmental transformation in colour and lux levels as darkness followed daylight. Translucent by day, the hearts would become saturated and opaque after dark in optical reaction to the projected red light, which then flushed or transfused the foyer, creating the external impression of a luminous blood curtain out of the glass skin of the building. Alluring, glassy-bright and richly chromatic, but with apocalyptic resonances of blood-bath or massacre.

Theatre or cinema-goers, arriving in daylight for an evening performance, would emerge in the same space drenched with this blood red light at the close of twilight. The human heart as the seat of emotion, and as the organ of blood circulation is invoked as a exposed and vulnerable entity, its life principle the very gateway or thoroughfare of contagion in a work where the subject of HIV is presented through a technique of unbroken silence. In addressing this theme, Petry was clear in his own mind that he 'didn't want to engage with the science of death'. The approach is neither forensic nor biographical, and begs no individual favours. Instead, the created environment hangs serious questions in mid-air, suffused with various lights, through which visitors cannot but make their individual ways.

My particular interest in this essay is to explore Michael Petry's distinctive approach, as an installation artist, to working with glass as a material, in ways that may work in unspoken counterpoint to the approaches of 'artists in glass', or those more commonly identified with the brittle medium on a similar scale. Did somebody mention Dale Chihuly?

His is the perfect art for boosters, wannabes, new money, and self-conscious arrivistes. In other words, perfect for the precociously wealthy, culturally callow New Northwest. Glass has the museum seal of approval, but it's supremely and (as practised by Chihuly) almost purely decorative – blissfully unburdened by threatening, ambiguous, or other meanings. "You don't have to be smart or art-historically sophisticated to understand these," a Chihuly's [sic] assistant explains in one of several documentaries on him by Seattle's public TV station. "They're merely beautiful"…..Glass also suits a money-drunk, technology-intoxicated place like the Northwest. It's showy and luxurious, as glittery as jewellery and a hundred times bigger.

For scholars of invective, the Slate web location for the complete version of this fairly sulphuric journalese appears as a footnote below. The rest of us may note a stern clutch of predictably belittling assumptions - regarding 'decorative' qualities in glass, all that glisters etc., luxury, mere beauty, and jewellery on an impossible scale - and then perhaps move on.

The two component installations that comprise Laughing At Time occupy adjacent sites, and are respectively entitled The Treasure of Memory, and The Forgotten Kisses. The geographical location of this work is as compelling and atmospheric as Trond Borgen's strong evocation here suggests: in the

characteristic marine light of its exposed seaboard location, and in the suggestive power of numerous archaeological finds unearthed from burial mounds strewn along the shoreline and dating from the Stone Age: the immemorial and continual cadence of open, northern light upon stony human artefacts.

A single glass bead necklace of Roman origin, and the pebbled beach itself, became points of imaginative departure for the development of two sibling installations, linking laughter, memory and forgetting, and counter-posing fragile human values of love and erotic pleasure or delight against mortality and landscape, the nature both of human and of geological time.

Out of curiosity, I should like to know more about that found Roman necklace, the jewel intricacy of its bead construction, its date and provenance, although already I'm aware that any such specialist intelligence would prove entirely superfluous to my present purpose: since no historical accountability is intended or even acknowledged by the artist; since his concern is with time as a condition of mortality rather than as history; and since, as the American poet e.e.cummings once put it, and Petry's companion piece might suggest: 'kisses are a better fate than wisdom'.

In construction, The Treasure of Memory stretches and extends the roman glass bead imagery in the dimensions of space and time, each 'bead' consisting of a free-blown colour cased glass bubble, of approximately 30-35cm in diameter, in one of three shapes: oval, lozenge, and 'head form'. The bubbles are opened at both ends, each pontil mark cut and ground out for the cable aperture.

Thirty-two inflated beads are threaded at roughly human neck-height along a line of black yachting rope. They compose a knotted string of maritime baubles, part bead, part fishing buoy, describing the loosely tensile arc of its own weight, and stretching this fragile strain across the length of the gallery, each bead held with yachting clips.

Petry's excited handling of brilliant grave goods in the shape of a discovered Roman glass necklace constitutes a very different engagement to that, say, of the Irish poet Seamus Heaney with similar Scandinavian source material derived from his reading of P.V. Glob's study The Bog People (1970). Heaney's poem 'The Tollund Man', from his 1972 collection Wintering Out, takes a rope noose for a necklace, and is preoccupied with wet organic textures in contrast to Petry's hard, dry and glassy mineral treasure:

> Naked except for
> The cap, noose and girdle,
> I will stand a long time.
> Bridegroom to the goddess,
> She tightened her torc on him
> And opened her fen…

In its forthright sexual animation, Heaney's sequence appears to share at least as much with Oshima's Ai No Corrida (1976) as with a literary interest in iron age sacrificial rite, and his distinctive earthing of human sexuality sits in violent antithesis to Petry's exhuberant, celebratory (and ever so slightly fetishistic) preoccupation with body ornament. This wholly unlikely comparison is revealing of qualities, contrasting Petry's playful metonymy (the body ornament invoking the body absent) with Heaney's deliberate metaphor. Loose talk instead of tightened torc. Haute couture in place of horticulture.

Something desirable, worthy of theft or desecration, is styled and re-invented as a great telling rosary of coded significances, private but not too inaccessible, arcana for knowing initiates perhaps. The Prada bead, the Gucci bead, the blue-and-yellow Egyptian bead, the Sumerian bead, the pink Muranese bead, the bottle-green fishing buoys, shot with the utter candour of common daylight.

As an installation, The Treasure of Memory engages and transforms this particular gallery space, articulating multiple surfaces - fluid glassyskins, hollow depths, graphic rope lines, white walls, window apertures - for the reception of light. Our attention is carefully conducted through a series of fluid chromatic relationships, in response to successive phases or equilibrium of daylight, directional spot light, reflection, refraction, in two and three dimensions.

The interior dimension is reconstituted through the direct interaction of these combining elements. Exterior space is admitted through windows like fixed lenses allowing the ingress of intense maritime light, heightened through watery reflection in the shimmering flux of the sea-washed, stony landscape.

At this worn edge of the world, the window perspective reveals more sea than land. We occupy this new space, trace our line, as if balancing on a tightrope.

This transformed space is the work. The technical realisation of a significant aspect of this work, namely in terms of studio glassblowing, and the relation of glass as a synthetic material to the static or shifting elements of its exhibition environment, comprise but two dimensions of the work, instrumental as they are with regard to the reception of light. So that, sly and alluring though the idea may at first glance appear, I would argue that, as glass art, The Treasure of Memory is very far removed from the kind of object-centred art making that so typifies and inhibits so much of the contemporary glass scene.

Petry's authorial stance would imply as much, insofar as, although technical precision might indeed be an aesthetic given, or prerequisite (even where an idea may be positioned at an extreme of technical expectation), the technical aspects of the work nevertheless remain something 'to get over', and the artist is essentially uninterested in the objects as objects per se.

Michael Petry no more makes his own glass than does Dale Chihuly these days. Rather, he commissions the work, in this instance from the London based glassmaker Ian Hankey, as does Chihuly, in his case from Venetian masters including the legendary Lino Tagliapietra. In extending to himself the authorial freedom of not-making, Petry successfully resists the shallow allure of mere virtuosity, preventing technique itself from assuming a kind of surrogate object-status, or substitute content, in glass.

It is not that qualities of seductive allure, or occasional shallowness, even, or decadence, are not instrumental to Petry's aesthetic. Which indeed they are if need be: invoked as deliberate choices. (Take a closer look at that Murano bead, if you don't believe me.) It is that these moments don't however repeat themselves helplessly, ad nauseam. And the number of creative decisions left to chance is in fact small. And the whole adds up to somewhat more than the sum of the component parts. It is perhaps in many of these terms that any drive for further correlation with Chihuly's work would risk running on empty.

The second Hå site is the barn location for The Forgotten Kisses, a second but related installation consisting of two thousand 'stones' handmade in clear lead crystal and organised as two contiguous semi-circles separated in their vertical axis by the raised wooden platform of a gallery upon which the upper of these half-circles is grouped. At this upper level, the stones are lit sideways, casting strong lateral shadows. The corresponding and lower half circle, spot lit vertically, elegantly litters the gravel floor of the open barn below, forming a glowing pool. Rays of narrow daylight, admitted through gaps in wall timbers, complete the light sculpture.

The glass stone surfaces are carefully textured, their sand-blasted outer surfaces making them opaquely to resemble to beach pebbles, though transformed and luminous ones, holding and retaining the light like beached glass fragments rolled by the sea. The two thousand units were commissioned from the English glassmaker Carl Nordbruch, and each is unique.

Where The Treasure of Memory established a highly charged visual environment of bright, tensile light, The Forgotten Kisses is darkly lit, for jewellery "a hundred times bigger" (pace Eric Scigliano's Slate diatribe) substituting a cold mineral residue strangely attended by human associations of tears and kisses, and also landscape associations of stones, innumerable and forgotten, without memorial, upon the rock and shore of time.

It is as if the high emotional charge (and moist, tensile forms) of both tears and kisses has undergone an alchemical transformation into hard vitreous substance in the neatly parted circle of glass scree.

If the ensemble smacks a tad of fairytale theatricality, forced camp, its very bleakness also militates in tone with the short text accompanying Petry's webpage entry for The Forgotten Kisses where, in the space of a single sentence, erotic imagination is quickly played out, with accelerating desperation, before breaking into the printed gesture of helpless laughter.

Hå! - even so. The very name of the place seems to resonate with this complex laughter. The play of emotional tension back and forth between bitter longing and despair, and desperate loss and aspiration, is the wavelength on which The Forgotten Kisses redeems itself from the mere elegance of self-parody, but not before those shallows have, as it were, been plumbed and measured.

Incidentally these glass kisses, proving as portable as they are attractive, and fitting very coolly and comfortably into the hand, apparently gave rise to mild anxiety in the security department. And so discreet arrangements were made whereby single kisses could legitimately be borne away from the gallery shop, and with appropriate pudeur, in exchange for 10 Norwegian Kroner a time.

An interesting extension of the project, this, through a scattering or dissemination of forgotten kisses. I don't know how those customers felt in new possession of their smooth mineral fetish, nor how many kisses were taken otherwise by indiscretion, but I imagine that the stolen kisses savoured more sweetly, for longer, than their bought equivalents, every time.

The active ingredients of narcissism and alchemy explored here achieve more overt expression in Pearl MAP Unit, which constitutes Site 3 of the Hå project, a quite separate entity to Laughing At Time.

Pearl MAP Unit consists of the artist's exact height rehearsed as a straight line of pearls, threaded on silk, seemingly erect though suspended invisibly from the roof timbers. Spot lit in the darkened roof space, they catch and hold the light and glow as only pearls do. They recall their natural freshwater predecessors, found earlier in abundance at the site. Two sterling silver rings at each end secure the line, which can be taken down and worn as a performance piece, for instance as a necklace. Pearl takes us closer to identifying the grit, so to speak, in Michael's oyster.

Of course the work is technically a self-portrait, as all of the MAP units are. A degree of self-absorption is expected of self portraits, and as you would expect of Petry, the essential narcissism at work here is carefully measured and controlled, though extreme. In order to be precise I need perhaps to extend the contemporary scope of this term. Narcissism is commonly defined as an excessive or erotic interest in oneself or one's physical appearance, deriving from the myth of Narcissus, a beautiful youth in Greek mythology who fell in love with his own reflection in a pool. Most dictionaries would have it that way, but in fact the modern use of the term – to mean auto-eroticism – seems almost its least significant currency.

More interestingly, perhaps, the punishment of Narcissus was that, having coldly spurned the amorous advances of both male and female suitors, he was condemned by the gods to endure the pain of unrequited love. More interestingly still, he fell in love not with himself but with an image. With a trick of light, in fact - a fluid, reflective, translucent image, unsteady and breaking at the water surface. There is at least an intriguing analogy with the visual artist here: whose passionate act is always, except through transformation, unrequited, and whose excessive, exorbitant interest lies with images.

Petry's use of pearls in recent MAP units draws a more explicit analogy with flux as body fluid, a 'pearl necklace' meaning a string of externally ejaculated semen as adornment to the body of the belovèd.

Sperm barely counts as a new medium these days, even in self-portraiture, at least since Marcel Duchamp's 1946 work Paysage fautif, a drawing on celluloid backed with black satin and included in the Boîte-en-valise he gave to Maria Martin, whose drawing medium was, some forty-three years later, identified by chemical analysis as ejaculated seminal fluid .

Petry's motif seems coy and alchemical by contrast, alchemical in its obsession with fluidity, chemical flux and with mathematical argument or obsession. He is thinking with pearls, alchemically almost, as he was thinking with glass, in an approach - both instinctive and intellectual - that seems as close in practice (and in relation to the pure physicality of his materials) to that of James Elkins' recent and extraordinary thesis, What Painting Is , as it does to the Elizabethan miniaturist, Nicholas Hilliard , carefully grinding stones of great virtue in the preparation of pure limner's pigment.

An earlier MAP work in glass, The Fluid Man (1999), made for the Devin Borden Hiram Butler Gallery at Houston, Texas, established a more complex mathematical and linear framework for the composition with corresponding lines, and gaps between lines, determined by bodily proportions, the gaps once again of his exact body height. Four glass courses, again free-blown and colour cased spheres of differing volume in opal, yellow, red, and blue, correspond to semen, urine, blood and sweat respectively. They are pitched at exact heights in relation to the floor, penis, heart and brow. Each of these fluids features strongly in alchemical practice, as material and as metaphor, each capable of flux and transformation.

The cool mineral excitement of Michael Petry's work in glass does not of course reflect any serious interest in alchemy, but works more immediately with the fluidity and luminescence of the material, for 'the reception of light', in ways that share with alchemical practices a commitment to thinking in substances and processes. Glass as our earliest synthetic material, and as a process in constant flux.

> As the substances mingle and fuse, they become purer, stronger, and more valuable, just as the soul becomes more holy. The philosopher's stone is the sign of the mind's perfection, the almost transcendental state where all impurities have been killed, burned, melted away, or fused, and the soul is bright and calm. Alchemists paid close attention to their crucibles, watching substances mingle and separate, always in some degree thinking of the struggles and contaminations of earthly life, and ultimately wondering about their own souls and minds.

He positions an idea at the verge or extreme of technical expectation, not as virtuosity, but rather as the play of new possibility against existing practice. The technical challenge is something always to be surmounted, and then dispensed with, gotten over, leaving no residue of interest in the object. The artist remains uninterested in the objects as objects per se. He may become entranced by qualities – glass as a vehicle for light, reflection, refraction, luminescence, glow. He may become intoxicated, as if by narcotic effect ('narcotic', deriving from Narcissus, the flower, from its chemical effect). He may become intrigued by the alluring duplicity of a technique like casing, in which successive glass layers create illusory colour or depth, essentially false appearances.

However complex, or contradictory, in circumscription, composition, and surface, Michael Petry's work in glass succeeds as a knowing and measured attempt at creative trans-formation, or transcendence, through the direct invocation of light and through the bright physical qualities of our essential mortality. For, as Leon Battista Alberti wrote:

> …From the composition of surfaces arises that elegant harmony and grace in bodies, which they call beauty.

## '…something rich and strange.': The Kiln-worked Glass of Keith Cummings

It is through a technique of endless patience, with irresistible pressure and sustained chemical attention, that fossils form in the natural occurrence of a mould-making process that seems to record a profound transaction between our organic and mineral lives. As children we split stones eagerly to prise

apart the negative casts and Cambrian patterns of their primitive, marine forms: perfectly appointed, and with sedimentary precision, in their every detail. Assertive, minute forms; saturated in time; experienced as pre-history; post-organic: immortal.

Perhaps this childlike recognition has always gathered deeply within our biochemistry - 'those are pearls that were his eyes' as Shakespeare's Ariel sings , 'of his bones are coral made'.

It is within this secretive algebra that any individual encounter with the work of Keith Cummings will find its natural equation: of intense wonder; obsessive material qualities; complex, constructed forms; sophisticated, multiple techniques; intimate local details; and of long implied histories, or endurance. These kiln-formed glass and metal objects seem to bear the hallmarks of some inscrutable alchemical process. 'Nothing of him that doth fade,/But doth suffer a sea-change/Into something rich and strange.', as Ariel's lyric closes.

As its title suggests, Wrack (1994) could indeed derive from The Tempest, meaning shipwreck, seaweed, rubbish cast ashore, ruin, overthrow. This small-scale glass, bronze and copper construct has the patina and feel of something dredged up from the ocean floor after long salt immersion, attended by shell forms, growing outward by crystalline marine accretion, splitting its horned case like a seedhead opening. A fossil, then, or seed form? Organic or mineral? A drowned implement? A ritual artefact, a mark of political office?

An earlier piece, Mariner (1987) presents similar ambiguities of form, and a characteristic integration of ammonite, marine vessel, and implement forms. Mariner introduces a string of 'instrumental' titles (Cutter, 1989; Ice Trigger, 1993; Sleeper, 1996; Garner, 1997; Rigger, 1998) in which function is implied as dormant or transcended component, and in which verbal ambiguity serves to stimulate our imaginative handling of the object. A cutter can be a fast seafaring vessel, or a sharp implement; a sleeper is at the same time a dormant figure, a timber component of a ship's architecture, and an earring; garner means harvest, gathering, storage; a rigger is both nautical equipment and an extended sable paint brush.

Sculptural in idiom, as decorative glass and metal objects on a domestic scale such works appear ambiguous, self-reflexive, strangely preoccupied, essentially private. They seem to work directly counter to the prevailing current in contemporary glass, against the vogue for filtered transparency and yet bigger, more extrovert, even shinier objects. Opaque and introspective by contrast, their accessibility (or otherwise) depends upon skilled reading of highly complex surfaces . As Cummings himself put it, in a 1993 interview:

"I think that craft objects are destinations, objects of contemplation. That's why craftspeople are passionate about nuances of texture, of surface. For me, also, craft objects work best in a domestic situation. I want to create a decorative nucleus within a room."

This distinctive oeuvre is currently one of the most reticent, and best-kept, secrets in contemporary British glass.

Cummings trained in Fine Art under Richard Hamilton and Victor Pasmore at Durham University from the late 1950s, acquiring a creative disposition towards constructed form and the synthetic use of multiple and diverse materials which has shaped his sculptural practice ever since.

"…my choice and development of kiln-formed glass as a primary method of creating form and assembling it with cast bronze and fabricated metal sections… has enabled me to create a drawn-out, many-staged process within which many opportunities present themselves for creative feedback. Possible new formal directions are spread across many processes, from wax to final assembly…I realise that I often deliberately court this process by delaying decisions to allow for maximum evolutionary change to occur…Klee's statement that 'formation is more important than form' has always seemed particularly true to me… In adopting a method that is long drawn out, complex and slow, I gain a creative process that suits me, but…I produce only a few pieces a year"

If this reads as something like a declared poetic (literally: a creative making process) it is clear that, in Cummings' work, a kind of open-ended dialogue with materials and processes, and the imaginative or contemplative possibilities they give rise to, radically informs decisions about construction and assembly at every turn. It is a technique of 'informed risk' rather than 'unbridled chance'. And if the finished 'craft object' is, in his terms, a kind of destination, then it is the formative process itself that presents a sequence of dynamic thresholds en route. We reconstruct these possibilities, through technical and imaginative contemplation, in our encounter with the finished work. Drawing seems to work similarly not as blueprint but as orientation or direction-finding.

Object precedents, in for instance enamelled artefacts such as the Alfred Jewel in Oxford's Ashmolean Museum, or ancient ritual objects, torcs and body ornament, also present points of creative departure rather than fixed references (e.g. Torc, 1991; Torc, 1996).

Only a very shallow reading of Cummings' work would mistake its visual language for that of contemporary 'science fantasy', to which it is sometimes superficially compared. Iconic in their material richness and technical achievement, I think these sculptural objects function within an unorthodox, contemporary, three-dimensional expression of the icon craft tradition.

Icons (      meaning image) function as portable meditative technology and tools for communication within Eastern Orthodox practice. They provide windows or doorways to spiritual perception through which we gaze or pass in contemplation. As constructed layers of glaze, mineral pigment, wax (later egg tempera), gold leaf, red or yellow earth bole, gesso, linen, and wood, they occupy the physical threshold of divine grace and human need, and access the repeated journey of the interior life. We damage the complex, layered icon function where we allow its object status as fetish, commodity, or 'art history'. We obscure the icon function through the sugarings of false sentiment.

With Rigger (1998), el cos es comunica amb l'exterior a través de la seva superfície  (The body communicates with the exterior through its surface). Veins of thinning threadwork in copper wire, borrow from the language of body ornament, ship's rigging, botanical seedheads, almost containing the outer skin of an opaque crystalline mass, itself the vitreous secretion of external skeleton. What it shows, presents at the surface, is drawn from obscure origins and from an opaque, inscrutable interior.

The construction is perfectly balanced and complete, at rest as a fully considered three-dimensional form. It has the equilibrium and surface tension of a tear held in the eye, the architecture of a tear not shed but held deliberately in position.

So what holds together all these local events at the complex surface? What prevents the artefact from spilling into kitsch, as a saccharine accretion of gems and qualities, of gorgeous emptiness?

Perhaps such questions are more properly addressed to the viewer, rather than the object. And how might the artist respond to such questioning?

"I make my work for myself and I am always amazed when it appeals to someone else."

**Touchstone**

Between his 1996 solo exhibitions in London, Hamburg, and San Francisco, and his May 2000 show at the Maurine Littleton Gallery in Washington, the British glass artist Colin Reid chose to resist the singular pleasures of 'one artist' exposition in a sustained and deliberate effort to invent new directions for his work. I mean invent rather than evolve, or guess, or determine, and Reid's quality of invention is in a sense the true subject of this essay, scanning almost a decade of creative development.

Reid's path has drawn him out of the closed gallery space and into corporate or public environments for the location of new work on a more ambitious scale. More recently it has taken him outdoors into the English landscape with River Rocks, a Public Arts commission for the new River Lune Milleniun Park in

Lancashire.

With this latest installation, shown here in the catalogue, it would be difficult to envisage a location or an environment more removed from the clean shelter of a contemporary gallery space. The quality of exposure here is new and striking. Reid has positioned three cast boulders of sand-blasted optical crystal upon a stone outcrop at the river's edge, held by 20mm steel studs pinned and chemically bonded to their bedrock. Their surfaces are sand-blasted to opacity, with raised ridges ground and polished back to transparency.

The installed work has been adopted as landscape furniture by walkers who sit and rest upon the luminous refractive objects, which the river in spate will submerge to a depth of three metres, sinking jewels in the stream, and introducing the river itself as agent or technique in an extended 'making' process. In time, the river will change the work, evolving it through bruising, erosion, debris, algal growth, perhaps to the point of fracture or eventual destruction.

River Rocks marks, as it were, a tidal margin in Reid's recent development.

Where earlier work had appeared more determined, even pre-determined, by external drivers such as gallery deadlines or the uneasy creative dependency of supply-and-demand in the art glass market, Reid's new landmark pieces have about them qualities of enquiry, discovery, or recognition, and engage with the imaginative difficulty of seeing new material possibilities of scale, technique and risk through works made in a new idiom, sometimes against the polished commercial grain of the gallery scene.

It was not that Reid had withdrawn from the exhibition circuit, and he continued throughout the 1990s to maintain an international profile through group shows with a small number of galleries throughout Europe, in the USA and Japan, working 'with owners I respect and like'. But over the last decade new work to commission has opened up a fresh scale of creative invention in Reid's sculptural work, breaking the dynamic of introspective pursuit of a single direction, and enabling the production of, in his own words, 'not just another Colin Reid'. These significant commissions have provided a breathing space, extended Reid's technical range, opened new optical properties and possibilities of scale in his use of the material, and supported imaginative experiment.

Colin Reid established early success with a characteristic line in drip-cast table sculpture and perfume flasks or vessels of much smaller scale. As self-contained abstract forms, these pieces explored the artist's continuing preoccupation with primitive human, or naturally-occurring, geometrical motifs - the circle, the spiral, the pyramid, the cross – or with geological qualities and materials, chiefly volcanic in nature. A small group of pieces dating from 1992 are included in this show, works such as R460 and R659 providing, as it were, points of departure for more recent imaginal destinations.

These apparently distinct visual tendencies or associations - human and mineral - may sit closer in imagination than we might casually assume. Dip into even the most straight-laced of textbook geologies, and you connect immediately with something of the imaginative, cross-cultural force of this igneous, volcanic matter. Take, for instance the glassy basalt threads known as Pele's Hair:

These filaments of basalt glass form when particles in a molten lava spray are caught by the wind and drawn out. Pele is a mythical
lady, believed by native Hawaiians to reside within the volcano Kilauea.

This short caption to this amazing slide identifies physical, mineral evidence of the play of primeval weather upon the poured outcrop of the earth's molten skin, its surface edge, and signals the respective human appropriations of myth and science that attempt to name its condition.

Reid has never sought to develop detailed or deliberate symbolic associations in his work, but overt visual interests such as these seem outwardly to have defined for him a working aesthetic, and to have established formal parameters for a process of sustained technical development in glass casting. His consistent reticence with respect to interpretation or suggested meaning in his work is evidenced most obviously in their titles, which are nothing if not concise.

With the exception of commissions such as River Rocks or Bamboo Scroll, these titles consist in clipped serial numbers each commencing with the letter 'R'. They indicate the making sequence, but are utterly resistant to interpretation, and refuse to point in the least way linguistically beyond the physical piece. Whether or not the R stands for Reid, is not clear. If so, we are allowed at least that signature, the acknowledgement of authorship, with each coded work thus amounting to a piece of Reid.

The earlier, characteristic Reid line seemed in formal terms to have acquired and internalised all the graphic energy of a Japanese Edo periodseascape of the Ukiyo-yi ('floating world') school. And just as the black printed outline of a Hokusai wave marks its graphic limit by a sudden negation of that frothing white condition - eliminating perspective, stretched taut against the picture plane - so Reid's early work in three dimensions often contrasted an abruptly textured exterior cortex with the curling striations and pigmented folds of a fluid interior space, illuminated within and through a finely ground-and-polished window-plane.

Hokusai's outline does not exactly complete the wave but registers, rather, its sudden absence, abruptly containing all that loosening spiral energy. Similarly, Reid's small-scale sculptural objects are singularly frontal, self-contained or sufficient. Tension arises from the play of lucid, interior perspectives, and the simple disposition of colour, against a rough-cast outline and against strong, stable forms.

These complexities are played out at the object surfaces, at their edge limit. Works such as R659, included here, succeed in precisely this way, at its edges, at once strangely contained and yet strongly metamorphic. As Andrew Graham-Dixon remarks, on the subject of frames in the work of the English painter Howard Hodgkin:

Sculptors have always understood the importance of edges, which define precisely how form contains space....a painting's edge is its
most vulnerable point. It is where the work of art ends and the world begins. It is where the painting completes itself or,
conversely, declares its incompletion. It is where the painting...negotiates with its limits. The edge of the painting is where the
artist makes his own entrances and exits. It is the mark of his competence and confidence, his control or lack of it. Paintings
succeed or fail at their edges.

As a sculptor, choosing to work in a translucent or transparent medium, Reid frequently plays energetic interior colours, lines or veils simultaneously against a highly textured and opaque, or polished and planar frame. This balance of energy and containment works best where there is a tangible sense of surface tension in the achieved object.

Reid's rare engagements with the bowl form, and his collectible flacons, share this shaping quality, moving with just the slightest holding/containing gesture away from their central purpose of self-containment. As a vessel, earlier experiments such as R848, which combined cast glass and slate, and later developments such as R911 (in optical glass with blue copper surface patina and white gold), or R937 (optical glass with basalt), seemed to originate as much with a technical interest in the mark of the milling machine, and an aesthetic interest in the found mineral fragment as they did with an intentional bowl form. As if the bowl hollow reduces to the merest gesture, though by no means a hollow gesture.

All very Japanese, you might say, in descriptive short-hand. Of course no serious analogy is intended here between contemporary glass by Colin Reid and Japanese printmaking of the Ukiyo-e school, or the paintings of Howard Hodgkin. Nor does occasional commentary on Reid's work by direct reference to geological sources - particularly to volcanic materials - rise often above the level of critical impressionism. It is, though, interesting to note how some of

Reid's aesthetic choices pre-date or anticipate, say, his formative experience of Japan, while other choices engage more immediately around a starting-point in the natural world or in diverse human cultures.

A year in Auckland, New Zealand, as artist in residence at Carrington Polytechnic from 1990-91, provides a strong case in point. The sheer physical beauty of the natural environment, clear crisp light, and the strong presence of Polynesian culture, may in various ways have delivered a new working environment, but you would search in vain for overt or defining reference points in the work itself.

Auckland, built upon a plateau of basalt lava, provided not a formal occasion for research, nor a literal foundation in natural history, but rather the simple analogy, through melting and cooling processes, of glass and basalt, and an opportunity to work in new materials, namely basalt and sand.

Basalt in its contrasting blackness, and glass ash density, in the unique way in which it resists light. A touchstone. Basalt, from the Greek word basanos, meaning 'touchstone'.

There is a natural economy in Reid's approach to making, trading extreme openness (to an environment; to a commission) with another kind of sufficiency in respect of knowledge. As he put it, "I don't look at the meanings…it is the form: how I respond to that. There's no overt message." In his technique of invention, a lively and enquiring creative mind intelligently avoids 'finding out too much'. The break point occurs on a scale of sufficiency where a surfeit of information might disable invention. Because, essentially, he insists, 'glass is my field'.

Statements such as these identify Colin Reid within a craft tradition in which, necessarily, the act of making comes before the process of understanding: where the making process itself provides a kind of cognitive method. Ideas are developed through three-dimensional models, maquettes, or found objects. Drawing plays a limited part in this process, which has less to do with design than it does with enquiry, vigilance or invention in three dimensions. A way of seeing, if not of participating in the world. A world in which:

> …trusting in a craft tradition, the artist thinks of himself as a maker, not a creator; as the supplier of something that is
>
> needed…not as the unacknowledged legislator of mankind.

Working to commission, as the supplier of something needed, represented a new kind of challenge, or negotiation, within Reid's work. In 1996 a large-scale Standard Life commission for the East India Company buildings in London drew on a historical awareness of trade links with India and China, resulting in two new works combining glass with pigmented wood. The India piece develops the motif of a lotus flower in black and white, constructing cast crystal blocks into bent wood laminate sections. The idea for the China piece began with a simple joinery detail, that of perpendicular timber-frame building construction, again contrasting black wood with white optical crystal casts.

These works address questions of scale and construction at that stage unprecedented in Reid's work, and their themes evolve through simple binary opposition: of wood/glass, light/dark, black/white, positive/negative, but nowhere overtly the symbolic reciprocation of yin and yang.

Reid has also extended his technical range in large-scale casting through manufacturing commissions, for example to provide cast glass plinths for ancient standing stones at the National Museum of Scotland. A technical exercise, you might think; an ostensibly practical arrangement which however occasioned renewed attention to the adjacent qualities of glass and stone. On the surface a routine production job, this modest commission quietly combines a number of strong lines in Reid's work.

These themes include a governing technical preoccupation with the making process, working consciously into the optical properties of the material; the counterpoint of glass and stone; a point of departure in the external world, in this case the early Christian culture of the Western Isles; and a crucial interest in found object, often integrated within the finished piece.

Reid's work with found objects, principally of wood or stone, begins with an act of recognition or seeing: "to find an object is quite difficult in the first place, to see the way in which it could work". His approach is neither ludic, in the wake of Picasso, nor subversive, after Duchamp. In intention it differs radically from that of another contemporary British glass artist, Diana Hobson.

Reid has made a continuing sequence of pieces dating from 1997 working with found wooden strips, fragments of up to a metre in height or length, specifically the worn sections of a dismantled Elizabethan fence, its scarred and drilled oak fibres recording a form modified over several hundred years by successive human purposes and indefatigable English weather. The scraps of weathered oak were salvaged from restoration work at Charlecote House, near Stratford-on-Avon in Warwickshire.

In Reid's hands, such objects are found and then applied, assembled, transposed, within a new construct. Reworked as glass casts, or wholly re-integrated with duplicate glass positives or negatives, the human associations are simple, workaday and anonymous: those of making and of use.

In the case of R803, a cast has been taken from the original form – a large knot of hard oak through which a mortise joint had been cut, the tough wood enduring where the softer grain had worn away on either side. There is some evidence that the timber in question had already been reclaimed from some previous structure, and the piece has therefore undergone several 'incarnations', in the hands of unknown carpenters long since vanished, before entering a new purpose in the work of Colin Reid. The section is mould-cast in optical crystal with fused copper patina, a luminous and fluid mineral replica of the original organic fibre.

The work is completed by a tenon piece of the original oak, very deep-grained and blackened. The design thus enacts a meeting, a matching, or inter-section of contrasting qualities, rehearsing innumerable handlings and making a subtle resistant object out of time.

Compare the bronze juniper branch of Diana Hobson's 1994 piece, Talking Stick. In this work the found branch lingers as a spectral presence in finely cast bronze detail, authenticated by personal experience, though ultimately transformed. Here the original medium is transcended, left behind, as the artist's attention moves through and beyond its stripped-down and originating moment of recognition.

Where Hobson translates the found object, Reid interprets, or re-interprets it. Hobson's art seems to invoke a presence, or enact a threshhold, where Reid's central preoccupation is with location and use. As Wittgenstein wrote in Philosophical Investigations, 'Let the use teach you the meaning.'

In the summer of 1999 another significant commission come to fruition with the installation of Bamboo Scroll, a 4 metre-high glass and steel sculpture, as a permanent feature of the main entrance hall of the new Shanghai Library, the third biggest library in the whole of Asia, and the largest public library in the world. It was the culmination of a 3 year project negotiated by the School of Art & Design at the University of Wolverhampton, where Reid is currently engaged as a Visiting Professor.

The concept for this sculpture takes as a point of departure ancient Chinese literary artefacts, namely engraved bamboo strips bound together and forming a kind of flexible scroll, of the kind developed by scribes during the Western Zhou dynasty (1045-770 BC) as an earthly archive, the counterpart to the cast bronze inscriptions adorning the inside surfaces of vessels which were intended as a spirit offering.

The brief may have been unconsciously informed by the bamboo scaffolding that filled the library as a building site in April 1996 when the project first took seed. Chinese written characters are incorporated within sand-blasted cast optical crystal blocks in raised and polished relief, providing cursive transparent windows into the light medium. The glass is held in a parallel ribbon structure of flame-cut and patinated steel.

The Chinese characters derive from engraved print originals, reversed out in raised relief through the mould making process, and they comprise a loosely ordered series representing elemental natural and human qualities. This is not a text as such - there is no woven narrative connection within the word sequence - but the layered disposition of Chinese written characters has clearly influenced the overall composition of the piece. This is in a sense Reid's first engagement with written symbols as 'found objects', and it is the visual energy of these characters rather than their linguistic meaning, that stands foremost. Physically and metaphorically speaking, the characters hang luminous and illuminated in the light of day. Material precedes meaning; making comes before knowing.

Reid's attention to the site of this work, his response to the library as a location, its cultural purpose, the eventual elevation of the installation against a great curtain of daylight, and the central well space of the entrance hall, characterise his technique of invention. A technique that travels light, wears its learning lightly, and has resulted in a major work which draws deftly upon two cultures, winning immediate acceptance in both.

The present exhibition may well span the best part of a decade in Colin Reid's creative development, but it does not have the feel of a 'retrospective'. Collectively, these works reveal more a convincing sense of 'work in progress', determined by compass points far beyond the gallery horizon, both purposeful and open-ended, and moving on.

## On Making: Towards a Glass Poetics

The Ausglass 2003 conference counterpoint of collaboration (literally co-laboration, 'working or labouring together') and isolation (literally 'the island condition; being cut-off from the main') might at first have appeared to offer a simple choice between diametrically opposed positions, perhaps within an implied hierarchy (i.e. collaboration is 'a good thing'; isolation is bad for you). But this does not mean that these positions are mutually exclusive, for - as the English Romantic poet and visionary William Blake also wrote - 'Without contraries, there is no progression.'

The images that accompany this text are drawn from collaborative work in contemporary glass at the University of Wolverhampton, in industrial, international, and academic contexts, including previous work from my time as Head of Design and Development at Dartington Crystal.

But in this shortened version of my Ausglass keynote lecture I shall argue that, in practice, this dialectical or oppositional process is essential to creative learning and development, and applies to us equally as makers and as users, viewers or readers of contemporary glass. And, what's more, that the work of 'reflective practice' includes successive or simultaneous acts of creative reading that constitute not a theoretical, nor a critical, but a poetic dimension to making. In glass, this may occur in the reading of surfaces, of line and movement, of edges and limits, of temperature, structure and dimension, change or metamorphosis, throughout the creative development process. As the poet Robert Sheppard puts it:

Poetics, of necessity, makes its practitioners creative readers, as well as writers.

I would like to develop and defend this concept of poetics, as opposed to theory or criticism, and Robert Sheppard might as well continue as my first witness:

Poetics is a secondary discourse, but it is not 'after the event'; it doesn't simply react to making. The making can change the

poetics; the poetics can change the making.

For me, the key ingredient here is change, or metamorphosis. And change is also, I would argue, the essential characteristic of all learning: insofar as anything worthy of the name induces some form of identifiable change in the learner.

And glass, as what my colleague Keith Cummings calls a 'chameleon material', is capable of extremely dynamic shifts in all these terms, and in more-than-three dimensions, encompassing as it does both exterior and interior form and opening up perceptual depths and imaginative possibilities to which other materials cannot easily approximate.

'Reflective practice', what the French poet Paul Valéry might have called 'a specialised application of the mind', is continually comparing information received in the act of making with an idea, a mental image or intention, through in-tuition, learning as it goes. And without contraries, remember, there is no progression.

So, in this spirit, allow me to be contrarious or adversarial, and play devil's advocate for a moment, in caricaturing the 'clear and present danger' that, in its comparative isolation from other contemporary art forms or art practices, and from wider cultural, or cross-cultural perspectives, the world of contemporary glass risks settling for what it already knows. Settling for that which has merely proved successful. That contemporary glass risks containment or, worse still, a kind of self-delusion, for, as the Italian poet Giacomo Leopardi wrote almost two hundred years ago, The most certain way to conceal the limits of one's own knowledge is not to go beyond them.

The risk here is of negative isolation - inward-looking, glassy and rather beguiling - the mirror-culture of Narcissus, in European mythology: the youthful figure of astonishing beauty that drowned in his own image, reflected in a glassy pool.

Given our thematic context of collaboration and isolation in contemporary glass, one identifiable hazard would seem to be a risk that a blinkered, naïve or disingenuous account of making could develop within a closed critical culture that fears to stray beyond its known limits. Or that an introspective, or self-regarding culture, by critical default, would promote making as an end in itself, or as a rhetorical posture, as a means of critical evasion, perhaps, or as a 'crafty' sleight-of-mind.

Put crudely, there is a danger that contemporary glass risks, as it were, disappearing into its own ars (Latin - ars, artis: a feminine noun, signifying skill, craft, science or learning acquired as the result of knowledge and practice. Meaning also artifice, and interestingly,fraud.). My assertion is that there is no such thing as 'simply making'.

But there are worse things than rhetorical postures of course. For instance, there is bad poetry which, believe me, is much, much worse. Bad poetry can originate in bad poetics, a word we derive from classical Greek. And, as poetics is a declared theme of this article, perhaps I might usefully define this term, with the careful health warning that, as the cubist painter Georges Braque acutely observed: to define something is to replace it with its definition.

By invoking the term 'poetic' I am keen to restore something of its original sense of a technical, creative process, and to strip away what seems these days a commonplace corruption of the word, in its lazy adjectival form, to mean 'imprecise', 'exaggerated', 'decorative', or 'merely sentimental'.

The sense of poetry as artifice, of the poem as artefact, is here implicit. In fact that is technically what the word poet originally signified, what its Greek root **ι**** **ή** (poiētēs) means, and what poetry, **ί**** ***σις (poiēsis), is: from **ιειν (poiēin), to make. The poet is, literally, a maker. Thus psychiatrists speak of autopoesis with regard to the making of self, and musicologists invoke the term poietics with reference to the compositional dimension of music . As the American poet Robert Duncan wrote, in an essay entitled 'The poetics of music: Stravinsky':

Poetics is the contemplation of the meaning of form: it is what is common to painting, sculpture, music and poetry. Poiein,

Stravinsky reminds us, means to make. We might keep in mind that, in the days of William Dunbar the poets were Makeris.

Makeris, or makers, was the name by which Scots troubadour poets of the 15th century court lyric tradition, including William Dunbar (c.1456-c.1515), were known.

This idea gained currency in twentieth century writing, and in critical writing such as the late Veronica Forrest-Thomson's book Poetic Artifice , but so radical (i.e. rooted) an idea cannot be reduced to the matter of a simple technical or artisan allegiance, as at first it may seem. In the way of personal investment, the stakes could be high. Here for instance is the German-language poet Paul Celan, born Paul Antschel, a Rumanian Jew, writing after the holocaust in the language of his oppressors:

…craft, like cleanliness in general, is the condition of all poetry. This craft most certainly does not bring monetary rewards…it
has depths and abysses…
Craft means handiwork, a matter of hands. And these hands must belong to one person, i.e. a unique, mortal soul searching for its
way with its voice and its dumbness. Only truthful hands write true poems. I cannot see any basic difference between a handshake and
a poem.
Don't come to me with poiein and the like. I suspect that this word, with all its nearness and distance, meant something quite
different from its current context.

So, here we have poiēin, making, poetics: a process invoking nearness and distance; and the idea of truth to (and truth through) the material, with all its depths and abysses – in Celan's case the material of the German language after Auschwitz.

We notice Celan's concern here for the 'matter of hands…truthful hands' - that is to say, of truth to, and truth in, the act of making. His commitment to the authenticity or integrity of craft, is both tangible and pragmatic, and amounts to a critical, even ethical, preoccupation with signature: with the individual mark in all its human fragility.

A matter of hands, of knowledge acquired, and meaning created, by touch. I am reminded that most English pewter was struck with a maker's personal hallmark, known as his 'touch'.

Inescapably, the currency of the Greek word **ιειν (poiēin) will for 2½ millennia have shifted in value and meaning, across all kinds of nearnesses and distances, but the poet remains a maker and their method, as distinct from theory, is their poetics.

But if, as I am suggesting, a narrow or blinkered account of the making process has long proved simply untenable, and if we have by now seen through the false innocence of making as an end in itself, in what critical values might we now place our trust, and with what kind of poetics could we begin to articulate and inform contemporary glass practice: both in the beneficial isolation of its characteristic and unique qualities, and in the collaborative context of wider, more discursive visual cultures? I'd like here to introduce the writer Gabriel Josipovici:

Trusting in a craft tradition, the artist thinks of himself as a maker, not a creator; as the supplier of something needed, not as
the unacknowledged legislator of mankind.

In these terms, Josipovici steps back from the English romantic poet Shelley's high romantic claim for poets as the unacknowledged legislators of the world, but retains Shelley's emphasis, in A Defence of Poetry (1821), on the poet as maker . He identifies a distinctive post-modern tension or difficulty in relating the work of contemporary artists simply and directly to a craft tradition, and poses essential questions for object-makers at the close of the twentieth century:

…the spirit of suspicion has at some point to yield to the spirit of trust – trust in the material, trust in our abilities, trust
in the act of making itself. The problem is how to keep suspicion from turning into cynicism and trust from turning into facileness.
Trust without suspicion is the recipe for false and meretricious art; but suspicion without trust is the recipe for shallow and empty
art.

In rejecting the kind of freewheeling post-modernism that would appropriate all traditions - which in contemporary applied arts might render craft content as at best therapy, at worst sentiment or mere indulgence - Josipovici retains an urgent and pervasive sense of lost innocence. He refers to something the Irish poet William Butler Yeats dramatised in a poem from The Wild Swans at Coole (1919) :

Hic.          And I would find myself and not an image.
Ille.          That is our modern hope, and by its light
     We have lit upon the gentle, sensitive mind
And lost the old nonchalence of the hand;          [my emphasis]
     Whether we have chosen chisel, pen or brush,
     We are but critics, empty and abashed…

If that 'old nonchalence of the hand' is no longer available to a modern, let alone our post-modern, condition, then the simple invocation of a craft tradition would appear to take a form of denial, a facile act of infantile escapism, a meretricious business, all sugary with false sentiment. A case of empty poetics.

At the same time, 'suspicion without trust' might be a recipe for shallow art, for propaganda, or tick-box significance. Programmatic work, in other words, and conceptual one-liners. A case of bad poetics.

Almost exactly contemporary with Yeats's poem, an early leaf from Georges Braque's private notebook of 1917-47 contains a graphic insight into this methodological dilemma. Beneath the crude outline of a bone form he writes in longhand, both word and image carrying equal weight upon the page:

Le peintre pense en formes et en couleurs, l'objet c'est la poetique.
[The painter thinks in forms and colours, the object is his poetics.]

Braque's preoccupation with painting as a thinking process, his identification with the object as poetic in-formation – a bone; a jug; a still life, say – determined a complex poetic engagement with reality which was very far removed from any derivative act of imitation, or a merely descriptive trade in images:

Il ne faux pas imiter ce que l'on veut créer.
['You should not imitate what you want to create'].

The work is a deliberate process of attention, reflection and discovery within the creative act of making art – difficult, and without innocence.

Ecrire n'est pas décrire. Peindre n'est pas dépeindre.
La vraisemblance n'est que trompe-l'oeil.
['Writing is not describing, painting is not depicting. Realism is just an illusion.'].

If, as reflective practitioners in glass, we have indeed lost the old nonchalence of the hand then, according to Gabriel Josipovici, in that fall from innocence what we now risk is facile sentiment or cynical distortion through art. Inauthenticity in the act of designing and making.

## Salamander: for Silvio Vigliaturo

Lustre, which in reality moves over the surface of things as the spectator moves, is played down in favour of the broader, more stable,

architecture of colour; surface shine is renounced in favour of internal glow, and transparency purged of lustre is reified in colour.

Paul Hills, in his richly absorbing thesis Venetian Colour, from which our epigraph is taken, cites the art historian James Ackerman in remarking upon a shift, in the aesthetics of late quattrocento Italian painting, 'from Alberti's notion of colour as a property of the objects to Leonardo's of colour as generated in the eye', identifying Alberti's view of pictorial mimesis as 'object-centred', whereas:

> … for Leonardo painting was a record of things seen by a subject – crucially affected by point of view and by atmosphere between the surface seen and the eye. But this model of the shift in the conception of mimesis between Early and High Renaissance fails to take sufficient account of how colour that is non-descriptive gets framed within a representational context, thereby transforming the merely visible into the meaningfully visible.

Well, I admit this might appear at first glance a rather strange place to begin these very brief reflections on the glass sculptural work of Silvio Vigliaturo. But this little lesson – in Venetian colour; in the act of looking; in how and where exactly the eye comes to rest in the vitreous exchange of luminosity between surface lustre and deep transparency – all of these observations seem to offer, to my mind, a sharper and more focussed insight into Vigliaturo's work than any passing graphic affinity the work may have with that of modernist masters such as Chagall, or Picasso or Mirò.

Paul Hills goes on to contrast the quattrocento use of colour subdued (for the purpose of pictorial modelling), or finely graded (to indicate the edges and angles of things), with colour that lay beyond the boundaries of the figure – that is to say, colour released from the full accountability of descriptive reference. This vibrant colour 'field' was an intrinsic quality of Venetian glass, and was to transform the symbolic order:

> In Bellini and Titian, as in glass vessels, the arcs and scherzi of colour create space which – far from being plotted and pinned down by linear perspective – is alive with curvilinear energy.

An adequate account of Vigliaturo's work in these terms must await a more extended thesis, exploring in greater depth the central significance of emergent colour within the phenomenology of the artist's making processes – his distinctive poetica. For the time being, however, these observations on Giovanni Bellini seem to take us quite close to the direct visual impact of Vigliaturo's figurative glass structures.

I mean, of course, the experience of colour folded into its own radiance.

Of colour constructed as, simultaneously, both 'figure' and 'field'. Colour saturated in something other than descriptive function or decorative convenience. Colour that resides in the act of seeing, rather than the inherent properties of 'things-as-they-are'.

Colour, to borrow a phrase from Maurice Blanchot, that appears:

> …to make of the work a road toward inspiration – that which protects and preserves the purity of inspiration – and not of inspiration a road toward the work.

As visionary artefacts, in their translucent figuration, Silvio Vigliaturo's works are iconic windows or lenses upon the textured opacity and sheer radiance of the world we occupy, shot through with mythological forms of human attention, imagination – human narrative. Fools. Generals. Musicians. Lovers. Maternity. Angels. Devils. The god Pan himself. The dramatis personae of any number of half-remembered narratives.

Figures whose primitive energy we seem occasionally to encounter still, just beneath the surface of our daylight hours – at Cocullo in the processione dei serpari, perhaps; at the festival of the mamuttones in Barbagia. In the writing of Roberto Calasso. At the movies.

As I ventured to say previously, a more enduring account of the expressive significance of Vigliaturo's work awaits an extended exploration of the raw phenomenology of the artist's making processes – his essential poetics – in and through the fierce radiance of the fused glass medium that is his continuing preoccupation. Chroma. Figura. Anima. But what kind of figure is the artist himself?

In my mind's eye I imagine Silvio at his studio in Chieri, looking into an opened kiln at the molten figure inside, attentive, taking in the shape and impression of it, preparing to add some metal leaf, perhaps. The figure returns his vivid gaze. It is a kind of salamander, as the Oxford English Dictionary defines it – 'A spirit supposed to live in fire (1657)'… 'ever in the fire and never consumed'… 'an emblem of constancy, represented in flames'.

But I am digressing once again, and think perhaps that I might now have confused the figure of the artist with the molten liquid mass of the work itself.

A great spirit, able to live in fire. A certain constancy, represented in flames.

## The Ranamok Glass Prize, 2003

Now in its ninth year, the RFC Glass Prize, re-established two years back as Ranamok, is surely one of the best-kept secrets on the international contemporary glass scene. Under the beady collector's eye of its now familiar magpie logo, this luminous road show convenes all that a discerning panel of four judges agree to be the year's best work in contemporary glass from Australia and New Zealand. And dependably, once again, they have done an excellent job.

For Ranamok 2003, 37 finalists emerged, with 42 pieces exhibited, by a process of blind slide selection from a strong field of some 124 entries. I had thought last year's show, which I saw at Craftwest in Perth, a revelation: simply the most interesting and diverse exhibition of contemporary glass that I had witnessed in a long while. Ranamok 2003 is its equal.

The work on view here is consistently of the highest quality, and evidences real energy and excitement on many levels - in terms of its range and diversity; its aesthetic ambition; its openness, and inclusiveness; and its technical achievement. For all this shared range and diversity, as was clearly evident with last year's show, Ranamok 2003 holds a remarkable degree of coherence, and would appear to add up to something tangibly more than the sum of its constituent parts.

That is to say, it seems to represent a distinctive and recognisable creative community of glass interests in this part of the southern hemisphere, backed in turn by the formidable commitment of Maureen Cahill and the Glass Artist's Gallery, and Andy Plummer of Eureka Capital Partners, and underwritten by an impressive range of partners and sponsors.

The formative rôle of glass departments in Higher Education institutions also reads like a continuous signature throughout; and that of the artist associations, and Craft institutions, completes what amounts to a critical consortium of commitments - each informing this self-evidently vibrant sector of what is increasingly these days referred to as 'the creative industries'.

Ranamok 2003 is a celebration of sheer visual energy in glass. The cool mineral excitement of this wide-ranging show is alive with colour incidents and sudden optical events arising from the most sophisticated relationships of form and surface, employing multiple, and often contrasting, techniques within the span of a single object.

The most successful of these works evoke a powerful figural presence, and create or organise the physical spaces they occupy - arguably an attribute of even the simplest of human artefacts, but intensely so here. For so many of these objects have a formal resonance beyond their actual, physical scale - a phenomenon that bears further exploration in the form of digital images scanned and manipulated on a computer screen.

Often new kinds of space are created between the gaps, as it were, or in the counterpoint with which constituent elements articulate within a given piece. The way, for instance, that Kirstie Rea's kiln-formed, wheel-cut Rosette I draws spokes of white light away from a central nimbus of bright amber, itself the product of a simple disposition of points in space defined by the tips of placed glass tines.

Or the way the facing edges of Charles Butcher's mould-blown and cold-worked piece, The View from Corunna, produce an airy ravine of light, cut by sail forms – a fluid and empty triangulate void, edged with soft razors.

Or, beyond their colourful exhuberance, you encounter this new dimension in the unexpected density of Laurie Young's casts with inclusions, Kamaaina and Da Kine, that unsettle our familiar relationship with personal effects - here associations with clothing – thickening as these works do into luminous garments, garments of light that never were woven and never will be worn.

And it is in these terms, as a sensuous apperception of space within a single sheet of material, that Christine Cathie's work speaks for itself. If you had a moment's doubt about that, her catalogue entry for S will set you straight, with more sinuous consonance and slinky 's' sounds than Susheela Raman singing 'Trust in me....'.

I could go on, and on, for practically every single object here would bear reflection. Daniela Turrin's kiln cast crystal wall installation, Hover, for instance, creates a kind of 'hesitation' in three-dimensional space, pointing through and beyond the phenomenal world and invoking the French philosopher Maurice Merleau-Ponty on the relationship between concave and convex planes, 'the solid vault and the hollow it forms...', as the bond between the soul and the body.

Indeed there are various kinds of alchemies at work in Ranamok 2003, practical alchemies, working attentively and immediately with the fluid and luminescent spirit of the material, as Alberti might have put it, 'for the reception of light'. Working in ways that share with alchemical practices an uncompromising commitment to thinking in and through substances and processes. Thinking in glass, this time, as our earliest synthetic material, and as a process in constant flux.

> As the substances mingle and fuse, they become purer, stronger, and more valuable, just as the soul becomes more holy. The philosopher's stone is the sign of the mind's perfection, the almost transcendental state where all impurities have been killed, burned, melted away, or fused, and the soul is bright and calm. Alchemists paid close attention to their crucibles, watching substances mingle and separate, always in some degree thinking of the struggles and contaminations of earthly life, and ultimately wondering about their own souls and minds.

Glass of the calibre represented here seems often poorly served by words, and it is perhaps time for a sea-change in the critical reception, or reading; or in the poetic dimension of contemporary glass.

For, as I have argued elsewhere , it is poetics, and not criticism or theory, that can provide a discursive dimension to making. But in much commentary on the contemporary applied arts there is manifest tension between word and image, or between the ambition of the work and that of the word.

Suffice it to say that there is a great deal more to speak of in Ranamok 2003, for which the small space of a catalogue could not suffice. And there is a curious paradox here.

I doubt that the domestic Australia-New Zealand market could be anywhere near sufficient to absorb or accommodate the combined creative output of even the thirty-seven artists represented here, let alone the significant work of those who didn't quite make the shortlist this year, or those that didn't put themselves forward. And yet work of this calibre can in my view compete with anything on the international glass scene today.

So what is to be done with this embarrassment of riches?

Besides the steady incremental development of individual profiles and reputations in the international collectors' market, it might be that one route to sustainability for contemporary glass practice of this quality and standard could lie in stronger state- or national commitment to the export dimension of contemporary Australasian glass, through international exposure at key overseas exhibition venues.

It is perhaps high time that Ranamok took to the wing, with its curious magpie emblem, and soared beyond that big, wide, parish boundary.

Notes

Susheela Raman, Salt Rain (Narada Productions, 2001) track 6

Leon Battista Alberti, Della Pittura (1436), translated as On Painting (1436) by Cecil Grayson, with an introduction and notes by Martin Kemp (Penguin Books, London, 1991) pp.64-5

James Elkins, What Painting Is: How to Think about Oil Painting, Using the Language of Alchemy (Routledge, New York and London, 1999) p.4

Andrew Brewerton, 'On Making: Towards a Glass Poetics', in Craft Arts International No. 59, October 2003, pp. 2-4.

## Out of Darkness... The British Glass Biennale, 2004

If the fragile history of glass can be held to consist in what is known, or can be said / of all that is available / of what has been preserved and collected / of that which has come to light / of what survives / of everything that was made.... then the inaugural British Glass Biennale Exhibition – the most extensive account of contemporary British glass in more than a decade – may be said to trace a similarly provisional though, generally speaking, less accidental, genealogy.

Unlike the 1993 Crafts Council touring exhibition, The Glass Show, this first Biennale showcase has not aimed to establish an historical survey of the current scene. Where The Glass Show, and its landmark catalogue publication Contemporary British Glass , made a summative retrospect of almost thirty years of studio glass art making in the UK, the present Biennale show had always, both in concept and in curatorial intent, a very different ambition.

As its inaugural show, the British Glass Biennale Exhibition set out to configure, in the gutted shell structure of the former Webb Corbett/former Royal Doulton glasshouse, a curated event arising from a juried competition of recent work.

In these terms this show is necessarily provisional, and it is so with a purposeful, deliberate, and possibly contentious objective – to take, just as it occurs, the pulse or measure of recent achievement in contemporary British glass, and to display this wide range of creativity within the interior confines of our post-industrial heritage.

All of the submitted work was therefore required to have been produced at some point no earlier than March 1st, 2002. In the spirit of inclusion, and with a broad generosity of aspiration, the competition took the form of an open invitation from which, frankly, only one artist was specifically excluded.

The panel would like to record a particular debt of gratitude to Candice-Elena Evans, not least for her extremely scrupulous preparation, which ensured the seamless blind-slide and anonymous digital file presentation of submitted work by some 228 practitioners (about one thousand images in all) from which the jury, over a two-day April sojourn, selected and commissioned more than 150 works by 81 artists and designers.

A group of five jurors, from markedly differing backgrounds in glass, we had from the outset adopted a rigorous protocol for selection. This proceeded by

simple majority view, allowing no abstentions and leaving thereby absolutely no room for split decisions or hung votes – but providing 'quality time', as they say, for reflection, second thoughts, advocacy, and liberal quantities of (normally!) reasoned argument.

Our method also involved the occasional outbreak of (increasingly surreal) humour – of the almost involuntary kind that develops when a small group of people has been concentrating very hard for long hours in an enclosed space.

In our defence, on such occasions, we were usually provoked – and couldn't then help rising, from time to time, to a kind of mischievous intelligence or animation that surfaced as a frequent (invariably welcome) aspect or quality of a number of works on view. This is not exactly a hallmark of the UK glass scene these days, and the full emotional range – from fairground slapstick to acid satire to tragic irony – remains strangely unexplored territory for so dramatic a medium, in these shores.

Our selection method involved reviewing, at least once, every decision we had made at the first cut, so as to confirm in each case the individual merit we were acknowledging by the final selection of work

… that reflects the highest levels of creative imagination and technical achievement across the full range of contemporary glass

practices – from architectural, installation and sculptural work to object-based work, including product design, in which glass is a

principle or significant material.

Our task concluded for the time being, this marked but the beginning of Candice-Elena's quite formidable curatorial remit – to then configure the sum total of our collective decisions as the first British Glass Biennale Exhibition, in the raw and rather poignant location of the former Webb Corbett glasshouse.

The historical resonance of this site, and its contemporary situation, could hardly have been lost on the jury members. Walking about this derelict shell, with the after-image of a thousand contemporary glass slides in all their immediate visual richness and creative vitality, and following two longish days of talking and arguing, we were suddenly lost for words.

In a few paces, and an equal number of vivid memories, I for one felt suddenly washed-up upon the dark side of the difficult reality that constitutes the present state of British glass: pulled-up sharply as if from an illusion. And although each of us walked around with their private version of this shared preoccupation, I am confident that we had not a shred of nostalgia between us.

And the work we had viewed was surely real enough.

It was, rather, a matter of recognising a difficult and contradictory, perhaps intractable, reality of our post-industrial regional manufacturing economy.

That is, to acknowledge, on one hand, the degree to which the British handmade crystal industry could not, and did not (through design or technological innovation), respond effectively to successive waves of European competitor product in the 1980s and 1990s – from the lower-cost artisan production of the Eastern states to machine crystal production of increasingly high quality from the West. And on the other hand, to witness the contrasting richness, invention, and still-to-be-developed potential, of the creative ambition and technical achievement we envisioned as the prospective Biennale show.

It is the gap between the creative ambition and the economic reality, and common elements that characterise both the ambition and the reality, that make this event to my mind such urgent viewing. I shall return to this contradiction later in this essay but, meanwhile, back to the show.

The inaugural Biennale exhibition features glass as a primary material in blown, cast, fused, slumped, forged, centrifugal-formed, flame-worked, cut, carved, ground, polished, gilded, engraved, electro-formed, mirrored, constructed and kinetic glass forms – as vessels, jewellery, object, sculpture, interior architecture, lighting, and installation, with many works involving multiple techniques and/or adventurously crossing idioms.

Of the sixty-five named artists represented in the 1993 Crafts Council exhibition, and featuring in the landmark Contemporary British Glass publication, some twelve appear in the present show. Of the eleven artists subsequently selected, by curators Alexander Beleschenko and Tim Macfarlane, for the Crafts Council's 1997 follow-up exhibition of architectural glass, Glass, Light & Space , only Harry Seager appears in the Biennale exhibition.

These overlaps, though interesting, are outweighed by the surprising, though significant, statistic, that 84% of the artists represented in the inaugural British Glass Biennale Exhibition have, for the most part, emerged during the eleven intervening years.

Truly, this has been a period of intensive change and transition: the very time in which handmade crystal manufacturing in the Stourbridge tradition entered an all-but-terminal phase. This was also the period in which glass in the Higher Education sector – the college tradition upon which Ray Flavell had written in 1993 – began a gradual but insistent decline in national applications to undergraduate programmes in applied arts and 3D design subjects such as glass and ceramics. Along the same time-line such subjects became, generally and nationally speaking, increasingly marginal to the school curriculum – as a space-hungry, resource-intensive provision, making little obvious contribution to government targets for literacy and numeracy.

Against the framework of this decade, this Biennale show stretches, therefore, a very broad and diverse canvas but, as we have noted, not yet a comprehensive survey of glass in Britain today.

Makers predominated. Where the studio sector predictably made for a strong response, current work in architectural and engraved glass, lighting and furniture design appeared curiously under-represented at the point of submission, as indeed did design for manufactured product.

Such a slender showing, in important areas of developing glass practice, came as a felt disappointment to the jury panel who would, collectively, have welcomed submissions from designers and artists perhaps notable by their absence, who chose it seems not to enter the field.

With the encouragement of the 2004 achievement, perhaps the 2006 Biennale exhibition will demonstrate a more comprehensive impression of the British glass scene to both regional and international audiences. For the time being, there is however plenty to evidence a growing ambition in terms of scale, and a more open and direct engagement with interior architecture, site, and location, beyond the closer atmosphere of the domestic object, and the steady insistence on the primacy of making.

This is necessary if contemporary British glass is to make a stronger and more sustained impact – on the international scene; on the regional development agencies; on export figures; on adventurous commissioning agencies; on planning departments and 'percent for art' schemes; on the attention of venture capitalists, business incubation projects, and the like. And on youthful creative aspiration in our schools and colleges.

That is to say: if the recent historical misfortunes of the Stourbridge crystal industry are not to be relived by a post-industrial generation, and if the shades that haunt these former glasshouses are finally to be laid to rest.

Out of such darkness, I notice, cometh many lights.

## Figura

A little way out from the land the water was frozen solid. Even the bottom was white with rime and had the thick layer of steel-ice
on top of it. Frozen into this block of ice were broad, sword-shaped leaves, thin straws, seeds and detritus from the woods, a brown,
straddling ant – all mingled with bubbles that had formed and which appeared clearly as beads when the sun's rays reached them.
Smooth, black, fresh-water stones from the lakeside were also transfixed in the block together with peeling sticks. Bent bracken stood

in the ice like delicate drawings…

Unn lay watching, captivated by it; it was stranger than any fairy story….

Tarjei Vesaas, The Ice Palace (1963)

I admire the open ambition of this show, and the definite edge of curatorial risk involved in drawing together so diverse a range of contemporary work in glass around a shared preoccupation with the human form configured in the interior and exterior dimensions of this brilliant, synthetic medium.

Because the risk here struck me as complex, in anticipation.

For instance there was the possibility that, taken collectively, our sense of what these works variously embody, figure, re-create, enact, reveal, or intend, would prove thin or one-dimensional; or that individual pieces might submerge or strain themselves in a shallow or tenuous narrative expectation.

There was perhaps a hazardous way in which so wide a range of work in glass may fail to measure, develop, stretch or test itself on an extended human scale; or, worst of all, that these assembled figures would, as it were, refuse to speak.

So, interestingly, the curatorial stakes seemed high. And in these circumstances, inevitably perhaps, we would have searched in vain for reassurances, or keys, clues, or plain daylight, even, in the artists' statements that might accompany the show. For all that we discover there is, well… quite the reverse in fact. The words in question would point invariably away from the work, leading us carefully awry of the heart of the matter, like just so many vociferous skylarks, going out on a wing to protect their nesting sites from dangerous attention in the heather.

And rightly so, in my view. For, when it comes to defining words, as the philosopher Ludwig Wittgenstein wrote:

Let the use of words teach you their meaning.'

And, as with words, so it is with art. For naturally enough visual artists have primarily to do with materials and processes, think in these terms, and this specialised kind of use pre-figures meaning.

Working in, and through, and against the glassy medium, it is only then that they find themselves engulfed by significance, perhaps, or opening to the prospect of new meanings, as the cast shadow of the self might turn and suddenly slip away, to lose itself deep in the freshly achieved work.

She lay flat on the ice, not yet feeling the cold. Her slim body was a shadow with distorted human form down on the bottom. Then she changed her position on the shining glass mirror. The delicate bracken still stood in the block of ice in a blaze of light.

There was the terrifying drop…

Unn moved, and the gliding shadow followed her, fell right across the chasm and disappeared as if sucked down so quickly that Unn flinched. Then she understood.

Her body quivered a little as she lay there; it looked as though she were lying in the clear water. Unn felt a fleeting dizziness, and then realised afresh that she was lying safely on top of thick, steel-hard ice.

Making, it would appear, comes before knowing. And, in making this catalogue text for The Visible Man, my own 'skylark tendency' (you will have noted in the epigraph to this essay) involves a subliminal hommage to the Norwegian poet and novelist Tarjei Vesaas (1897-1970). Perhaps I should explain why.

For no other writer, in my reading, can touch Vesaas for the sheer depth and nuance of sensibility with which he recreates – through the creative gaze or visionary imagination of two young schoolgirls, Siss and Unn – that impenetrable material distance (translucent, transparent even: tough as steel) which at the same time both separates us from, and connects us with, our lived experience and our sense of knowing in the world.

Hence in my epigraph we find, carefully observed, all the optical excitement of glass as a medium for human imagination. And further, in his 1963 novel The Ice Palace, Vesaas pre-figures a quite extraordinary leitmotif for The Visible Man.

This image or device is the tiny figure of Unn, losing her way within the walled chambers and complex tracery lights of an immense, frozen waterfall – the ice palace of the book's title. Unn becomes, firstly in imagination and then physically, corporeally embodied in the glassy medium, the figure of a little girl lost and frozen, suspended in its interior dimensions:

The late, cold sun retained a surprising amount of its strength. Its rays penetrated thick ice walls and corners and fissures, and broke the light into wonderful patterns and colours, making the sad room dance. The icicles hanging from the ceiling and the ones growing up from the floor, and the water drops themselves all danced together in the flood of light that broke in. And the drops shone and hardened, and shone and hardened, making one drop the less each time in the little room. It would soon be filled.

This is an image of quite astonishing, indeed disturbing, power. It appears before our very eyes to build or fabricate, workmanlike, its own perception. Indeed the image seems almost bound-up with the physiology of perception: within those translucent interior dimensions in which the object and the act of looking merge as water, ice, and glass, in shared viscosity with the aqueous and vitreous humours of the human eye:

It was a room of tears. The light in the glass walls was very weak, and the whole room seemed to trickle and weep with these falling drops in the half dark. Nothing had been built up there yet, the drops fell from the roof with a soft splash, down into each little pool of tears.

Still more of The Ice Palace later, which I shall continue to invoke as a kind of oneiric counterpoint to the exhibition. But my title, Figura, has a different origin, borrowed from a 1938 essay by the German romance philologist Erich Auerbach. He too knew and understood well that 'the use of words' teaches meaning, and his thesis may provide another way into the work collected here at Ebeltoft as The Visible Man.

For our preoccupation here is with human form, and with the human figure. Figura. Auerbach credits the Latin usage of Varro, Lucretius, Tertullian, Cicero, and Augustine in developing the words forma and figura beyond their technical origins in linked etymologies that may both surprise and intrigue contemporary glassmakers:

Strictly speaking, forma meant 'mold', French 'moule', and was related to figura as the hollow form to the plastic shape that issues from it…

From their simple artisan origins, Auerbach traces the incredible speed with which the Latin words forma and figura came to signify abstract meaning:

In…the language of Plato and Aristotle…morphē and eidos were the form or idea that 'informs' matter; schēma is the purely perceptual shape.

In Latin, forma came to be used for morphē and eidos, and figura translated schēma as outward shape. The original 'plastic' signification rapidly acquired new meaning in terms of grammatical mathematical, rhetorical, logical, musical and even choreographic form. Further meanings, including 'portait', and 'the impression of a seal in wax', entered usage. Verbal 'figures'; and usages such as 'model', and 'copy' arose. In Lucretius, the word is found to signify 'figment', 'dream image', and 'ghost'.

With Dante, the theological development of figura as phenomenal prophesy in the work of the Church Fathers acquired a new poetic and semantic complexity, grounded as he saw it in the historical reality of Christ's incarnation, as 'the Word made flesh', and building on a tough Tertullian realism.

In phenomenal prophesy, the figure possessed as much historical reality as the historical fulfilment it prophesied. Figure and fulfilment are thus related in the foreshadowing of truth, and abstract spiritual truth had thus become history, human flesh.

In mediaeval art, it is not clear to Auerbach how far aesthetic ideas were determined by figural conceptions, i.e.:

– to what extent the work of art was viewed as the figura of a still unattainable fulfilment in reality.

But my point here is that all of this semantic evolution, and the imaginative technology it gave rise to, had as its origin the primal, plastic sense of female and male forms, of mold and cast. And what is clear is that the figura concentrates veiled, layered or hidden meaning – spiritual, moral, poetic, metaphorical, psychological, allegorical – in the physical dimensions of a historical human presence.

Returning, then, to The Visible Man, what kind of fulfilment do these objects pre-figure; how exactly do they engage (beyond words) with meaning; and what is it that meets our creative gaze, our experience of perception, in their translucent dimensions?

What is it that these figurative works embody, give form to, in their veiled company? And how, as viewers, should we engage with this assembly? And what of Siss?:

She climbed down a hollow of transparent, solid ice. The sun shone on it and sparkled in hundreds of different patterns.

She screamed as she did so: for there was Unn! Straight in front of her, looking out through the ice wall.

In a flash she thought she saw Unn, deep in the ice.

The March sun was shining directly on her, so that she was wreathed in glinting brightness, all kinds of shining streaks and beams, curious roses, ice roses and ice ornaments, decked as if for some great festivity….

….Unn was enormous in this vision behind the running ice walls, much bigger than she should have been. It was really only her face that showed; the rest of her was vague.

Sharp rays of light cut across the picture, coming from unseen fissures and angles. There was a dazzling brilliance about Unn that made it difficult to grasp.

A few moments in this exhibition, and the obscure sense of risk with which I began this essay will quickly be dispelled. In The Visible Man, a material engagement with the human form in glass, and the figural celebration of translucency in all its imaginative interior dimensions, succeeds in both range and in detail, and is equal to its curatorial ambition.

It succeeds to the point at which these formal and material qualities begin to invoke their opposites: the counter-awareness that form will dissolve into formlessness, and that darkness will extinguish light.

So, gentle reader: hold onto this work 'against the darkening of the light', and we will leave the last word to Tarjei Vesaas:

A wild commotion in the empty, half-light, half-cold, spring night. A crash out towards nothing, from the innermost holds that have worn loose. The dead ice palace takes on an echoing tone in its last hour, when it releases its hold and must go. There is a clangour in its struggle; it seems to be saying: it is dark within. …

The blocks of ice tumble away pell-mell towards the lower lake and are spread out across it before anyone has woken up or seen anything. There the shattered ice will float, its edges sticking up out of the surface of the water, float, and melt, and cease to be.

## Shells

Our artists do not derive the material of their works from their own substance, and the form for which they strive springs from a specialised application of their mind, which can be completely disengaged from their being.

Perhaps what we call perfection in art (which all do not strive for and some disdain) is only a sense of desiring or finding in a human work the sureness of execution, the inner necessity, the indissoluble bond between form and material that are revealed to us by the humblest of shells.

In this brief essay touching upon the work of four contemporary British glass artists - Keith Cummings, Sara McDonald, David Reekie, and Colin Rennie - I would like to explore the poetic dimension to the work on show.

My essay is of course itself an artefact in language, a material construct, an object made of words. Look into the material of language, and you discover the nature of any text to be that of a continuous web. The English word, text, derives from the Latin textus, meaning tissue, from the verb texere, to weave . This etymological detail is of radical significance, having directly to do with the act of writing itself:

Like the weaver, the writer works on the wrong side of his material. He has only to do with language, and it is thus that he finds himself surrounded by meaning.

So, if my essay happens to develop a descriptive tendency in relation to the works and techniques of these contemporary British glass artists, please bear in mind the following 'health warning', in the words of the French painter Georges Braque:

Writing is not describing, painting is not depicting. Realism is just an illusion.

Perhaps I might also usefully then define the term poetic, also warily conscious of another of Braque's characteristically acute observations, that to define something is to replace it with its definition.

By 'poetic' I would restore something of the original sense of the word to intend a technical, creative process, and to strip away what seems these days a commonplace corruption of the word to mean 'imprecise', 'exaggerated', or 'merely sentimental'.

The sense of poetry as artifice, of the poem as artefact, is here implicit. In fact that is technically what the word poet originally signified, and what its Greek root ****** means: the poet is, literally, a maker.

'Trusting in a craft tradition, the artist thinks of himself as a maker, not a creator; as the supplier of something needed, not as the unacknowledged legislator of mankind.'

With this critical insight, the writer Gabriel Josipovici steps back from the English Romantic poet Shelley's high romantic claim for poets as the unacknowledged legislators of the world, but retains Shelley's emphasis, in A Defence of Poetry (1821), on the poet as maker . Josipovici identifies a distinctive post-modern tension or difficulty in relating the work of contemporary artists simply and directly to a craft tradition, and poses essential questions for western object-makers at the close of the twentieth century:

…the spirit of suspicion has at some point to yield to the spirit of trust – trust in the material, trust in our abilities, trust in the act of making itself. The problem is how to keep suspicion from turning into cynicism and trust from turning into facileness.

Trust without suspicion is the recipe for false and meretricious art; but suspicion without trust is the recipe for shallow and empty art.

In rejecting the kind of freewheeling post-modernism that would appropriate all traditions - which in contemporary applied arts might render craft content as at best a kind of therapy, at worst mere sentiment or indulgence - Josipovici retains an urgent and pervasive sense of lost innocence.  Something that the Irish poet W.B. Yeats in 1919 dramatised in The Wild Swans at Coole :

Hic.  And I would find myself and not an image.
Ille.  That is our modern hope, and by its light
We have lit upon the gentle, sensitive mind
And lost the old nonchalence of the hand;
Whether we have chosen chisel, pen or brush,
We are but critics, empty and abashed…

If that 'old nonchalence of the hand' is no longer available to a modern, let alone our post-modern, condition, then the simple invocation of a craft tradition would appear to take a form of denial, an act of infantile escapism, a sugaring of false sentiment.  A case - not simply of the 'gentle, sensitive mind' - but of bad poetics.

Almost exactly contemporary with Yeats's poem, an early leaf from Georges Braque's private notebook of 1917-47 contains a graphic insight into this dilemma.  Beneath the crude outline of a bone form he writes in longhand, word and image carrying equal weight upon the page:  The painter thinks in forms and colours, the object is his poetics.

Braque's preoccupation with painting as a thinking process, his identification with the object as poetic in-formation – a bone; a jug; or a landscape, say – determined a complex creative engagement with reality which was far from an act of imitation ('you should not imitate what you want to create').  The work is a deliberate process of attention, reflection and discovery within the creative act – difficult, and without innocence.

These are the terms, and this is the difficult critical or cultural context, in which each of the four British glass artists showing here at the Hsin-Chu International Glass Arts Festival operates.  And each of these artists - Keith Cummings, Sara McDonald, David Reekie, and Colin Rennie – has developed a distinctive and individual response to the contemporary dilemma through their very different work.

There are similarities.  Each of these artists works with two quite separate perspectives, and creative dispositions, in time: on one hand drawing upon the acquired knowledge of extensive craft traditions, and at the same time pitching skills, knowledge and understanding forwards in a new synthesis, in the production of fresh and original creative work.

Each artist has chosen to work with glass as a primary material, each in subtle ways that avoid the overt showmanship that characterises the approaches of some 'artists in glass'.  Did somebody mention Dale Chihuly?

His is the perfect art for boosters, wannabes, new money, and self-conscious arrivistes.  In other words, perfect for the precociously
wealthy, culturally callow New Northwest.  Glass has the museum seal of approval, but it's supremely and (as practised by Chihuly)
almost purely decorative – blissfully unburdened by threatening, ambiguous, or other meanings.  "You don't have to be smart or art-
historically sophisticated to understand these," a Chihuly's [sic] assistant explains in one of several documentaries on him by
Seattle's public TV station.  "They're merely beautiful"…..Glass also suits a money-drunk, technology-intoxicated place like the
Northwest.  It's showy and luxurious, as glittery as jewellery and a hundred times bigger.

For scholars of vitriolic invective, the Slate e-magazine www. location for the complete version of this fairly acidic journalese appears as an endnote below.  The rest of us may note a clutch of predictably belittling assumptions - regarding 'decorative' qualities in glass, all that glisters etc., luxury, mere beauty, and jewellery on an impossible scale - and then perhaps move on.

Sculptural in idiom, as decorative glass and metal objects on a domestic scale the work of Keith Cummings appears ambiguous, self-reflexive, strangely preoccupied, and essentially private.  His works seem to run directly counter to the prevailing current in contemporary glass, against the vogue for filtered transparency and yet bigger, more extrovert, even shinier objects.  Opaque and introspective by contrast, their accessibility (or otherwise) depends upon skilled reading of highly complex surfaces.  As Cummings himself put it, in a 1993 interview:

"I think that craft objects are destinations, objects of contemplation.  That's why craftspeople are passionate about nuances of
texture, of surface.  For me, also, craft objects work best in a domestic situation.  I want to create a decorative nucleus within a
room."

If this reads as something like a declared poetic (literally: a creative making process) it is clear that, in Cummings' work, a kind of open-ended dialogue with materials and processes, and the imaginative or contemplative possibilities they give rise to, radically informs decisions about construction and assembly at every turn.  It is a technique of 'informed risk' rather than 'unbridled chance'.  And if the finished 'craft object' is, in his terms, a kind of destination, then it is the formative process itself that presents a sequence of dynamic thresholds en route.  We reconstruct these possibilities, through technical and imaginative contemplation, in our encounter with the finished work.  Drawing seems to work similarly not as blueprint but as idea-orientation or direction-finding.

Cummings develops works of intense wonder, combining obsessive material qualities; complex, constructed forms; sophisticated, multiple techniques; intimate local details; and long implied histories, or evidence of endurance.  These kiln-formed glass and metal objects seem to bear the hallmarks of some inscrutable alchemical process.  They have the patina and feel of something salvaged miraculously from the ocean floor after long salt immersion, attended by shell forms, growing outward by crystalline marine accretion, splitting their horned cases like sea-borne seedheads opening.  Strangely suspended between organic and mineral existences, they draw us unerringly into meditative re-acquaintance with some old and familiar questions.  What is the origin of this?  Who made it, and for what reason?  How was it made?

At first glance, David Reekie's work would appear in complete contrast to that of Keith Cummings.  We witness the latest outcome of a long engagement with an instantly recognisable, and consistently figurative, sculptural language.  We note a characteristic tendency to bleak, or black, humour; to philosophical satire; or to political critique.  Reekie's work in three-dimensional kiln-cast glass has a deep root into the folk tradition of English stone-carving from the twelfth century onwards - in the satirical, iconoclastic and occasionally obscene figures that decorate leer and scowl at us from the roofs and gutters of our ancient parish churches and cathedrals.

The work has another, equally nourishing, root into a more recent graphic tradition – that of satirical cartoon drawing, in a journalistic spirit of social comment and political irony.  In fact this critical emphasis on drawing as an exploratory, thinking process, provides a methodological link with Keith Cummings, although to very different ends.  Two-dimensional, graphic devices, such as the frame or window, seem often to evoke a direct reference to cartoon frames or architectural features, and provide a threshold or aperture as it were between the second and third dimensions, through which startled and extraordinary figures peer with nervousness, indignation or bewilderment in contradictory or unequal measure.

Reekie's expressive exploitation of this ambiguous space – let's call it 'the 2½th dimension' – is masterly.  A 1996 piece, entitled Dancer VIII, shows a half-

squatting cartoon-like figure balancing on a wooden board, which in turn pivots upon a fulcrum. The figure's short though extended arms end in enormous hands, and its facial expression registers bewildered surprise, as if a cartoon drawing had suddenly woken to find itself inhabiting a third dimension, and was uncomprehendingly weighing the enormity of these hands, whilst simultaneously struggling for equilibrium.

The composition is direct and frontal, masking the flat back of the figure, formed at the fill-level of the open kiln mould. The fused colour of its surface decoration retains a drawn aspect, and an evident enjoyment, or celebration, of the graphic mark in an otherwise monumental glass idiom.

More recent series have explored a similar formal tension between two- and three-dimensional space. In the sequence 'Living in Confined Spaces', groups of two or more lost wax cast glass figures occupy constrained flat surfaces usually in the form of a wooden plinth. Often the ground is painted as a chequerboard, emphasising the strange game-like nature of the tableau, and referring obliquely to undeclared rules of confinement that imprison the captive figures in extraordinary situations. In these works, Reekie is addressing the human condition as one of essential ignorance or bewilderment in which, despite all absurdity, human qualities and human vices and human values persist.

This seems true of Reekie's most recent Self Portrait series, which plays insecurities of language and number against the cast glass form, combining figure with plinth in a sequence of 'severed' portrait heads: the most literal image of the mind/body divide that you will see this year!

Sara McDonald also works with kiln-forming, and with equal formal emphasis on composition, but to very different ends, and with a different palette and range of materials and techniques. Her most distinctive work to date consists of quite shallow, but large in diameter, fused, slumped and laminated bowls. Characteristically, their subtle, even narrow, chromatic range is determined by layers of fused metals: silver and gold leaf, aluminium, copper, and Dutch gold.

Though impressive in scale, the tone of these pieces is highly restrained, subtle and nuanced. The limited colour range is a chosen constraint. It is a question of focus, and the focal point is here located inwardly. The fused surfaces of these wonderful pieces are carefully layered and laminated with fine geometrical precision. They capture, retain, and reflect light as it were through a sequence of veils.

The plate glass curtain of cupped light is patched, threaded and seamed with minutely varying tones and hues that move and change in luminosity with the intensity of the light source. The viewer can look across the surface complexity, or allow their gaze to work through the successive veils, the half-veils, and the screens of gentle metallic resistance offered to the eye.

The presence that is evoked here is highly patterned and sequential, having to do with number, measure and proportion, following rules that seem to have as much to do with music as they do to the vessel as such. It is from these complexities, McDonald says, that 'the piece becomes coherent' .

What is it that coheres, in these terms, therefore? To me what coheres is at once a technical, an aesthetic, and a contemplative object. Despite the very deliberate geometry, and the complex physical demands of these delicate materials, there is no programmatic agenda, no discernable message involved here.

McDonald's work typically creates a controlled and considered, domestic space, which admits daylight and delight without question. It is as if the work evolves very slowly, though ideas developed in sketchbooks – marks, observations, designs, phrases, voices, transcriptions, memories, reverie – the focus of which seems to open and dilate until the point at which its essential abstract gesture, cadence or significance is revealed.

As this descriptive language suggests, it is difficult to resist the idea that these extraordinary works are patiently but insistently exploring a tangible, spiritual dimension of the vessel form as a vehicle of light.

By complete technical contrast, Colin Rennie's work is blown, formed and forged in lead crystal with colour inclusions at the furnace mouth. Each piece is the outcome of a technique of multiple re-heatings, successively extending the working range of the material until the moment of balance is reached, in which the completed form achieves a point of animated equilibrium, where component parts seem organically to connect and inform each other in a kind of purpose. Often the finished object invites the kind of wonder identified by Gaston Bachelard, in the opening to chapter five of La poétique de l'espace (1958), which he devotes to the poet Paul Valéry's meditation on shells:

> For this poet, a shell seems to have been a truth of well solidified animal geometry, and therefore "clear and distinct"…the created
> object itself is highly intelligible; and it is the formation, not the form, that remains mysterious…

If Colin Rennie seems to work with just such a language of 'animal geometry', then these highly photogenic appearances may be only the most superficial aspect of his work. Rennie plays out the possibilities of form and formation, at turns constraining, releasing and shaping eventual form through the tempered outer skin of the molten glass medium. The cooling skins appear barely to congeal or chill the animated, hot internal energy of each piece. The eventual form thus appears to have arisen as the necessary outcome of this contest between interior and exterior energies, internal and external space. Bachelard pursues this distinction, and locates this mystery, in his reading of Valéry:

> …a shell carved by a man would be obtained from the outside, through a series of innumerable acts that would bear the mark of a touched-up beauty;
> whereas "the mollusc exudes its shell", it lets the building material "seep through", "distil its marvellous covering as needed"….In this way Valéry returns to the mystery of form-giving life, the mystery of slow, continuous formation.

Both sides of this analogy seem to provide useful insights into Rennie's hot glass technique, in which the building material of liquid glass does indeed 'seep through', slowly yielding or exuding its outer surface, cooling to a transparent, shell-like exterior. On the other hand, each work is a 'specialised application of the mind', that is to say a work of acquired craftsmanship and intentional design. This is a distinction of which Valéry was most perceptively aware:

> But the making of a shell is lived, not calculated: nothing could be more contrary to our organised action preceded by an aim and operating as a cause.

Colin Rennie creates marvellous objects that function and perform in exactly this contested space, sculptural glass objects that establish a stilled, though animated presence. They invite amazement at both form and formation, and open curiosity as to their interior purposes. Their exterior beauty is if anything a barrier to meditation on their intimate, inhabited form. And these are artefacts of course, not lived organic vessels of sea life.

At this early stage in his glassmaking career, Rennie's work seems to enact a working meditation on these themes: on the poetic nature of the act of making, in his case glassmaking; on the nature of tools and implements, whether fabricated or organic, hammers or claws; on the relationship of interior and exterior form.

To me the work of all four of these artists is moving consistently and in quiet ways from strength to strength, gaining in depth and significance, and asserting a subtle influence on the ostentatious world of glass today.

## He Yunchang

Catalogue text commissioned for the New York solo début of the Chinese performance artist He Yunchang at Chambers Fine Art (New York and Beijing). Text in English and Chinese. This gallery represents significant established and emerging Chinese artists (including Ai Weiwei, Cai Guoqiang and Qiu Zhijie) and in September 2007 opened a sister gallery in Beijing.

A new live work, 'Mahjong' was presented as part of 'PERFORMA07' in Washington Square Park. The exhibition itself showed previous work, including 'The

Rock Touring Around Great Britain' (curated by Amino (Newcastle) and Spacex (Exeter) during 2006-7).

This essay constitutes the first sustained study in English of the work of He Yunchang, now recognised as one China's leading performance artists. It extends Brewerton's academic writing beyond the scope of contemporary object-centred art making and poetics and installative work into live practice.

The rôle or position of the human body as the site of performance and as the subject of oppression is examined, together with the performative representation of the body, in a sequence of live works and installations. The essay identifies a distinctive poetic of performance-making across an extreme and diverse body of live work produced by He Yunchang over a decade.

Human Scale – He Yunchang in Performance

> …deconstruct what you like – that's always an open game – but you can't deconstruct this: the performance of our lives in their
> anguish, pleasure and belief.

An oblique epigraph, perhaps, for the New York début of the Beijing-based performance artist He Yunchang, deriving disconnectedly as this does from the 'double memoir and meditation' of an English poet – the late Douglas Oliver (1937-2000) – and the French militant anarchiste and heroine of the 1871 Paris Commune, Louise Michel (1830-1905).

But by chance such words may offer, on this occasion, a critical take on performance: its direct implication in (and essential distinction from) the continuous if finite seam of our lived experience, attended – beyond critical theory – by angels of anguish, pleasure and belief, and entangled in the games we play. Words that acknowledge the tectonic overlay of performance both in and of our lives. Indeed each of these terms has acquired a serial significance in the radical art of He Yunchang: game, performance, lives, anguish, pleasure, belief, together with the acute temporal sense, both of duration and of endurance, that each involves.

In a Western postmodern art-critical context, Oliver's words have the cursive smack of poetry and radicalism:

> …the moment by moment performance of our lives is when our possibilities of good and evil (or good and bad art) arise,
> notwithstanding the grand ideas we have about the workings or significance of the human mind or soul or about poetry and form.

One might take a thought such as this by way of license – certainly not as a prescription – in almost any encounter with He Yunchang's work in performance. Publication and commentary has in recent years carefully if sparingly documented the photographic record with the leanest written account of his work as performed on precise dates and times and at specific locations. Co-ordinates in space and time registered without elaboration. Two examples:

> Wrestling: One and One Hundred
> Performance Art
> Time: March 24, 2001   Place: Kunming
> Course: He Yunchang wrestled with one hundred persons in a row. The final record showed that He Yunchang got 18 wins and 82 defeats.
> The whole course lasted for 66 minutes.
> Eyesight Test
> Date: March 27.2003     Venue: Beijing, P.R. China
> Event: He Yunchang fixed his eyes on a 10,000w light for 60 minutes to make his eyesight become worse.
> Materials: 1. A stainless mirror, 2. 256 lights, 3. A cast-iron chair, 4. A figure of eyesight testing.

A shared quality of physical endurance , widely-noted as a common hallmark of these, and of other more extreme performances by He Yunchang may prove however the least significant aspect of his work, serving teasingly for the time being to obscure a deeper, performative preoccupation with duration. For these are all – painstakingly, sometimes painfully – measured performances, requiring and deploying time with deliberate intent. Measured in the various senses in which they are considered, constructed, and sustained in time. Measured also insofar as they give rise to interior spaces – clearings which the performances open up and then sustain incrementally within the life – moral or spiritual dimensions, as our epigraph would have it, necessarily entailing 'anguish, pleasure and belief'.

The games at stake have perhaps little to do with either the scale or extent of endurance per se, or with location or context, and play against quite different odds.

Occasionally the catalogue record seeds a clue, most likely suppressed at the time of the performance. In the case of Dragon Fish, a 2006 performance involving sub-clavicle (under the collar-bone) piercing , Adele Tan notes that "North Korean escapees to China were chain-ganged through their sub-clavicles when caught and repatriated. The initiating story was suppressed in order not to have the context circumscribe the performance." (my italics).

> Starting at 17:45 on 11 March 2006, 15 minutes later than advertised, He Yun Chang began the 24 hour performance of Dragon Fish.
> Amino's Lee Callahan tied one end of the 20 metre length of scarlet twine around the steel balls at the ends of the PTFE rod in
> Achang's sub-clavicle piercing, the other end was attached to a specially rigged steel cable stretched taut across the atrium of the
> Central Square building.
> Once secured, Achang strode, naked, into the centre of the performance space to where two sheets of paper had been fixed to the floor.
> With a stick of blood red pastel he quickly and unceremoniously scribbled the two Chinese characters that form the words Dragon Fish
> and then casually sauntered off to the edge of the invisible circle he would follow over the next 24 hours. He began jogging in an
> almost indifferent way, in an anticlockwise direction, in a circle of about 10 metres across, around the Dragon Fish, on a journey to
> nowhere that would last through the night and into most of the following day.

The deliberate 'blinding' of a probable source reference is designed to free the work for quite different purposes. The performance is transcendent, both of its context and of the superficial cruelty of the piercing detail with that possible reference to human subjection. As the artist had remarked elsewhere, two years earlier, in relation to Casting (2004):

> As each piece of my work continues, it becomes more and more cruel. All games can ultimately be lethal. Behind the absurdity of
> showing heroism and apparent easiness of games, only with strong willpower can one [overcome] fear, establish confidence and experience
> the being of life as life slips away.

The acute existential anguish of that closing phrase in turn recalled his artist's statement for Fuck Off, the uncompromising independent show curated by Ai Weiwei and Feng Boyi in 2000:

> My concerns in recent years are about powerless groups and will of life. I seek enduring and fearless confrontation with reality and
> a poetic expression for this.

He's personal inflection of the spirit of militant resistance evident in the curators' summary note, About 'Fuck Off', shares its instinct for 'uncooperativeness with any system of power discourse':

Allegory, direct questioning, resistance, alienation, dissolution, endurance, boredom, bias, absurdity, cynicism and self-entertainment
are aspects of culture as well as features of existence. Such issues are re-presented here by the artists with unprecedented frankness
and intelligence, which leaves behind fresh and stimulating information and traces of existence.

Culture an existence, performance in and of our lives. For this show, He Yunchang's 'poetic confrontation with reality' put on a breathtaking, embodied
form, where what looks like shamanism is not so: is in fact poetics:

Dialogue with Water

Performance Art

Time: February 14, 1999 Venue: Lianghe, Yunnan, China

Process: He Yunchang was hung upside down on a crane. He cut the 4500m long river in half with a knife producing a 30 centimetre deep
cut. The river flows at 150 meters per minute and the performance lasted 30 minutes. He Yunchang ['s] arms had both a 1 centimetre
deep cut. Blood dripped down along his arms into the river. The entire performance lasted 90 minutes.

The astonishing resonance of this work, evident for this writer even in the after-image of a slim catalogue record, rests in the reciprocal exchange of incision
and flow, the pattern of blood and water, the organic and mineral bodies, and also the measure of the period involved. As He Yunchang remarked of Casting
(2004), 'Time is a key factor in the performance. How long a performance takes is the same [importance] as how it is completed….and the intensity that the
performance requires.' The performance as dialogue remains tacit, inimitable, barely susceptible to verbal reduction – invisible work, owing little if anything
to context beyond the figures of river and inverted human form. A transaction of individual will and the natural environment in which it was formed.

The question of context is duly minimised in the published captions to other performances of He Yunchang, where for instance a Daoist fable from Book 14
of the Zhuang Zi is recalled in the case of Appointment grasping the Column (2003); or again, in the 'note' to the human half-twist in the moebius-strip idea
that threads itself through a succession of engaged bodies, repeatedly coiling and uncoiling the workaday physical energy of Constructing a Moving Dragon
(2002):

Venue: Auditorium, Pusan, South Korea

Event: He Yunchang carried a participant on his back, in his arms, on his shoulder, to the stage, and then the participant carried him
in the same way back to the original place. The game was played with participants one by one.

Note: Constructing a Moving Dragon is a type of poker game.

In each of these catalogue entries a brusque word-trace retains the authentic signature of the pared-down performance it records, in response as it were to
the extreme austerity with which on every occasion the performances convene minimal materials – including the barely-dressed material body of the human
form – stripped of aesthetic devices and with little theoretical or aesthetic 'framing', at the service of a formal idea that has invariably been a long time in
gestation.

The shaved simplicity of the work often belies protracted deliberation – two years being by no means an uncommon gestation period for a fully rendered
and irreducible idea. This requires a consistent 'lessening of technique', pitching the performance beyond artistry (or sublimation) into the realm of lived
experience, what he calls 'normalness' ('normalness is a plain expression that I always use in my work, to keep artificial performing elements away' ). In
other words

My early works are very aesthetic and idealised. They have nothing to do with reality. My later works are more true to life and
closer to society. And they are more cruel and physically exhausting. I know some of these forceful actions harm my body. I'm not
stupid.

Extreme, even perverse physical restriction would appear an essential precondition for the various freedoms that many of these works are designed to acquire
beyond the physical wear-and-tear: primarily spiritual freedom which for this artist 'knows no constraint' . Constraint operates mentally – in, for instance,
the latent energy of free will and psychological limit, and the self-defining constraints of human existence and identity.

Elective constraints operate both in space (material, technical and environmental) and in time (anticipation, duration and completion) – through the grinding
futility of long-winded though deliberately measured processes of repetition involved in works such as Dragon Fish, or:

River Document, Shanghai

Performance Art

Time: November 3, 2000 Place: Shanghai, China

Course: In the lower part of the Suzhou River in Shanghai, He Yunchang with a bucket took ten tons of water and stored them in the
cabin of the boat, then transported it to a place 4 kilometers north, in the upper reaches, where he poured all the water back into     the river, making it
re-flow for 5 kilometers. The whole performance lasted 8 hours.

Material: A steamboat, a bucket

'We step', said Heraclitus of Ephesus, 'and we do not step into the same rivers; we are and we are not.' He Yunchang's laborious, doomed and knowingly
futile reversal of universal flux taps teasing undercurrents of significant antiquity in both Chinese Daoist and Western Pre-Socratic philosophies. The
hopeless audacity of this work is in vain to interrupt the original stream and draw it into the idea of repetition: to make of flux a re-flux, creating a tensile
mental space between those two movements that swims with ideas, as well perhaps as anguish pleasure and belief.

In River Document, Shanghai, the human body features as not so much the site of performance as it does the physical extension of an idea. The document
to which the work establishes title is a mental draft – the worked-for, willed and ludic consequence of a very real and vivid spiritual desire. Site and context
fulfil a fugitive purpose insofar as they provide the occasion of performance, but in key respects the work itself is essentially invisible, an interior process:

Performance is naturally body and psychological reaction of an artist while in a particular time, and environment.

a preoccupation with the human dimension of duration, where the key word is not 'time' or 'environment', but 'while'.

With Casting (April 23rd-24th, 2004), this process reaches its invisible extreme. The artist spent 24 hours, naked, inaccessible and alone with his chronic
fear of darkness, extremes of cold and heat, and the imagined risk of structural collapse, cemented into a narrow chamber that required ten hours of casting
and almost twenty tons of poured concrete, from which it took some time eventually to chisel him free.

…the sense of performance is decreased to zero. For other performance artists, they can be seen. But in my performance, nobody
knows what I have done inside. I can say I have done this or that. I may lie since everything is concealed. The sense of performance
was down to zero….people can see me getting in and out but that is not part of my performance. The real process is invisible to
anyone….Does every performance have to make sense? I don't think so.

But if, as I suggest, the human body is not the site of performance in He Yunchang's work, what kind of space opens here?

In a brief address, given originally at the opening of a sculpture show at St. Gallen in 1964, Martin Heidegger sharply contrasted the geographical domain of 'technical-physical space' with a more fundamental idea that

> The body of sculpture embodies something. Space? Is sculpture a kind of possessive hold on space? A sort of dominion over space?
>
> Does sculpture in these terms correspond to the technical-scientific conquest of space?
>
> ….To make space brings freedom, an openness for human settlement and dwelling….
>
> ….To make space is to confer location that from time to time prepares a dwelling-place. Profane spaces are invariably such as refer back to underlying sacred spaces.
>
> To make space is to make location possible.
>
> In making space, something occurs that at the same time both speaks and conceals itself.

Leaving aside, for present purposes, Heidegger's (unacknowledged) debts to Chinese philosophy , He Yunchang's performance practice offers a refusal of any such metaphysics of place or site. The artist renders the human body co-extensive with precisely the 'technical-physical' or material dimension that Heidegger sought to subtend. Encased like a seed, like physical information inside a concrete husk, inside a world that already bears the heavy imprint of human dwelling. Simply speaking,

> In this project, I expected to connect my body and the cement in a closer way…

he configures the human body as a responsive instrument of scale and measure, working at its somatic limits with visceral resistance and the concealed purpose of spiritual freedom, journey or discovery.

By extreme physical contrast, He Yunchang's most sustained durational performance to date, Touring Round Great Britain With A Rock (24 September 2006 – 14 January 2007), connected the body with the material of stone 'in a close way'. He selected the rock in question near the village of Rock, at Boulmer, on the Northumbrian coast of England, and carried it for about three thousand miles along a route that circumscribed counter-clockwise the island of mainland Britain, returning it to its exact point of (presumably random) origin 112 days later. This was not a circle, but a circuit – foregoing geometrical rigour for that of endurance. There is in this performance no trace of spatio-metaphysical ambition, no shred of human dominion, to distort the landscape accepted as given. Neither metaphysics as understood by Heidegger nor dominion of the formal artistic kind reflected in Wallace Stevens' Anecdote of the Jar:

> I placed a jar in Tennessee
> And round it was, upon a hill.
> It made the slovenly wilderness
> Surround that hill.
> The wilderness rose up to it,
> And sprawled around, no longer wild.
> The jar was round upon the ground
> And tall and of a port in air.
> It took dominion everywhere.
> The jar was gray and bare.
> It did not give of bird or bush,
> Like nothing else in Tennessee.

Rather, Yunchang's performative objectives in this work were stated with beguiling simplicity:

(1) The living condition of individual: Challenging the mainstream of current values such as efficiency, health, etc with a performance of invalidity.

(2) Lessening the element of technique: A work of perform[ance] art should be the natural reflections of body and psyche of an artist while he set himself in a specific condition. It is different from movie, drama, dance, music and other performance. The rock tour reduces the perform[ance] factor by (using) walking in a natural way and using difficult strength.

(3) Indefiniteness: …how from art, national geography, sports etc probably possible to understand the work but it seems impossible to understand it completely from any angle.

(4) Multi-dimensions: embodying the work in the nature to provide lots of possibilities of interpretation for observers, different viewer have different point of view so its idea could be extended.

Again, his critique of mainstream values – in this case the 'health and efficiency' culture and overt narcissism of body-worship and physical exercise – identifies a 'compromise between autocracy and instincts' or 'compromise between habits of custom and instincts'. As forms of cultural autocracy, fetishism and habit impede instinctual being, the raw existential condition which is the artist's true itinerary, and against which he pitches – with all the iron in 'irony' – the 'iron will of an individual' in a complex power-play characterised once more by arduous lengths of physical difficulty, and ultimate futility. The intrinsic purity of pure waste.

But in articulating such ideas by means of interviews or documentary materials, He Yunchang is perhaps playing another game, concealing his purpose behind a dead-pan performance. Where the true poetics are in fact more Buster Keaton than Wallace Stevens, and where the intellectual defiance is not so very far removed from Louise Michel.

For his first New York show, He Yunchang plans a work that he has long wanted to realise:

> The creative principal of this work is gentleness, normalness and long-suffering'.

The game of Majiang, no less, in what might for present purposes be termed an extraordinary rendition. The physical conditions of this performance derive from a story the artist heard – as it were, on good authority – whereby duty officers sought relief from prison routine by endless rounds of majiang. This game involved heavy bricks chalked-up with Chinese characters and moved around the compound by inmates until their hands were ruined and they could no longer stand.

Gentleness, normalness and long-suffering – in this case outwardly embodying victimhood, masking inner strength.

An old old game, in other words, and – once again for He Yunchang: the performance of his life.

**Irvine Peacock, The Secret Life of Objects**

> detail (d te l, di te l) sb. 1603. [ – Fr. détail, f.
> détailler, f. dé- DE- I. 3 + tailler cut in pieces.]

We think in generalities, but we live in detail.

Alfred North Whitehead

A female figure, masquerading with the cartoon face of a Japanese cat, floats in a canvas of infinite recession, the strong frontal of her upper body gently freighted with the supported weight of her head and arms, her lower form reclining upright against a high cumulus backcloth. In this suspended foreground, her left palm opens – in a gesture of misericordia, perhaps – toward the viewer, the arrested movement of her sky-blue kimono seeming to obey laws only of its own disposing. An Ascension, subverted by an iconography of doubt, gestures to the narrative ground it declines to occupy.

Elsewhere, scissors shoal like mackerel, in mid-air – purposeful, resonant objects, opening and closing, identically detailed in the flatware shine of their carbon steel bodies – the little spurs on their chipped black-enameled handles designed to stop them…well, just going too far.

A fresh encounter with these recent paintings on board and canvas by Irvine Peacock might recognise the useful agency of the two epigraphs to this brief essay – in the sharp French cut of English etymology; and in the similarly acute wisdom of Whitehead's double entendre: signalling both the routine texture of our singular, quotidian lives, and also the quality of creative attention by which we are compelled to live and dwell imaginatively within, or through, the circumstantial detail of our direct experience.

There seems, in Peacock's fine rendering of carefully nuanced detail, a consistent fidelity to things – a preoccupation that looks at first glance like realism, but would appear on closer inspection to explore a far more troubled engagement with uncertainty and illusion, and with the raw phenomenology of looking. As he himself puts it, in reality:

> …things only look like what they are from certain angles, in certain light conditions, at certain distances – otherwise they don't
> look like the real thing at all.

And so the sure-fired, porcelain-certainty of these painted surfaces, in the clear-cut definition of all the observed detail they contain, may prove deceptive ground for the unwary viewer. For, plain to say: images of things are not the things themselves.

Images are, rather:

> …"lived", "experienced", "re-imagined" in an act of consciousness….

As an imaginative condition, therefore, the natural term for the 'second sense' of Whitehead's caveat, 'we live in detail' – and the word that may best convey the kind of meditative technology involved in the paintings of Irvine Peacock – is reverie.

That is to say, reverie as a state of creative vigilance – as Colette Gaudin defines it vis-à-vis the philosopher Gaston Bachelard – an imaginal condition which,

> … far from being a complacent drifting of the self, is a discipline acquired through long hours of reading and writing, and through
> a constant practice of "surveillance de soi". Images reveal nothing to the lazy dreamer.

If, for 'reading and writing' we substitute 'drawing and painting', then we begin to appreciate the characteristic singularity of observed detail that clearly distinguishes Peacock's waking reverie, his oeuvre as a painter, from the work, say, of René Magritte, Frieda Kahlo, Leonora Carrington, Remedios Varo, or Giorgio de Chirico – artists with whom he would at first glance appear to share an idiosyncratic tradition, or visionary affinity. For Peacock it may be, as Bachelard himself wrote, that 'It is reverie which delineates the furthest confines of our mind.'

In, as it were, graphic contrast to Magritte, Carrington, and others, Peacock is drawn to – he seems disturbed by – actual phenomena in the local circumstance of all their scandalous detail, rather than to archetypal or ideal forms. His male characters seem plausible enough not to have wasted money on expensive haircuts – they occupy a staged foreground at the furthest possible remove from the ethereal figuration of Remedios Varo.

Peacock's oneiric labour is less dream-work than conscious daylight reverie, its atmosphere distilling pure detail in successively finer brushstrokes – a patient and focussed elaboration of images involving time both as a worked duration and as a mental space in which subject and object may, or may not achieve, albeit temporary, reconciliation.

His realism, if such it is, strikes us as the product of amazement – a kind of narcosis, almost – the least academic and the least reactionary of creative dispositions in the face of the phenomenal world and the work of painting. He finds little use for the modernist fine art legacy. Instead, his painterly fidelity to objects, in their powerful authenticity, their histories and immediate presence, recalls Fernand Léger's damascene conversion from abstraction:

> … I was suddenly stunned by the sight of the open breech of a .75 cannon in full sunlight, confronted with the play of light on
> white metal. It needed nothing more than this for me to forget the abstract art of 1912-13. It came as a total revolution to me,
> as a man and as a painter…I made dozens and dozens of drawings. I felt the body of metal in my hands, and allowed my eye to stroll
> in and around the geometry of its sections. It was in the trenches that I really seized the reality of objects.

Peacock's intense childhood fascination with print reproductions – the pronounced sexual candour and expectancy of painted flesh in Boucher's reclining nude portrait of Louise O'Murphy, or the private interior of a Jan Steen genre scene – combines something of this visceral feel for objects in themselves with a technical eye for the qualities of worked pigment for its own sake: 'I just couldn't understand how he painted metal…the shine on copper and urine…I still like the shine on things.'

The edge of surprise – by turns absurdly comical, euphoric, subversive, mischievous, erotic or obliquely threatening – that occurs in Peacock's direct experience of making paintings, and which the viewer re-creates in the act of looking, happens '…when you draw something, and it looks like that thing: and suddenly it's looking back at you.'

So seemingly candid a remark veils a complex moment, in which the painter's extreme absorption in technical control permits the free play of creative reverie, where the fresh figuration appears to the artist to re-present, to assume an independent anima, and itself to determine its next move.

Thus we are drawn by reverie into a narrative space in which the narrative fails to reveal itself; where a cast of clothed and nude figures, masked and unmasked, attended by recurring object motifs, plays out in an inscrutable game, the rules of which have already been stolen or forgotten, or have yet to be considered.

## Grid Level: new work in raku by David Jones

It was my privilege, not so long ago, to speak at the opening of Fixing Light – Fixing Fire, an installation comprising raku ware by David Jones and landscape photographs by Rod Dorling, at a gallery in rural Shropshire, in English border region of the Welsh Marches. The exhibition drew together the most earthbound, and the most ethereal, of materials as media – clay and light.

The gallery happened to be located at the Western reach of one of the most significant geological formations in the British Isles, a long escarpment known as Wenlock Edge – an ancient coral reef, formed of the crushed shells and exo-skeletal remains of corals, sponges and sea-lilies some four hundred million years ago, under shallow Silurian waters, some 60° south of the equator, and now exposed as a wooded limestone ridge, with parallel dales of softer siltstones

and shales.

This purest of calcium carbonate deposits was quarried as flux for blast furnaces that fuelled the industrial revolution at nearby Coalbrookdale during the eighteenth century. The raised reef sits on basal Ordovician rock, in a region of astonishing geological diversity, just south of the pre-Cambrian metamorphic and igneous outcrops of the Long Mynd range.

So, that was our physical situation – where it was, precisely, that we were grounded – at the opening of Fixing Light – Fixing Fire: upon the deep crustal suture of a geological fault-line, on a rock mantle composed of lava, ash, ancient mud flats, sedimentary deposits of sand and silt, across various eræ lifted, folded, melted, layered, dissolved, broken, punctured and otherwise formed under enormous tectonic movement, intense volcanic activity, river and marine solution, and glacial pressure.

And there, resting upon the outer skin of this long mineral history, a raised installation of raku artefacts, deploying as craft something of the same physical forces – of heat, pressure and movement; of chemical and mineral suspension – in what is materially perhaps the most earthbound form of object-making in contemporary art. For despite such evident means, and such materials, this work bears no relation to land art, having at its heart instead a core preoccupation with the nature of the vessel as artefact: a practice with a long history of human attention. Having more therefore to do with memory. Having to do with alchemy, even. But more of that later.

In a lecture delivered on June 6th, 1950 at the Bayerischen Akademie der Schönen Kunste, Martin Heidegger gave a brilliant reading of a simple vessel artefact – a clay jug:

> …the potter who forms sides and base on his wheel does not, strictly speaking, make the jug. He only shapes the clay. No – he shapes
> the void. For it, in it, and out of it, he forms the clay into the form. From start to finish the potter takes hold of the impalpable
> void and brings it forth as the container in the shape of a containing vessel. The jug's void determines all the handling in the
> process of making the vessel. The vessel's thingness does not lie at all in the material of which it consists, but in the void that
> it holds.

This, you might agree, is perhaps as close as Western philosophy ever got to earthenware! In his lecture Heidegger proceeds to define the distinctive holding and keeping that is the essence of the jug, which is then gathered and fulfilled in the outpouring of a ritual offering: a libation to the gods, uniting heaven and earth.

But Heidegger is merely appropriating the clay jug as an occasion for theory. And strangely, for a philosopher so committed to poetry as the 'speaking' of truth and of the 'un-concealèdness' of being – and to poetry as dwelling and thinking – Heidegger dismisses the making process, or poesis, from a meditation that in fact suppresses its source, in chapter 11 of the Laozi, or Dao de jing, the early classic of Chinese Daoist philosophy compiled during the Warring States period, around 4th – 3rd c B.C.

> Thirty spokes share one hub.
> Adapt the emptiness within…and you will have the use of a wheel. Knead clay in order to make a vessel.
> Adapt the emptiness within …and you will have the use of a vessel.
> Cut out doors and windows in order to make a room.
> Adapt the emptiness within …and you will have the use of a room.
> Thus what we gain is Something, yet it is by virtue of Nothing that this can be put to use.

Richard Willhelm's 1911 German translation of Chapter 11 of the Laozi, which was available to Heidegger, reads 'The work of jugs consists in their nothingness.' Heidegger's suppression of this likely source is at best a curious omission, and a controversial form of 'tacit knowledge' – knowledge that in this case just keeps its mouth shut. As Reinhard May's research , has shown, in 1930 Heidegger had consulted Martin Buber's 1910 translation of the Zhuangzi, another Daoist classic. He had available to him German translations of the Laozi by von Strauss (1870) and Willhelm (1911). And he collaborated, during the summer of 1946, with the Chinese philosopher Paul Shih-Yi Hsiao on a translation of the Laozi, which was discontinued after eight chapters at Heidegger's request, and that preceded the essay 'Das Ding' by just four years.

Despite his longstanding interest in philosophy and literature, David Jones is careful to avoid theoretical or cultural appropriation, or the burden of narrative interpretation, in his ceramic practice. His new work at the Westerwald Museum develops the material focus of his earlier show, Fixing light – Fixing Fire, in a growing preoccupation with pre-history, or with memory – human and even personal, but in mineral substance. The layered installation is suspended above a rectangular grid, like the diagram of an archaeological site where the earth in which these grave-goods might have been interred is absent, a deliberate and constructed void.

As artefacts, the vessels in themselves register a kind of equilibrium between presence and absence, in the material and in the emptiness around which they have acquired form.

But, as James Elkins suggests in his remarkable thesis, What Painting Is, the artist is thinking in and through materials in the making of new work. These works are not descriptive of some other subject, or material, or purpose: they are that purpose itself.

The artist, in Elkins' words, like the alchemist, thinks in materials, and through a process in constant flux:

> As the substances mingle and fuse, they become purer, stronger, and more valuable, just as the soul becomes more holy. The
> philosopher's stone is the sign of the mind's perfection, the almost transcendental state where all impurities have been killed,
> burned, melted away, or fused, and the soul is bright and calm. Alchemists paid close attention to their crucibles, watching substances
> mingle and separate, always in some degree thinking of the struggles and contaminations of earthly life, and ultimately wondering about
> their own souls and minds.

## Liquid Horizons

'East is East', so they say, 'and West is West'. Well…. not in this essay.

Nothing here, beginning with the title of this piece, will prove quite what it seems. Because no sooner have you paused to consider them, than ideas and things move, flow, lose static. This, we understand, is the accelerating condition of our 'liquid modernity', the term coined by the Leeds-based Polish emigré sociologist Zygmunt Bauman to characterise the human consequence of a software-driven silicon modernity effecting instantaneous and global migration of knowledge and finance, and rendering everything held familiar as mere flux: time, space, work, individuality, community. Human emancipation, even – self-determination, or the very possibility of freedom itself.

His concern is with the shedding of human ethical interests and obligations that accompanied the emergent, remorseless primacy of the cash nexus 'among the many bonds underlying human mutuality'. As a sociologist, Bauman's thesis accords to technological modernity a radical agency in determining this

liquid condition:

> Power can move with the speed of the electronic signal – and so the time required for the movement of its essential ingredients has
> been reduced to instantaneity. For all practical purposes, power has become truly extraterritorial, no longer bound, not even slowed
> down, by the resistance of space.

In such an equation, value no longer resides anywhere but it 'crystallises', it applies rather, attaching only in the transitional moment of its transfer across the non-viscous surface of a barely perceptible movement in space/time. You hardly need a full-blown global financial crisis to work out quite how ephemeral an arrangement this may be:

> Fluids, so to speak, neither fix space nor bind time… In a sense, solids cancel time; for liquids, on the contrary, it is mostly time
> that matters.

Such then is the restless space occupied however fleetingly by these liquid reflections on glass in Western Australia – an essay grazing human, geological and virtual time, on the potential of material, place, direction, and identity even, in this apparently engulfing erosion of terra firma. In what one might call the displacement of physical space – in which 'all that is solid melts into air' – unsettling the most ancient and dependable of sedimentary, layered and fixed things, even: place; identity. The very points of the compass, even, as an earlier commentator noted:

> To the landsman 'the East' and 'the West' are places, to the sailorman they are directions in which he may move.

Buckminster Fuller , in Fluid Geography (1944), published to accompany his World Map on Dymaxion Projection, provided a corrective cartography for the territorialist distortions of the Mercator projection within an enveloping awareness of the planet surface as but 26% dry land, with far-reaching implications for human orientation in history:

> The ceaseless universal motion of the sailorman's life persists in his brain, even when he is landed on the beach…. He sees
> everything in motion, from the slopping of the coffee in the pot to the peregrinations of the major magnitude stars….
> The sailorman, alert to currents, can see the flows of history as the static historian fails utterly to do. He sees how some people
> have turned adversities into technical advantages, how they have gradually reduced the limitations to their elected motions, and how
> they have in fact accelerated their movements….
> …land activities generally are based on eight-hour workdays, after which the office and factory are shut down; whereas the sea can
> never be shut down… Inertia, unchallenged, promotes careless philosophy.

In Fuller's analysis, the residual histories of human inscription in the landscape are in reality confined to the tall peaks and high plateaus of continuous submarine mountain ranges, the surface environment of a planet whose primary condition is liquid. Fluid Geography was published in 1944 in the acute awareness of aerial storms, engineered by modern flight technology, that had recently visited sudden catastrophe upon entire cities left bereft as human wreckage on the bed of the great ocean that is our terrestrial atmosphere, the mass of aeriform fluid surrounding the earth. Guernica, Dresden. Hiroshima, then to come.

So this liquid agency that Bauman ascribes to virtual modernity was always perhaps our true temporal, tectonic, geo-spatial and philosophical condition: determining the ocean-borne effluvia of human migratory patterns, their technologies and ensuing cultures, and framing ambivalent space:

> …the sailorman's One-World Ocean, fringed by the shoreline fragments which are his particular concern

Unbinding thus our deepest associations with place.

Place. Though my thoughts here are in Western Australia, I am writing in the Welsh Marches, in view of the long escarpment known as Wenlock Edge – the celebrated landscape and 'blue remembered hills' of A.E. Housman's A Shropshire Lad (1896), poems set to music by the likes of Ralph Vaughan-Williams, George Butterworth, Arthur Bliss and Ivor Gurney – names whose mere invocation is itself a charm of pure Englishness. Or so it seems. Scratch the surface, however, and Wenlock Edge shows itself as both a boundary and a horizon in time: an ancient coral reef, formed of the crushed shells and exo-skeletal remains of corals, sponges and sea-lilies more than four hundred million years ago, under the warm shallows of Silurian coastal waters in the South Pacific, some 30° or so South of the equator, the exact latitude of Perth, WA.

I write upon the deep crustal suture of a geological fault-line, sitting above a rock mantle composed of lava, ash, ancient mud flats, sedimentary deposits of sand and silt, in various eræ lifted, folded, melted, layered, dissolved, broken, punctured and otherwise formed under enormous tectonic movement, intense volcanic activity, river and marine solution, and glacial pressure, and only now exposed at this modern latitude as a wooded limestone ridge, dividing parallel dales of softer siltstones and purple shales, 53° North.

Well, 'thanks for the postcard' you may be thinking – but what exactly does all this liquid musing have to do with contemporary glass in Western Australia? My implication is perhaps that all human identity – cultural, national, regional, spiritual, individual – is forever determined more by where we set the horizon than by where the boundary happens to get fixed. That horizons, and not boundaries, determine places as essentially dynamic rather than inert things – that all landfall is the living coast of arrival, before it becomes the fixed place of venturing (or not-venturing!) out.

There exist of course more staid or proprietorial – even reactionary – ideologies, both of place and of belonging, boundary positions, boding inevitable consequences of cultural sclerosis and inertia: in economic and social development; for the individual, and for the artist. They tend inwardly, nurturing exclusive territorial sentiments or interests, with sometimes pernicious attitudes to kind, and verge ultimately on what Fuller terms the 'fallacy' of isolationism. As John Donne, isolated 'in a dangerous sickness' (Isaac Walton), wrote in 1623, in earshot of that tolling bell, 'no man is an island, entire of itself'. But for Buckminster Fuller:

> Isolationism was something deeper; it was staticism, blind inertia

which (we were warned) "… unchallenged, promotes careless philosophy". But horizons seed direction, inviting careful ad-venture, though – in Bauman's liquefactive analysis of the post-modern condition – the skyline would appear barely tolerable to the here-and-now:

> Life will be a constant chase after a forever elusive horizon, you know, you run after [the] horizon but [the] horizon moves as you
> run…

Well, it is of course in the nature of horizons so to move. But Bauman is perhaps here diagnosing a post-modern condition, one of pathological consumerism – the slippery dystopia in which:

> Desire does not desire satisfaction. To the contrary, desire desires desire.

The surface tension of this instantaneous, liquid modernity, the giddying meniscus upon which – held like tears, like ice floes or shelves – float urgent contemporary questions of place and of identity, discovers a familiar ambivalence in the nature of glass as a material: in its metastable and disordered state, is glass a liquid, or a solid?

> There is no clear answer to the question "Is glass solid or liquid?". In terms of molecular dynamics and thermodynamics it is possible

to justify various different views that it is a highly viscous liquid, an amorphous solid, or simply that glass is another state of
matter which is neither liquid nor solid.

In molecular physics, glass is technically distinguished from crystalline solid and from liquid states in that glass molecules configure in a disordered but rigidly bound arrangement, sharing properties of both liquid (although firmly bound) and solid (although lacking a regular lattice form). Glasses are characterised by their viscosity – viscosity being defined as the degree of resistance to flow, whose unit of measurement is poise. The fluid identity of glass is thus one of continually becoming what it already is. Glass, our first synthetic substance, is truly the material of our time.

Needing to become what one is is the feature of modern living…. Compulsive and obligatory self-determination.

What then is the potential place of glass in WA today, what kinds of self-determination would it seek, and where might we locate its formative horizons? Glass as a dynamic presence within a liquid modernity in which, as all artists know, making (compulsive, obligatory) can prove an active agent, both of identity and of place.

With the new glass studio at Midland Atelier, there arises a 'once-in-a-lifetime' opportunity for significant large-scale artist-led glass development that, if realised, would configure a unique centre for contemporary glass art in a wide range of public and architectural applications, nationally and internationally. No other Australian centre can offer the existing infrastructural and studio accommodation potential of the Midland Railway Workshops – they are purpose-built for large-scale work.

But what is the working range or limit, where to set the horizon line, for so upstart an ambition? When, in August 2004, Ross Garnaut (Australian Ambassador to China 1985-8) spoke of expanding trade links to China in terms of WA's 'destiny', he was recalling a long legacy of historical interaction, as well as recent growth in trade. The rapid expansion of the WA economy has been in no small way due to its favourable geographical location in respect of China, India and Southeast Asia.

So openness to this determining horizon, an outward-facing strategic commitment to collaborative partnership in China and the creative economy of the Pacific Rim, would evolve new partnerships by means of linked glass initiatives in Higher Education, creative business development, cultural and artistic programming, and large scale public art projects. This would accord with WA government priorities for international collaboration in the strategic arena of 'cultural richness and diversity' – "as a key way of building markets for Western Australian arts and culture".

Either through collaborative joint-venture partnership, or in purely domestic terms, it would also support the extended InnovateWA objectives: for innovation as a driver for economic and technological change; for capacity-building in education and research; for the commercialisation of ideas arising from industry-focused research; and for new job creation, and expansion of the export potential of the State.

In his 2008 Boyer Lecture series, Rupert Murdoch, touching upon contemporary Australian identity as artefact, a self-determination to be fashioned and made , pitches education, technology, and the importance of cultivating human capital in the context of confident Australian 'frontier spirit' of a modern, diverse society in the face of the expanding internationalism of a global marketplace compellingly characterised by the increasingly competitive and cultured presence of China and India.

The East is in his terms clearly more 'direction' than 'place', which returns us to our point of departure, with Buckminster Fuller and his Dymaxion projection:

We can see by experiment with this map why [the sailorman] laughs at the suggestion that 'East is East and West is West and never the
twain shall meet', for he sees that men as individuals have not only moved in the total course of time in all directions over the
face of the earth, but that they emigrated essentially out of one major pool of civilization, which was Indo-China. Here East and
West were originally one. From this one major pool there grew two main spearheads which we have come carelessly to identify as
unrelated. This division into East and West occurred as the offshoots drew into diametric global positions in the course of their
eventual encirclement of the earth.

## Andrew Breweton in conversation with Zhao Jiongwei

ZJW    Keith Cummings has said that your essays "transcend mere criticism" and that you are "attempting nothing less than the creation of a new type of craft writing", but you yourself refer almost casually to 'writing on glass', which sounds like some kind of graffiti! Do you see your essays on glass as a large-scale, cumulative project?

AB    Well, Keith's characteristically generous appreciation is something I value beyond words. His achievement as a glass artist and educator is unparalleled in the UK and his interests are very wide-ranging, so he has identified this little interface of glass and writing
that I am quietly working at as a new sound. I certainly hope this will be new and interesting to a Chinese readership, and it's true perhaps that there's nothing quite like it in the West.

As a body of work, whether this 'writing on glass' adds up to more than the sum of its parts will only become clear in time. But I suppose there is a continuous thread of thinking involved, because I keep wanting to go back and revise old texts after new essays get written!

ZJW    How does your experience as a poet influence your practice as an art critic?

AB    That's an intriguing question, because I've never really thought about this! I guess that the 'habit' of language – the experience, and the leavened voice-act, primarily of reading and of writing – is fundamental to both experiences and must be self-evident in the essays. At Cambridge I was schooled in 'close-reading' techniques of 'practical criticism', applied usually to unattributed texts stripped of history, and of all contextual alibis. This was an approach that privileged textual analysis above all forms of literary interpretation. I spend extravagant amounts of time on the compositional 'fine-tuning' and the linguistic nuances of essays (and emails, even!) and when I write I don't necessarily start at the beginning and finish at the end. The text gets woven and patched in time. Too much time. 'Haven't you finished that essay yet?' my wife will say, with a kind of mock despair!

The philosopher Ludwig Wittgenstein wrote "Do not forget that a poem, although it is composed in the language of information, is not used in the language game of giving information." (Zettel, §160) . I suppose that I am always acutely aware of this playful or promiscuous tendency of words to reach beyond their narrow informational purpose in a given context and to discover multiple or layered meanings, and so inadvertently I extend Wittgenstein's warning to common language. Sometimes this gives rise to 'found poems', or to different voices within the scope of a single poem.

ZJW    How did you manage the transfer from a glass production manager to a glass art critic?

AB    Well, such stories really only make sense with hindsight! And change, in my experience, has never been gradual but always complete and decisive – in my case from literary scholarship to glass factories to Art School and then back to poetry in a College of Performance Arts. Work in England, Italy, China, Australia.

After five years working in glass manufacturing at Stuart Crystal, I moved to Dartington Crystal for five years as Head of Design and Product Development.

I worked in various ways with a large number of designers, and made links with Glass departments in Art Schools. I started writing about glass in order to promote a collection of limited edition pieces we were developing. Some of these pieces are now in the Victoria & Albert Museum in London.

When I left Dartington Crystal in 1994 to become Subject Leader and Principal Lecturer in Glass at the University of Wolverhampton, the writing took on more of an academic focus, with editorial encouragement from Uta Klötz at Neues Glass/New Glass magazine for example, and through lectures and seminars, and so I developed a more deliberate approach to the business of 'writing on glass'. I didn't really fit the available categories. At Wolverhampton I was seen as an industrial glass specialist with this strange interest in poetry. When I was appointed Principal of Dartington College of Arts, I was regarded as a poet with this bizarre interest in glass.

ZJW     Do you think the former experience help a lot with the latter? If yes, how?

AB     Yes, very much so. I spent many years in very close proximity with what Keith Cummings has called the 'chameleon material' of glass; working daily with glassmakers, glass-making processes, and glass technologies in an extremely volatile environment. Long, hot, endless and exhausting hours making several decisions every minute of the day. In the urgency of this situation, you have quickly to learn to 'think on your feet', but then there comes a time when you can't think unless you are on your feet!

I was alert to the distinctive dialect of glass and the various 'languages' (verbal and non-verbal) that I encountered. For example, to watch a team of glassmakers at work is to witness a kind of dance. The work is minutely choreographed, requiring perfect timing and precision of movement, because this kind of time is money.

You learn respect for the material of glass, its volatility and diverse 'moods', and distinctive animating spirit. Its liquid intelligence, what it wants to do and what not. Glass furnaces are strangely living, breathing things, populated by craftsmen and cicadas that curse or sing in their own sultry micro-climate from season to season.

The factory I worked in was founded in the 1790s, and generations of the same families had worked there as glassblowers, glass cutters etc. The hand-made lead crystal glass manufacturing tradition was in sharp decline, and it felt like an unusual historical privilege for me to be inducted into that astonishing if sometimes brutal workplace culture almost at the last moment before it disappeared. The factory finally closed in 2002, some thirteen years after I left, and you could say that three hundred years of craft skills and manufacturing tradition went with it.

So all those people, the places, all that history and craft intelligence has a deep resonance for me. I was part of that; it is part of me. To that degree, it made me who I am – as a writer and educator, and as a manager or catalyst for innovation. Certainly it shaped my approach to glass. This for me is all a matter of lived experience, and not merely some history I happen to have studied.

ZJW     How did you begin to work in the glass industry?

AB     By complete accident! I had just given up my PhD study (on the nature of metaphor in late Renaissance English and Italian poetry) and got a job in a glass factory, Stuart & Sons Ltd. (Stuart Crystal). I grew up in an industrial town and had worked in factories during student vacations. Naïvely, I had thought that a manageable 'day job' would leave me plenty of time to write creatively. How wrong can you be! My work at Stuart's involved very long hours in a physically punishing factory environment where I had neither the time nor the inclination to write. I was watching and listening, gathering experience and understanding, and getting on with my life. Pan Yaochang mischievously calls this my own personal 'cultural revolution'!

ZJW     You did an very wide range of jobs in the glass industry. Can you say something more about this?

AB     Well, when I left Stuart Crystal in 1989 I had worked as a manager in every aspect of manufacturing from production to distribution. But mostly I worked in glass making – as Glasshouse Manager and eventually as Production Manager. I arrived at Dartington Crystal with all that specialist knowledge together with a complete sense of how a factory and a company worked. In all companies you find both creative and negative tensions between Design, Sales and Production functions and their differing pressures and vested interests, but the insight I had developed into making allowed me to cut to the quick of a given product decision very quickly, and I enjoyed the teamwork and the urgency involved in this process.

My work at Dartington Crystal then moved from pure Design to encompass Product and Process Development, and then Marketing. The job titles have varied, but I see all these rôles as different aspects of a single continuous and decisive process of thought and action.

ZJW     What do you want to express as a poet? And as an art critic?

AB     Mostly, my critical essays seek new ways of writing about glass both as a creative medium and as a distinctive contemporary artform. They concern the poetics of making, that is to say: thinking in, with and through the possibilities of physical materials and properties as imaginal media, and relating these perceptions to various ideas or aspects of human experience.

I was impatient with the anecdotal nature of much of the commentary that passes for Western criticism on contemporary glass practice, and I don't regard myself as an art historian. The link to poetic writing is of course an interest in the material of language and in poetics – the making of texts as artefacts in language – though I've never thought of my poetry as an act of personal expression. Voice, persona and anima are to me very distinct phenomena.

If it works, then it is the poem itself that speaks, and its composition if anything involves more a kind of listening – it needs the quality of time, and the stillness and attention that it takes to observe a bird or a wild deer without scaring or disturbing it too much. As a poet, you try to make yourself invisible, as the poet and falconer Helen Macdonald says of taming a goshawk. Well, you try.

I work in the material of embodied language and the many silences that engulf it. This language thickens and unfolds in time – it makes time and, in metre, it keeps time. Physically, it is rich in visual, musical and gestural dimensions. This seems more explicit in Chinese calligraphy, for example in the term fei bai – 'flying white' – the dry-brush style attributed to Cai Yong whose inspiration we are told came from watching a stone mason brushing written characters with slaked lime.

I feel a huge affinity with this calligraphic sensibility, no doubt accentuated by my inborn dyslexic tendency to 'read' the white spaces of a printed page with almost the same weighting or visual emphasis as the words themselves. The many gaps and silences and blanknesses in the printed field of my own poetry in some ways explore that aural, visual and gestural sensibility.

ZJW     What do glass artists want to express in your opinion?

AB     Artists that interest me seem to present 'questions' that they pursue through the making of glass artefacts. Although I call them 'questions', they are sometimes difficult to put into words, but you experience these things directly through the work.

Such works may explore or resolve a formal or technical problem – the relationship between 'inside' and 'outside', for example, in a transparent medium – but the aesthetic encounter or philosophical experience of the work reaches far beyond that technical baseline.

Often the work points to its origin in reference material that may include ideas or subjects that are transformed in the work of art. '"Thingsas they are/ Are changed upon the blue guitar"' as Wallace Stevens' poem says.

ZJW     What do they pay more attention to, skills or thoughts? How to keep balance between skills and thoughts/personality?

AB        This is a very good question, because it has artistic and educational dimensions. Naturally, skilling is important – of course it is. But skills are only tools, necessary to the reflective process of thinking and learning through making. Skills are insufficient ends in themselves, and eventually they get mechanised. At this point, as technology, they stop being complex living knowledge and become simple equipment.

I think all art making is cognitive process: representing the embodied, true intelligence of hand, eye and mind – of all the senses, familiar and unfamiliar. It is a way of thinking that discovers, invents or modifies both ideas and personality. And if I'm not interested in mere technical virtuosity, empty surface glamour or shallow learning, it is precisely because these things rarely result in this kind of transformation.

ZJW        What do you think are the similarities and differences between the creation of poems and works of glass?

AB        Similarities? Both use complex, volatile and highly demanding materials – glass andlanguage – synthetic materials whose histories are intimately bound up with thousands of years of human development, and far outdistance the individual artist.

The difference is extreme – it's the difference between the heaviest and the most ethereal media of human creativity…. but I'm not sure which is which!

ZJW        What kind of glass can be called glass art?

AB        Any glass object that creates a transparent visual threshold for a new experience, perception or understanding. Ever since Marcel Duchamp's Fountain, which was not glass of course but ceramic. But that doesn't matter.

ZJW        Do you think there is art content in ordinary glass products?

AB        Absolutely. In the 1930s, the English critic Herbert Read talked of pottery as abstract art in its purest essence – by which he meant plastic (i.e. sculptural, three-dimensional) art created without any imitative intention. I have some time for this idea, but there is here something still more fundamental: the fact that, as a species, we have this defining urge to make artefacts in the first place. I notice a Shanghai taxi driver drinking green tea out of a piece of glass packaging – a screw-top jar – and this speaks to me something of what it is to be human.

ZJW        What do you care more about, skills or expression when criticizing glass art? Or your own thoughts/feelings?

AB        I don't know. It can be difficult to know which of these things is leading the experience of the work at a given point in time, and in my own case I can only discover this by writing.

ZJW        Do you think poets or artists will be frustrated if others don't understand them?

AB        It is even worse if their work is obscured by understanding.

ZJW        What makes industrial design and fine art practices different?

AB        Well, external expectations differ – though expectations regarding design and 'fine art' practices change very rapidly and often even within the space of a generation. Externally speaking, design and fine art practices still account for different segments of the collectors' market. Much has been written on this art/design divide, and I have little desire to add to that heavy commentary. I'd prefer here to distinguish between different modes of human imagination.

The English Romantic poet, Samuel Taylor Coleridge (1772-1834) thought that there is one kind of creative genius that builds on what it knows, through the painstaking development of craft, technique, invention, method and practice, according to intentional design. This thinking constructs from, learns and essentially depends upon experience.

There is another kind of creative genius however that seems to come from nowhere: it is the visionary, often involuntary, ability to 'see' something that is completely new, for which there is no prior experience. Or to rediscover some existing thing in an utterly new light. Here there is no identifiable method. No development process is involved. Here the creative moment is instantaneous – more a mode of perception than of technique. I am paraphrasing and expanding upon what Coleridge wrote in Biographia Literaria (1817), so these are hardly new ideas.

Ideally, these creative impulses feed each other, spar and argue – they bear no hierarchical relationship to each other in terms of value, and these are certainly not mutually exclusive, false polarities of the creative spectrum. Proportionately speaking, the well-known definition of creativity as "98% perspiration and 2% inspiration" seems the usual mix!

My point is that all designers and artists will recognise both of these creative impulses at work at different points in their practice, and indeed at different stages in the making of a single work or series.

ZJW        OK, so how do art and design objects, and their markets, differ?

AB        It is sometimes well said that the objects of design are destinations, whereas art objects are thresholds, but these demarcation lines are becoming increasingly blurred. Clearly design objectives tend to be more focused and circumscribed by a given brief and a target market, but I can think of a lot of contemporary fine art that is similarly self-limiting, or plays to market expectation. Which of us has the artistic courage to live entirely in the moment, to do everything as if for the first time, and never to repeat ourselves?

Western design trends shifted their gearing from the manufacturing/object-centred consumer markets of the 1970s and 80s, to a marketing/lifestyle-focus in the 1980s and 90s, and then to the increasingly customised/participatory or interactive product culture of the 1990s/2000s. Consumers no longer simply 'buy' products or brands. Instead, they 'buy-into' branded objects in which they feel they have a personal stake, and that therefore through choice extend their self-image or individual identity by some quality or degree.

It would of course be simplistic to equate this gear-shift in design culture with that from object-centred abstract art making (1950s/60s), to conceptualism, (1970s/80s) and then to relational art practices, including virtual participatory 'second life' experiments of morerecent times (a good example being Cao Fei's RMB City project at Vitamin Creative Space).

But there are big contemporary global issues: of communication; regional and individual identity; the impact of religious and political fundamentalism on human freedom; environmental sustainability; the threatened diversity of species; and human ecology, which surely cut across these art/craft/design distinctions and engage all artists and designers in multiple ways.

ZJW        What do you think is more important, to design something the market likes or something you like? How do you balance the market and artists' personality?

AB        Another huge question! Perhaps this can best be illustrated by extremes. In the case of new product, the mass market does not know what it wants until it sees it. Often the commercial buyer (e.g. for a retail chain) doesn't know what they are looking for either – they want what already sells – and so the designer must choose the degree to which she or he is prepared to compromise by imitation. Further design compromises accrue inevitably in terms of quality, direct cost, sales margins &c., as the pressure of cost-cutting high street or trade competition increases.

Actually, much commercial design amounts to imitation or re-styling of already-existing product concepts and ideas, and in the worst cases this deliberately breaches intellectual property and design rights in the service of an undiscriminating market motivated by low-cost consumer envy. This is of course one extreme.

At the other extreme, with the highest 'value-added' luxury brands, design criteria appear paramount, evolving a signature style to meet élite market expectations regarding the quality, ethos, aesthetics and values into which a comfortable or affluent clientèle will buy. The brand 'signature' wants to be a hallmark both of distinctiveness and of distinction (quality, ethos, cultural values &c.) to which the designer must actively connect and stay tuned.

Top brands tend to have much longer-term and predictive planning horizons, more enduring business models and more coherent philosophies, and this determines the parameters, the design sensibility and production values that the design team then works with.

But everything is connected. Good design rarely occurs in isolation. Design culture is discursive, omnivorous, and has finely-developed social instincts. Perhaps the 'artist's personality' and 'the market' aren't as distinct as your question may suggest.

Truly original design is wholly innovative and surprising – creating new ideas for which there was previously no market. Markets don't just happen, anyway: they are made.

ZJW    As an art professor, what do you want your students to learn from you? What do you think is the most important thing that they have to know?

Hmm…. two imperatives, I hope conflicting ones:

firstly, the hunger to learn (from everyone, and everything you see, hear, touch, taste, scent, or otherwise encounter) everything you can possibly learn – from whatever source and by preference through direct experience and through making art;

secondly, to know that the way that can be followed is not the true way.

ZJW    What was it that brought you to China?

AB    Well, I would say: a life affinity I somehow intuited around the age of six or seven. An affinity whose origin I can't account for, the intensity of which I can't explain – not in this life, anyway, as my friend Jin Xing would say! At school this took the form of interests in the arts, poetry, philosophy and political history of China, but this interest developed outside the school curriculum, with the encouragement of certain teachers.

So, in practical terms: in 1995, as Head of Glass at Wolverhampton, I volunteered to participate in British Council Education Fairs in Guangdong and Hong Kong, on the understanding that I could visit Shanghai in the three days separating Guangzhou and Hong Kong events. When my boss, Vaughan Grylls, then Head of the School of Art & Design, asked me Why Shanghai?, my naïve and honest answer was that I couldn't say, but that my instinct told me there was an interesting opportunity for our School there.

To his great credit, Vaughan backed my rather threadbare motive and so, in January 1996, with my colleague Ida Wong, I met Wang Dawei in Shanghai for the first time, and we embarked upon the professional partnership and a friendship that continues to this day. From these chance beginnings developed the Shanghai Glass Studio, the 1999 New Glass Economy exhibition and Bamboo Scroll sculpture installation at the Shanghai Public Library, and the new Baoshan glass developments, including the Shanghai Glass Museum. And a new generation of Chinese glass artists.

Wang Dawei and I were always very clear that this was to be a long-term project, designed to serve future generations of students, artists and educators in and beyond Shanghai.

Thirteen years later, we seem temporarily to have swapped daughters: Wang Dan is in London studying for her M.A in Curating, and my daughter Ruth is working in textile design with Jiang Qiong-er in Shanghai.

ZJW    So who were, or are, your closest associates in China?

AB    It is invidious to name names, and there are anyway too many to mention! But our work in Glass has always been a group project, one that would not have happened with such speed and understanding without the help of Ida Wong and Chen Zenghao, to whose memory this book is dedicated.

That group project, this sense of partnership and all that shared creative energy, is the real subject of this book.

It has been my privilege to work with formative and emergent figures in Chinese glass such as Zhuang Xiaowei and Xue Lu, and Yang Hui-shan and Chang Yi in Shanghai, and Guan Donghai in Beijing. Qian Weichang's encouragement and inspirational leadership at Shanghai University has always been a positive influence, as has Zhou Zhewei and his predecessor Zhuang Yongqian. Qiu Ruimin as Dean of the Fine Arts College has been very supportive of our work.

In academic circles I have known Hang Jian and Fan Di An in Beijing for many years and always valued their ideas and conversation. In the wider art scene I have worked with Hu Fang and Zhang Wei at Vitamin Creative Space in Guangzhou; with Lu Jie at Long March; with Qiu Zhijie and with Liu Ding. Li Xiaoqian organised the Artist Links residencies at Dartington. I have written on He Yunchang's work in performance. I am immensely grateful to Lu Jian and Zhao Jiongwei, as editor and translator respectively, of this book.

I continue to learn from these and many others I have the great fortune to count as friends and colleagues. There isn't space here to continue with this list, but… they know who they are!

ZJW    How do you feel about the present situation of the Chinese glass industry?

AB    Enthusiastic. I see enormous potential for design innovation within the glass manufacturing base, and interesting prospects for glass art in relation to architectural space in China, and I see this emerging as a distinctive Chinese presence on the international glass scene.

I don't think that Yang Hui-shan and Chang Yi at Liuligongfang have received sufficient credit for their formative contribution to contemporary Chinese glass and, quite apart from Yang's work as an artist on whom I have written, I will be very interested to see how that brand continues to develop over the next few years.

But there is now a new generation of Chinese glass artists, the first Glass graduates of Shanghai and Tsinghua universities, and they have yet to make their impression on glass manufacturing industry in China. More and more Chinese art schools seem keen to develop new glass curricula, and this is very promising.

There seems also to be a renewed interest in the very distinctive and little-known history of Chinese glass, which is intriguing, and the new Shanghai Glass Museum at Baoshan, together with the Liuligongfang Glass Museum, should make an important contribution to this development.

ZJW    How do you feel about the present Chinese industrial design education compared with the English? Do you have any suggestions for Chinese fine arts and industrial design education?

AB    I think that the very nature of the art & design academy is changing, and that both education traditions can benefit from cross-disciplinary practice, and from cultural exchange. While it's true that art and design disciplines can no longer function effectively in 'subject-silos', it is extremely important that traditional and specialist skills and the craft intelligence of learning-through-making are preserved in this and for future generations. Students these days graduate immediately into global markets, and so for this reason I am always more interested in horizons than boundaries, as the essay Liquid Horizons included here perhaps elaborately suggests.

ZJW    What do you think is the priority in China, a mature art market or a group of mature artists?

AB    Where artists move, markets follow. Sooner or later.

图　版

冲破黑暗（Out of Darkness） 彼得·芬克（Peter Fink） 伍尔弗汉普顿大学艺术与设计学院霓虹灯 2002年

冬至（Midwinter） 邱智杰（Qiu Zhijie） 2005年

星形收藏品（Star） 查理・麦克（Charlie Meaker） 达汀敦水晶工坊藏品 1990年

玻璃花瓶（Glacier vases） 雷切尔・伍德曼（Rachael Woodman） 达汀敦水晶工坊藏品 1991年

彩盘（Joined Clear and Double-cased Coloured Dish with Graal Border） 雷切尔·伍德曼 (Rachael Woodman) 达汀敦水晶工坊藏品
直径500mm 1991年

冬景·月亮 (Winter Landscape — Moon)  薛吕  直径158mm  2006年

冬景·池塘 (Winter Landscape—Pond)  薛吕  直径158mm  2006年

海岸线 (Shoreline) 约·纽曼 (Jo Newman) 长80mm, 宽10mm 2000年

记忆的玻璃瓶（Memory phial） 约·纽曼（Jo Newman） 长120mm，宽100mm，高100mm 2006年

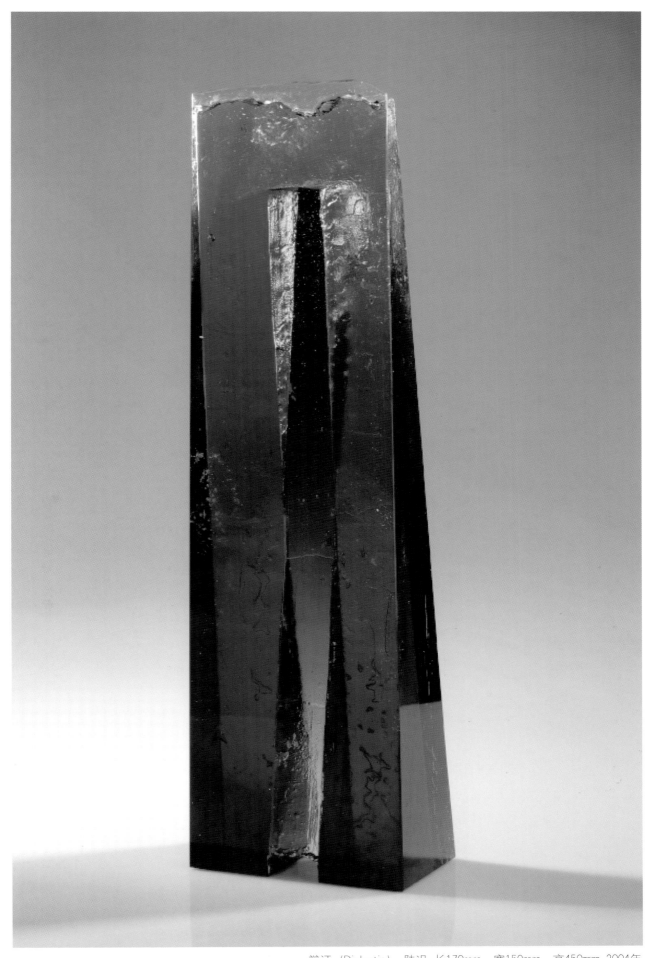

辩证（Dialectic） 陆迟 长170mm，宽150mm，高450mm 2004年

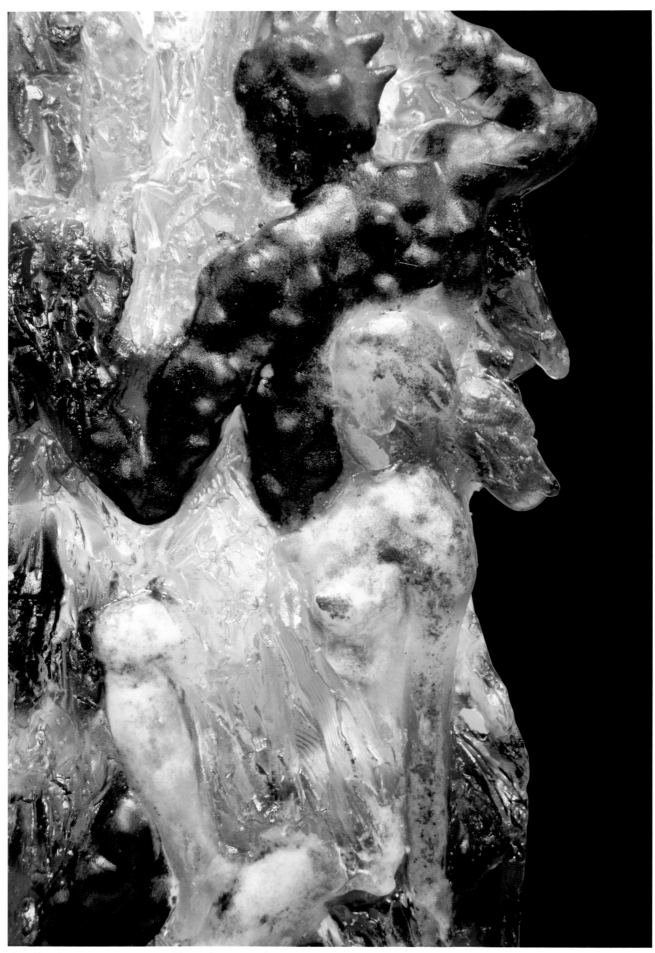

女人花1（Woman Flower 1） 潘红飞 长70mm，宽240mm，高200mm 2006年

红河 II (Red Sea II)　方敏　直径50mm　2006年

夏季的水果——樱桃（Summer Fruit — Cherry） 熊嘟嘟 长200mm，宽200mm，高80mm 2006年

书法 6 (Non—calligraphy & calligraphy IX) 王琴 长320mm，宽70mm，高470mm 2007年

编织（Weave） 庄小蔚 长20mm，宽10mm，高25mm 2003年

方尖碑（Memory） 庄小蔚 长12mm，宽12mm，高55mm 2004年

蓝笛（Blue flute） 庄小蔚 长180mm，宽180mm，高620mm 2006年

身体（Body） 庄小蔚 长120mm，宽80mm，高250mm 2003年

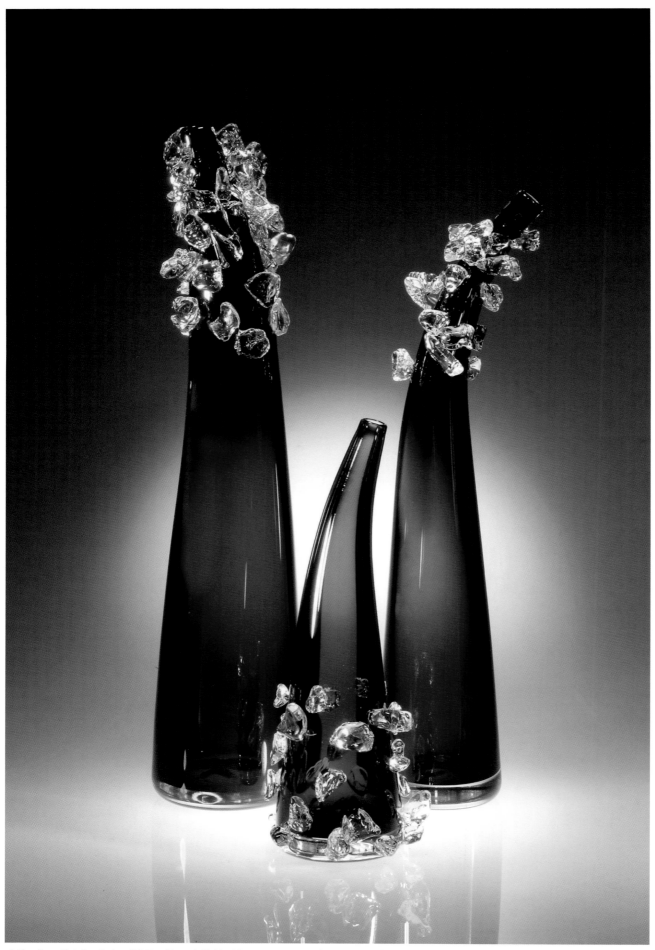

冰族（Ice Chi family） 斯图亚特·嘉伏特（Suart Garfoot） 长420mm，宽300mm，高470mm 2005年

记忆的影响 1 (Effets de la memoire I)　安东尼·勒彼里耶 (Antoine Leperlier)　长600mm，宽170mm，高700mm 1993年

记忆的影响10（Effets de la memoire X） 安东尼·勒彼里耶（10Antoine Leperlier） 长250mm，宽250mm，高250mm 2000年

曾经 8 （L'Instant juste avant VIII） 安东尼·勒彼里耶 （Antoine Leperlier） 长180mm，宽180mm，高200mm 2003年

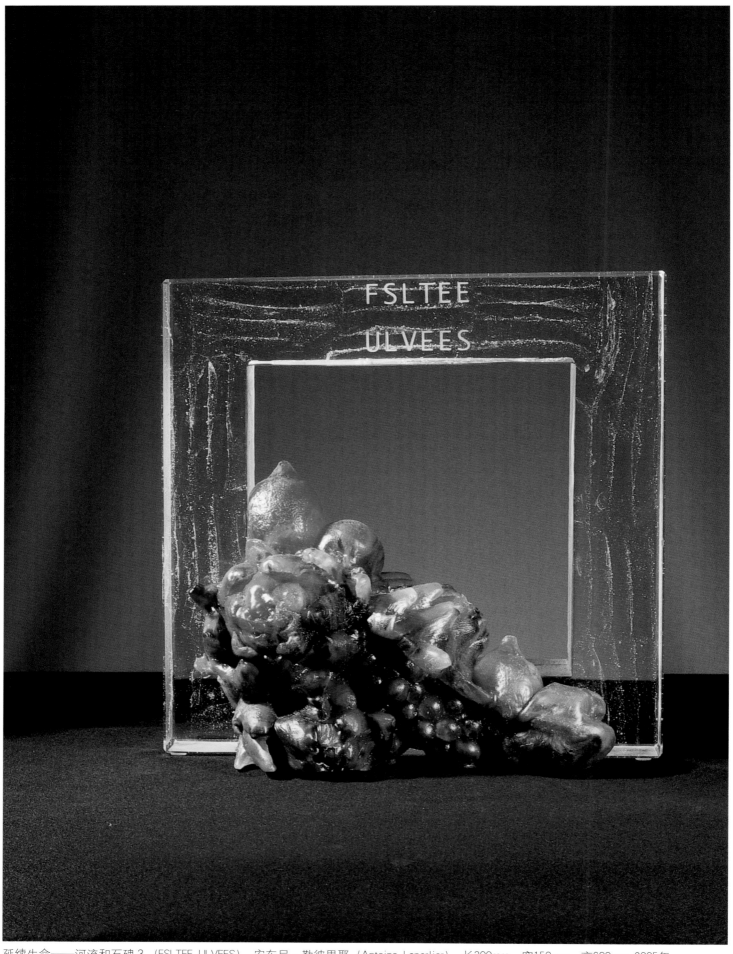

延续生命——河流和石碑 3 (FSLTEE ULVEES) 安东尼·勒彼里耶 (Antoine Leperlier) 长300mm，宽150mm，高600mm 2005年

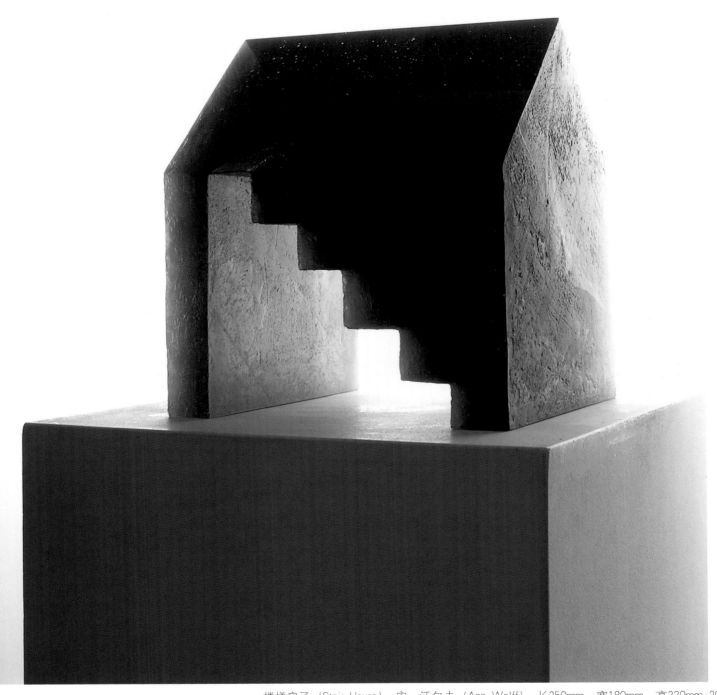

楼梯房子（Stair House） 安·沃尔夫（Ann Wolff） 长250mm，宽180mm，高220mm 2004年

楼梯房子模型 (Mould for Stair House)  安・沃尔夫 (Ann Wolff)  2004年

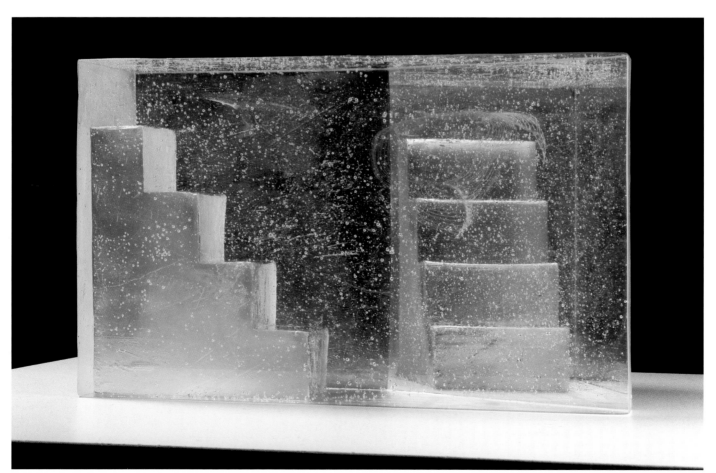

住宅 (Residence)  安・沃尔夫 (Ann Wolff)  长380mm，宽180mm，高250mm 2006年

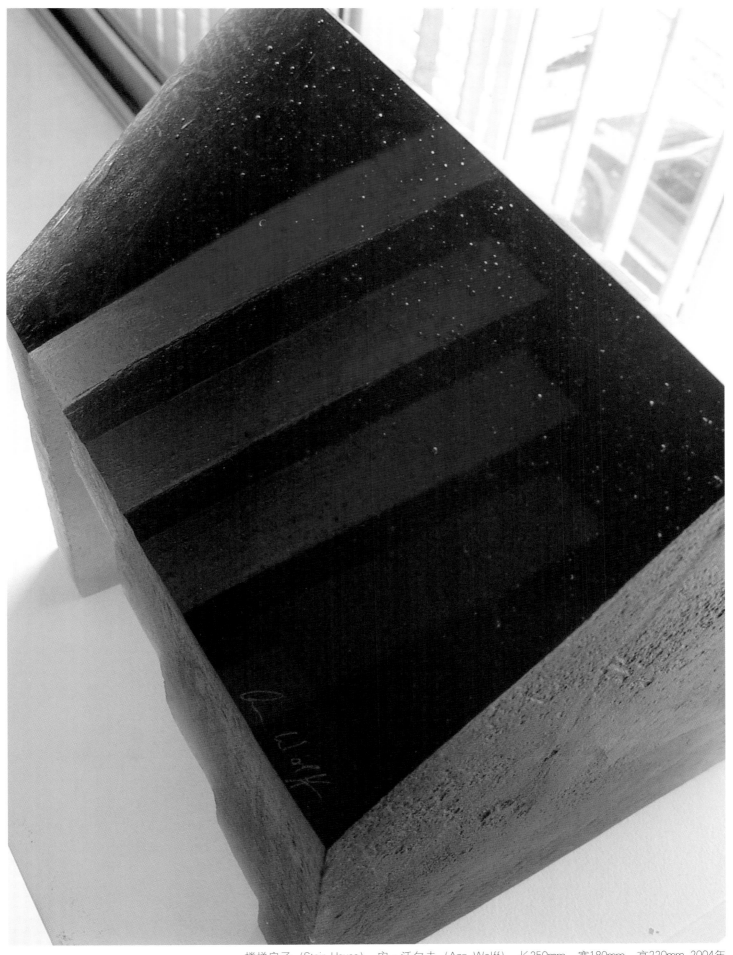

楼梯房子（Stair House） 安·沃尔夫（Ann Wolff） 长250mm，宽180mm，高220mm 2004年

屏风（Screen） 安·沃尔夫（Ann Wolff） 长1200mm，宽120mm，高220mm 2006年

阶梯（Step Out） 安·沃尔夫（Ann Wolff） 长690mm，宽190mm，高520mm 2007年

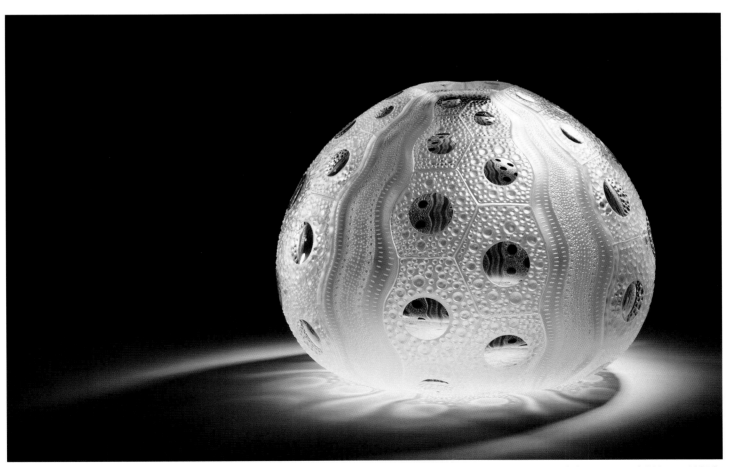

海胆 1（Clear Sea Urchin） 凯文·戈登（Kevin Gordon） 直径370mm，高300mm 2007年

海胆1（Clear Sea Urchin detail） 凯文·戈登 （Kevin Gordon） 2007年

海星（Acanthastrea） 凯文·戈登（Kevin Gordon） 直径240mm，高410mm 2007年

菌类（Agariciidae） 凯文·戈登（Kevin Gordon） 2007年

珊瑚（组群）（Galaxea Coral group） 凯文·戈登（Kevin Gordon） 2007年

珊瑚灯 (Faviidae Coral Lamp) 凯文·戈登 (Kevin Gordon) 2007年

红河扇 (Red Sea Fan) 凯文·戈登 (Kevin Gordon) 直径400mm，高130mm 2007年

珊瑚（Turbinaria Coral Vase） 凯文·戈登（Kevin Gordon） 直径310mm，高310mm 2007年

光辉翱翔 (Soaring Lucidity)　杨惠姗 (Loretta Yang Huishan)　长200mm，宽170mm，高670mm　2001年

为自己祈祷 (Wish upon Yourself)　杨惠姗 (Loretta Yang Huishan)　长350mm，宽180mm，高360mm 2001年

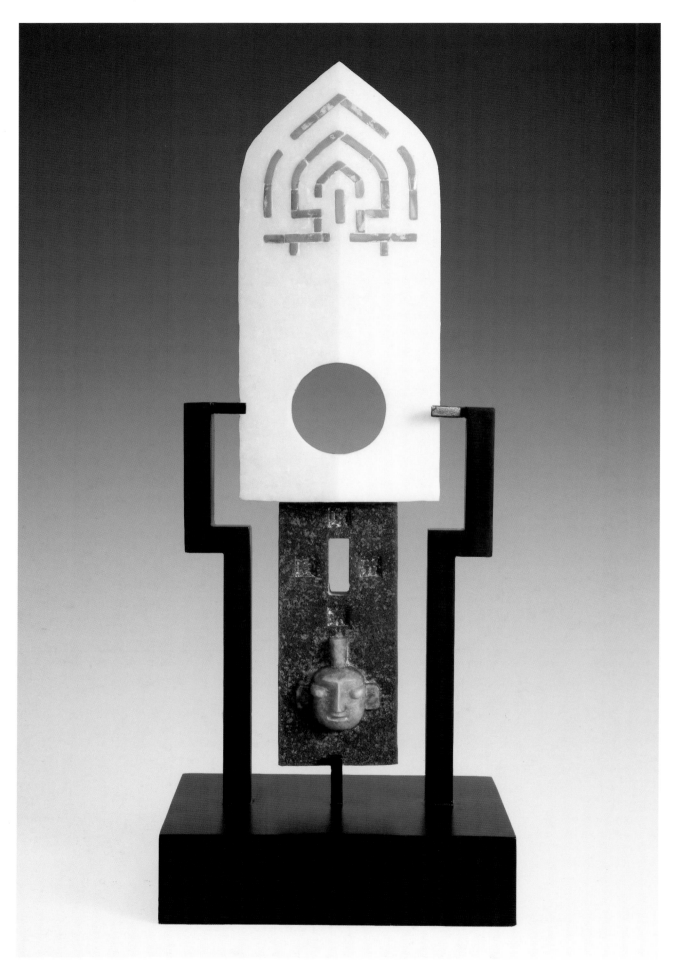

武器系列 3 （Weapon Series No.3） 关东海 （Guan Donghai） 长140mm，宽160mm，高510mm 2006年

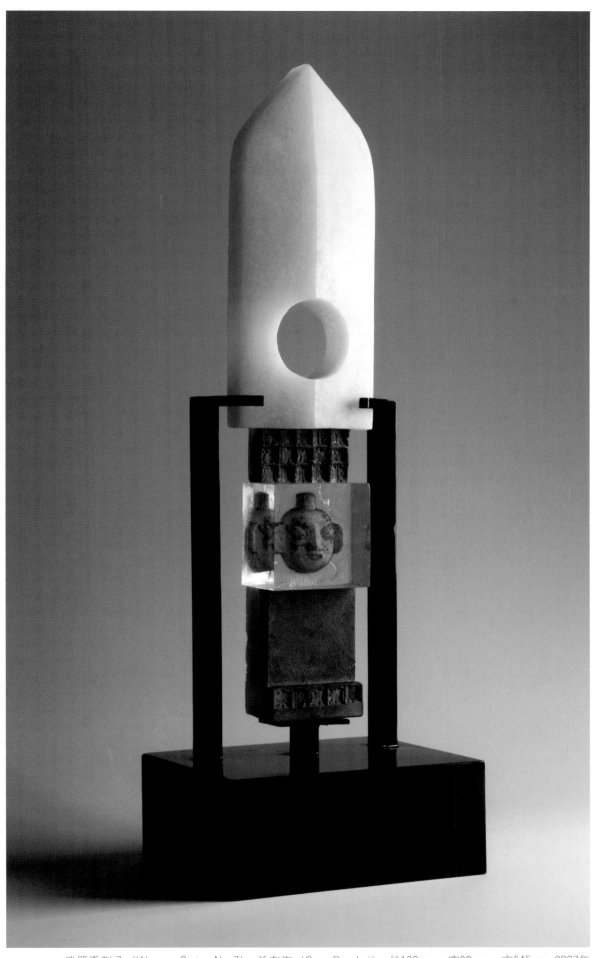

武器系列7 (Weapon Series No.7) 关东海 (Guan Donghai) 长120mm，宽60mm，高645mm 2007年

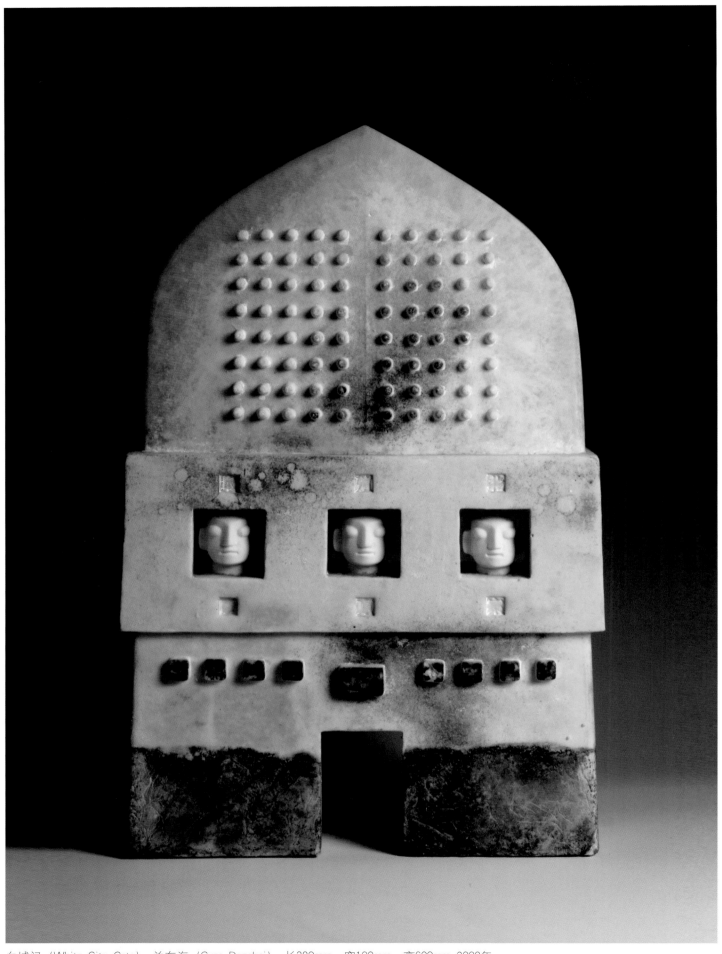

白城门（White City Gate） 关东海（Guan Donghai） 长380mm，宽100mm，高600mm 2008年

城门系列 "Biao" (City Gate Series 'Biao') 关东海 (Guan Donghai) 长310mm, 宽80mm, 高420mm 2006年

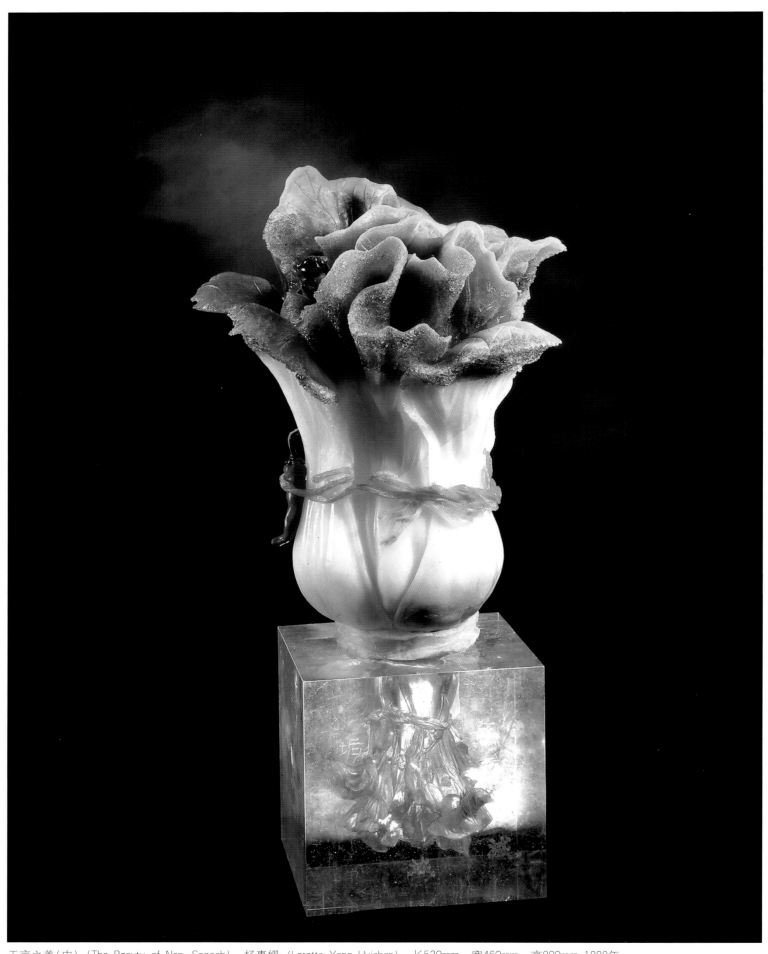

无言之美（中）（The Beauty of Non—Speech） 杨惠姗（Loretta Yang Huishan） 长530mm，宽460mm，高900mm 1999年

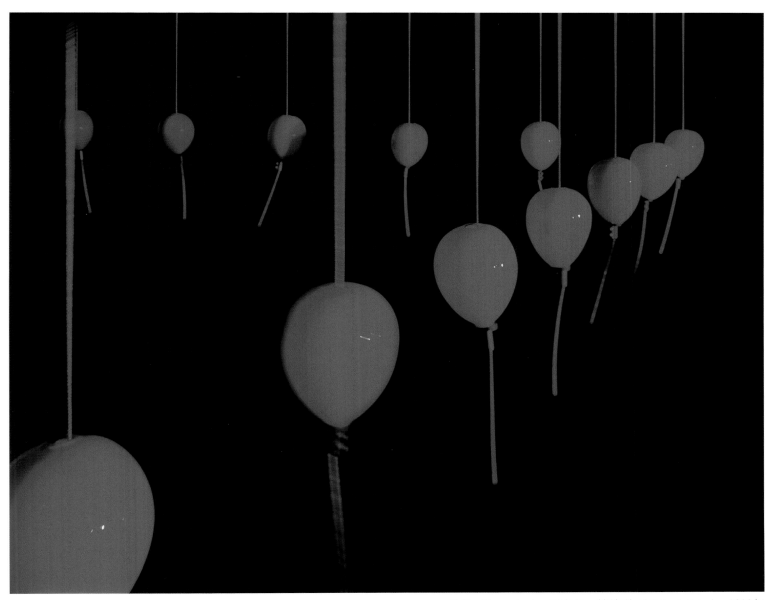

传染（Contagion） 迈克尔·帕特利（Michael Petry） 2000年

记忆珍宝（Treasure of Memory） 迈克尔·帕特利（Michael Petry） 2000年

记忆珍宝（Treasure of Memory） 迈克尔·帕特利（Michael Petry） 2000年

被遗忘的吻（Laughing at time） 迈克尔·帕特利（Michael Petry） 2000年

MAP单元（MAP Unit） 迈克尔·帕特利（Michael Petry） 2001年

Barc 基思·卡明斯（Keith Cummings） 1995年

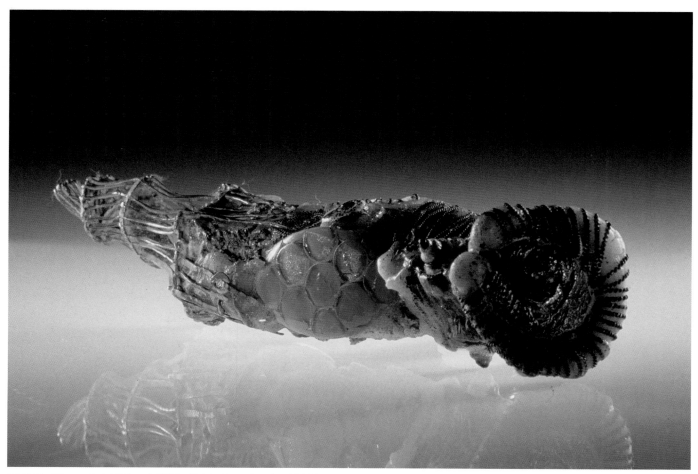

沉睡者（Sleeper） 基思·卡明斯（Keith Cummings） 1996年

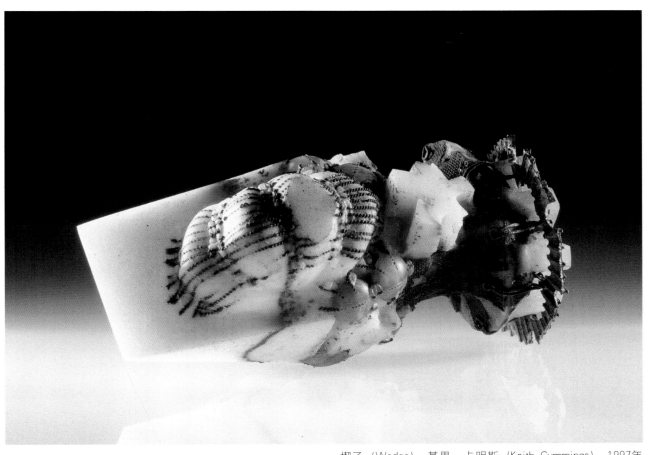

楔子（Wedge）　基思·卡明斯（Keith Cummings）　1997年

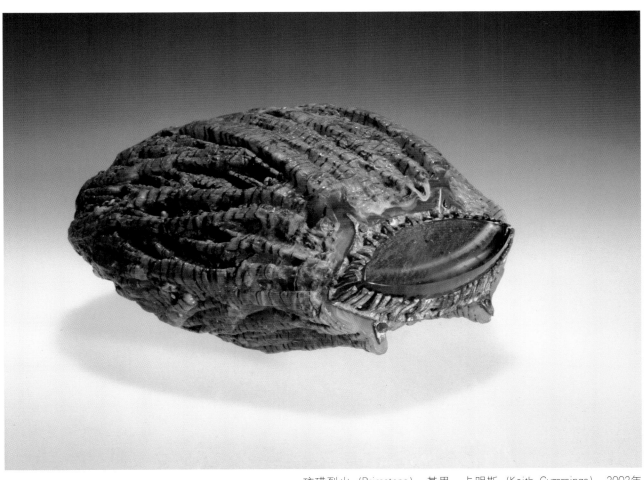

硫磺烈火（Brimstone）　基思·卡明斯（Keith Cummings）　2002年

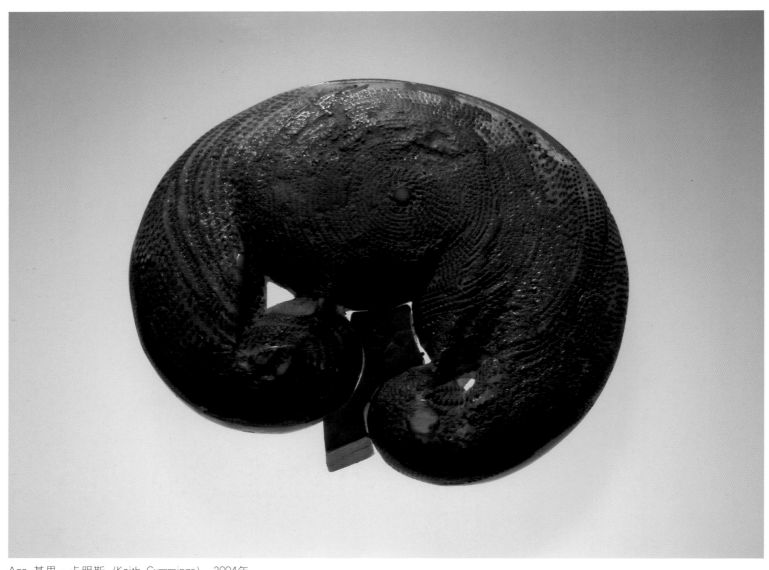

Ace 基思·卡明斯 (Keith Cummings) 2004年

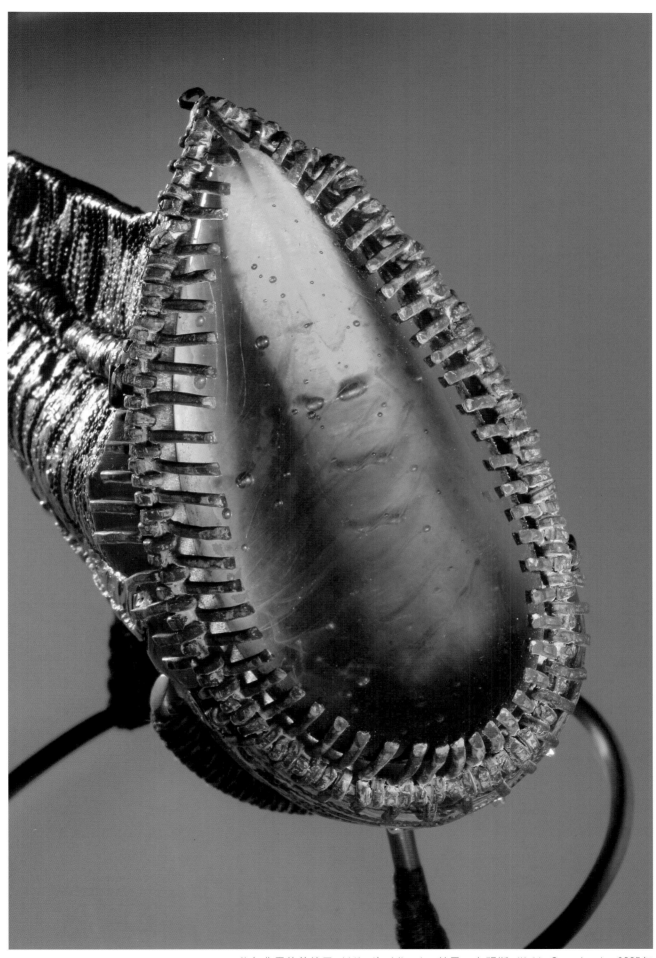

艾尔弗雷德的镜子（Alfred's Mirror） 基思·卡明斯（Keith Cummings） 2005年

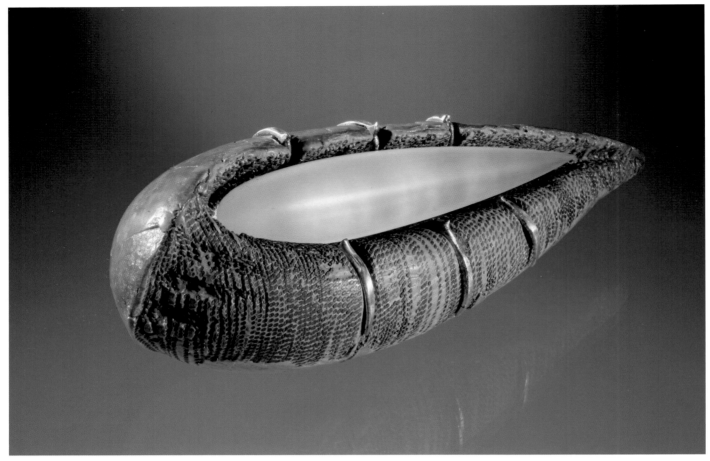

掷弹兵（Grenadier） 基思·卡明斯（Keith Cummings） 2006年

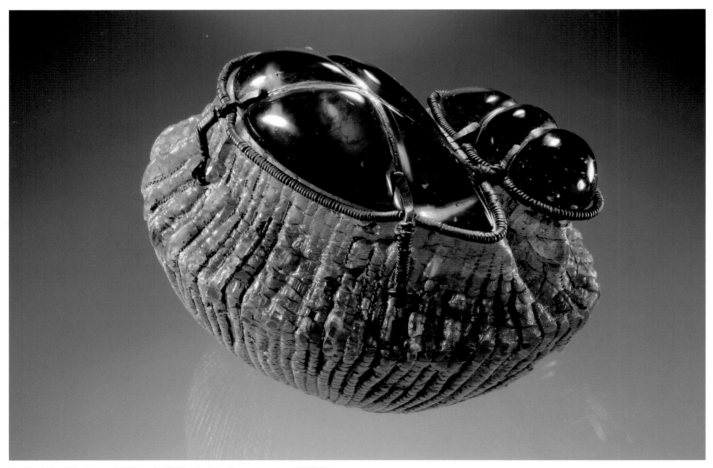

王朝时代（Tudor） 基思·卡明斯（Keith Cummings） 2006年

竹简 (Bamboo Scroll) 科林·里德 (Colin Reid) 上海图书馆 1999年

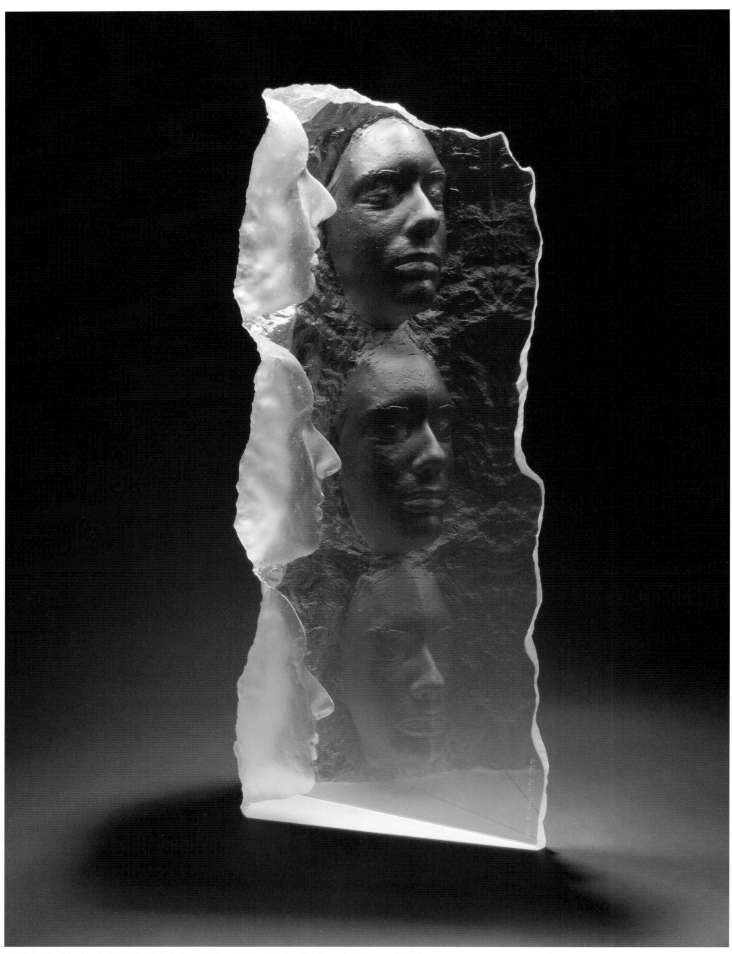

光学水晶 (Untitled R1233 'Kaja') 科林·里德 (Colin Reid) 高610mm 2004年

对比（Contrast） 科林·里德（Colin Reid） 高820mm 2007年

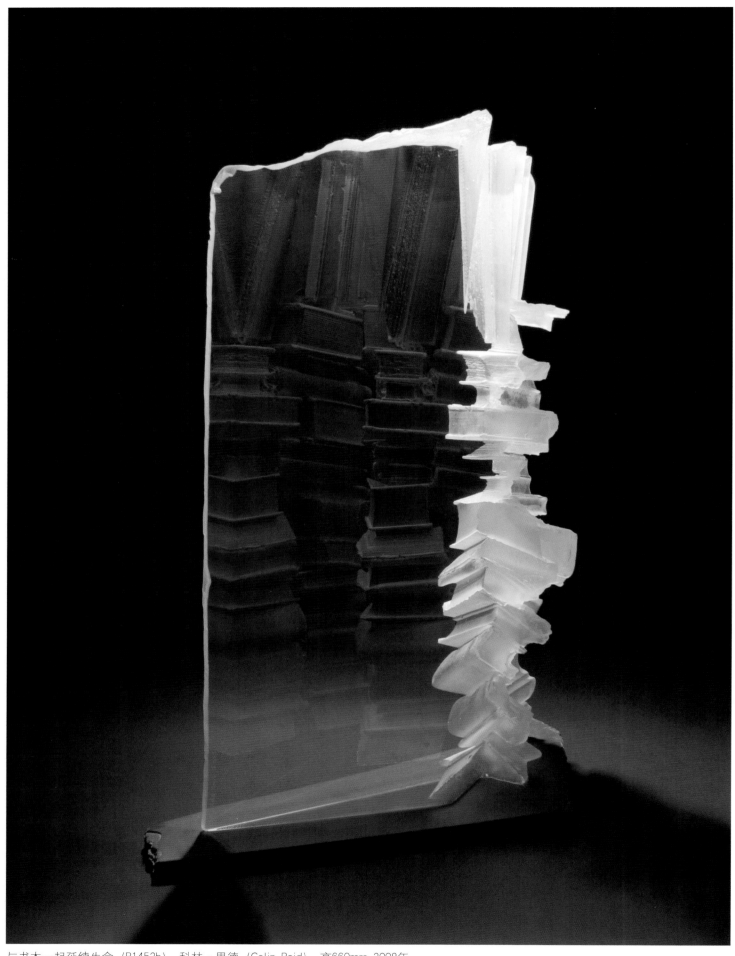

与书本一起延续生命（R1452b） 科林·里德（Colin Reid） 高660mm 2008年

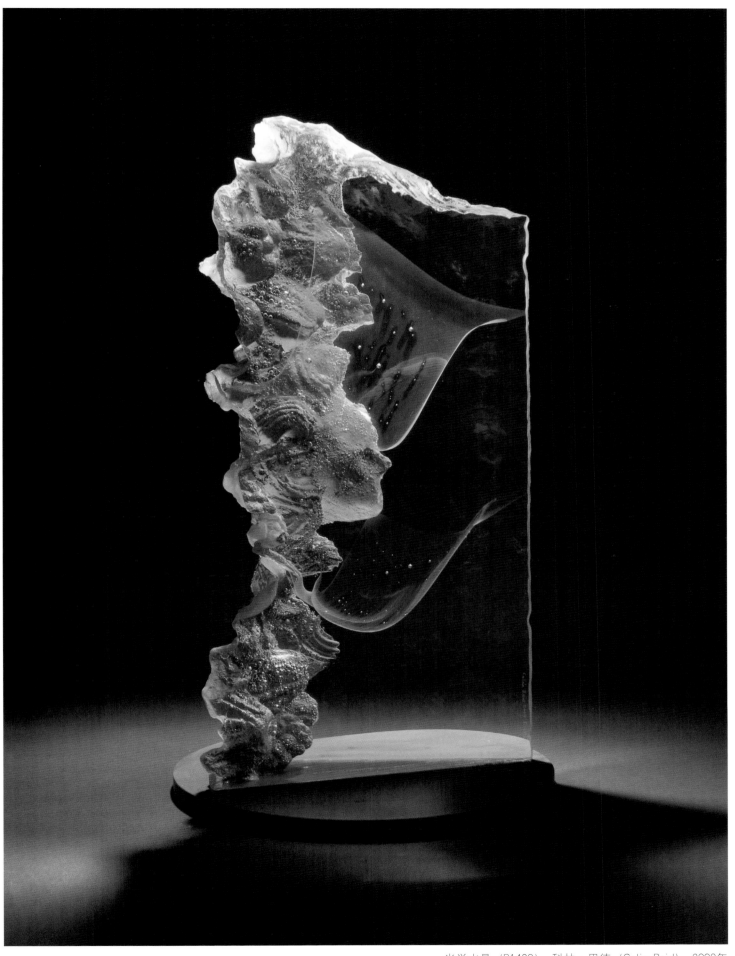

光学水晶 (R1480)  科林·里德 (Colin Reid)  2009年

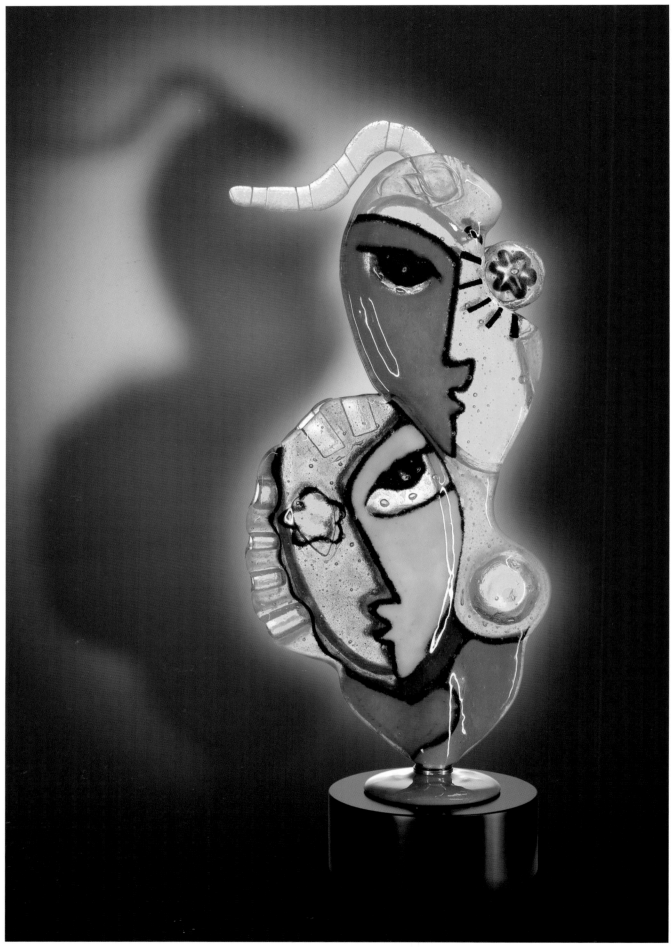

情人（Lovers） 斯维欧·维利亚托柔（Silvio Vigliaturo） 长320mm，高830mm 2009年

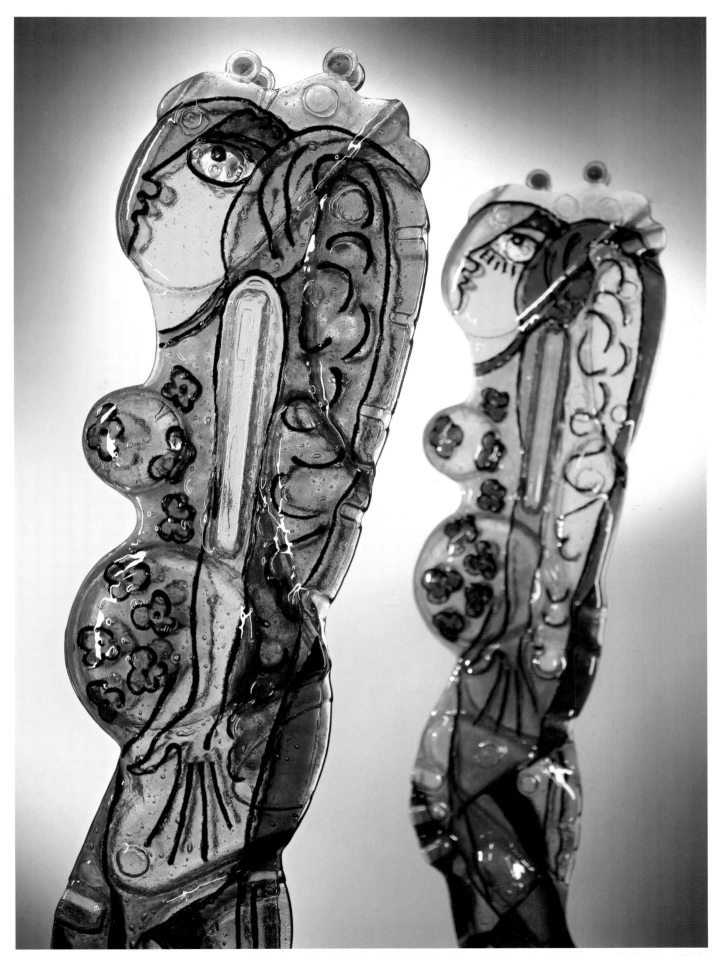

天使（Angeli）　斯维欧·维利亚托柔（Silvio Vigliaturo）　长4000mm，高2200mm　2007年

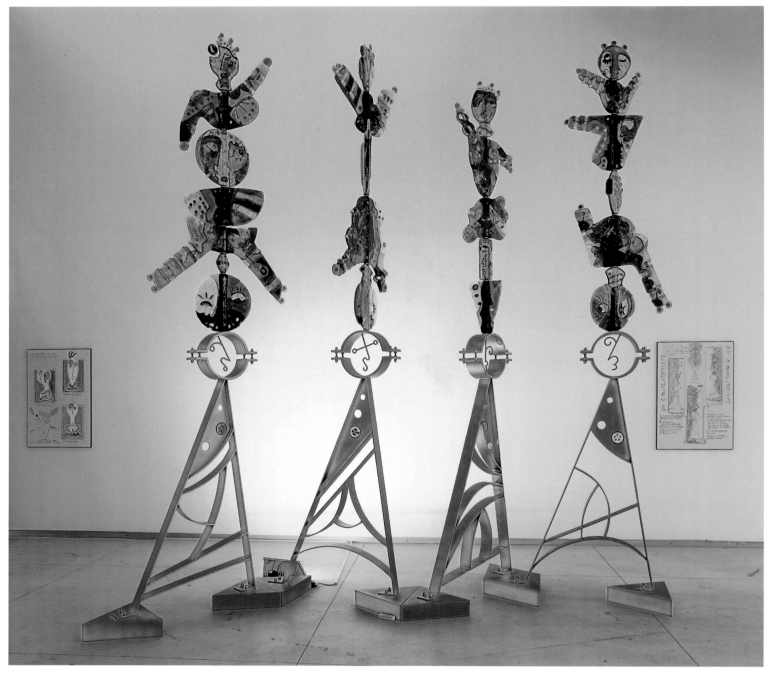

走钢丝的人（Tightrope Walkers）　斯维欧·维利亚托柔（Silvio Vigliaturo）　高4500mm 2005年

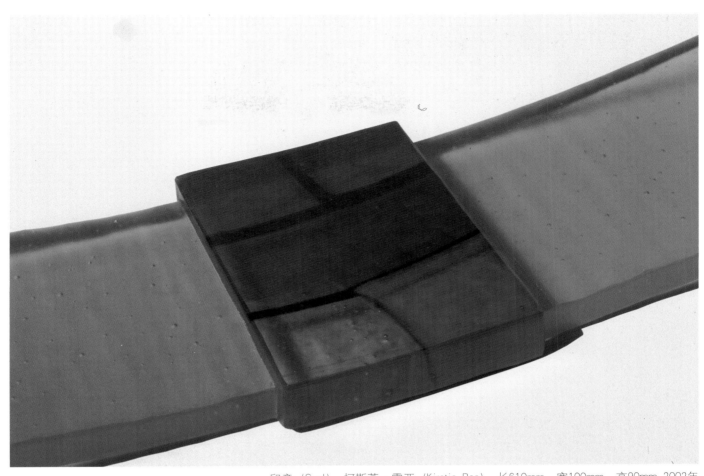

印章（Seal） 柯斯蒂·雷亚（Kirstie Rea） 长610mm，宽100mm，高90mm 2002年

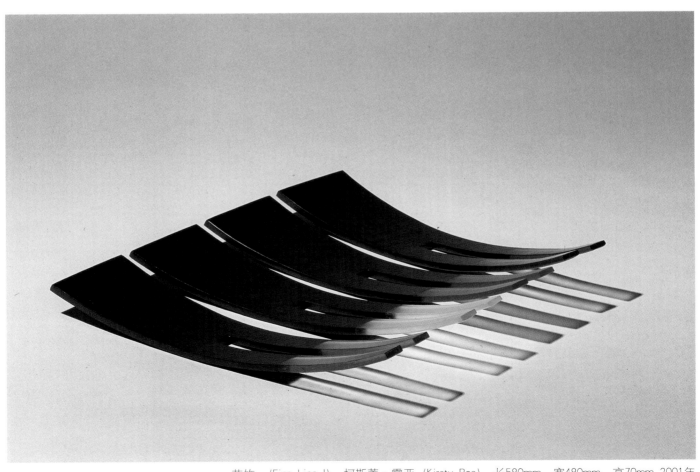

花饰 （Fine Line I） 柯斯蒂·雷亚（Kirsty Rea） 长580mm，宽480mm，高70mm 2001年

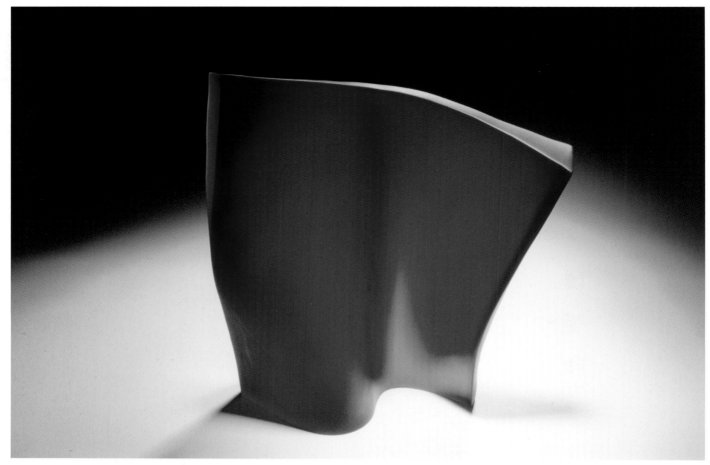

S 克里斯汀娜·凯斯 (Christine Cathie)  长380mm 宽150mm 高410mm 2002年

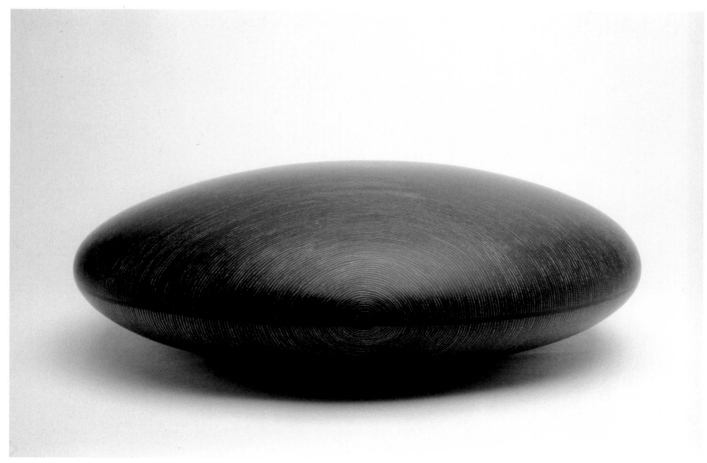

颠倒 梅·道格拉斯 (Mel Douglas)  直径450mm，高150mm 2002年

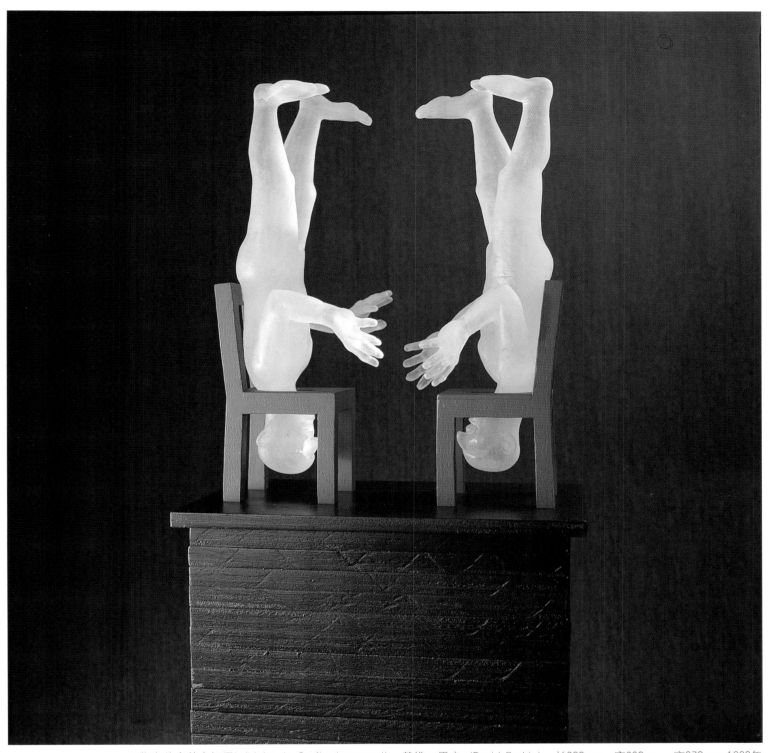

居住在狭窄的空间里I（Living in Confined spaces I） 戴维·里克（David Reekie） 长300mm，宽260mm，高670mm 1998年

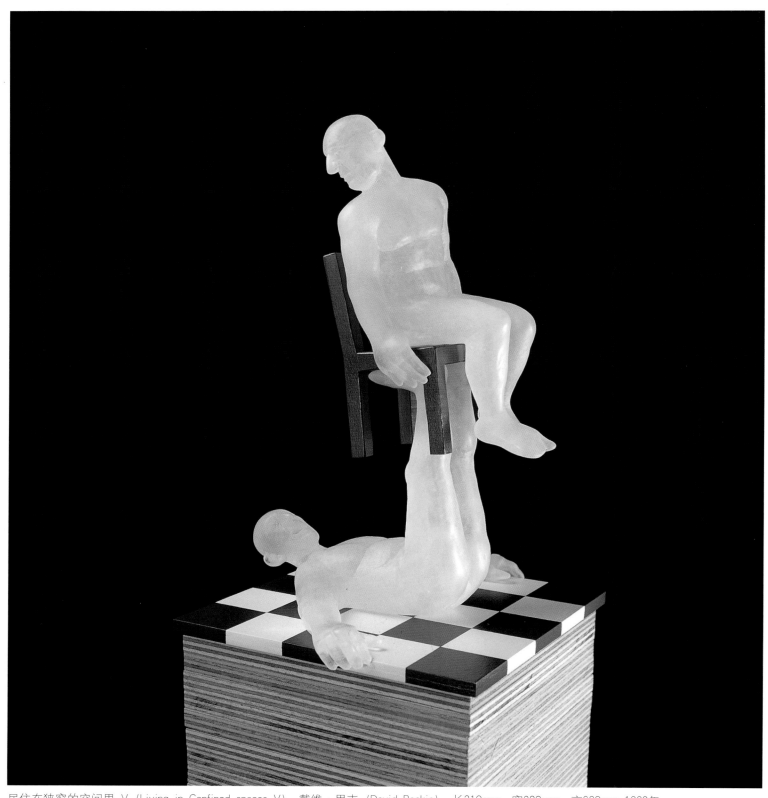

居住在狭窄的空间里 V（Living in Confined spaces V） 戴维·里克（David Reekie） 长310mm，宽280mm，高690mm 1998年

在摇摆的地面上Ⅵ（On Shaky Ground Ⅵ）　戴维·里克（David Reekie）　长330mm，宽200mm，高630mm 1997年

无法用言语表达——自己的肖像画5 (I can't get my words out – Self Portrait V) 戴维·里克 (David Reekie) 长170mm, 宽180mm, 高350mm 1998年

埋葬在作品中 (Buried in My Work) 戴维·里克 (David Reekie) 长270mm，宽270mm，高250mm，2002年

盘子 (slide) 萨拉·麦当娜 (Sarah Macdonald) 直径550mm 2001年

原始人类（Primal Animal） 科林·伦尼（Colin Rennie） 1997年

原始人类Ⅳ（Primal Animal Ⅳ） 科林·伦尼（Colin Rennie） 1997年

还原 （Reducere） 科林·伦尼 （Colin Rennie） 直径320mm，高450mm 2005年

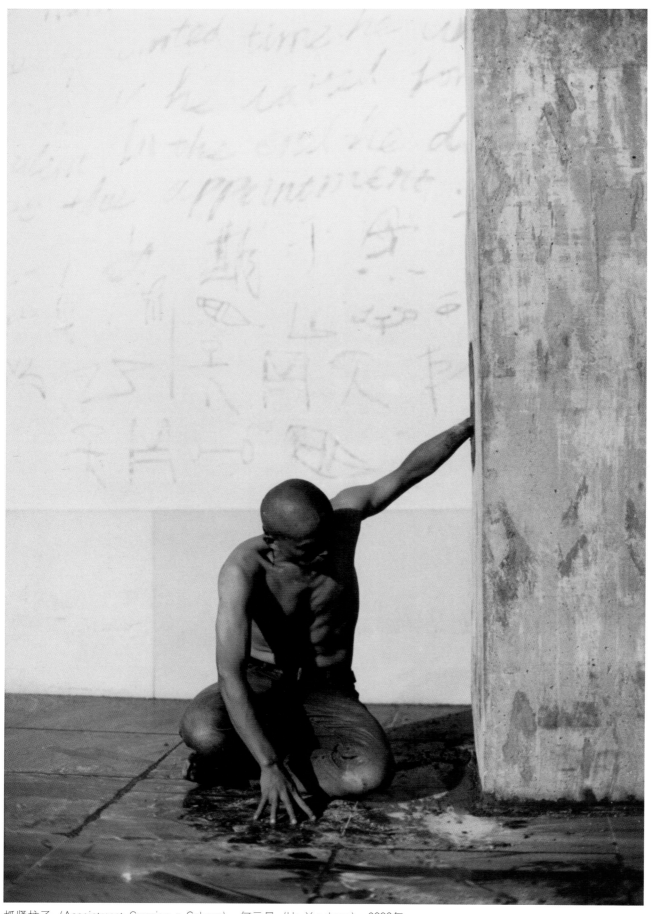

抓紧柱子 (Appointment Grasping a Column) 何云昌 (He Yunchang) 2003年

铸造舞动的龙 (Constructing a Moving Dragon) 何云昌 (He Yunchang) 2002年

大不列颠摇滚旅行（A Rock Touring Around Great Britain） 何云昌（He Yunchang） 2006年7月

大不列颠摇滚旅行（A Rock Touring Around Great Britain） 何云昌（He Yunchang） 2006年7月

骨音（Bone Song）欧文·皮科克 Irvine Peacock 长500mm，高395mm 2001年

历史学家（Historian）欧文·皮科克 （Irvine Peacock）长760mm，高760mm 2002年

等待早餐（Waiting for Breakfast） 欧文·皮科克 Irvine Peacock 长620mm，高910mm 2003年

警告（Warning） 欧文·皮科克 （Irvine Peacock） 长310mm，高290mm 2008年

窑制容器 (Large Raku fired vessel) 戴维·琼斯 (David Jones) 2001年

两件窑制容器 (Two Raku—fired Vessels) 戴维·琼斯 (David Jones) 2001年

容器（破碎的心）（Vessel Broken Hearted） 戴维·琼斯（David Jones） 2001年

容器俯瞰图（Vessels from above） 戴维·琼斯（David Jones） 2001年

# 后　记

　　"大师艺术教育经典"是上海市高校教育高地建设项目，为上海市人民政府关于艺术教育设立的重点项目之一。

　　上海市高校教育高地建设是上海市教育委员会全面贯彻落实"科教兴市、人才强市"战略决策和上海市教育工作会议精神，切实加强上海高等教育内涵建设的重大举措，其目的是为上海城市发展和经济建设提供人力资源保障，使优秀的治学精神与风范百代传承，泽被后世。

　　"大师艺术教育经典"结合"十一五"规划，在美术教育界推出10位具有世界影响的艺术教育大师。这10位大师亲历、见证共和国美术教育发展的历程，本身就是一部生动的新中国美术教育发展史。他们在各自的专业领域成绩斐然，成为该领域的学科带头人。总结其艺术教育人生经历，展望艺术教育前景，将为中国当代艺术教育建立一个经典型、权威型的人才知识库，为当今艺术教育提供借鉴，为中国民族文艺复兴起到推波助澜的作用。

　　该丛书旨在展示一种教学成果，发扬一种治学精神，光大一种教育理念，并为艺术院校的学科建设服务，建立一种可资借鉴的精神风范，树立一种治学与教学的长期楷模！

　　布华顿为我国玻璃艺术教育的开创者，他是将英国玻璃艺术引入中国美术教育的先行者，改变了以往把玻璃作为材料应用于工程的现状，使其成为一种独立的艺术形式，为学院派玻璃艺术奠定了基础。在玻璃艺术教育人材的培养和结合中国国情改革课程体系方面，布华顿作出了大量的实践，并且为中英玻璃艺术交流付出了辛勤的劳动。

　　在编书过程中，我们得到了当年留学英国学习玻璃艺术的老师的积极响应、配合与支持。他们用大量时间，接受了我们的专访，并提供了关于布华顿教学、评论和从艺的相关资料。

　　我们尽量尊重本人、尊重历史，客观地、原汁原味地进行史料性保存与记录工作，以抛砖引玉、去伪存真，为今后相关专业研究人员提供翔实的史料，共同梳理、推进新中国艺术教育的光辉成果，并向这批经过历史洗礼、勤恳耕耘在第一线的美术教育工作者们致以崇高的敬意！

　　此外，对刘向娟老师的前期编撰工作和赵炯蔚老师的翻译以及马丽丽、沈忱、杨炜的编排设计工作表示衷心的感谢！

　　本丛书获得上海市教委"教育高地建设"项目的资助，并得到上海书画出版社的大力支持，特此鸣谢！

<div align="right">

汪大伟

2010年7月

</div>

**图书在版编目（C I P）数据**

大师艺术教育经典.布华顿 ／吕坚主编.—上海：上海书
画出版社，2011.4
　ISBN 978-7-5479-0164-9
　Ⅰ.①大… Ⅱ.①吕… Ⅲ.①玻璃－工艺美术－英国－现
代－文集 Ⅳ.J527.3-53
中国版本图书馆CIP数据核字（2011）第014413号

总 策 划　汪大伟
主　　编　吕　坚

责任编辑　金国明
统　　筹　华逸龙
审　　读　朱莘莘
技术编辑　钱勤毅
责任校对　柏　龙

大 师 艺 术 教 育 经 典
## 布华顿
吕坚主编

上海书画出版社 出版发行
地址：上海市延安西路593号
邮编：200050
网址：www.shshuhua.com
E-mail：shcpph@online.sh.cn

上海丽佳制版印刷有限公司制版印刷
各地新华书店经销
开本：635×965　1/8
印张：31　印数：0001-1000
2011年4月第1版　 2011年4月第1次印刷

ISBN 978-7-5479-0164-9
定价：230.00元